THE CRY OF NATURE

THE CRY OF NATURE

Art and the Making of Animal Rights

Stephen F. Eisenman

REAKTION BOOKS

Published by Reaktion Books Ltd
33 Great Sutton Street
London EC1V 0DX, UK
www.reaktionbooks.co.uk

First published 2013
Copyright © Stephen F. Eisenman 2013

Printed and bound in Great Britain by Bell & Bain, Glasgow

A catalogue record for this book is available from the British Library

ISBN 978 1 78023 195 2

Contents

All creatures have been turned into property, the fishes in the water, the birds in the air, the plants on the earth; the creatures, too, must become free.

Thomas Müntzer, *Hochverursachte Schutzrede* (1524)

All wholsom Food is caught
without a net or a trap.

William Blake, *The Marriage of Heaven and Hell* (1790)

Once I saw the village butcher slice the neck of a bird and drain the blood out of it. I wanted to cry out, but [the butcher's] joyful expression caught the sound in my throat. This cry, I always feel it there.

Chaim Soutine

Introduction

In the middle of the eighteenth century, a new perspective on animals started to challenge prevailing viewpoints. Appearing in learned treatises and children's books, popular poetry and visual art, it proposed that animals were neither slaves nor unfeeling automata, and that they possessed the capacity to feel and perhaps even to think. It further suggested that the biblical injunction to humans that they exercise dominion over animals was mere prejudice and that animals might in fact possess certain rights. But the movement to protect animals was riven by disagreement from the start, with proponents divided into two main camps.

The first employed a reformist or animal-welfare discourse, derived either from the long tradition of Christian paternalism or the new philosophy of utilitarianism. As God's anointed stewards, one strain of the reformist argument went, humans were responsible for protection of the 'brute creation', and abuse of animals was a violation of the principle of just sovereignty.[1] Another strain of reformism, drawing upon Jeremy Bentham's utilitarianism, employed a quantification of pleasure and pain (a so-called 'hedonic calculus'), proposing that if certain actions increased aggregate happiness for beings capable of that sentiment (animal as well as human), they were to be promoted; and if they increased aggregate unhappiness, they were to be condemned.[2] Therefore since wanton cruelty to animals greatly increased pain – offering pleasure only to the isolated and morally deranged torturer – it should be discouraged or prevented. Utilitarian logic did not proscribe all exploitation or killing of animals, however. If the benefit was great enough – say, because of

the large number of humans who benefited from the meat and skins of animals – then it was perfectly all right to kill them, albeit as humanely as possible.

In some instances, animal welfare advocates in the late eighteenth and nineteenth centuries, such as the Reverend William Paley, combined Christian and utilitarian perspectives, proposing that their faith decreed that animals be granted certain basic rights such as protection from 'wanton, and what is worse, studied cruelty', while still upholding the God-given dominion of humans over brutes.[3] And in fact, since the time of Paley, limited rights and protections for animals have been gradually codified in law, and many national and local societies for the 'prevention of cruelty' were established to ensure their proper enforcement.[4] Animal welfare organizations such as the RSPCA (established 1824) in Britain and the Humane Society of the United States (established 1954) are a legacy of this reform tradition.[5]

However, a second, non-welfarist approach to animal rights – more radical in theory and more encompassing in its intended practice – also emerged at the end of the eighteenth century. It was the product of the Enlightenment cult of nature, abolitionism, and the universalistic aspirations of French and English Jacobins in the years following the start of the French Revolution in 1789. This movement proposed a veritable overturning of human–animal relations. Its adherents believed that humans had no God-given or natural right to exploit animals at all – for food, clothing, research or any other purpose – and that the laws of nature cried out for universal freedom and mutual respect for all. The Scottish Jacobin John Oswald's book *The Cry of Nature* (1791) is the most forceful early expression of this position, and a veritable manifesto of animal liberation long before Peter Singer's book of that title.[6] His position is both ecological and moral. Arguing that the vegetable kingdom can supply all the food and other resources people need without recourse to bloodshed, Oswald's personified Nature – represented as a many-breasted Pomona in a frontispiece etching by James Gillray – asks humanity:

Why shouldst thou dip thy hand in the blood of thy fellow creatures? Have I not amply, not only for the wants, but even

Attributed to James
Gillray, frontispiece
to John Oswald, *The
Cry of Nature* (1791).

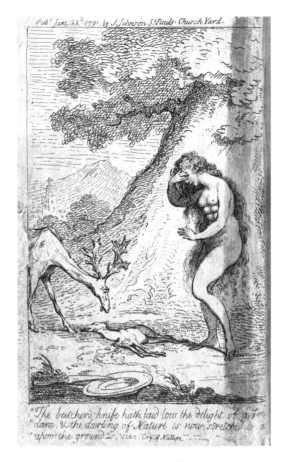

"*The butcher's knife hath laid low the delight of a fon*
"*dam, & the darling of Nature is now stretched*
"*upon the ground* – Vide 'Cry of Nature' ——

for the pleasures of the human race provided? . . . [Why]
dost thou still thirst, insatiate wretch, for the blood of this
innocent lamb?[7]

Though less frequently cited by later reformers than the sober
Bentham, Oswald now appears to have been the more original and
incisive. His book marks the start of a tradition of texts – veritable
manifestos – that may be called' abolitionist' in their demand for
an end to the enslavement of animals by humans, and the initia-
tion of a new age based upon recognition of an individual creature's
rights and autonomy.[8] But just as with slavery, it was not only enlight-
ened reformers who advanced animal abolitionism; it was also the
oppressed themselves. Animals demanded their emancipation. This

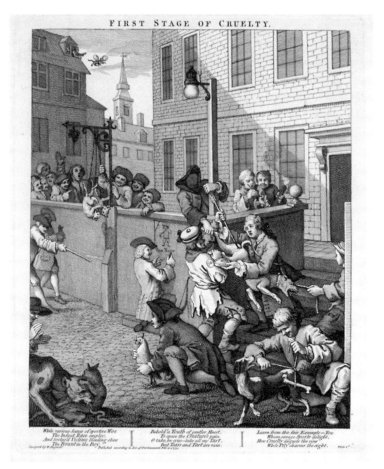

William Hogarth, 'First Stage of Cruelty', from *The Four Stages of Cruelty*, 1751, engraving.

proposition will be elaborated later, but for now I owe the reader a brief explanation of what I mean.

During the late eighteenth and early nineteenth centuries, farm and working animals entered the theatre of history.[9] Their mass congregation in stockyards and slaughterhouses, their roles in trade, manufacture and transportation, and their symbolic importance for the wealthy (in feasting, hunting, riding, breeding and racing) made them essential in the lives of hundreds of thousands if not millions of people. But by virtue of their very numbers and close congregation, they came to perceive at a somatic level their common exploitation

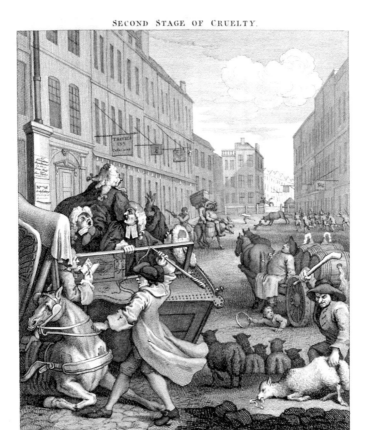

Hogarth, 'Second Stage of Cruelty', from *The Four Stages of Cruelty*.

and suffering, and to find ways to protest and even resist it. Scientific research conducted in the late 1950s first proved that animals confined in tight quarters or who are about to be killed emit fear pheromones detectable by other animals through vomeronasal organs, found at the base of their nasal cavities.[10] These animals in turn produce stress hormones that trigger the classic and recognizable signs of fear: rapid breathing and heart rate, agitated movements, sweating and loud, agitated vocalizations. Such contagious behaviours clearly impeded the slaughtering process in early modern markets and abattoirs and thus may be considered forms of resistance. And while they probably

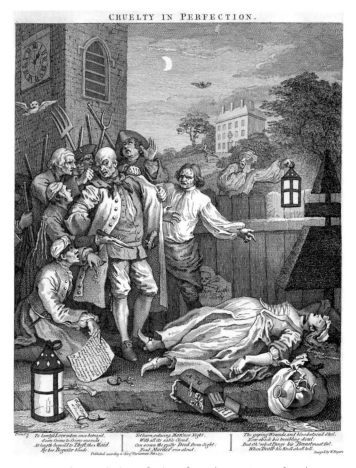

Hogarth, 'Cruelty in Perfection', from *The Four Stages of Cruelty*.

did not save many animal lives, they made the process of killing slower, more dangerous and more expensive. Moreover, the public spectacle of animal terror, and the din caused by animal outcries, increasingly attracted human sympathy. Recognizing these manifest signs of fear and resistance in animals – perhaps even smelling the fear itself – some people decided they must intervene to stop the slaughter.[11] It was thus the combination of animal protest and public compassion that generated the first campaigns for animal protection – as well as efforts by the meat industry at their suppression.

The Cry of Nature traces the main paths of critical thought and art about animals from roughly the middle of the eighteenth century to

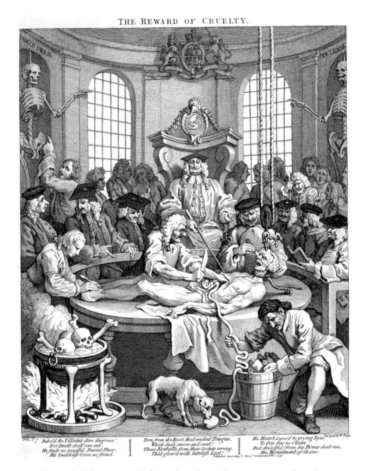

Hogarth, 'The Reward of Cruelty', from *The Four Stages of Cruelty*.

the beginning of the twenty-first. And though the history of ideas cannot be precisely mapped on to the history of art, a shared direction and mutual reinforcement is nevertheless clear. Indeed, the image of animals, as well as their actual sight, sound and smell, has always been instrumental in their treatment by humans. The visual tradition of animal welfare and rights begins approximately with the English artist William Hogarth, whose *The Four Stages of Cruelty* (1751) was an indictment of blood sports and animal cruelty that was in advance of most writers or philosophers of his time. Though its basic point – that childish cruelty to animals conditioned adults to criminality and violence – was widely held, it had never been so

clearly and vividly rendered, or been circulated in such an accessible form.[12] Hogarth's series is unique in his *oeuvre* for having been initially cut on wood and subsequently on steel to ensure the widest distribution – 'so that men of the lowest rank' may learn its moral lesson.[13] A generation after Hogarth, the animal painter George Stubbs took an additional step toward the creation of an art of animal protection. His paintings of horses, dogs and other wild and domesticated animals, such as *Gimcrack on Newmarket Heath with a Trainer, a Stable Lad and a Jockey* (c. 1765), possess a previously unknown and even startling verisimilitude and expressiveness, the result both of deep, anatomical research and an obvious sympathy with his subjects. The inevitable result for Stubbs was images that attest to the particularity of his animal models, and the suggestion that they possessed minds and intentions independent of their wealthy owners or keepers. Works by Hogarth and Stubbs were in fact specifically cited by many reform-minded authors and theorists – and the figures John Trusler, Thomas Young, John Lawrence and John Scott are notable here – who were influential in determining the development of animal welfare policies in the early nineteenth century.

The more radical approach to animal rights found in Oswald's *Cry* is less clearly exposed in the work of Hogarth and Stubbs than in the contemporary and succeeding Romantic generation of artists, including William Blake and Théodore Géricault. The former, whose poetry may be more ardent in this respect than his art, argued that the

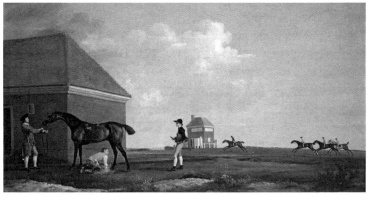

George Stubbs, *Gimcrack on Newmarket Heath with a Trainer, a Stable Lad and a Jockey*, c. 1765, oil on canvas.

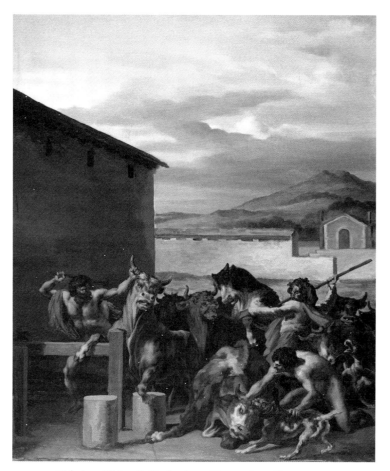

Théodore Géricault, *The Butchers of Rome*, 1817, oil on canvas.

abuse of animals augured a crisis in the political and social order. The latter, in one important group of works titled *The Butchers of Rome* (1817), depicted the contest between slaughterers and animals in a Roman abattoir as an epic or revolutionary struggle, like the battles of Alexander in Persia, or Napoleon in Egypt. And echoes of Oswald's radicalism may be seen as much as a century later in the work of Chaim Soutine and Pablo Picasso, and later still with Francis Bacon, among others. For these artists, the treatment of animals as mere things – meat to be consumed, fur to be worn or laboratory specimens to be experimented upon – signified the extreme of modern alien- ation and an assault on their sense that humans were in fact animals,

and animals were in many ways human. Thus my goal in this book is not to provide a general survey of animals in art (indeed, many major animal painters are left out of this account), but to describe and explain the ideological trajectory of the movement for animal rights and the position of art and artists within or alongside it. In some cases, as we will see, artists were in the avant-garde of animal rights and protections, and in others not. But in all instances, artists brought substantively different insights from writers to the definition and role of the animal – understandings based upon the unique, perceptual character of visual art.

Today a growing number of artists and theorists posit that the longstanding hierarchy that placed humans at the pinnacle of creation must be overturned in the name of a new, posthumanist logic that understands people as one among many animal species and due no more deference than any other. Indeed, recent changes in the global political, economic, social and ecological order have revealed that the long upheld divisions between human and non-human animals have become increasingly untenable. Revelations concerning the co-evolution of humans with other animals and what has been called 'the animal connection' (the hundred-millenia-old bond between humans and animals), the vulnerability of humans to harmful micro-organisms, pathogens and mutagens nurtured in factory farms, the role of industrialized agriculture in global warming, and new discoveries concerning the complex intellectual and cultural capacities of animals have all contributed to the sense that humans may no longer consider themselves the crown of creation.[14] In such a context, the vision – artistic and imaginary – of human and animal relations must change. It is the argument of this book that the changes started in the middle of the eighteenth century may now be reaching a kind of crescendo. A new age has begun in which animals are ever more tightly bound into the web of human social relations.

What is an Animal?

MORAL RIGHTS

While it is easy to visually distinguish animals from humans – infants can discern differences in body format as early as six months – it is much harder for people to ascertain moral differences between animals and humans. Do humans have a remarkable quality that implies that they alone deserve to possess basic moral rights or consideration, for example, the right to life and liberty, and the right not to be experimented upon, hunted, killed and eaten? Can the mere fact of membership in the species *Homo sapiens* be enough to justify the infliction of pain and early death on other animals?

Prior to the modern period, it was generally claimed that only humans had the capacities and skills germane to the possession of moral rights. These included basic sentience (sensitivity to pain and pleasure), language, emotion, empathy, tool use, close family ties and the possession of culture, the latter being a socializing instrument that allows intellectual, expressive and technological discoveries to be passed down to successive generations. Absent of these capacities, it was argued, an animal would not suffer from the denial of freedom or even the loss of life itself. But a brief review of the research concerning sentience, language use and consciousness (including self-consciousness) in animals will call into question any capacities-based argument for the denial of moral consideration – of basic rights or consideration – to animals. Equally importantly, the very idea that there is a fundamental human–animal divide, like that between predator and prey, is simply not one to which people have universally subscribed. Though humans have always scavenged

19

and sometimes hunted, they are primarily herbivores by evolution-ary design.[1] Thus, unlike lions and wolves, they do not view other large animals as prey.[2] Indeed, humans may possess what has been called an 'animal connection': an intimate and reciprocal bond with animals that began with early hominids more than 2.5 million years ago and includes the adoption (or alloparenting) of non-human animals, domestication, nurturance, communication, co-habitation and co-dependence.[3]

Human hunter-gatherers (also known as 'foragers'), whose life-ways prevailed for the first 70,000 years of anatomically modern human history, variously understand people and animals to be part of a common landscape or shared life force, and not ontologically dis-tinct. This perspective, foreign though it is to Western understand-ing, may in fact be much closer to a Darwinian view that recognizes the shared evolutionary lineages of humans and other species. Artworks made by hunter-gatherers – for example, by animists such as the Inuit in the circumpolar north, and by totemists in Aboriginal Australia – therefore propose an answer to the question 'what is an animal?' that is quite different from the conventional Western one.

LANGUAGE

All animals possess language in the broadest sense of the word. At both the macro-organic and the cellular level, they are constantly engaged in a process of semiosis: the exchange, collection and ordering of signs. Semiosis allows an animal to obtain from its envi-ronment the data necessary to facilitate growth and reproduction and avoid danger.[4] By means of chemical and electrical impulses, messages and codes, energy is constantly transferred to and from cells within an organism, and to and from whole organisms and their environment. These electrical and chemical signs are com-bined to form communicative matrices that range in design from the nerve nets or receptors found in the epidermises of jellyfish to the central and peripheral nervous systems of mammals, the latter comprising autonomic and somatic systems, with their correspon-ding brains and spinal cords. These systems and organs perform complex evaluative and communicative acts.[5]

Animals communicate with each other and interact with their environments by means of their varied senses and organs of expression. Animals may signal aggression, alarm or amorous intent by displaying and moving certain body parts, employing grunts, calls or songs, leaving marks on their environment, depositing scent or emitting chemicals such as pheromones. They may communicate in more or less automatic ways in response to certain stimuli, or they may express themselves with considerable nuance and exhibit significant cognitive abilities. Most monkey species – but some other animals as well, including squirrels, marmots and even chickens – exhibit what has been called 'referential' signalling; that is, vocalizations that 1) have a distinct structure, 2) are produced in response to specific stimuli, and 3) elicit the same response that would have been aroused had listeners confronted the stimulus directly.[6] But far more nuanced, proto-linguistic vocalizations are widespread among primates.

Vervet monkeys, for example, learn to call out distinct alarms for each predator they encounter, such as leopards, eagles and pythons.[7] The escape response to each is also different: if it is a leopard, the monkeys climb up a tree and out onto a narrow limb; if an eagle, they hide in the bushes; and if a snake, they stand on their hind legs and look all around in order to be poised to flee, since they can easily outrun any snake. Vervets practise these skills when they are young, with correct calls repeated by the adults and incorrect ones met with an admonishment. A researcher observed that after a mother vervet scrambled up a tree in response to her offspring's mistaken call that a leopard was approaching, she quickly descended and gave her child a sharp rap as punishment.[8]

The greater spot-nosed monkeys of West Africa do even better, combining and multiplying distinct calls into something like sentences, which may be used to precisely direct the movements of the troupe.[9] Among the rhesus macaques of Cayo Santiago island near Puerto Rico, there exist what Donald Griffin called 'semantic screams'.[10] Researches have identified five clearly distinct categories of screams by young males, with their use dependent upon the age and kinship status of the antagonist. In addition, each scream will prompt a different defensive response from the protective mothers of the boys,

ranging from simple attentiveness to charges and threat displays. Diana monkeys employ 'semantic modifiers' to inflect the meaning of alarm calls.[11] And great apes – chimpanzees, bonobos, gorillas and orang-utans – are known to use a vast and complex range of gesture to express a variety of wants and needs, and to attain specific social goals.[12] Many gestures are invented by individuals, used only within a particular community and then passed down to successive generations, an example of what may be called 'cultural development'. The full extent of the expressive and communicative abilities of primates is the subject of much research and debate.

In describing primate communications, many researchers prefer the word 'proto-linguistic' to 'language', reserving the latter term for humans alone. And indeed it remains controversial to propose that non-human animals possess language; that is, forms of communication that rely upon syntax, the latter defined as rule-based combinations of words that both retain discrete meanings and are mutually inflective. (An example of the use and understanding of syntax is the phrase *The purple spotted dog*, which describes two distinct characteristics of one unusual canine, not a single combined being. The rules of phrase structure allow us to understand it even though we have never seen such an animal.) And while it is apparently true that non-human animals lack the ability to form and recognize morphemes and phonemes (the smallest meaning and sound units of speech), research into the language abilities of parrots (the famous African grey parrot Alex), dolphins (Ake and Phoenix) and bonobos (Kanzi and Panbanisha) has shown that these animals are capable of 'discrete combinatorics' – the ability to understand and perform an expressive action with words or sounds and still understand that each has a discrete meaning.[13] Certain animals can understand, for example, that a 'red doll' is a toy of a certain colour, not a unique object intermediate between the two words. Alex, in fact, who worked for 30 years with animal psychologist Irene Pepperberg before his death in 2007, was able to master category-based rules, accurately describing the characteristics of things he had not seen before by using words he had learned in a different context.[14] So, for example, when presented with a piece of triangular rawhide, he described it at first as 'three-corner paper', with which he was

familiar. But after chewing it, he corrected himself by calling it 'three-corner hide', with which he was unfamiliar, though he did understand rawhide. When presented with an apple, he called it a 'banerry', combining the words 'banana' and 'cherry', which he knew. He was also capable of counting up to six objects, and understanding the number zero.

At the Kewalo Basin Marine Research Laboratory in Honolulu, founded in 1970 by Louis M. Herman, and then later at The Dolphin Institute, resident bottlenosed dolphins – including Ake and Phoenix – were trained to understand gesture- and acoustic-based languages and to carry out commands.[15] The sentences were generally between two and five words in length, and the word order mattered, so that 'person surfboard fetch' meant 'bring the surfboard to the person', while 'surfboard person fetch' meant 'bring the person to the surfboard'. The dolphins were thus able to master the syntactic as well as semantic components of language, albeit at a somewhat rudimentary level. They were also able to understand the concept of presence/absence; they were trained to correctly touch a white paddle when an article was present, and a black one when it was not.

Perhaps the most remarkable successes in animal language acquisition have been among the great apes, particularly chimpanzees and bonobos. The chimpanzee Washoe at Central Washington University, who in the late 1960s was taught a simplified version of American Sign Language (ASL), is especially well known, though his achievements remain controversial. The initial use of operant conditioning to train Washoe (rewards for correct answers, mild rebukes for wrong ones) led some scientists to argue that her correct signing was nothing more than stimulus-response behaviour. In addition, the natural adeptness of the great apes at detecting subtle behavioural expressions – known from the work of Jane Goodall, among others – caused concern that Washoe only chose the correct signs because she was being unintentionally cued by her human minders in what is sometimes called the 'Clever Hans effect'. (Hans was a Russian trotting horse who lived in the early twentieth century in Berlin, Germany. Believed by his owner to be able to understand German and perform complex mathematical feats, he was later revealed to be following subtle and inadvertent physical cues in order

to arrive at his correct answers.[16]) Nevertheless, the many elaborate precautions taken to prevent cueing, plus Washoe's increasing capacity to generate new meanings on her own by means of word order and word combinations (syntax), as well as her invention of new words (portmanteau words, or a single morph derived from two morphemes), suggests that her basic mastery of ASL was real. (The instruction was successfully repeated with the gorilla Koko and the orang-utan Chantek.[17])

The bonobos Kanzi and his sister Panbanisha, born at the Language Research Center at Georgia State University and trained by Sue Savage-Rumbaugh, are capable of hearing words and pointing out their equivalent lexigrams (symbols for words and concepts), and of combining lexigrams to produce commands and questions.[18] They are also capable of roughly drawing the lexigrams with chalk in order to express a wish. For example, when Pabanisha wanted to go for a walk in the adjacent forest, she drew on the floor of their laboratory the lexigrams for 'woods', 'A-frame lodge' (a small building that they generally visited) and 'collar', which she must wear whenever she goes out.[19] In addition, she can understand spoken commands that require an understanding of syntax, ('Pabanisha, put the salt in the water'), and is able to consider past and future and her own place in time. For example, she could indicate by sounds and lexigrams her understanding that because of her bad behaviour the day before, she could not go out today, but that if she behaved better today, she would be able to go out tomorrow. Though these are relatively simple utterances, many researchers argue that Kanzi and Panbanisha – as well as the apes that use ASL – possess a 'proto-grammar' at the very least.[20]

All these studies indicate that many non-human animals are capable of marshalling language or at least proto-language, including basic rules of syntax, in order to follow directions; express aversions, preferences and intentions; and describe or enumerate the objects or people that are presented to them. But the greatest unanswered question concerning language use is not whether a bird, marine mammal or primate can learn to understand a limited number of human words, and reply using signs or symbols, nor whether it can correctly name objects or communicate likes and dislikes. It is whether it can deploy

language of whatever sort as a form of cognition – as a means of satisfying curiosity, understanding the natural environment, remembering past events and imagining future worlds. And beyond cognition lay the question of animal consciousness itself.

The great ethnologist Lewis Henry Morgan in his *The American Beaver and his Works* (1868) claimed that the variety of beaver lodges indicated the existence of animal intelligence and 'animal psychology' (he may have been the first to use the phrase):[21]

> When a beaver stands for a moment and looks upon his work, evidently to see whether it is right, and whether anything else is needed, he shows himself capable of holding his thoughts before his beaver mind; in other words, he is conscious of his own mental processes.[22]

In common with Morgan, Donald Griffin believed that beavers, and indeed many animals, possess self-consciousness and intellect – though of varying depth and complexity – and that the only reason (apart from prejudice) that humans do not recognize this is that non-human animals are mute. Echoing Morgan, Griffin wrote, 'I do not yet know of any way to ask a beaver whether it contemplates

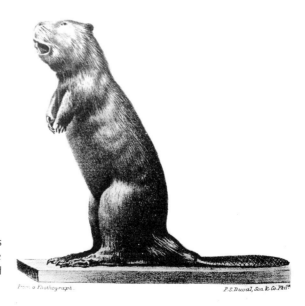

Frontispiece, Lewis Henry Morgan, *The American Beaver and his Works* (1868).

a pond as it drags mud and branches to the middle of a shallow stream.'[23] It is precisely the 'beaver question' – consciousness and what the cognitive psychologists call 'Theory of Mind' (ToM) – that bedevils considerations of the cognitive capacities of non-human animals.[24] If animals truly possessed ToM, or even some semblance of it, then they would certainly be capable of being wronged, and would be owed significant moral consideration: they would have to be granted rights.

Consciousness

The Swiss child psychologist Jean Piaget argued that communication with others is merely one among many functions of language. Words may also be organized into assertions, exclamations and cries of anguish, joy and desire. For children especially, language may have 'a significance that is not only affective, but well-nigh magical', producing immediate, sensual gratifications.[25] The American linguist Noam Chomsky went much further than Piaget, arguing that language was 'associated with a specific type of mental organization' unique to human beings. Dismissing the evolutionary argument that human language was simply a more complex version of animal communication, he argued that for animals, linguistic elements exactly correspond to specific behaviours: for example, the vervet's cry signals flight, Panbanisha's lexigrams help her to obtain walks and choice food morsels and, to cite an example of Chomsky's, the rate of alternation of pitch in a European robin's song precisely indicates her willingness to defend her territory.[26] For humans, on the other hand, language does not easily map onto behaviour. People possess a 'universal' or 'generative grammar' permitting them an infinite range of utterances, most of which are non-propositional and non-behavioural. Humans may use language to reflect upon the cognitive capacity of non-human animals, consider the evolutionary advantage of consciousness over mere cognition or even evaluate the history of the representation of animals in art. Animal and human language are thus two entirely different processes and systems, Chomsky argued, no more alike – and with no more evolutionary relationship – than breathing and walking.

Chomsky's *Language and Mind*, from which this brief summary was drawn, was first published in 1968, during the heyday of behaviourism and before the development of cognitive ethology. The parrot, dolphin and primate studies discussed earlier would appear to have put paid to the idea that animals lack significant cognitive capacities, but what about the idea – central to Chomsky's position – that only humans possess a generative grammar that permits them nearly infinite breadth of thought and imagination?[27] Less expansively, do any animals have the capacity to consider the feelings and ruminations of other animals, possess empathy or reflect upon the functioning of their own minds and being? That is, do they possess ToM?

ToM may be considered second-order or meta-cognition. To have ToM is to possess 1) sentience – the experience of pleasure and pain; 2) cognition – emotions, a sense of physical existence and bodily limits; 3) self-consciousness – the recognition that I am I and not you or some other creature; and 4) the knowledge that other beings possess separate and distinct sentience, cognition and self-consciousness – in other words, intuition and empathy: the capacity to feel what others feel and have concern for their well-being. The concept of ToM was first developed by the psychologists David Premack and Guy Woodruff in 1978 in a study of chimpanzees, but has since been widely deployed in human brain and behaviour studies as well as ethology.[28] Researchers have sought, for example, to determine the stage of development at which human children are typically capable of detecting intentional versus accidental behaviours, and which other animals possess the same abilities.[29] Chimpanzees, orangutans and two- to three-year-old children, for example, have all been shown to have this basic, intuitive capacity.

One does not have to be a professional psychologist or ethologist, however, to be able to recognize at least the rudiments of ToM in non-human animals. For example, if I accidentally step on the foot of my dog Echo, she yelps in pain, but does not shrink from me, or drop her ears as she does when she knows I am angry with her for excessive barking or jumping up. She knows it was an accident. Even if I unintentionally kick her, as sometimes happens when we are running together, she knows I mean her no harm, though as a formerly

abused shelter dog she has undoubtedly felt the sting of the boot and shrunk from it. Echo understands my intention and appears to recognize that human mood and affect is changeable and contingent upon ambient circumstances.

A further instance of this sensitivity to affect is Echo's evident sense of humour. When I first started to play Frisbee with her, she would leap high in the air to catch the disc in her mouth, and sometimes tumble on the soft grass as she landed. On one occasion, she actually fell into a somersault, making me laugh. Since then, she sometimes purposely does somersaults, but also rolls, tumbles or performs other slapstick to see if she can make me laugh again. Is Echo trying to discover the extent of my sense of humour? Also, when we start out on an off-lead run, I usually ask her to sit completely still before saying 'Go!' Sometimes I have to call her back when she starts prematurely. In one instance, however, she started from her sit, but then quickly stopped and sat back down again before I could even say 'Come back.' She did this twice more to see if she could get me to call her back before she stopped and sat by herself, wagging her tail and pulling back her gums in an unmistakable doggy grin. She had turned the tables on me, playing master to my servant, and seemed greatly amused by her own trick.

Ethologists and psychologists generally dismiss as useless anecdotes about animal consciousness like these about my dog Echo. For them, the gold standard is carefully controlled studies done in laboratories and research centres. But this objection presupposes that there exist pure, natural or uncontaminated environments that enable scientists to obtain access to the essential character of animal minds, whereas it is far more likely that the laboratory setting itself inhibits the expression of the full range of animals' communicative and expressive abilities. Moreover, the sheer quantity of time that humans spend with their animal companions, not to mention the close, even obsessive attention that each pays to the other, suggest that greater insights may be obtained through non-professional looking and describing – anecdotes – than is generally allowed. Such informal research may be understood as a version of the anthropological 'participant-observation'. Rather than viewing human–animal interactions as always essentially contaminated, we should view them

as one among many types of interspecies communication and exchange, each of which has its own particular dynamic.

In any case, even the most rigorously controlled laboratory research has to date yielded only approximate conclusions regarding the existence of ToM in animals. Indeed, for a determined behaviourist, what appears to be evidence of mind can always be attributed to operant conditioning, or a stimulus-response mechanism: if Panbanisha signed to Savage-Rumbaugh that she had been well-behaved the day before and therefore expected to go for a walk in the woods today, it was not because she understood the concepts of past and present, or of actions and consequences, but because obedience to a specific behavioural rule was immediately associated in her mind with a reward such as going out for a walk in the woods. If Echo yelped but did not cower when I stepped on her foot, it was not because she intuited that I meant her no harm, but because the first time it happened, I gave her an apologetic pat on the head, and she ever after associated the two events. (If she ever begins to perform handstands for my amusement, it will presumably be because some prior accidental acrobatics were rewarded with approbation!)

Given the great difficulty of objectively locating and identifying mind, whether in animals or humans, many biologists, psychologists and philosophers remain agnostic on the whole question. Donald Griffin preferred to speak of 'perceptual consciousness' rather than 'reflective consciousness' or ToM. Perceptual consciousness means conscious awareness, including 'memories, anticipations, or imagining non-existent objects or events as well as thinking about immediate sensory input'.[30] For Griffin, such consciousness, including self-awareness, may be found in many animal species from ants to great apes. Self-awareness, however, does not require that animals concern themselves with the thoughts of others. Animals are themselves behaviourists, deeply engaged with what others do, not what they think.[31]

The philosopher Gary Steiner has recently made an argument similar to Griffin's, though he bases it on the theory of associationism, first developed in the seventeenth and eighteenth centuries by John Locke, George Berkeley and especially David Hume. Because animals are non-linguistic, Steiner argues, they are incapable of

drawing rational inferences, or building abstract theories from events or experiences beyond their 'specific contexts of action'.[32] They draw their understanding from their physical senses (as Hume argued that humans did). Lacking innate ideas, an animal's reactions to present stimuli are therefore based upon associations with anterior perceptions and experiences. For example, if a dog had once been beaten after hearing the bass tones of a man's voice, she might begin to associate men (or low notes) with physical threat; if she was once petted and rewarded after hearing a woman's higher timbre, she might associate all women (or treble notes) with safety and comfort. And the chains of association could be long and complex, accounting for what rationalists such as Descartes supposed – in the case of humans alone – were abstractions arising from the mind and the exercise of pure reason.

For Steiner, Hume's associationism fails to account for the cognitive breadth and complexity of human thought, but does offer a viable model for animal cognition, since, as he states, 'all the inferences made by animals are perceptual'.[33] He does not mean that animals are not conscious, or that they function like the machines imagined by Descartes and behaviourists, but that they understand their world and draw inferences based upon sensual perceptions and mental representations. When Echo jumps into my car, she has no idea whether she is going to my campus office, the supermarket (where she will remain in the back seat while I buy groceries) or the vast and alluring Prairie Wolf dog park in nearby Deerfield. But by the time I have made the third or fourth turn, she has a pretty clear idea of where she is headed. If to the first or second destination, she lies down quietly on the seat, sometimes sitting up to look out the side window, or to press against the door to steady herself for a sharp bend in the road. But if we are going to the dog park – even though it is as yet three more turns and 5 miles away – she stands on all fours, yips, perks up her ears, sniffs the air and tenses with excitement as if she can already see, hear or smell the other dogs she will soon meet. Echo clearly has a set of mental images and maps in her head, some of which trigger patience or resignation, and others anticipation and excitement. To be sure, her reactions could also be accounted for along behaviourist lines; but, as Steiner observes, dogs – like

many other animals – have such powerful organs of perception that it is highly likely that her mental associations are accompanied by complex and subtle representations or images.[34]

Consciousness need not be linguistic, as studies of babies and people who have had massive left-hemisphere strokes or injuries have indicated. Individuals with such impairment are unable to receive or produce language, but are fully conscious, capable of complex thought and able to understand and display a complete range of emotions. For this reason, some scientists argue that 'primary process conscious abilities' or 'core consciousness', based upon perception and emotion, is fairly common in nature, though hard to demonstrate in the laboratory.[35] However, the psychologist Jaak Panksepp has recently used positron emission tomography (PET) studies to demonstrate the similarity of deep, subcortical responses between humans and animals when they are subjected to events with strong emotional cues. Logical parsimony and evolutionary logic suggest that these common brain responses must indicate common affective experiences. (In 1872, Charles Darwin in his The Expression of Emotions in Man and Animals first posited an emotional and affective evolutionary continuity between humans and animals.) The complex perceptual and emotional experiences of animals are therefore probably best understood as versions of thought.[36] ToM, however, appears to be inadequate to describe the different types of consciousness in non-human animals.

Though a vast body of research and writing, as we have seen – evolutionary, ethologic, ecologic, philosophic, linguistic and neuropsychological – describes the difference between human and non-human animals, the distinctions are in the end elusive and highly contingent. One after another, the traditional distinctions between human and non-human have fallen away: capacity for pleasure and pain, play, tool use, language, learning and culture itself are no longer considered the sole domain of humans. A recent much-discussed study published in Science has shown that empathy or 'an other-oriented emotional response elicited by and congruent with the perceived welfare of an individual in distress' is characteristic of laboratory rats.[37] When confronted with a trapped rat, a free rat will do everything it can to liberate its cagemate, even when offered chocolate instead, one of

its favourite foods. (After liberating the caged rat, the free one shared its chocolate.) Consciousness, memory, emotion and empathy may therefore be characteristic of animals as well as humans, with the differences between them appearing more and more to be quantitative rather than qualitative. This idea is very much in keeping with classic evolutionary theory, which posits continuity between species provided that a given character is adaptive to its evolutionary niche – and it would be highly unlikely if consciousness, at least perceptual and emotional consciousness, were adaptive only for humans. The argument for denial of moral rights to larger or more complex animals on the basis of their diminished capacity must therefore collapse in the face of the mountain of evidence for animal intelligence.

ETHNOLOGY

Research into animal biology, communication and consciousness – disseminated to the general public through teaching in schools, zoos, museums, books, magazines and popular nature programming on television – has persuaded many people in the U.S. and elsewhere that animals experience pain, and have a right to humane treatment. According to a recent poll, 81 per cent of Americans believe that animals and humans have the same capacity to suffer pain, and 95 per cent said it was personally important to them how farm animals are cared for.[38] But whatever people's stated views, their behaviours are largely the same as they have been for generations. The percentage of vegetarians and vegans in the U.S. – approximately 3.2 per cent and 0.5 per cent respectively – has barely increased in the last two decades, and while the number of hunters and fishermen continues to decline, the reasons appear to be urbanization, lack of free time, the high cost and competition from other more sedentary activities, not concern for animal rights.[39] In addition, people continue to encroach upon or destroy animal habitats through suburban sprawl and pollution, and to support, by their buying habits, the exploitation and killing of animals used in testing for medicines and cosmetics. Nor have widely reported discoveries concerning the linguistic and cognitive competencies of parrots, dolphins and primates earned them special legal rights and protections in the

U.S., though very limited rights have been granted to great apes in the UK and a handful of other countries.[40] This disconnect between expressed views and actual behaviour – with recent signs of possible narrowing, however – suggests that it is not the state of scientific research or public understanding of animals' cognitive and other capacities that determines whether animal welfare or rights are accepted, but what may be called the state of the human and animal class struggle; that is, the actual material and social relation of people and animals to each other and their environment at given moments of history. The point is most clearly made by a brief glance at the behaviour and attitudes of people who live in circumstances very different from those in modern Western capitalist society, namely foragers (also called hunter-gatherers) and pastoralists. Foragers' understanding of human–animal relations – easily as subtle and complex as Western theories of moral rights – arises from completely different premises and arrives at different conclusions. In other words, under diverse social, economic and class conditions, the very definitions of 'human' and 'animal' may vary dramatically.

Anthropologists have taught us that hunter-gatherers such as the Australian Aborigines, the Inuit and the Batek people of Malaysia – whose lives involve moving from place to place, setting up camp at one location and then another, having few personal possessions, being largely egalitarian and essentially living from one day to the next – have a different attitude toward animals from people who live according to the contours of other modes of production. (A 'mode of production' is the way in which a community produces its necessities, and the social life that arises from that productive order.) Though few people in the world now live by foraging alone, this system prevailed for the first 70,000 years of human history, until the rise of horticulture (gardening), pastoralism (herding animals) and agriculture (large-scale farming and animal husbandry). Even then, it was not until the active encroachment into forager terrain – sometimes with genocidal intent – of agricultural and industrial settler societies in the nineteenth and twentieth centuries that this way of life was threatened with extinction. But there exists a sufficient history of direct contact with hunter-gatherers for anthropologists to have been able to piece together a fairly persuasive account of their

life-ways and attitudes toward animals, among other things. Though I can only address this in a very abbreviated fashion, the subject is important because it suggests that changes in the definition and representation of animals over time and across space have not primarily been due to religious injunctions or scientific discoveries, but to transformations large and small in the productive lives and social structure of communities, and the resistance of animal communities to human predation.

Hunter-gatherers generally embrace the idea that animals, no less than humans, possess autonomy; that is, they have active mental lives, exercise choice and construct their own natures, while at the same time being fully part of the nature that surrounds them. This belief is found, for example, among the Mbuti people of the Ituri rainforest in the Congo, the Nayaka of Tamil Nadu, India, and the Inuit of the Arctic. In common with other animists, they believe that life is a free-flowing force that pre-exists any individual being; it spreads everywhere, and if interrupted in one place – say, by a death – it is resumed in another. Thus no single species or individual has greater or lesser worth than another, and the death or ingestion of any creature is significant on a social and even a cosmic level since it perpetuates the exchange and passage of the animating life force. In addition, during the hunt, the unique character and capacity of individuals is recognized; the animal must willingly surrender itself to the hunter, and the hunter, in turn, must treat the prey animal with respect, implicitly acknowledging its autonomy.

This attitude of mutual recognition is suggested by Inuit artist Simon Tookoome's (b. 1934) linocut titled *I Am Always Thinking of Animals*, in which a man extends his mind and thoughts into the body and soul of animals. Each thinks of the other and shares the spirit of the other. Inuit generally believe that animals, in common with humans, possess souls that must be honoured and understood, and the hunt itself is seen not as a contest of wits but a communion between equals. Tookoome explained this perspective when narrating a harrowing hunting trip from his youth:

In the winter of 1957 to 1958, the caribou took a different route to the calving grounds. We could not find them . . .

Simon Tookoome, *I Am Always Thinking of Animals*, 1979, linocut.

and many of the people died of hunger . . . We had thirty
dogs. All but four died but we only had to eat one of them.
The rest we left behind. We did not feel it was right to eat
them or feed them to the other dogs. My father and his broth-
ers had gone ahead to hunt. We had lost a lot of weight and
were very hungry. I left the igloo and I knelt and prayed at a
great rock. This was the first time I had ever prayed. Then
five healthy caribou appeared on the ice and they did not
run away. I thought I would not be able to catch them because
there were no shadows. The land was flat without even a
rock for cover. However, I was able to kill them with little
effort. I was so grateful, that I shook their hooves as a sign
of gratitude because they gave themselves up to my hunger.
I melted the snow with my mouth and gave them each a
drink. I was careful in removing the sinews so as to ease
their spirits' pain. This is the traditional way to show thanks.
Because of what those caribou did, I always hunted in this
way. I respected the animals.[41]

While it is unlikely that caribou would willingly surrender their
lives for any Inuit family, the care exercised by the latter for the

former may create an environment in which an animal's fear of humans is diminished. The struggle between human and animal is thus highly vitiated.

Among the totemist Australian Aborigines, too, hunting is a collective activity, and respect is similarly given to animals that are killed. Meat is fairly distributed to everyone involved in a hunt (as well as to the wider band), and animals are understood to be inextricably tied both to the land in which they are found, and to the mythic time that brought them into being.[42] Indeed, animals are believed to be part of the landscape itself, put there by primordial gods – which the Pintupi of Central Australia call *Tjukurrpa* or 'Dreaming' – that deposited something of their essence as they roamed the early world.[43] In this way, animals, no less than humans, are eternal and essential,

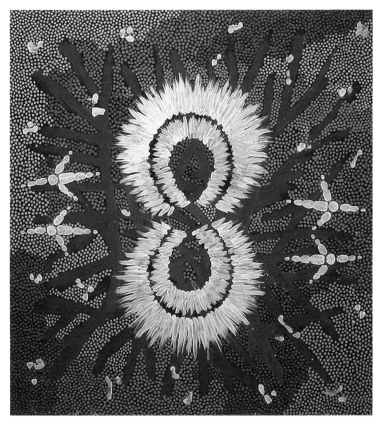

Clifford Possum Tjapaltjarri, *Eagle Dreaming*, c. 1975, acrylic on canvas.

drawing their unique substance and energy from the land. Aboriginal artists, who during the past 30 years have attained great international renown, often represent animals created by the Dreaming. Clifford Possum Tjapaltjarri's painting *Eagle Dreaming* depicts the bird as a white, feathery figure-of-eight impressed upon a primordial land-scape, with white footprints and grey trails branching out across the shimmering Pointillist desert.[44]

So powerful and persuasive are animist and totemic perspectives on the natural world, and of such long duration, that some psychologists, anthropologists and cognitive scientists say they come naturally to people, and are superseded or overcome only with great difficulty. Children, for example, as Piaget argued, live in a 'pre-operational' egocentric universe where inanimate as well as animate forms possess great affective power: household pets are understood to be siblings, stuffed animals regularly come to life, and drawings by five- to seven-year-olds of the sun, moon and clouds reveal smiles, tears and other signs of animation. Piaget's viewpoint may be derived in part from early anthropological theorists such as E. B. Tylor (who in 1871 first defined the term 'animism') and Emile Durkheim, who wrote in 1915:

> Since the first beings of which the child commences to have an idea are men, that is himself and those around him, it is upon this model of human nature that he tends to think of everything . . . Now the primitive thinks like a child. Consequently, he also is inclined to endow all things, even inanimate ones, with a nature analogous to his own.[45]

Durkheim's observation significantly misrepresents the depth and complexity of Inuit and other forager epistemologies.[46] It mistakenly suggests that animists share with modern Western philosophers the same subject/object knowledge system that distinguishes humans from nature, but then simply mistakes the one for the other. Like the child, according to these older accounts of animism, the 'primitive' sees around him other humans like himself who possess intentionality, and mistakenly assumes that the non-human world must be similarly volitional. But in fact, as the anthropologists Timothy Ingold, Nurit

Bird-David and others have recently argued, totemists and animists do not share a modern, Western egocentrism. Theirs is a 'relational epistemology' which derives from a deep, personal engagement with the human, animal, plant and non-biotic world around them. To the Nayaka of Tamil Nadu, for example, according to Bird-David, elephants may be either ordinary elephants or *devaru*: spirits, gods or super-persons who sometimes take human form.[47] They may act with benevolent or malevolent intent, and may choose to punish Nayaka for violating norms of reciprocity and sharing.

Members of hunter-gatherer communities in tropical and sub-tropical zones, Bird-David argues, see themselves as children of the forest, and view the forest spirits as their generous mothers and fathers to whom they in turn offer love, honour and sometimes gifts, thereby establishing a cycle of mutuality and exchange that is the very obverse of the system of production and consumption in Western capitalist society.[48] In the industrial West, food animals are generally nothing more than meat, the latter resulting from the combination of raw materials (domesticated animals), human labour and fixed capital. Meat is simply one contingent form of valorized capital. This is roughly what the relationship looks like:

Capital \rightarrow Raw materials (domesticated animals)
Labour power (meat cutters)
Means of production (slaughterhouse) \rightarrow Meat \rightarrow Capital*

By contrast, in the case of the Batek people, who live in the rain-forests of western Malaysia, meat in the modern sense – an inert, alienated product, with no evident past and no possible future except as valorized capital – does not exist. The deceased relatives of the Batek are sometimes transformed into spirits (*hala'*) who in turn may become animals who offer themselves to their ancestors to be eaten. Thus the shared identity of hunter and prey or human and animal is complete; the circuit is closed but infinitely repeating.

Among the San or Bushmen of Botswana, the exchange between human and animal is even more perfect, built into their very cosmology. According to one version of their origin myth, animals were once humans, and humans, animals, but now the roles are reversed. Each

being, however, carries traces of his or her former state, resulting in special care and prohibitions during hunting and meat-eating.[49] This is roughly what the hunting economy of foragers looks like:

Spirits → Humans
Animals
Plants
Things → Gifts
Songs
Dances → Communion with Prey → Eating → Spirits*

In this mode of production and exchange, spirits enter into the bodies of humans and animals, as well as into plants and the inanimate world. These four groups then bestow or exchange gifts, songs and dances, facilitating human communion with prey animals, successful hunting, consumption and the liberation of new spirits. In forager ideology and practice, the human–animal conflict is denied or diminished.

As we can see, any ascription of naivety or childishness to hunter-gatherer communities is profoundly mistaken, but Durkheim's and Piaget's views of animist belief systems nevertheless correctly highlight one thing: the near ubiquity of some elements of animist thought – in particular, the idea that animals, plants and rocks may be persons – in certain non-hunter-gatherer contexts. Among children, in folklore, dreams and in a number of literary and artistic genres (fantasy, science fiction, magic realism), animism appears to play a central role. Tylor would have called these motifs 'survivals', the cultural equivalent of vestigial organs in animals – elements of primitive thought that have survived into the present day simply because there was insufficient evolutionary pressure to destroy them. But on the face of it, that explanation is inadequate: why these survivals and not others, and why, if animist motifs are merely vestigial, are they so elaborately developed and so centrally featured in highly ambitions works of art and literature?

One answer is simply that in certain contexts, animist or totemic thought is the most reasonable or practical available. The Gaia hypothesis, for example, promoted in the 1970s by the environmentalist

James Lovelock and so named by the novelist William Golding, is a version of animist thought. Initially ignored or derided, it has gained increasing authority in recent years among geoscientists and others studying the earth's ecology. The theory basically states that the biosphere and non-living components of the earth – the atmosphere, cryosphere, hydrosphere and lithosphere – comprise a single organism kept in homeostasis by the interaction of all the parts. Recent human interventions, however, particularly the introduction of vast quantities of carbon dioxide into the atmosphere, have disrupted or changed the earth system in such a way that the feedbacks and interactions of Gaia may be becoming less hospitable to human and certain other forms of life. Animism in this case is not simply good science; it may also prove protective if we follow its lessons.

In contrast to the cooperation and trust that exists between hunter-gatherers and animals, the terms 'conflict', 'domination' and 'hierarchy' characterize the interaction of pastoralists and their herds.[50] Pastoralists such as the Gujar buffalo-keepers of Uttar Pradesh, or the Maasai cattle-herders in Kenya, also depend upon the animals that live with or near them, but they do not see the animals as partners to the same degree that hunter-gatherers do.[51] Instead they exercise the role of masters to that of animal slaves, working them at will and extending or taking life as they wish. They may subject animals to the yoke, the plough or the saddle, use their milk or blood for food, and slaughter them whether or not the animals make themselves available to be killed. But pastoralists have one important thing in common with hunter-gatherers that distinguishes them from modern agriculturalists like us: they understand animals to be part of the same life-world as themselves, and to be beings worthy of respect. In many cases, pastoralists have formed intimate, reciprocal relationships with particular animals over many years, and learned special ways to communicate each other's needs.[52] If pastoralists 'dominate' animals, as Ingold argues, they do so with the understanding that they are 'endowed with powers of sentience and autonomous action' which may be controlled by means of superior force.[53] When, under the pressure of modern economic forces, pastoralists such as the Sami (Laplanders) have been forced on some occasions to slaughter large

numbers of their reindeer for the purposes of a wider market, they have reacted with shame and horror, certain that they have betrayed the animals upon whom they exercise guardianship. It was as if they had killed their own pets.[54]

The nineteenth-century French Realist painter Jean-François Millet provided a glimpse at pastoralism as it survived in the French countryside. His paintings are nostalgic images of a pre-modern, pastoral mode of production in which animals, though vassals of their human lords, are also looked upon with respect and even benevolence. The relationship is summarized by Millet's *The Pig Killers* (1867–70) and *Peasants Bringing Home a Calf Born in the Fields*. In the first, hog and humans occupy equal halves of the composition; though the latter will prevail in the end, the struggle nonetheless exacts an emotional as well as physical toll on all participants. Pigs were especially prized in nineteenth-century France. While the cattle population in France at this time was more than 15 million, pigs numbered 5 million and were more valued and depended upon than cows.[55] Farm families often raised just a single pig at a time, and its slaughter was a major economic and social event for

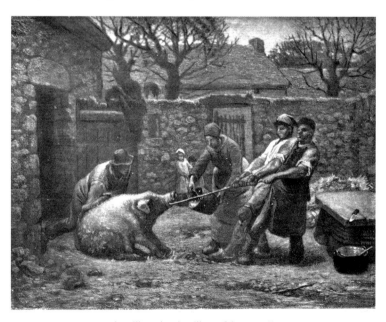

Jean-François Millet, *The Pig Killers*, 1867–70, oil on canvas.

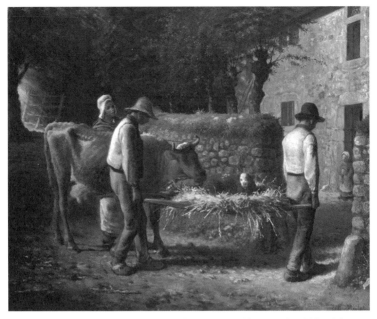

Jean-François Millet, *Peasants Bringing Home a Calf Born in the Fields*, 1864, oil on canvas.

them and their community. In *The Pig Killers*, Millet recognized and represented the centrality of pigs in farm family life, and the drama of their slaughter. In *Peasants Bringing Home a Calf*, he represents birth, not death, but again suggests the close relationship between human and animal. He shows the newborn resting and being carried on a litter – like an adored Golden Calf – licked by its mother, and tended by the peasants who will help raise and nurture it.

In the teeth of relentless modernization, the thoughts and practices of pastoralists and hunter-gatherers may be articulate and effective recourses against the oppressive logic of capitalist, instrumental reason that sees all of nature – human and non-human – simply as a means to a profitable end. Animism especially resists that perspective by endowing what Westerners call 'nature' (which animists see as largely indistinguishable from culture) with indepen-dent rights and prerogatives. Given animism's continued existence even among some Western agriculturalists – especially radical envi-ronmentalists, deep ecologists and anarchists, but also many others – this attitude may be an example of what George Rudé calls an

'inherent ideology', an attitude or belief of long standing held by non-elite communities that exists in opposition to official discourse, and that motivates people to action.[56] In any case, animist, totemic and allied postures, including the practices and beliefs of pastoralists, starkly reveal that the definition of the animal and of the human–animal divide has always been subject to contestation, and that the modern, Western denial of animal rights is a single, extreme perspective on the scale of human attitudes toward other creatures.

Animals into Meat

WHICH ANIMALS?

Cows become beef, pigs become pork, sheep become mutton and chickens become tenders, drumsticks, nuggets and buffalo wings through a long process mediated by history, economics, politics and religion. The complex and contingent actions that turn animals into meat become apparent when we observe that while there are at least 2 million species of animals on Earth, the number consumed as food is far, far smaller. Leaving aside fish, whose variety is dependent upon seasonal and local availability, and arthropods and molluscs, which humans recognize as consumable more at the phylum than the species level, the list of food animals is limited to about a dozen. Of these, chickens, pigs and cows are the most commonly consumed worldwide; after that come sheep, goats, rabbits, ducks, geese, turkeys, deer and horses. If you add guinea pigs (commonly eaten in the Andes), dogs (eaten in China, Korea and elsewhere in the Far East and Pacific) and locusts (consumed in Africa), then the number of animals that are routinely consumed as meat is around fifteen. The total population of the thirteen vertebrates I have listed may outnumber the entire world population of all other vertebrates combined, excluding birds and rodents. The point here is that what distinguishes animals from meat – like what distinguishes humans from animals – is human culture, which functions as a sorter, designating some animals as meat sold in the supermarket, some as prey for sport hunting, some as pets and still others as specimens to be observed at zoos or protected in the wild.

The selection of animals for the dining table is not arbitrary, however. Some species are more easily dominated than others, and anthropologists have argued that the ideal animal for domestication is one that is slow, not territorial, lives in large herds of both sexes, welcomes hierarchy and can subsist on a wide range of foods.[1] The wild forebears of domesticated pigs, cows, chickens and goats all fit this profile. A mountain goat, for example, or a wild sheep, is built for agility, not speed (and thus cannot easily run from human or canine herders), is both highly sociable and hierarchical (and will therefore accept human control), and can thrive in many different landscapes and ecologies (and thus subsist on whatever grasses or grains humans may provide). Red and grey junglefowl, endangered ancestors of the domesticated chicken, are poor fliers – they can just manage to fly into trees to escape predators – territorial but well adapted to various ecologies, hierarchical (the males control a harem) and omnivorous. The current population – the 'world stock' – of domesticated chickens is estimated to be between 19 and 50 billion.[2]

Junglefowl and other native species are transformed from sentient or conscious beings into meat by means of processes that are both ideological and material. The first is 'speciesism', the assumption that humans have the right and even the obligation to exercise dominion over non-human animals. The second is agriculture: the cultivation of plants and forests and the rationalized domestication of animals for the purposes of obtaining food, clothing and labour for a large-scale society or civilization. Speciesism and agriculture constitute a reciprocal and mutually reinforcing dyad: without the one, the other would be impossible.

SPECIESISM IN ANTIQUITY

'Speciesism' is the awkward-sounding term coined by the British psychologist Richard D. Ryder in 1971, and popularized by Peter Singer in his book *Animal Liberation* (1975), to describe the bigotry of humans toward animals and the resulting regime of domination.[3] The prejudice has existed for at least 7,000 years, or since the Sumerians domesticated sheep (mouflon) and cattle (aurochs). The first animal to wear the harness, suffer the whip or have its young

taken from it so that its milk could be used for human consumption suffered the world-historical defeat of animal rights. And from the pastures of the Fertile Crescent to the laboratories of modern behaviourists, the bigotry of humans concerning animals has flourished, with oppression and violence sown in its wake. Modern speciesism is built upon ancient and classical foundations.

The most frequently discussed textual basis for the modern human domination of animals is the ancient Hebrew Bible, but that source is more ambiguous than is usually recognized. It is true that the Book of Genesis includes the injunction that humans 'have dominion over the fish of the sea, the fowl of the heavens, and all the living things that crawl about on the earth' (1:28).[4] But that dominion was not extended at first to killing and eating them. In the next section of Genesis, God says that all plants, seeds and fruit, and 'all green plants', are 'for eating'. This implicit proscription of flesh-eating is repeated a little later (2:9; 2:16) and emphasized by a naming imperative that highlights the fellowship of human and non-human animals: God brought before man every bird and every herd animal 'to see what he would call it; and whatever the human called it as a living being, that became its name' (2:19–20). To name a creature was to grant it respect and even a degree of autonomy.

Only after Adam ate from the Tree of Knowledge, according to the Hebrew Bible, did humans wear animal hides to cover their nakedness, herd flocks of sheep and subject brute nature to their domination. After the Flood, the treatment of animals grew worse as humans were enjoined to pitilessness. God said to Noah and his sons:

> Fear-of-you, dread-of-you, shall be upon all the wildlife of the earth and upon the fowl of the heavens, all that crawls on the soil and all the fish of the sea – into your hand they are given. All things crawling about that live, for you shall they be, for eating, as with the green plants, I now give you all. (9:2–3)

In their natural, prelapsarian state, in other words, humans were vegetarian; only after they sinned did they begin to consume meat. The prophet Isaiah foretold the return of an age of peace and amity

by a prophetic vision of vegetarianism among all creatures: 'The wolf also shall dwell with the lamb, and the leopard shall lie down with the kid; and the calf and the young lion and the fatling together; and a little child shall lead them' (11:6). Vegetarianism was a hall-mark of the Age of Gold.

For millennia thereafter, and even now, the image of Eden, Arca-dia and the Golden Age, derived from the animistic or totemic belief systems of foragers and pastoralists and described by Isaiah, has existed as an imaginary recourse for agriculturalists living in periods of discord and want. In the fifth-century BCE texts of Empedocles, which we know chiefly from the writings of Plato and Aristotle as well as from a few Egyptian papyrus fragments, humans are described as having once lived in a Golden Age free of violence and strife under the guidance of Aphrodite, goddess of love and sex. Even sacrifices to the gods were forbidden during this period, as was the eating of animal flesh. Because animals were reincarnated as humans and vice versa, to kill and eat an animal was considered murder and cannibalism. During the Golden Age, in which love was dominant, 'the altar did not reek of the unmixed blood of bull, but this was the greatest abomination among men, to snatch out the life and eat the goodly limbs'.[5]

Empedocles' texts were an important source for the Roman authors Ovid and Porphyry. The former described in his *Metamorphoses* the four ages of history: Gold, Silver, Bronze and Iron. In the first of these there existed no laws, properties, warfare, fear or want:

> Earth herself, unburdened and untouched by the hoe and unwounded by the ploughshare, gave all things freely. And content with food produced without constraint, they gath-ered the fruit of the arbute tree and mountain berries and blackberries clinging to the prickly bramble-thickets, and acorns which had fallen from the broad tree of Jupiter.[6]

Ovid and many other ancient authors – Greek as well as Roman – were the anthropologists of their day, describing a hunter-gatherer mode of production known only dimly from stories of people living on the geographic margins of empire, or at the distant antipodes.[7]

The fifth-century BCE historian Herodotus described a people he named Argippaeans – living in proximity to the Scythians and wearing similar clothes – who ate no meat (eating only the fruit of a particular tree), lived in the open air or beneath tents suspended over trees, had no weapons of any kind, settled the quarrels of their neighbours and offered sanctuary to any that needed it. 'No one harms these people, for they are looked upon as sacred.'[8] The Roman geographer Strabo remarked upon the habits of many other nomadic, foraging and pastoral peoples – generally with disparagement – including the Asturians, who subsisted two-thirds of the year on acorns, and the Lotophagi, who ate only lotus leaves.[9]

The third-century CE writer Porphyry was the author of *On Abstinence from Killing Animals*, probably the best-known plea for vegetarianism from antiquity. His arguments for abstention from eating meat, derived from Jewish and Egyptian traditions, are first that vegetarianism – like other forms of frugality and restraint – fosters spiritual purity; and second, that humans owed animals justice. Animals he states, posses logos, the gift of language, and while it is true that humans do not understand their language – any more than a Greek understands the language of an Indian – that does not mean that non-humans cannot communicate, form communities or exist within the realm of *oikeiosis*, that form of virtuous belonging that links people together in a common circle of generosity and reciprocity, obligation and entitlement. 'For the several species of these understand the language which is adapted to them, but we only hear a sound, of the signification of which we are ignorant, because no one who has learnt our language, is able to teach us through ours the meaning of what is said by brutes.'[10] And despite the wall of mutual incomprehension created by language difference, we can easily tell that the sounds animals make possess meaning by the fact that

> we hear one kind of sound when they are terrified, but another, of a different kind, when they summon their young to food, another when they lovingly embrace each other, and another when they incite to battle . . . And if it appears . . . that they learn the Greek tongue and understand their

keepers, what man is so impudent as not to grant that they are rational because he does not understand what they say?[11]

Thus, according to Porphyry, animals cannot justly be killed or cruelly treated, or denied their due access to the domain of rationality, rights or morality.

In Virgil's famous *Fourth Eclogue*, the Golden Age was now not simply a lost past but a realizable present and future. Here the Roman poet described the end of the Iron Age of warfare and want, and the beginning of a Golden Age of peace and pleasure in which labour would cease, the fruits of nature would be bestowed freely upon humans and animals would no longer be slaves to men.

> The ground will not suffer the mattock, nor the vine the pruning hook; now likewise the strong ploughman shall loose his bulls from the yoke. Neither shall wool learn to counterfeit changing hues, but the ram in the meadow shall dye his fleece now with soft glowing sea-purple, now with yellow saffron; native scarlet shall clothe the lambs at their pasturage.[12]

Almost two millennia later, this image of Arcadia and the restoration of animal rights, derived, as we have seen, from Greek and Hebrew sources, would be a significant basis for writers and artists of the radical Enlightenment, including William Blake. The Age of Reason meant to many artists and philosophers a revival of Golden Age thinking and an imagined restoration of the harmony between animal and human, or even the revolutionary re-creation of the age of animal rights.

But other ancient works were clearly foundational for modern speciesism. In the writings of Aristotle and the Stoics, for example, the critique of archaic Greek animism (elements of which survived even in the thought of Plato) extended so far that humans and animals were considered utterly divorced from each other. The one, according to Aristotle, possessed rationality and a soul, and the other only instinct and sensation; the one had a capacity for virtue, and the other only desire; and whereas humans could participate in the realm of politics and community, animals could not because they

lacked language. But, in his zoological writings at least, Aristotle still maintained a continuity between human and animal:

> For almost all animals present traces of their moral dispositions, though these distinctions are most remarkable in man. For most of them, as we remarked, when speaking of their various parts, appear to exhibit gentleness or ferocity, mildness or cruelty, courage or cowardice, fear or boldness, violence or cunning; and many of them exhibit something like a rational consciousness, as were marked in speaking of their parts. For they differ from man, and man from the other animals, in a greater or less degree; for some of these traits are exhibited strongly in man, and others in other animals.[13]

Aristotle was thus a key figure in the development of the idea of the Great Chain of Being (*scala naturae*), the notion – unimaginable among animists – that the universe was organized in a hierarchical manner from the smallest, most insignificant stone to the perfection of the gods, and that while the dividing line between creatures in the chain was imperceptible, the highest – humans and gods – held dominion over the rest.[14] (His works were also a basis for physiognomical treatises of the seventeenth and eighteenth centuries, the most substantial of which, by the Swiss Johann Kaspar Lavater, proposed that the resemblance between animal and human faces and expressions could be cues to the interpretation of each.)

For the later Stoic philosophers, however, humans differ from animals not in degree but in kind, and the former have no obligation whatsoever to the latter. Animals are said to lack all reason, reflection, ability to plan ahead and capacity for community. Most of all, they do not possess *oikeiosis*, that capacity for fellowship and projection of self to the wider world. Without reason and virtue, so the Stoics believed, animals are excluded from the domain of justice; for this reason, nothing done to them can be construed as an injustice. Indeed, humans possess such moral and intellectual superiority to animals, according to the Greek-born Epictetus (55–135 CE), that they are entitled to consider them as mere instrumentalities 'destined for service'.[15] And just as the Virgilian ideal of a Golden Age in which

humans and animals inhabited a peaceful kingdom had its later echo in the work of such figures as Blake, so Stoic justifications for the exploitation of animals had their subsequent revival in the person of Blake's slightly older contemporary, the philosopher Immanuel Kant. He proposed, as we shall later see, that animals lack all reason and are guided purely by instinct and necessity. Unlike humans, they may be understood as means, not as ends.

In ancient Rome, Stoic belief was put into concrete practice. An empire whose wealth was generated by the conquest of territory and the establishment of vast plantations (*latifundia*) categorized slaves, animals and vehicles, according to the Roman Marcus Terentius Varro, as either 'articulate', 'inarticulate' or 'mute' instruments to be used and disposed of at will. Varro carefully elucidated the proper employment of each class of tool, and proposed the appropriate rewards and punishments for each.[16] In such a context, consideration of human obligation toward non-humans – much less any notion of animal rights or autonomy – was nearly impossible, and unimaginable cruelties were visited upon animals during gladiatorial and other games at the Coliseum in Rome.

Elsewhere in the ancient Mediterranean world, animals were placed in a *scala naturae* derived from the laws and ideologies of

Rampant lion, one of the Lion Hunt reliefs formerly in the North Palace of King Asurbanipal at Nimrud, 668–631 BCE.

kingship. Scenes of a staged royal lion hunt appear in alabaster reliefs from Room C of the North Palace at Nineveh built by Asurbanipal (shipped to the British Museum in 1845 by Austen Henry Layard). The king in his chariot, accompanied by bodyguards, soldiers and beaters (who rouse the animals so that they will act more ferociously), stabs and shoots with arrows the many lions collected for the purpose. The lions are shown charging, fleeing, suffering and dying. One scene shows captive lions being released from cramped wooden cages; another a lion leaping up to attack the king and his shield bearer; and several reveal the king and his guards shooting and spearing the animals from the back of a chariot. But the most compelling reliefs are those of the dead or dying lions. In one, a wounded male lion, pierced by four arrows, his eyes shut from agony, jerks back his head to uselessly lick at his left paw. In another, a wounded male, also penetrated by four arrows, lowers his head and vomits blood. One relief shows a lion from above, an arrow piercing its eye socket and muzzle. And in perhaps the most terrible of all, a lioness raises her head in her last roar as she drags her useless rear legs, paralysed from the arrows lodged in her back. Typically of ancient herders or pastoralists, the artists of Nineveh represented the lions as fully sentient beings that were capable of autonomous action, but at the same time subject to the power of their human masters.

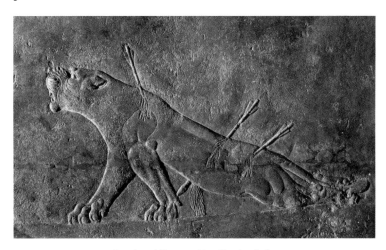

Paralysed lioness, Lion Hunt reliefs.

A chariot-horse and the King in the Lion Hunt reliefs.

The purpose of these reliefs is not to engender sympathy for the lions; it is to sufficiently humanize and ennoble them so that their defeat will be deemed worthy, an expression of the king's ability to rid the landscape of any warriors and predators, animal or human, whose prowess might rival his own. Indeed, any sense the viewer may have of the individuality or autonomy of the lions is undercut by examination of the treatment of the horses and humans in the reliefs. The former are depicted with extraordinary care and precision – the bridle, bits, straps, thongs, bands and bells are all exquisitely detailed, as befits a king's mount. Their mouths, nostrils, eyes and manes – the last trimmed, combed and plaited like the hair and beards of the human hunters – are exquisitely individualized.[17] Of course, it is the king himself who is the largest, most powerful and most

Young cow and herdsmen, Parthenon, Acropolis, Athens, c. 443 and 438 BCE.

particularized figure throughout the reliefs – the work of the very finest of the master carvers (brought against their will from conquered territories) employed to decorate the palace chamber.[18] By comparison the lions are generic, particular only in the character of their suffering.

Here in the ancient Near East, more than two centuries before the sculptors of the Panathenaic Frieze at the Parthenon depicted in marble and paint *A Young Cow Led to its Sacrificial Death*, is exposed what I have called elsewhere the pathos formula of the beautiful death: humans or animals whose suffering is rendered so exquisite, piteous or erotic that they seem to welcome it, or at least to accept it without serious complaint.[19] The function of the motif or symptom – present in Western representation from the Pergamon Altar (and before) to the photographs from Abu Ghraib – is to make rational or inevitable what is in fact illogical and contingent: the choice to torture or kill another sentient being in order to satisfy a transient need. The beauty of the lions' deaths in all its inert majesty is its

very justification; the poignancy of the animals' suffering affirms the aristocratic dominance of a few humans who impassively assert their authority over the entire order of nature. Speciesism is thereby made to seem natural, timeless and inevitable. And yet it is difficult not to imagine that the sculptors at Nineveh – themselves captured, enslaved or impressed, their families and homes destroyed – were expressing empathy for the dead and dying animals; indeed, that is the sentiment that primarily survives among viewers today.

MIDDLE AGES

Early Church teaching about human dominion over animals closely followed Stoic precedents.[20] Paul, for example, rejected with scorn the idea that oxen deserve to be treated with kindness. Peter commanded men to kill and eat animals without scruple. (Some of the apocryphal texts, however, including the Gnostic gospels of Phillip and Thomas, are quite a different matter, with their suggestion of animal baptisms, Eucharistic rites and the possibility of resurrection.[21]) And Christ himself, as recounted in the four gospels accepted by mainstream Catholic and Protestant churches, cast the legion of Gadarene demons out of a man's body into the bodies of 2,000 pigs, all of whom were promptly drowned in the Sea of Galilee. A pagan critic of Christianity and follower of Porphyry, Macarius Magnus, particularly objected to this act in his *Apocriticus*, arguing that Christ should have sent the demons directly into the sea without killing so many pigs.[22] There has never been a time when speciesism has been entirely unchallenged.

St Augustine in the fifth century, however, celebrated Christ's actions at Gedera, and interpreted them to mean that humans had no moral duty toward animals: 'Christ himself shows that to refrain from the killing of animals is the height of superstition, for judging that there are no common rights between us and the beasts . . . he sent the devils into a herd of swine.'[23] Other acts of Christ display somewhat greater gentleness toward animals, and sheep or lambs in particular are described in the Gospels with affection, but that is because they are generally metaphors either for Christ himself or for the followers of the 'Good Shepherd'. Christ was seen as sacrificing

his life for his flock (John 10:1–21; Psalm 23) or as the shepherd in the Parable of the Lost Sheep who was willing to leave behind in the wilderness 99 sheep in order to find one who had strayed (Matthew 18:12–14; Luke 15:3–7). Doves, which often represent the Holy Spirit, and the ox and ass of the Nativity are described with considerable warmth, but once again, these creatures are more metaphorical than real. Indeed, animals are rarely described in the Gospels as having intrinsic worth, and Christ is never represented as showing them particular kindness.

During the Middle Ages, this divinely ordained subservience of beast to man was interpreted according to what may be described as a functionalist perspective. This understood animals to be God's gift to humans for the purpose of providing them with food, labour and entertainment. Following from both Aristotle and Augustine, animals were thought by theologians and other elite or educated communities to lack both rationality and immortal souls and thus to be far distant on the Great Chain of Being from God, the angels or humans. But for this very reason they were enormously useful in the symbolic arena. Their moral inferiority helped to distinguish human superiority; their carnality, human spirituality; their ignorance of the world, human knowledge; and their muteness, human articulateness.[24] The literature of bestiaries and fables is one clear expression of this anthropocentrism, combined in the latter case with a new anthropomorphism that in some later contexts was a basis for identification and sympathy.

All bestiaries derive from Physiologus (meaning 'the naturalist philosopher'), a Greek author who composed and compiled his texts – derived from Herodotus, Aristotle, Pliny, St Paul, Origen and others – some time between the second and fourth centuries CE. They consist of stories about animals and sometimes rocks (!), and generally include short moralizing lessons. They were copied, recopied, expanded, contracted, translated and illustrated for centuries after their creation, and became enormously popular in Europe around the turn of the twelfth century. By then, the text also generally included the *Etymologiae* of Isidore of Seville (d. 636 CE), which used the names of the animals to explain their true natures. For example, in the section devoted to cats in the twelfth-century Aberdeen Bestiary we read:

Dragon
suffocating an
elephant, from
the Ashmole
Bestiary, *c.* 1250.

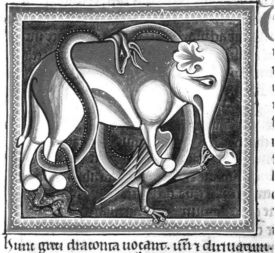

ʄunt gᵘᵘ diaꞇoŋꞇa uoçaŋꞇ. u̅ɩ ɪ diɪꞇuaꞇum·

Cat: The cat is called *musio*, mouse-catcher, because it is the
enemy of mice. It is commonly called *catus*, cat, from *captura*,
the act of catching. Others say it gets the name from capto,
because it catches mice with its sharp eyes. For it has such
piercing sight that it overcomes the dark of night with the
gleam of light from its eyes. As a result, the Greek word *catus*
means sharp, or cunning.[25]

Because of their etymological function, some scholars have pro-
posed that the bestiaries were dictionaries of animal names, thereby
augmenting their scientific purpose. But bestiaries are not as useful
as either dictionaries or learned treatises – the animal names are not
organized in any helpful order, and their scientific function is clearly
inferior to that of Pliny's *Natural History*, which was very widely
copied and circulated.[26]

Instead, bestiaries affirmed scriptural truth and used animals'
appearances and habits to instruct humans about themselves, giving
examples of virtuous or vicious behaviour. In the Ashmole Bestiary
(*c.* 1250), a dragon is shown in one panel suffocating an elephant, just
as Satan, the text informs us, waits to strangle humans with their
sin. Bestiaries also provided illustrations of God's ingenuity in design-
ing such varied creatures. (Thus, according to Thomas Aquinas, God

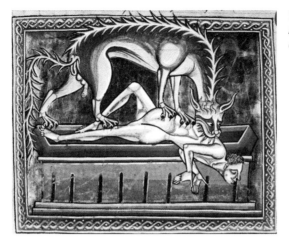

Hyena, from the
Ashmole Bestiary,
c. 1250.

was the great artificer, and the 'efficient and exemplary cause' of all
natural things.²⁷) The hyena in the Ashmole manuscript, ostenta-
tiously equipped with male and female genitalia, is evidence of that.
But late medieval bestiaries revealed very little about animals them-
selves; their schematic representations, however sumptuous the illu-
mination, cannot have permitted readers and viewers much
imaginative identification with the creatures. In the Aberdeen Bestiary,
as in the contemporaneous Ashmole Bestiary (which was probably
by the same artist), surface pattern, colour contrast, richness of ma-
terial and decorative pattern all supersede anatomical accuracy or
emotional expression.²⁸ It is the human experience of the animal
world, mediated by God, that is important. There are minor excep-
tions, however: in the illustration for the lion in the Ashmole Bestiary,
the cock kicks out its left leg and holds its head erect, proud of
the fact that it can frighten the cowering lion. The popularity of the
bestiary continued long after the development of printing technology
in the fifteenth century; the tradition has survived into the twentieth
century and beyond, for example, in Alexander Calder's medievalizing
A Bestiary (1955), compiled by the poet Richard Wilbur.

Western fables were derived from the writings of Aesop, the
legendary Greek author from the sixth century BCE, and consist of
short tales about animals (or sometimes humans) that are moraliz-
ing and often humorous in which the foibles of humans are given
animal form and vice versa. They may or may not actually have been

invented by someone named Aesop – no texts clearly by him have
survived – but fables identified with the name are cited by a number
of Greek authors, including Sophocles in the fifth century BCE, who
referred to the story of the 'Sun and the North Wind' in a mocking
poem about Euripedes.[29] Written collections of Aesop's fables were
first created in Roman times, and have been revised, rewritten, added
to, amplified and elucidated ever since. One reason for their ubiquity
is their evident political utility. Fables have variously been interpreted
to buttress divinely established hierarchies (as in the English edition
edited by Roger L'Estrange in 1692) and to repudiate tyrannies or
any system of authority based upon superior birth or wealth (as in
Samuel Croxall's Whig-inspired edition of 1722). Aesop's supposed
status as a slave, recounted in biographies of the fabulist that pref-
aced most collections until the late nineteenth century, itself lends
a critical gloss to the texts: they are presumed to be stories the weak
tell about the powerful or the wily about the treacherous.[30] Such, in
any case, was the attitude of many interpreters of Aesop from Croxall
to Mark Dornfoed-May, who staged an all-black production of *Aesop's
Fables* for the Fugard Theatre in Cape Town, South Africa, in 2010.[31]

The anthropomorphism at the heart of the fable – animals reg-
ularly assume the wisdom and folly of humans – may have provided
an infusion of toleration and kindness toward animals in an elite
culture and society otherwise indisposed to it. While the thirteenth-
century Thomas Aquinas believed that the consumption of meat was
a moral duty since it reaffirmed humans' God-ordained superiority,
he also asserted that individual kindness toward animals was hon-
ourable because it was an expression of a person's admiration for
God's creations and of respect for property. He argued in addition that
cruelty toward animals was wrong because it was a violation of
humanity's essential goodness, and could create a habit of violence
injurious to humans. But Aquinas's position did not permit animals
any degree of autonomy. For him, their subservience to humans
was an article of faith, and they were believed to have no independ-
ent right to life or happiness. In this dependency, of course, the wider
feudal hierarchy is exposed: human is to animal as lord is to serf,
and neither animals nor serfs can act as sovereign over their own
bodies or domains.

Nevertheless, animals in the medieval and early modern periods were not fully consigned to the domain of mere 'mute instruments', to use Varro's term. The rise of Neoplatonism and other forms of occult and neo-animist thought during the Renaissance encouraged a belief that matter and spirit, the animate and inanimate worlds and even humans and animals constituted, as the historian Keith Thomas described it, 'an organic unity in which every part bore a sympathetic relation with the rest'.[32] In such a context, animals might be thought to possess some of the same feelings, rights and responsibilities as humans. Indeed, even before the appearance of neo-pagan thought in the Renaissance, there were manifestations of surviving belief in animal consciousness and reason. From about the thirteenth to eighteenth century (peaking in the late sixteenth and early seventeenth centuries), it was relatively common in Europe to subject animals to criminal trial and judgement. Secular courts tried domestic animals for acts of violence against humans, usually killings, while ecclesiastical courts tried animals that were considered pests or vermin – including insects – for acts against a community, such as destroying a harvest or damaging a building.[33] Animals were granted the same range of rights as humans – a public accounting of charges, the appointment of a defence lawyer, the seating of a jury – and were subjected to the same punishments: execution, the severing of limbs, banishment and excommunication. In the town of Pont-de-l'Arche in Normandy, about 10 miles south of Rouen, a man and a pig were held in the town jail from 24 June to 17 July 1408. The jailer's modest charge for maintenance was exactly the same for man and pig – two *denier tournois* per day. (The pig was ultimately hanged for the killing of a child.)[34] In some instances, however – especially in the case of ecclesiastical trials – animals were acquitted of the charges against them. In one proceeding from the fifteenth century against the beetles of Chur, France, the offending insects were granted the status of minors and permitted to live out their lives on a designated parcel of land.[35]

Despite the legal formalities, however, these animal trials were not purely the province of elite jurisprudence – of royal decrees, seigneurial courts, philosophers, judges and magistrates. They also belonged to customary law and popular culture. Whereas Aquinas

in the thirteenth century (an epoch of especially intense philosophical rationalism) denied the validity of these trials on the basis of the argument that since animals lacked moral reason, they could not be held responsible for its violation, peasants and other non-elites at that time and long after – perhaps recognizing their own, parallel subservience in the feudal system – believed that animals possessed moral will, or at least the right to fair treatment. They derived their viewpoint from the nature of their own productive lives, which were spent in the closest possible proximity to farm animals – which greatly outnumbered them – and from their nearly unlimited opportunities to observe animal behaviour. If early modern peasant culture exacted at trial unjust punishment upon innocent animals, it at least recognized their autonomy and accorded them respect. In this, peasants acted like the pastoralists they often were by dominating their animals, but at the same time recognizing that they were 'endowed with powers of sentience and autonomous action' as Ingold wrote.

Peasants and pastoralists were supported in their views about animal reason and responsibility by various types of popular religious literature that included stories of animals who worked miracles, died as martyrs or were otherwise agents of the divine.[36] Jacobus de Voragine collected some of these tales, which often have pre-Christian sources, in the *Golden Legend*. This thirteenth-century text, which exists in more than 800 manuscript copies, was among the first to be published when moveable type became available in the 1450s. It was quickly translated into most European languages, including an English version by William Caxton in 1483. From this text, the literate – and others who heard the stories recited to them – found out about St Francis, who 'commanded in winter to give honey unto bees, that they should not perish for hunger [and] called all beasts his brethren', and about the hunter Placidus (later St Eustache), who 'saw between [the horns of a hart] the form of the holy cross shining more clear than the sun, and the image of Christ'. And the hart spoke to Placidus, 'I am Jesu Christ, whom thou honourest ignorantly, thy alms be ascended up tofore me, and therefore I come hither so that by this hart that thou huntest I may hunt thee.'[37] The Quattrocento artist Pisanello, who, according to Vasari, learned to paint horses in

Pisanello, *Vision of St Eustace*, 1436–8, tempera on wood.

the workshop of Paolo Uccello, and who specialized in hunting and battle pictures, depicted the scene in his jewel-like *Vision of St Eustace* (1436–8). Though there is little sense here that the hart has turned the tables on Placidus, the animals – and not just the hart – appear at least to have gained a reprieve. Deer, rabbit, bear, elk, egret, stork, swan and others all freely stand or gambol in a landscape spared from aristocratic predation, though one hound in the foreground still gives chase to a rabbit. The animals are mostly indifferent to Placidus' vision – one dog sniffs the rear end of another – but the horse registers some recognition of the miracle. He has pulled up short as if in response to the apparition and dips his head slightly, even though his rider is not pulling on the reins. (In thus suggesting the horse's perception of the miracle, Pisanello was following medieval precedent as seen in an English psalter dated 1260 and a window from Chartres Cathedral, among other works.[38]) Though animals, according to Aristotelian, Augustinian and Thomist doctrine, are devoid of reason and thus excluded from the domain of moral rights, they were judged to have 'sensitive souls' – the capacity for

movement and perception, including imagination and memory – and the horse's expressiveness is a sign of that fact.[39]

But by the time of Albrecht Dürer's engraving of St Eustace (c. 1501), all traces of animal soul appear to have been banished. The composition is very similar to Pisanello's work – authorship of the latter was for a long time ascribed to Dürer – but the horse has switched positions: he now faces his rider, not the mysterious hart.[40] And rather than revealing signs of a sensitive soul, the animal stares blankly past the right shoulder of the saint, oblivious to the miraculous vision to his right and behind him. (In fact, it can be said that the hart occupies the horse's blind spot.) The five hounds in the foreground too (the extinct breed of Hirschhund, Canis acceptorius) – each of which looks off in a different direction, the better to display their anatomy – register no recognition of the miraculous event. Here in Renaissance Germany, in the circle of the Nuremberg humanist Wilibald Pirkheimer, Dürer widened the perceived divide between human and animal by denying any possibility that animals possess a sensitive soul.[41] He thereby took a step toward the rationalist and mechanist view of animal life that would become widespread during the age of Descartes and after.

A tale sometimes associated with Eustace is that of Julian, a young nobleman who loved hunting more than anything else.[42] One day, while hunting, he took aim at a great hart which, before the arrow landed in his breast, prophesied that the man that hunted him would one day kill his own mother and father. So alarmed was the young lord that he fled the kingdom, fearful that the prophecy would come true. He became a great and celebrated warrior as well as hunter, and soon met a beautiful woman whom he took as his bride. They lived very happily. Years later, the hunter's parents, still searching for their long-lost son, came to the village in which he lived and found his beautiful young wife. She welcomed them into her and her husband's home and, finding that the old couple were exhausted from their travels, ushered them into her bed so that they might rest. When Julian came home later that day, he went at once to his bedchamber, and saw the shapes of two people in his bed. Believing they must belong to his wife and her lover, he drew his sword and killed them both. Drawing back the bedclothes, he discovered he had slain his

Albrecht Dürer, *St Eustace*, c. 1501, engraving.

own parents and that the prophecy had proven true. At that moment, he vowed to abjure hunting and always to be kind and gentle to all creatures, and to dedicate his life to tending to the weak and sick.

Tales of animal strength, intelligence and autonomy were also available in the late Middle Ages and early modern period through a flourishing oral and written tradition of *mirabilia*: unicorns, mermaids, werewolves and other creatures who lived half in the human

and half in the animal world. The Swedish story of Sivard the Strong – the hybrid offspring of a peasant girl and a bear, and the founder of a royal lineage – is representative of the tradition. Rooted in early medieval sagas, it was told by Saxo Grammaticus in the *Gesta Danorum* in the late twelfth century, and retold, albeit with some ambivalence, by the Swedish Catholic Olaus Magnus in the middle of the sixteenth century.[43] The later fate of the legend indicates the broader trajectory of the human–animal class struggle. By the early eighteenth century, the tale of bearish Sivard had been transformed from being about a powerful and admired human–animal hybrid, to being about an act of sodomy, bestiality and abomination; in a medical treatise of 1730, a censorious account of the story preceded a discussion of inter-course with demons. The neo-pagan age of human–animal collab-oration or sympathy was drawing to a close, and a much harsher regime of oppression was drawing near.

The close association of demon possession and human–animal intercourse in much early modern religious thought is most clearly exposed in the Puritan Cotton Mather's *Magnalia Christi Americana* (1702). Here the New England minister and pamphleteer recounted the arrest, devil possession, bestiality and execution of a man from the New Haven Colony, and the killing of his violated animals:

> On June 6, 1662, at New-haven, there was a most unparallel'd wretch, (one Potter, by name, about sixty years of age,) exe-cuted for damnable bestialities; although this wretch had been for now twenty years a member of the church in that place, and kept up among the holy people of God there a reputation for serious Christianity. It seems that the unclean devil which had the possession of this monster, had carry'd all his lusts with so much fury into this one channel of wicked-ness, that there was no notice taken of his being wicked in any other. Hence 'twas that he was devout in worship, gifted in prayer, forward in edifying discourse among the religious, and zealous in reproving the sins of the other people; every one counted him a *saint*; and he enjoy'd such a peace in his own mind, that in several fits of sickness, wherein he seem'd 'nigh unto death', he seem'd 'willing to die;' yea, 'death', he

said, 'smiled on him'. Nevertheless, this diabolical creature had liv'd in most infandous buggeries for no less than fifty years together; and now at the gallows there were kill'd before his eyes a *cow*, two *heifers*, three *sheep*, and two *sows*, with all of which he had committed his brutalities. His wife had seen him confounding himself with a *bitch* ten years before; and he then excused his filthiness as well as he could unto her, but conjur'd her to keep it secret: but he afterwards hang'd that bitch himself, and then return'd unto his former villanies, until at last his son saw him hideously conversing with a *sow*. By these means the burning jealousie of the Lord Jesus Christ at length made the churches to know that he had all this while seen the cover'd filthiness of this hellish hypocrite, and expos'd him also to the just judgment of death from the civil court of judicature.[44]

The wave of fear concerning bestiality or zoophilia in the early eighteenth century was a vivid iteration of the larger tidal change in human and animal affairs. Just as the actual physical and emotional intimacy of humans and domesticated animals – what John Berger calls 'an unspeaking companionship' – diminished with the rise of rationalized agriculture and large-scale, metropolitan civilization, so the literary and artistic tradition of cooperation and affection between human and non-human animals also generally declined, replaced by theological and then scientific texts and images that affirmed an absolute barrier between man and beast.[45] Anthropomorphism – which Berger describes as 'the residue of the continuous use of animal metaphor' – also declined, to be replaced by anthropocentrism, followed by the reduction of animals first to machines, and then simply to raw material for capitalist production and profit.[46]

Humanism, cited above in reference to Dürer and his circle, was an exalted version of Stoic anthropocentrism, and an extension of medieval speciesism. The ancient agnostic philosopher Protagoras' ambiguous saying 'Man is the measure of all things; of things which are, that they are, and of things which are not, that they are not' was transformed during the Renaissance not into scepticism toward

enshrined belief, but into a legal and moral *raison d'état* that at its extreme was summarized by the name Machiavelli. The political philosopher, today considered the apostle of *realpolitik*, argued that the rule of law was natural to men, and the law of force to animals, and that the ideal prince should be a centaur, comprised equally of both. But when it came to actual cases, Machiavelli argued that force was always preferable to law, and that humans must behave like beasts. Employing the language of fable, he wrote that the lion and the fox, or 'force and fraud', were always the best guarantors of stability and the continued thrall of the established regime. 'Therefore as a prince is obliged to know how to act like a beast, he should learn from the fox and the lion.'[47] Machiavelli thus maintains elements of the anthropomorphism of Aesop and the later churchmen, but transforms the fables from repositories of moral truths to sources of amoral politics, useful to sustaining the many competing tyrannies of sixteenth-century Italy. The realm of the non-human animal, according to Machiavelli, was thus invariably ruled by violence, deception and manipulation rather than moral reason; the latter was a property of humans, albeit only weak ones vulnerable to domination.

CARNIVOROUS EUROPE

Almost any animal in early modern Europe was at risk of becoming fur or getting eaten. Indeed, the two centuries from about 1450 to 1650, roughly coincident with the emerging modern perception of animals as mere organic machines, was the great age of meat-eating in Europe. The historian Fernand Braudel calls the zone 'carnivorous Europe' and notes that all sorts of game was plentiful: for example, at the market stalls of Orléans, France, in the fifteenth and sixteenth centuries, hare, rabbit, heron, partridge, woodcock, lark, plover and teal were all available, a bounty suggested by the Antwerp artist Frans Snyders in his painting *The Pantry* (1620).[48] Snyders was one of the first *animaliers* (dedicated animal painters) in European art, and he received important aristocratic commissions for hunting pictures from Philip III and Philip IV of Spain, among others. And were it not for patronage from the leading hunters and carnivores of Europe, we

would be tempted to see a caution against gluttony in an image of a servant and her stores in *The Pantry*. But instead we simply witness a paean to the variety and grotesque superabundance of mammals, fish and birds available for the aristocratic table.

Rabelais described seeing at market herons, egrets, swans, bitterns, cranes, partridges, francolins, quails, wood pigeons, turtle-doves, pheasants, blackbirds, larks and flamingos. Cooked geese were common in the market stalls of Châtelet–Les Halles in Paris, as we learn from Pantagruel's tale about a porter

> in the Roast-meat Cookery of the Petit Chastelet, before the Cook-Shop of one of the Roast-meat Sellers of that Lane . . . eating his Bread, after he had by Parcels kept it a while above the Reek and Steam of a fat Goose on the Spit, turning at a great Fire, and found it so besmoaked with the Vapour, to be savoury.[49]

(A comic dispute followed concerning whether the porter, by smoking his bread, had stolen merchandise from the meat-seller.) In 1580, Michel de Montaigne observed tiers of meat offered at a common roadside inn in northern Germany, though by contrast, while travelling in Lucca, he remarked that

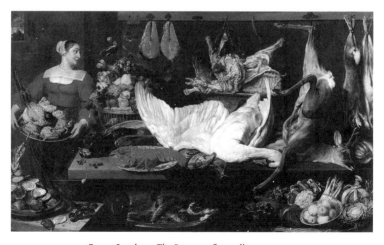

Frans Snyders, *The Pantry*, 1620, oil on canvas.

68

These people are not the great meat-eaters that we are, and they use nothing but the common sorts of flesh, upon which they set but little store, that is to say, while I was there I bought a choice leveret [young hare] for six of our sous without any bargaining.[50]

It was not only the rich who ate vast quantities of meat. The meals of craftsmen, according to an ordinance of 1482 from the Duke of Saxony, contained plentiful amounts of meat every day except Friday, when one or two kinds of fish were served. And even peasants ate roast beef in late fifteenth-century Alsace, according to local records. In Paris in 1557, a visitor observed, 'pork is the habitual food of poor people, those that are really poor. But every craftsman and every merchant, however wretched he may be, likes eating venison and partridge at Shrovetide [Fat Tuesday or Mardi Gras] just as much as the rich'.[51]

Vast numbers of animals – pigs, cows, chickens, sheep and goats – were herded across Europe and brought through the gates of the great cities into urban markets for sale and slaughter. Single herds of 20,000 were not uncommon, and the slaughter was carried out in small sheds or out in the open, with little regard for the pain of the animals or the bloody spectacle of death. By 1600, some 400,000 head of cattle were being transported annually to the markets and abattoirs of the major cities of central Europe.[52] But starting in the late sixteenth century, and especially in the wake of the Thirty Years War (1618–48), meat-eating, along with general economic conditions, began a long decline that lasted until the middle of the nineteenth century. Wages gradually fell during these centuries, and annual per capita consumption of meat in Germany declined from an estimated average of 100 kg in the Middle Ages to just 20 kg in the early nineteenth century.[53] However, there were great regional differences, with less meat in Southern than Northern Europe, where the temperate climate permitted enormous pasturages, as Montaigne's travel diary suggested. England remained a meat-eating bastion, even through the lean years following the Napoleonic Wars.

During the period of greatest European meat-eating, German, Flemish and Netherlandish artists from Hans Baldung Grien to

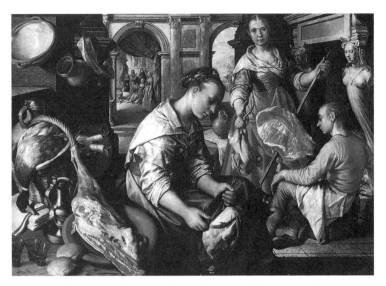

Joachim Beuckelaer, *Christ in the House of Martha and Mary*, 1565, oil on wood.

Frans Snyders employed animals, especially dead or butchered ones, to convey a wide variety of biblical or moralistic stories or lessons. Baldung Grien's woodcut illustration for Geiler von Kaiserberg's *Das Buch Granatapfel* (1511) shows a chef eviscerating a dead rabbit while cooking pots boil on the hearth. The text reveals that every part of the food preparation – the skinning of the animal, the cooking, serving and even the preparation of sauce – symbolizes a specific Christian duty, such as repentance, discipline and the union of human and heavenly spirits.[54] Joachim Beuckelaer's *Christ in the House of Martha and Mary* displays the women's close attention to the preparation of slabs of meat in order to highlight the excessive pride of Martha, who cared more about her cooking than about learning the message of Christ. (In case we miss the point, a more traditional biblical scene appears in the background.) Pieter Aertsen's *Meat Stall with the Holy Family Giving Alms* (1551) displays a gross multitude of meat in its many forms: a slab of ribs at left, a cow's head in the centre and pig's trotters below it; above and to the right is a pig's head hanging from a hook, and many kinds of sausages; below and to the right are a pair of dead birds, and in the centre and lower left corner are dead fish. Fat, lard and butter are shown in vats and sculpted into a cone. In the background at right hangs a pig's carcass,

while in the background at far left is a scene of the Flight into Egypt, and in the middle Mary giving something to a kneeling boy. The picture may propose that overindulgence in meat, and an excessive focus on worldly things (*vanitas*), are expressions of the mortal sins of gluttony, greed and pride, a subject common in the classical and Renaissance satires from which the artist drew inspiration.[55] The Holy Family in the background giving alms puts into moral relief the extravagance pictured in the foreground.

But these pictures and many others in the same genre also propose that animals are no more than meat on the hoof and on the wing, or the malleable subject of sermons and satires, and that their slaughter is as much ordained by God as the biblical stories that appear in the background of their canvases. Paired with religious narratives, pictures of butchers' stalls or piles of meat may offer moralizing sermons about the significance of corporeal versus spiritual existence, but they also suggest the inevitability and sacramental character of slaughter.[56] Just as biblical accounts are imaginatively relived with each telling, and the suffering of the Saviour is re-experienced by every pious Christian who undertakes spiritual self-examination, so the killing, butchering and sale of animals, according

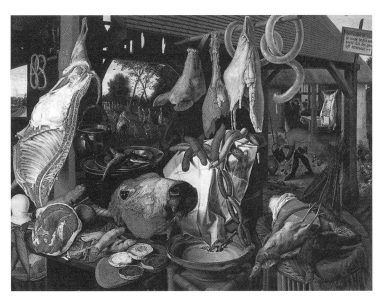

Pieter Aertsen, *Meat Stall with the Holy Family Giving Alms*, 1551, oil on wood.

to these pictures, is essential, timeless and inevitable. Access to abundant and inexpensive meat at the market is as natural and certain as the purity of the Virgin Mary or the divinity of her son Jesus. The chief patrons for Aertsen's work, as well as can be discerned, were precisely the urban men who had come to expect the sanguinous cornucopia that their butchers and painters delivered: civic leaders, wealthy merchants, manufacturers and craftsmen.

The height of early modern humanist arrogance toward animals may have been achieved a few decades later during the period called by Francis Yates the 'Rosicrucian Enlightenment'.[57] Sometime around 1620, Michael Maier, a German alchemist, physician and counsellor to Emperor Rudolph II, composed his *Lusus Serius, or Serious Passe-Time: A Philosophical Discourse concerning the Superiority of Creatures under Man*. In this book, the author described a trial to determine who would represent the combined animal, vegetable and mineral kingdoms in the palace governed by man. Calf, sheep, goose, oyster, bee, silkworm, flax and mercury all testify, extolling their separate worth and indispensability. The calf (or ox) boasts that without his dung and his strength pulling the plough, there would be no agriculture. The goose speaks of the value of his feathers for beds and pillows, the excellent taste of his flesh when turned on a spit and roasted over a fire, and, most of all, the importance of his quills – for without them there would be no pens, and thus no arts and sciences and no laws, all of which are necessary for kings, princes and dukes to rule over their dominions. The oyster boasts of the great value of its pearls (*margarites*) as medicines, aids to men and women's fertility and of course as jewellery and a form of wealth. And the bee, silkworm and flax make equally persuasive cases – the bee creates sweetness from its honey, the flax boasts of the necessity of its fibres in the making of paper, and the silkworms of the unique merit of the fabrics they make possible, fit most of all for the bodies of kings. All of these living things line up to extol the virtues of man and their wish to subordinate their own interests to those of their human masters. But standing above them all is the element mercury, for quicksilver is essential in the mining of the precious metals silver and gold, in making iron and gunpowder, in the creation of physic or laxative (essential in 'carnivorous Europe'), and an equally important ingredient in a

dozen other medicines used to cure myriad diseases.[58] Mercury, in
fact, is the 'hermaphrodite' of metals, and may give birth to nearly
all others, with gold being its most favoured child. It is mercury
that in the end is judged 'the king of all worldly things under the
command of man'.[59] Here the Aristotelian hierarchy is challenged
– even minerals stand above non-human animals – and the willing
subservience and self-abasement of the animate world is shown to
be complete.

But a non-anthropocentric perspective was possible. Indeed, it
was in the teeth of carnivorous Europe, so to speak, that Montaigne
wrote his famous essay on the communicative capacities of animals
and the desirability of attaining with them a condition of mutual
respect. Soon other writers as well as artists began to suggest that
animals might have their own interests, feelings and meanings inde-
pendent of their relationship to humans. It is difficult to fully account
for the emerging perspectives. Perhaps it was the new understanding
of comparative anatomy, explored by Andreas Vesalius (*De humani
corporis fabrica*, Basel, 1543), that made possible Montaigne's under-
standing of the common functions and capabilities of human and
animal bodies. Perhaps it was the very sight of all that meat – piled
up on bottomless plates and trays in every coachhouse and tavern in
France – that allowed or encouraged critical thought about the
sources of all that protein. Perhaps it was simply the independence
of thought enabled by the rise of cities, the growth of universities, the
spread of literacy and printing and the appearance of dissident reli-
gious sects that permitted thinkers and writers to ponder the position
of humans in the wider natural world and the sentience of animals.
Or perhaps it was the sight and sound of the increasing numbers
of suffering animals herded though the hearts of the growing cities
and protesting their fate by cries and bellows and squeals – signs of
their consciousness of their desperate situations – that began to
change the minds of a few humans. We cannot know exactly what it
was that allowed Montaigne to recognize the subjectivity of his cat
in 1580, while contrarily, just two generations later, Descartes could
write a thesis testifying to an unbridgeable barrier between human
and non-human animals, providing a basis for future writers who
believed that the cries of animals in pain were no more than the

creaks of a mechanism under strain. Nor can we account for the fact that Rembrandt in Amsterdam – at almost exactly the same place and time as Descartes – could challenge the carnivorous and moralizing paradigms of Aertsen and suggest the autonomy of the animal that pre-existed the carcass he depicts and that we witness.

And witnessing is the best verb for the experience of seeing Rembrandt's *Flayed Ox* (1655). A woman peers into a room from the foot of a doorway at background right, just as we gaze from the front, embarrassed to see the once powerful animal so reduced. Its front legs are mere stumps and its rear legs are unnaturally spread wide. The flesh is scraped and scabbed like a wound, and it entirely lacks its head, present on the floor in an earlier version of the picture.[60] 'The flayed ox', Kenneth Clark wrote, 'has become a tragic – one might almost say a religious picture'.[61] Other scholars have explicitly compared the animal to Christ, and indeed the crossbeam from which the animal is hung recalls the cross upon which Christ was crucified, as seen, for example, in Rembrandt's own *Crucifixion* (1633). The point of view in both paintings (as well as Rembrandt's earlier version of *The Flayed Ox*) is slightly from below, and in each the bodies are placed on a diagonal. Each also contains a witness who looks out toward the viewer, and each culminates at the top with an oval, a format consistent with an altarpiece.

The comparison of the ox in Rembrandt's picture to Christ is iconographic as well as formal. The story and image of the slaughtered ox exists as part of a long tradition of pictures – engraved and painted – depicting the parable of the Prodigal Son, who gives up his spendthrift ways to return to his home and father. In commemoration of the reunion (Luke 15:11–32), the father slaughters a fatted calf so that family and friends may all celebrate together. This apparently minor detail of the parable is actually quite important; since Tertullian it has been interpreted to symbolize the sacrifice of Christ.[62] As St Jerome wrote: 'The fatted calf, which is sacrificed for the safety of penitents, is the Savior Himself, on whose flesh we feed, and whose blood we drink daily.'[63] And in picture after picture, including Maarten van Heemskerck's engraving of the *Prodigal Son* (1562), Pieter Brueghel the Elder's engraving of *Prudence* (1559) and David Teniers's *Butcher Shop* (1642), the slaughtered ox functions either as a figure of

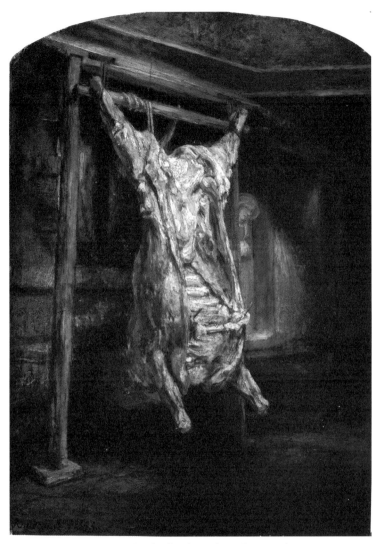

Rembrandt, *The Flayed Ox*, 1655, oil on panel.

Christ or as a memento mori: a reminder of the transience of life, and of the need to attend to spiritual things. Rembrandt painted and drew numerous scenes from the parable of the Prodigal Son and was therefore very familiar with the tradition; there can be little doubt that his ox partly derives from the story.

But how different Rembrandt's picture is from Aertsen and Beukelaer's paradigmatic butcher shop pictures, or from the comic

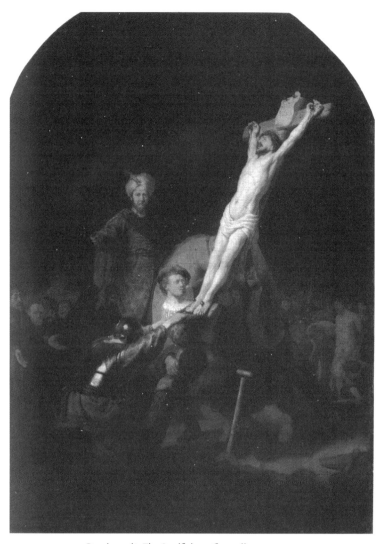

Rembrandt, *The Crucifixion*, 1633, oil on canvas.

and anecdotal images of cow and pig carcasses – whatever their iconographic basis – by Jan Victors and David Teniers! The former's *The Pig Slaughterer* (1648) depicts merchants, servants and children talking, working and playing while a butcher's assistant prepares to cut up a pig on the wooden slab. It may signify the omnipresence of death even amid the mundane labours and pleasures of the every-day. The latter's picture of the same subject shows a freshly killed

and gutted ox – its blood is still dripping – in a house or butcher's shop. At the right a woman busies herself cutting up some of the sweetbreads; in the background at the right, a man in the doorway is carrying outside a bucket of blood while another man and a woman gossip just to his left. In the left foreground is seen the horns and head of the animal, while behind it, a tongue has been nailed to a post. Once again, themes of *vanitas* or memento mori predominate – blood and death amid daily trivialities. It may even be a scene of the preparation of the fatted calf for the feast of the Prodigal Son. Rembrandt's picture does not lend itself so easily to parables, however, whether allegorical or moralizing. His ox will not rise on the Day of Judgment and usher the blessed to Heaven and the damned to Hell, nor does its presence suggest the insignificance of worldly or material things, or the saviour 'on whose flesh we feed', according to Jerome. The animal is most insistently physical, even visceral, however much the artist has drawn upon eschatological tradition. Its raw materiality makes it a sober or even ironic inversion of the paradigm of Christ's sacrifice and resurrection: the death of an ox is shown to be an event without redemption. And by virtue

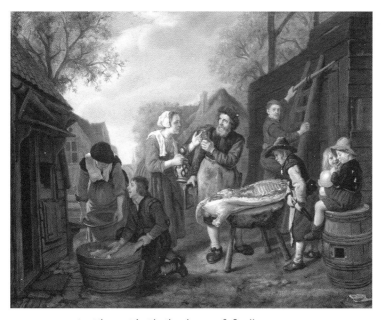

Jan Victors, *The Pig Slaughterer*, 1648, oil on canvas.

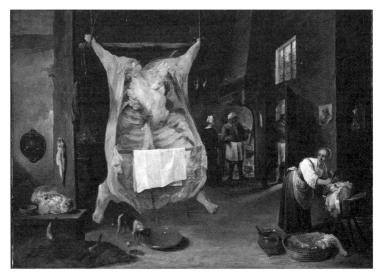

David Teniers, *Butcher Shop*, 1642, oil on panel.

of the artist's carefully constructed circuit of seeing and being seen, so too are the deaths of humans: the mystery posed by Rembrandt's *Flayed Ox* is why humans ever thought they possessed any more soul than animals.

DESCARTES AND HIS ANTAGONISTS

Rembrandt probably met René Descartes in either Leiden or Amsterdam and may even have drawn his portrait (they shared the patronage of Constantijn Huygens), but they apparently differed in their understanding of the essential nature of humans and animals.[64] For Descartes, animals were organic machines entirely lacking souls, rationality or moral reason.[65] This vacuum was basic to Descartes' epistemology and formal method. When he examined animals clinically (evidently by means of vivisection), they appeared to function very much like humans. They breathed air through lungs and their hearts pumped blood through veins and arteries. Their bodies, just like human bodies, seemed to act mechanically, like automata, albeit extremely complicated ones. And yet they differed in one fundamental way from humans: they lacked the capacity for spoken or written language and thus, Descartes believed, for thought. Whereas

even the most simple-minded humans – or ones with an organic impairment – could communicate their thoughts and desires, and respond in more or less cogent fashion to the many forms of stimulus to which they were exposed, animals, Descartes said, could not. And since there was no observable organ in humans that made language and reason possible, these must be the immaterial products of God. Reason, rationality and soul (all subsumed under the single French word *âme*) were the distinguishing characteristics of humans, proving the existence and beneficence of God and the validity of the *cogito* – 'I think therefore I am [human].'

The particularity of Descartes' position is even more apparent when it is seen beside the views of the writers he criticized or ridiculed, especially Montaigne. It was undoubtedly Montaigne whom Descartes had in mind (he read the *Essais* as a boy at the Jesuit College of La Flèche in Anjou) when he wrote the following near the end of Part Five of his *Discourse on Method*:

> For after the error of those who deny the existence of God, an error which I think I have already sufficiently refuted, there is none that is more powerful in leading feeble minds astray from the straight path of virtue than the supposition that the soul of the brutes is of the same nature with our own; and consequently that after this life we have nothing to hope for or fear, more than flies and ants.

In his 'An Apology for Raymond Sebond' (1576), Montaigne had indeed challenged the centrality of humans in nature and claimed that animals possessed the ability to communicate with each other. Echoing Porphyry, he argued that if we humans failed to understand their languages, then we should be faulted no less than they are for failing to grasp ours. Montaigne wrote that attentive humans can understand at least a modicum of the language of animals, and vice versa:

> The defect that hinders communication betwixt [animals] and us, why may it not be in our part as well as theirs? 'Tis yet to determine where the fault lies that we understand not

one another – for we understand them no more than they do us; and by the same reason they may think us to be beasts as we think them . . .We must observe the parity betwixt us: we have some tolerable apprehension of their meaning, and so have beasts of ours – much about the same. They caress us, threaten us, and beg of us, and we do the same to them.

As to the rest, we manifestly discover that they have a full and absolute communication amongst themselves, and that they perfectly understand one another, not only those of the same, but of divers kinds:

> The tamer herds, and wilder sort of brutes,
> Though we of higher race conclude them mutes,
> Yet after dissonant and various notes,
> From gentler lungs or more distended throats,
> As fear, or grief, or anger, do them move,
> Or as they do approach the joys of love.

In one kind of barking of a dog the horse knows there is anger, of another sort of bark he is not afraid. Even in the very beasts that have no voice at all, we easily conclude, from the society of offices we observe amongst them, some other sort of communication: their very motions discover it.[66]

The significance of this is that in recognizing animals' ability to communicate, Montaigne was also granting their intellectual powers and potential rights, though the latter word would not be used in conjunction with animals until the middle of the eighteenth century.[67] If animals could speak, they could also name, designate and describe the world; they could endow it in their own minds with order and measure, and thereby act like humans, the only being – as theologians and prior Christian authors agreed – that had been made according to the measure of God.

Montaigne's animals possessed the one thing that doctrines of anthropocentrism and speciesism denied them: singularity or autonomy. In 'An Apology', Montaigne writes:

When I play with my cat, who knows whether I do not make her more sport than she makes me? We mutually divert one another with our play. If I have my hour to begin or to refuse, she also has hers. Plato, in his picture of the Golden Age under Saturn, reckons, among the chief advantages that a man then had, his communication with beasts, of whom, inquiring and informing himself, he knew the true qualities and differences of them all, by which he acquired a very perfect intelligence and prudence, and led his life more happily than we could do.[68]

The French author's cat was thus not 'an animal' – one example of a large, undifferentiated set – but instead a specific individual likely given a name. (It may have been Lenore, his daughter's name, and also that of his lover's cat.) While Montaigne's comprehension of animal language was not as great as that which humans possessed during the Golden Age of Saturn, nevertheless it was enough that he could understand its rudiments. And by virtue of the fact that Montaigne's cat had the capacity to play, tease and become diffident or even bored, it may be said to have possessed autonomy. Boredom, after all, is the very sign of perceptual self-awareness – the knowledge of one's being in the world.[69]

In a letter of 1646 to the Marquess of Newcastle, Descartes explicitly rejected Montaigne's views on the intelligence of animals, stating that animals possess not reason but passion – the ability to make a sound in order to obtain a certain reward. He stated: 'There has never been known an animal so perfect as to make other animals understand something which bore no relation to its passions: and there is no human being so imperfect as not to do so, since even deaf-mutes invent special signs to express their thoughts.'[70] Animals lack speech, Descartes concluded, 'because they have no thoughts'.

Montaigne's text, by contrast, according to the contemporary philosopher Jacques Derrida, 'was one of the greatest pre- or anti-Cartesian texts on the animal' (and a basis for the modern philosopher's own criticism of the concept of 'the human').[71] 'Montaigne makes fun of 'man's impudence with regard to the beasts' . . .

THE CRY OF NATURE

especially when he presumes to assign them or refuse them certain
faculties.' Most of all, however, Montaigne – unlike Descartes –
refused to permit that animals' lack of reason was an excuse to deny
them the duty of toleration, respect and kindness (or the right not
to be treated cruelly). In his great essay 'On Cruelty', his argument
against 'the greatest vice' passed quickly from human to animal
and back again: 'Among other vices, I cruelly hate cruelty, both by
nature and judgment, as the worst of all vices. But here my weakness
extends so far that I cannot see a chicken's neck twisted without
distress, or bear to hear the squealing of a hare in my hounds' jaws,
though hunting is a very great pleasure to me.' And he added:

> For my part, I have never been able to watch without distress
> even the pursuit and slaughter of an innocent animal, which
> has no defense and has done us no harm. And when, as will
> commonly happen, a weak and panting stag is reduced to
> surrender, and casts itself with tears in its eyes on the mercy
> of us, its pursuers,
>> Bloodstained and groaning, like one imploring mercy. (Virgil,
>> Aeneid, VII, 50)
> this has always seemed to me a most unpleasant sight.
> I hardly ever capture an animal alive that I do not set it free
> in the fields. Pythagoras would buy them from fishermen
> and fowlers, to do the same:
>> I think the blood of animals was the first to stain our weapons.
>> (Ovid, Metamorphoses, XV, 106)
> Natures that are bloodthirsty towards animals show a native
> propensity towards cruelty. [72]

But there were others besides Montaigne who opposed animal
cruelty, especially in the decades immediately following the publi-
cation of the Discourse on Method. These included the great fabulist
Jean de La Fontaine, the physician and philosopher Julien Offray de
La Mettrie and, in more mitigated fashion, the French animal and
still-life painters Jean-Baptiste Oudry and J.-B.-S. Chardin.

La Fontaine's Fables, first published in 1668, are an explicit rejection
of Cartesian doctrine concerning the soullessness of animals. These

droll tales, derived from Aesop and many other sources including the Indian Panchatantra (also known as the Fables of Bidpai), were not intended to provide simple moral lessons but instead to offer ironic or critical perspectives on human and animal character and behaviour, especially concerning pride, greed, guile, status and the conflict between freedom and comfort, for example in the fable of the 'Wolf and the Dog', in which the latter promises the former ease and pleasure if only he will surrender his freedom:

> The wolf, by force of appetite,
> Accepts the terms outright,
> Tears glistening in his eyes.
> But, faring on, he spies
> A galled spot on the mastiff's neck.
> What's that? he cries. O, nothing but a speck.
> A speck? Ay, ay; 'tis not enough to pain me;
> Perhaps the collar's mark by which they chain me.
> Chain! chain you! What! run you not, then,
> Just where you please, and when?
> Not always, sir; but what of that?
> Enough for me, to spoil your fat!
> It ought to be a precious price
> Which could to servile chains entice;
> For me, I'll shun them while I've wit.
> So ran Sir Wolf, and runneth yet.[73]

La Fontaine's animals exhibit at once a remarkable social realism – they might be peasant, bourgeois or noble – and a surprisingly accurate animality; they behave something like how actual foxes, wolves, crows, storks and so on actually behave. Their language, La Fontaine wrote in rebuke to Descartes, is derived from their natural communicative abilities:

> For none is there in all the Universe but that
> Has language of its own. And far
> More eloquent in their own habitat
> Are they, perforce when they are

Characters in my work. If I have erred
By painting them less faithfully in word
And deed; if I present a model flawed,
At least I have opened a path untrod.[74]

In his poem 'Discours à Madame de La Sablière', which introduced the 1679 edition of the fables, La Fontaine was still more explicit about the intelligence of animals, mocking the idea:

That every animal is a machine,
No more; that everything within its breast,
Its head, is moved by springs – or so to say!
No soul, no choice, no sentiment;
Naught but a clock, ticking away
In even pace, with no intent.
Open it, and you find wheels, gears, the lot!
No mind; a simple mechanism, what!
From one wheel to the next the thought is sent
In a mechanical, unfeeling fashion!
So think these folk. An animal might feel?
Sense? Suffer? Love? No, no! It is a wheel
Moving a wheel within a wheel . . . No passion,
No will!' 'Then what are we?' you ask. Much more!
This is how good Descartes explains it . . . [75]

La Fontaine goes on in his essay to describe complex and intelligent animal behaviour among foxes, ants and especially beavers, whose lodges are the product of 'art' and 'scholarship': 'That these beavers possess a body and are devoid of spirit / Never in the world could you make me believe it.'[76] What is ultimately most disturbing to La Fontaine about Descartes is the philosopher's very certainty about the *cogito*. For the fabulist, as for Montaigne before him, knowledge, understanding and spirit are all relative and contingent. Humans have their spirit, he says, and animals and plants theirs, but only humans possess the clarity and distinctness of mind that Descartes claimed to be the basis for knowledge of one's own existence!

Making of Animal Rights

nan, Stephen F.

2138, US

for ordering from the
cholar Bookstore!

Scholar Order # 11182188 Payment Date

Amazon# *107-8072128-3709049*

107-8072128-3709049

CHIREA-SFS-648-4cs48

Quantity: 1

The Cry of Nature: Art and

[Paperback] [2013] Eise

ISBN: 1780231954
Nancy Etcoff, 15A Madison St, Apt 1, Cambridge, M

BOOKSTORE

The illustrations by Oudry for La Fontaine's *Fables* correspondingly grant animals intelligence and independence. Rejecting anthropocentrism and anthropomorphism, Oudry depicted animals with considerable naturalism, attending to their species-specific postures and expressive behaviours. The origins of his *Fables* project lie with a series of more than 200 black ink and white gouache drawings on prepared blue paper begun in 1729. It culminated with the publication between 1749 and 1755 of four folio-sized volumes of texts and engravings. In between, Oudry produced tapestry designs for the manufacturers at Beauvais and Gobelins (and posthumously for Aubusson), individual animal paintings, decorative panels and etchings. The engravings were prepared by a diverse group of some of the most skilled artisans of the day, directed by Charles-Nicolas Cochin, but all share a common format and Rococo style: each scene is vertically oriented, set atop a *trompe l'oeil* plinth inscribed with the name of the fable and surrounded by a double moulding resembling a wooden frame. The animals and landscapes are highly decorative, with twists and curls to tails and branches, diagonal postures, and architectural and landscape elements that lead the eye from the foreground, where the fable is illustrated, into the distance.

Oudry's attention to the particularities of each animal is revealed in his drawing and engraving for the fable of 'Animals Sick from the Plague'. The fable itself concerns a gathering of animals determined to propitiate Heaven so that they may be spared sickness or death from plague. The lion, as the most powerful among them, speaks first and declares that someone has committed a grave sin and must be sacrificed for the salvation of the rest. He then confesses to having 'played the glutton too much and too often on mutton', though 'sometimes, by hunger pressed, "I've eat the shepherd with the rest."'[77] He tells his audience, 'I yield myself, if need there be.' But as soon as he completes his mea culpa, the other animals, led by the fox, declare that the lion has always acted most naturally and appropriately and was free of any sin. No other animals step up to confess their crimes until finally the ass admits to having grazed a little on the grass in a meadow belonging to some monks. All at once a hue and cry arises, and the animals uniformly condemn the ass for his crimes and sentence him at once to hang. The lesson:

Jean-Baptiste Oudry, 'Animals Sick from the Plague', preparatory drawing for *Fables Choisies* (1755), engraving.

'Thus human courts acquit the strong, / And doom the weak, as therefore wrong.' Here the pathos formula – the tendency to make victims appear to be complicit with their own punishment – is shown to exist among animals no less than humans. But it is also subjected to satire; self-surrender here is nothing more than foolish self-destruction.

In the illustration for the fable, eight animals – ass, dog, leopard, boar, bear, lion, fox and elk in the back – are arranged roughly in a circle in front of an escarpment with a stunted tree at upper right that overhangs the scene. Though, according to the fable, they are all talking, none in this picture are standing and speaking like humans, as they are for example in the frontispiece to Roger L'Estrange's edition of *Aesop's Fables* (1693). Each instead assumes a pose common to members of their species: the dog at right with his spine curved, barking at the ass; the bear at left leaning forward with his head cocked; and the lion in the middle lying down with front paws extended and head twisted as he looks at the ass. Each animal appears to communicate to the others and the group, but does so in a physical manner appropriate to their species. Oudry's

capacity to suggest animal communication – a skill likely derived both from actual observations made at the menagerie at Versailles, and from the engraved *têtes d'expression* drawn and published by Charles Le Brun – was remarked by the artist's contemporaries. The editor of the 1759 edition of the *Fables* wrote that Oudry 'makes animals speak . . . and in their attitude, character and expressions, one sees the same passions that other painters have conveyed in human heads'.[78] The idea here was not that Oudry had anthropomorphized his animals, but that animals, like humans, felt and exhibited strong emotions and possessed the capacity to convey them through languages peculiar to their species.[79] This sentiment – pre-Darwinian in its suggestion of a human–animal continuity – was consistent with La Fontaine's own text and antagonistic to Descartes' speciesism. The proposition may have been reinforced for Oudry

Frontispiece to *Aesop's Fables,* Roger L'Estrange's edition (1693).

87

by other writings, including David Boullier's *Essai philosophique sur l'âme des bêtes* (On the Souls of Animals, 1728) and Guillaume Hyacinth Bougeant's popular *Amusement philosophique sur le langage des bêtes* (Amusing Reflections on the Language of Animals, 1729), which argued that animals were intelligent beings whose separate languages were essential to them in organizing their societies. Echoing La Fontaine, Bougeant specifically mentioned beavers, whose ingenuity and teamwork 'proves they mutually communicate their thoughts to each other'.[80]

The paintings of Chardin perhaps exceeded those of his contemporary Oudry in their capacity to suggest the presence of an animating soul, but ironically, they did so by depicting dead animals. Beginning in the mid-1720s, Chardin began to produce fish and game still-lifes that exhibit a striking materiality and tactility. His great *The Ray*, submitted in 1728 as his *morceau de réception* granting him membership in the French Academy, is a veritable treatise, as Sarah R. Cohen has argued, on the comparability of paint and flesh – a demonstration that the one can be turned into the other, offering the very semblance of life and soul.[81] The gross lusciousness of the ray's spilled guts, the fur of the cat at left – painted with enlivening approximation rather than with deadening precision – and even the abstract shapes of the bodies of the dead oysters on their shells all advance the viewer's sense of the weight and particularity of the bodies on view. And according to the philosophic logic of Chardin's day – best represented by the critic and *philosophe* Denis Diderot, and the physician and materialist Julien Offray de La Mettrie – this manner of painting animals implies the presence of an animating force, or soul.

Diderot understood Chardin's unique facture – painterly yet precise, daring but spare – to be a kind of prestidigitation that brought people, animals and things to life: 'The magic defies understanding. It is thick layers of colour applied one on top of the other and beneath which an effect breathes out. At other times, it is a vapour that has been breathed into the canvas; elsewhere a delicate foam that has descended upon it.'[82] La Mettrie never wrote about Chardin, but his discussion of animals in *L'Homme machine* (1748) was influenced by Diderot's clandestinely published *Pensées philosophiques* (1746). The

Jean-Baptiste-Siméon Chardin, *The Ray*, 1728, oil on canvas.

latter was a spirited defence of deism and natural philosophy (the idea that the beauty and diversity of nature implied the presence of a divine maker), but included so many concessions to the position of its fictional atheist interlocutor that it was embraced by the arch-materialist La Mettrie. In attempting to show that the existence of animals and humans are proof of divine creation, Diderot provisionally accepted that both are machines and both intelligent.[83] 'Have you ever observed in any man more intelligence, order, wisdom, and reasonableness than in the mechanism of an insect? Is not the Deity as clearly apparent in the eye of the flesh-worm as in the works of the great Newton?'[84]

In *Man a Machine*, La Mettrie argued that the souls of animals were manifest in their bodies. Surveying the many ways that contingent circumstances – including hunger, pain, temperature and physiognomy – profoundly affect the human spirit, mood, temperament or soul, La Mettrie concludes, in explicit contradiction of Descartes: 'The different states of the soul are therefore co-relative to the states of the body.' In other words, the mind and the body are one, a unity that characterizes animals no less than humans. 'The

transition from animals to man is no way violent', La Mettrie writes (anticipating Rousseau).

> What was man before the invention of words, and the knowledge of language? Nothing but an animal of his kind, with much less natural instinct than others, of whom in such a state he could not imagine himself king; and distinguished from the ape and from other animals only as the ape himself is distinguished, that is, by a more sensible physiognomy.[85]

The difference between humans and animals, La Mettie argues, is the consequence of chance, education and at most some minor differences in the size and shape of the brain. And La Mettrie also offers the following still more radical view, one that proved a foundation for subsequent writing about animal rights in England:

> A being resembling our own in the curious contrivance of its structure, who performs the same operations, who has the same passions, the same pain, the same pleasures more or less lively . . . does not such a being as this give us the clearest demonstration, that it feels the injuries done to itself, as well as to those it does to others; that it knows a right and a wrong, and in fine has a consciousness of what it does? This being has a soul, which like ours feels the same joys, the same misfortunes, the same disappointments.[86]

Chardin's empiricism, remarked by contemporary and later eighteenth-century supporters of his work such as Cochin, appears to parallel the theories of La Mettrie. Indeed, his 'utmost verity', and 'magical execution', as Cochin wrote in 1779 echoing Diderot, is strikingly apparent in the artist's mid-century paintings of dead animals, such as *A Rabbit, Two Thrushes and some Straw on a Table* (c. 1755).[87] Here the limp body of the rabbit, its front and hind paws drawn together, and the arc of its form softly enfolding the two dead birds, is given added poignancy by the modelling of the bodies, the light highlights and the colour complexity of the fur – brown, blue, white,

yellow and red – with the last occurring in multiple places to suggest at once the animation of life and the violence of death. Oudry's *A Hare and a Leg of Lamb* (1742), by comparison, for all its ostentatious *trompe l'oeil*, renders the animal lifeless and inert. Nailed to the wall, its leg parallel to a skinned leg of lamb, with a blank staring eye and a single drop of blood dripping from its nose, it is both highly contrived and utterly dead.

But however vivid or animated Chardin's treatment of the dead animal's fur, and however poetic the composition, the fact of the rabbit's violent death remains paramount for our understanding of the work. In this way, Chardin repeats the ancient pathos formula – earlier seen in Aertsen, Beukelaer, Snyders and others – that aestheticizes violence and renders timeless and inevitable the death of animals in the hunt or the slaughterhouse. A repudiation of that tradition would first occur in England at about the same time that Chardin was active in France. Two of the most important figures in this simultaneous rejection of speciesism and emancipation of animals were John Gay and William Hogarth.

Jean-Baptiste-Siméon Chardin, *A Rabbit, Two Thrushes and some Straw on a Table*, c. 1755, oil on canvas.

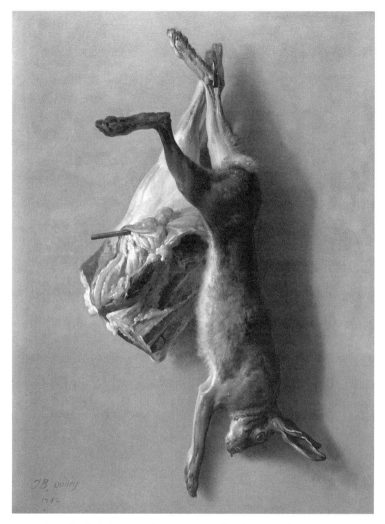

Jean-Baptiste Oudry, *A Hare and a Leg of Lamb*, 1742, oil on canvas.

John Gay's *Fables*, first published and illustrated in 1727 and republished and re-illustrated in many subsequent editions, highlighted the superior moral virtue of animals to humans, and rebuked the culture of violence that reduced animals to mere meat. In the fable of 'The Wild Boar and the Ram', a boar asks a sheep how he can quietly stand by while others in his flock are gruesomely slaughtered before his very eyes. The ram replies that his flock's silence should not be mistaken for insensibility, but that lacking the boar's tusks,

they must be contented with another sort of vengeance, one satisfied
by law courts and the fields of battle:

> The two chief plagues that waste mankind:
> Our skin supplies the wrangling bar,
> It wakes their slumb'ring sons to war;
> And well revenge may rest contented,
> Since drums and parchment were invented.[88]

In John Wootton's illustration of 1727 for Gay's fable, a ram in
the right foreground and a boar in the left engage in a sober colloquy.
Behind the ram at right are three sheep, and behind them is visible
another sheep, suspended by two legs from a tree and in the process
of being skinned. The latter motif recalls Titian's famous painting
of the *Flaying of Marsyas* (1575).[89] The reference to Marsyas is an obvi-
ous one – Hogarth would employ it two decades later at the lower
left of his engraving *The Battle of Pictures* – and emphasizes two under-
lying themes. The first concerns vengeance; it was Apollo's anger at
the musical challenge posed by the pipe-playing Marysas that led
to Marsyas' torture (the god preferred a lyre). Gay's text reverses the
meaning of the myth; here it is precisely the ram's withholding of
vengeance that will eventually allow justice to run its course. The
second theme concerns what may be called the 'popular' or 'demot-
ic' content of Gay's work. Apollo's destruction of Marsyas – half-
human and half-goat – is a triumph of the ideal over the real, the
Olympian Gods over mortals and the Apollonian over the Dionysian
or animalistic. But Gay's fable and Wooton's images suggest the
opposite: that human reason, represented by legal parchment and
war drum, will be humanity's own undoing and a basis for animal
triumph. And the illustrated fable exposes one further opposition
to the Renaissance tradition and the ancient pathos formula: the
assertion that death by torture has no beauty. Whereas the Marsysas
of Titian does not grimace or show any other signs of pain, thus
seeming to accede to the cruel punishment meted out by Apollo,
the tortured animal in the background of 'The Wild Boar and the
Ram' lacks idealization. (Fifty years later, John Bewick, brother of
Thomas, the pioneering wood engraver and champion of animals,

THE CRY OF NATURE

John Wootton, 'The Wild Boar and the Ram', from *Gay's Fables* (1727).

would illustrate the fable of 'The Wild Boar and the Ram' with a vignette that similarly shows the boar and ram in the foreground and the scene of slaughter in the back.[90] But this time, the man wielding the knife stands astride his victim, as peasants do with an animal about to be killed, without any reference to Marsyas at all; the art historical touchstone has shifted from the learned Titian to the more populist Brueghel.[91])

Another fable by Gay, 'The Elephant and the Bookseller', takes the fabulist literature itself as its subject. It describes an elephant reading some books of fable and objecting to the suggestion in one that 'strong reason' exists in humans while 'a beast's scarce instinct is allowed'.[92] In 'Pythagoras and the Countryman', illustrated by Kent, a meat-eating diet is condemned along with the supposition that God granted humans dominion over animals. One morning, according to the fable, the notable mathematician – claimed by Porphyry to have been a vegetarian – goes out for a pleasant morning walk to discover a farmer nailing a dead kite to a barn as a warning to other birds of prey not to attack his poultry.

136 F A B L E S.

FABLE XXXVI.

PYTHAGORAS *and the* COUNTRYMAN.

PYTHAG'RAS rofe at early dawn,
 By foaring meditation drawn,
To breathe the fragrance of the day,
Through flow'ry fields he took his way;

 In

William Kent, 'Pythagoras and the Countryman', illustration from
Gay's Fables (1727).

Friend, says the Sage, the doom is wise,
For public good the murd'rer dies.
But if these tyrants of the air
Demand a sentence so severe,
Think how the glutton-man devours;
What bloody feasts regale his hours!
O impudence of power and might!

Thus to condemn a hawk or kite,
When thou perhaps, carniv'rous sinner,
Had'st pullets yesterday for dinner!
Hold! cried the clown, with passion heated,
Shall kites and men alike be treated?
When heaven the world with creatures stor'd,
Man was ordain'd their sovereign lord.
Thus tyrants boast,' the Sage replied,
Whose murders spring from power and pride.
Own then this man-like kite is slain
Thy greater luxury to sustain;
For * 'Petty rogues submit to fate,
That great ones may enjoy their state.'[93]

The lesson here recalls the one suggested by La Fontaine's 'Animals Sick from the Plague' – that established law and custom favours the powerful and punishes the weak and poor – but extends the lesson further by highlighting the tyranny of human over animal.

However humorous, Gay's *Fables* are a clear rejoinder to the long tradition of Christian and European speciesism. By their rejection of the pathos formula that beautifies and therefore implicitly justifies the killing of animals for food or sport, and by their assertion that animals have the right to life and liberty, they stand on the cusp of modern animal rights sentiment: the idea that animals experience pleasure and pain – and in this Gay anticipated utilitarian thought – that they have intelligence (and souls); that they should not be treated cruelly; and, most radical of all, that human and non-human are equal in their right to be treated as autonomous beings deserving of respect.[94] These postulates would be asserted, denied and debated over the next 200 years. The first clear artistic advocate for animal rights and one of the most influential was William Hogarth.

HOGARTH'S *FOUR STAGES OF CRUELTY*

William Hogarth's engravings titled *The Four Stages of Cruelty* (1751) remain today among the most frequently reproduced images of animal cruelty, and for that reason are the most frequently embraced

by champions of animal rights or protection. The prints depict the deplorable and rapid descent of one Tom Nero, a ward of St Giles parish, from petty ruffian to murderer. Instead of focusing upon the corrupting influences of greed, gambling, drink and debauchery, as Hogarth did in his *Rake's Progress*, the artist examined the marriage of criminality and cruelty to animals. The general argument of the series is that the latter is a precondition of the former, a posture that, as we have seen, has roots in antique and early Christian thought, and which was also found in the writings of John Locke, Henry Fielding and others. For example, in his essay 'Some Thoughts Concerning Education and Cruelty' (1693), Locke wrote:

> One thing I have frequently observed in Children, that when they have got possession of any poor Creature, they are apt to use it ill: They often torment, and treat very roughly young Birds, Butterflies, and such other poor Animals, which fall into their Hands, and that with a seeming kind of Pleasure. This I think should be watched in them, and if they incline to any such *Cruelty*; they should be taught the contrary Usage. For the custom of tormenting and killing of Beasts will, by degrees, harden their Minds even towards Men; and they who delight in the suffering and destruction of inferiour Creatures, will not be apt to be very compassionate or benigne to those of their own kind.[95]

Hogarth's series, like Locke's essay, proposes that the contemporary plagues of criminality and violence might be arrested or slowed if children – at their base as savage as the brutes – were prevented from acts of cruelty toward animals. The principle was a staple of Enlightenment pedagogy, and is found in many books intended for the education of children, from the polite and pragmatic John Trusler's *Proverbs Exemplified and Illustrated by Pictures from Real Life* (1790) to the more bold and Rousseau-influenced *Original Stories from Real Life* (1791) by Mary Wollstonecraft.[96]

The idea that animal cruelty predicts human cruelty is also found in Thomas Young's *An Essay on Humanity to Animals* (1798). Here the author specifically cited Hogarth as the chief source for the idea

that murderers 'might trace the progress of their wickedness' from their cruelty to animals: 'Hogarth . . . makes the career of the hero of his *Four Stages of Cruelty*, commence with the barbarous treatment of animals, and conclude with murder, the gallows and dissection.'[97] Thomas Gainsborough, too, embraced the subject, after his fashion, in his *Two Shepherd Boys with Dogs Fighting*, a large painting exhibited at the Royal Academy in 1783. It shows a pair of biting and snapping dogs (smooth collies) at the bottom of the picture and two shepherds, one of whom – the fair-haired and tender-looking boy at right – attempts to break up the fight with a stick. He is, however, restrained by the dark-haired shepherd who appears to delight in the conflict. (This ruffian is the descendant of Tom Nero, who is bound for the gallows if he does not mend his ways.) But in fact the picture defies easy analysis. On the one hand, Gainsborough displayed his indifference to the moral iconography of the picture by writing to Sir William Chambers, Treasurer of the Royal Academy: 'I sent my fighting dogs to divert you. I believe the next exhibition I shall make the boys fighting and the dogs looking on – you know my cunning way of avoiding great subjects in painting and of concealing my ignorance by a flash in the pan.'[98] Indeed, so apparently indifferent is he that the pose of his good shepherd was borrowed from that of the evil Tom Nero beating his horse in plate two of Hogarth's print series! On the other, Gainsborough's words precisely draw a moral equivalency between human and animal: 'next exhibition I shall make the boys fighting and the dogs looking on'. Perhaps he knew his Hogarth better than supposed and meant exactly what he said?

In fact, the cruelties depicted in Hogarth's series are so vivid and appalling that it seems likely that animal cruelty per se, not its brutalizing effect upon humans, is the artist's chief concern. If this is correct, then Hogarth is perhaps the first major artist in the European tradition to see animals as ends in themselves, and not merely as means to human ends.

In Trusler's *Hogarth Moralized* (1768), published in collaboration with the artist's widow, Jane, the author meticulously catalogued the various horrors shown in each plate of the *Four Stages*. In the first we see:

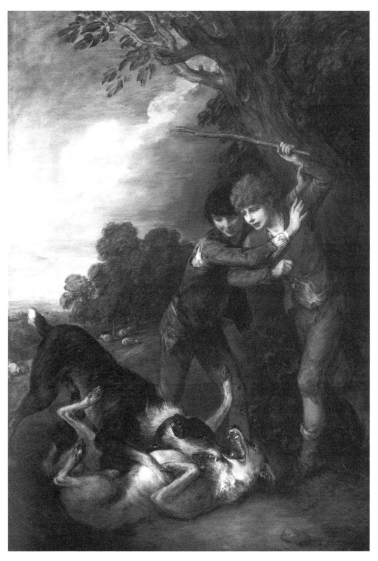

Thomas Gainsborough, *Two Shepherd Boys with Dogs Fighting*, 1783,
oil on canvas.

One [boy] throwing at a cock [cock-fighting] . . . another is
tying a bone to a dog's tail in order to hurry him through
the streets with fear and pain . . . [while] the faithful creature
is licking the hand of his merciless master! . . . A third is
burning out the eyes of a bird with a red-hot knitting needle

in order to make it sing . . . a barbarous custom chiefly prac-
ticed upon bullfinches. Behind is a number of boys diverting
themselves by hanging up two cats by their tails, purposely to
make them fight . . . Above these from a window is one throw-
ing out a cat, with a pair of blown up bladders fastened to
their sides . . . But the principle group in this plate is that of
a boy's piercing a dog, with an arrow, a deep studied piece
of barbarity . . . We are told his name is Tom Nero by his
companion behind him, not quite so inhuman as the rest,
who is drawing his effigy in charcoal upon the wall, hanging
from a gibbet, intimating the fatal end he imagines this
genius will come to.[99]

In the second plate, we see 'that spirit of inhumanity . . . ripened by
manhood'. Here Tom has become a hackney carriage driver, and is

cruelly beating his poor beast for not rising, though in his
fall . . . he had the misfortune to break his leg; and so sensi-
ble is the afflicted creature of the unkindness of his master,
that we see a big, round drop, trickling down his cheek, a
manifest proof of his inward feelings . . . On the right is
represented one of those inhuman wretches whose employ
is to drive cattle to and from Smithfield Market. Behind him,
beating a tender, over driven lamb . . . and the poor faint
creature dying under his blows, its entrails issuing from its
mouth. Further back is a drayman belonging to a brewer,
falling asleep . . . and his dray running over a child playing
with his hoopOn the background of this plate are a num-
ber of people diverting themselves with baiting or worrying
a bull.

Though Trusler is at pains to emphasize the cost to human moral-
ity and well-being of cruelty to animals, his catalogue of abuses is
so great that the reader, and of course the viewer, of Hogarth's engrav-
ings cannot but feel that the fate of the animals, not the humans, is
the chief concern. The artist's particular focus upon the beaten and
dying horse must have struck a particular chord in a city in which a

great number of horses were being used for transportation. The motif was clearly derived from Rembrandt's early painting of *Balaam and the Ass* (1626) – the legs of the animals are nearly identical in position – a narrative from Numbers (22:22) that recounts how an ass was permitted to see an angel of the Lord in order to prevent his master Balaam from crossing the river Jordan to denounce Israel. The ass is even given the gift of speech to protest his cruel treatment by Balaam, a detail suggested in Rembrandt's work by the animal's open mouth. Hogarth's horse does not speak, but instead sheds a tear in eloquent testimony of his suffering.

Hogarth's focus upon cruelty to animals – his first two plates are a veritable Massacre of the Innocents – and his implicit suggestion that such violence is every bit as abhorrent as violence toward people would be repeated in the numerous treatises on animal protection that appeared later in the century. In *The Duty of Mercy . . . to Brutes* (1776) Humphrey Primatt writes: 'It is certain, however, that the cruelty of man to brutes is a greater act of injustice than the cruelty of men to men.' While a person can 'plead his cause', an animal cannot, and there is no court to protect him. In addition, an injury to an animal, Primatt writes, cannot usually be repaired; in destroying his limbs or eyes you have usually destroyed all his sources of both happiness and survival.[100]

The final two plates of the *Four Stages*, 'Cruelty in Perfection' and 'The Reward of Cruelty', show Tom's arrest after the murder of his pregnant lover Ann Gill, and the post-execution dissection of his body. Trusler writes about this last image:

> See his wicked, blasphemous tongue pulled from the root, his guilty eye-balls wrung from their sockets, and his iniquitous heart, torn from his body, which the dog is gnawing beneath the table. To give us a true idea of this scene of horror, in one place is a man pulling the entrails into a bucket, and in another some skulls and bones boiling in a cauldron, by way of cleaning and whitening them in order to have them linked together by wires, as they were connected in the human frame.[101]

In his *Autobiographical Notes*, Hogarth wrote:

> The four stages of cruelty, were done in hopes of preventing
> in some degree that cruel treatment of poor animals which
> makes the streets of London more disagreeable to the
> human mind, than any thing what ever . . . it could not be
> done in too strong a manner as the most stony hearts were
> meant to be affected by them.[102]

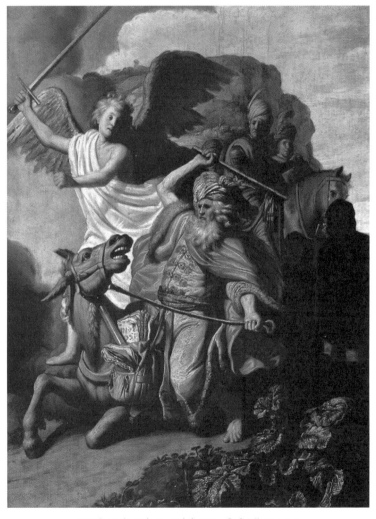

Rembrandt, *Balaam and the Ass*, 1626, oil on canvas.

He said in addition that he would rather have been the creator of the *Four Stages* than the Raphael Cartoons, the very summit of classical poise and Christian rectitude.

William Hogarth's *The Four Stages of Cruelty* thus articulates in modern vernacular form the Christian rationale for kindness to animals (represented by the writings of Aquinas): that the brutalization of animals is but a step on the path toward the brutalization of fellow humans. But precisely because of the vividness of its modern subject and style, the print series supersedes anthropocentric moralism. Hogarth's art and the above testimony suggest that it is cruelty toward animals – abuse, torture and blood sports – not its effects upon humans, that is most objectionable. But however trenchant and affecting the images, and however successful the series was in evading the lure of the pathos formula that ensnared his French contemporary Chardin, the *Four Stages* provided little insight into the peculiar life and character of his animal subjects themselves. Indeed, partially excepting the *Self-portrait with the Artist's Pug* (1745) that depicts the pugnacious animal as the painter's alter ego, Hogarth's animals have no inner life. They are instead cyphers for animals, and offer little to support the more radical notions then emerging concerning animal autonomy and the abolition of human domination of animals. Hogarth's work thus became a foundation for the emerging utilitarian and welfarist perspective, such as that of Francis Hutcheson, who argued in 1755 that even if animals lack reason, they possess the capacity for pleasure and pain, and therefore must not be subjected to cruel treatment. [103] And they provided a foundation for Jeremy Bentham, who offered what is still the most influential, if limited, argument in favour of animal liberation, one that was the basis 200 years later for Peter Singer's book of that title.

In his discussion of ethics in *An Introduction to the Principles of Morals and Legislation* (written 1780; published 1789), Bentham introduces the 'greatest happiness' principle and then asks what 'agents' are susceptible to pleasure. His answer is 'human beings who are styled persons' and 'other animals, which, on account of their interests having been neglected by the insensibility of the ancient jurists, stand degraded into the class of *things*'. Then follows a long footnote

which, because of its great importance for future discussions of animal rights, is printed below in its entirety:

> Under the Gentoo and Mahometan religions, the interests of the rest of the animal creation seem to have met with some attention. Why have they not universally, with as much as those of human creatures, allowance made for the difference in point of sensibility? Because the laws that are have been the work of mutual fear; a sentiment which the less rational animals have not had the same means as man has of turning to account. Why *ought* they not? No reason can be given. If the being eaten were all, there is very good reason why we should be suffered to eat such of them as we like to eat: we are the better for it, and they are never the worse. They have none of those long-protracted anticipations of future misery which we have. The death they suffer in our hands commonly is, and always may be, a speedier, and by that means a less painful one, than that which would await them in the inevitable course of nature. If the being killed were all, there is very good reason why we should be suffered to kill such as molest us: we should be the worse for their living, and they are never the worse for being dead. But is there any reason why we should be suffered to torment them? Not any that I can see. Are there any why we should *not* be suffered to torment them? Yes, several. See B. I. tit. [Cruelty to animals] . . . The day has been, I grieve to say in many places it is not yet past, in which the greater part of the species, under the denomination of slaves, have been treated by the law exactly upon the same footing as, in England for example, the inferior races of animals are still. The day *may* come, when the rest of the animal creation may acquire those rights which never could have been withholden from them but by the hand of tyranny. The French have already discovered that the blackness of the skin is no reason why a human being should be abandoned without redress to the caprice of a tormentor.* It may come one day to be recognized, that the number of the legs, the villosity of the skin, or the termination of the *os*

sacrum, are reasons equally insufficient for abandoning a
sensitive being to the same fate. What else is it that should
trace the insuperable line? Is it the faculty of reason, or, per-
haps, the faculty of discourse? But a full-grown horse or
dog is beyond comparison a more rational, as well as a more
conversable animal, than an infant of a day, or a week, or even
a month, old. But suppose the case were otherwise, what
would it avail? The question is not, Can they *reason?* nor, Can
they *talk?* but, Can they *suffer?*

*See Lewis xiv's Code Noir.[104]

Singer's influential manifesto of 1975, *Animal Liberation*, is written
from this perspective. In short, his argument is that while differ-
ences in strength, intelligence, keenness of senses and so on exist
among people, none of these differences are functionally significant
for the exercise of basic rights such as voting, owning property,
attending school or getting married. Most of us agree that to dis-
criminate on the basis of such abilities is wrong. By the same token,
Singer argues, while most humans are smarter than animals, intel-
ligence is insignificant when it comes to the most basic right of all
sentient beings, as Bentham argued: to avoid being tortured, killed
and eaten as meat. To argue or act otherwise is to indulge in species-
ism, a bigotry that sanctions the torture and killing of billions of
animals every year. However, Singer, again like Bentham, does not
reject all exploitation of animals. As a utilitarian committed to the
principle of the greatest good for the greatest number, he can accept
the death and even the suffering of laboratory or other animals if it
means a greater amount of suffering and death of humans can be
prevented. (The pleasure derived from eating meat would not count
as a sufficient justification for killing an animal – humans can be
perfectly healthy and happy without eating meat.) Moreover, Singer
argues, following Bentham, that because animals lack the cognitive
capacity of humans – for example, they lack an understanding (and
therefore fear) of suffering and the finality of death ('those long-
protracted anticipations of future misery') – their killing may be
justified where the killing of a human may not be. In this way, Singer
belongs in the camp of those who support what the activist and

legal theorist Gary Francione calls 'animal welfare', 'animal protectionism' or 'regulated exploitation'. This is the tradition of activist reformers from Bentham's day to our own who have tried to reform laws to lessen the suffering of animals while still permitting their ownership, exploitation and even consumption as food. Hogarth, as well as a number of poets and writers in the tradition of sensibility, stand at the beginning of this lineage.

The word 'sensibility' denotes the cult of emotionalism that marked the literature and letters of the mid- and later eighteenth century, and love of animals was a clear marker of elevated sensitivity. But even those poets and philosophers most sympathetic to animals – such as James Thomson, Alexander Pope, Hutcheson, Bentham and William Cowper – who condemned blood sports, hunting and the daily cruelties visible on London streets, accepted and even trumpeted the value and necessity of a meat-eating diet and human domination of animals. They rarely if ever wrote of animal autonomy or the right to be left alone. William Cowper, for example, wrote some of his most affecting and popular verses in condemnation of hunting in his book-length poem *The Task* (1785):

> . . . Detested sport
> That owes its pleasures to another's pain,
> That feeds upon the dying shrieks
> Of harmless nature. Dumb, yet endued
> With eloquence that agonies inspire
> Of silent tears and heart-distending sighs! . . .
> Well – one at least is safe. One sheltered hare
> Has never heard the sanguinary yell.
> Of cruel man, exulting in her woes.
> Innocent partner of my peaceful home,
> Whom ten long years experience of my care
> Has made at last familiar, she has lost
> Much of her vigilant instinctive dread,
> Not needful here, beneath a roof like mine.[105]

But he was not a vegetarian, and *The Task* also contains the following lines:

On Noah, and in him on all mankind,
The charter was conferr'd by which we hold
The flesh of animals in fee, and claim
O'er all we feed on, pow'r of life and death.
But read the instrument and mark it well.
Th' oppression of a tyrannous control
Can find no warrant there. Feed then, and yield
Thanks for thy food. Carnivorous through sin
Feed on the slain, but spare the living brute . . .
The sum is this: if man's convenience, health,
Or safety interfere, his rights and claims
Are paramount, and must extinguish theirs.[106]

Indeed, many authors made open display of their conviction that whatever responsibility they may have to kindness toward 'the brute creation', they had an unimpeachable right to consume as much meat as they wished, claiming natural law, Christian doctrine and medical necessity as justification. Though Alexander Pope condemned a meat-based diet in the celebrated *Essay on Man* as both cruel to animals and unhealthful to humans, he also stated that carnivorousness was natural: 'Say, will the falcon, stooping from above/ Smit with her varying plumage, spare the dove? / Admires the jay the insect's gilded wings?'[107] This animal welfare perspective may in fact be an expression of what Tristram Stuart in his recent *The Bloodless Revolution* calls 'counter-vegetarianism', which 'fortifies the bulwark around man's right to eat meat' against, in Hutcheson's words, 'the many great sects and nations [who] deny this right of mankind'.[108]

The Welsh Druid-priest David Williams in 1789 went even further, arguing with perfect utilitarian sophistry that it was actually humanity's duty to kill and eat more animals, because that was the only way of bringing more happy animals into the world, and thus increasing the overall store of happiness.[109] The obvious flaw in this 'hedonic calculus' is that the suffering of a living animal is of greater significance than the absence of happiness in an animal that does not yet even exist! But even if the logic were correct, the calculus would be flawed. The absence of farmed animals need not mean the absence

of animals. The space and resources taken up by capital intensive agriculture could be marshalled to provide subsistence to an equal or greater number of large and small wild animals, happy because they are able to indulge the many pleasures of freedom.[110]

Williams nevertheless insisted that it was both desirable and possible for humans to exercise compassion to animals:

> All animals, of acknowledged or indisputable inferiority . . . are subject to our power. But . . . the highest utility we invariably find allied to strict justice or extensive humanity. We observe that men or nations, as they advance in excellence, soften the condition of brutes, and gradually emancipate them from slavery or wretchedness.[111]

In time, Williams thus argues, the worst abuses against inferior animals, like those again human slaves, will be ameliorated. This and similar viewpoints prospered and grew in the age of industrialized agriculture that emerged in the nineteenth century, and have accelerated today, as animal welfare groups such as The Humane Society and Farm Sanctuary inveigh against factory farms and in support of 'happy meat': meat from animals raised and slaughtered humanely.[112] But it is difficult to avoid the conclusion that most movements to improve the treatment of farm animals have actually enabled the rapid acceleration of carnage. Animal slaughter was in fact increasingly rationalized as the nineteenth century progressed, and plans were drawn up to keep the killing out of sight and persuade meat-eaters that the slaughter was done mercifully. 'Without pain', Stuart summarizes, 'animal slaughter no longer needed to excite compassion'.[113]

Of course, many writers were immune to even reformist arguments. In the mid-1780s, Immanuel Kant argued that animals, unlike humans, are governed by instinct, impulse, external stimuli and 'brute necessity'.[114] They are wholly subject to the law of nature and lack the autonomy essential to moral beings. And since for Kant, moral life – a virtuous life lived according to the laws of reason – is the only worthwhile one, animals lack intrinsic value. Their value is based instead on the extent to which they promote

the moral aims of humans; they are instruments to be used and discarded as needed.

> Man has in his own person an inviolability; it is something holy, that has been entrusted to us. All else is subject to man . . . That which man can dispose over must be a thing. Animals are here regarded as things; but man is no thing.[115]

A more succinct definition of speciesism than this could not be devised.[116]

THREE
The Cry of Nature

GEORGE STUBBS

When we examine the works of George Stubbs, we see the expression of a changed relationship between animals and humans, one that upholds the uniqueness and autonomy of each. If his dogs and horses are at one level mere 'things' in the Kantian sense, the product of careful and selective breeding according to the modern methods described by James Burnett (Lord Monboddo) among others, they are also individuals with names, unique comportments and attitudes. Stubbs's animals even bear marks of weariness, anxiety, and loss. His painting of *Gimcrack on Newmarket Heath with a Trainer, a Stable Lad and a Jockey* (c. 1765) depicts the great thoroughbred (the term was new) and his rider after a race or hard workout. (The picture was commissioned by William Wildman after his pony-sized horse won his first race at Newmarket Racecourse in Suffolk.) The animal glistens, his head leans forward approaching the head of his trainer, oblivious to the ministrations of the groom beneath him.

Similar expressiveness is apparent in *The 3rd Duke of Dorset's Hunter with a Groom and a Dog* (1768), in which the circuit of silent communication between horse, groom and dog is especially eloquent; they are all awaiting the arrival of the Duke. It is hard, here, not to think of the arguments of Porphyry, or the famous passage from Montaigne's 'An Apology of Raymond Sebond':

> In one kind of barking of a dog the horse knows there is anger, of another sort conclude, from the society of offices

we observe amongst them, some other sort of communication: their very motions discover it.

Most of Stubbs's contemporaries were generally dismissive of the idea that horses had intelligence or complex communicative abilities. In his *Inquiry into the Structure . . . of the Horse* (1809), Richard Lawrence, summarizing a generation of thought, insisted that horses were governed by instinct and habit alone. A horse extends devotion to its feeder, 'but it is probable that this attachment is less the effect of gratitude, than the result of simple recollection of the source from whence they satisfy one of the most urgent calls of nature'.[1]

Stubbs, on the other hand, from early on in his career shared with the French naturalist Georges-Louis Leclerc, Comte de Buffon, the conviction that animal and human alike possessed the primary 'passions' and 'appetites' – 'fear, horror, anger and love'.[2] Stubbs's *Horse Attacked by a Lion* (c. 1762), a motif that the artist painted or engraved nineteen times in various sizes, formats and variations

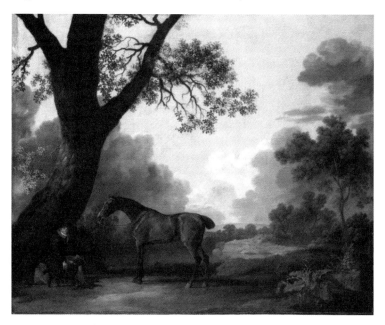

George Stubbs, *The 3rd Duke of Dorset's Hunter with a Groom and a Dog Dog*, 1768, oil on canvas.

George Stubbs, *Horse Attacked by a Lion*, c. 1762, oil on canvas.

over a period of 30 years, was at once a reprise of the anthropomor-
phism of earlier animal aesthetics and an anticipation of a new and
more radical perspective that accepted the uniqueness and autonomy
of non-human animals. The physiognomy of the frightened horse that
appears to scream in fear and pain is human in its peculiar mobility
and intensity, and is derived both from a Hellenistic sculpture of a lion
attacking a horse then at the Palazzo dei Conservatori in Rome (now
in the Capitoline Museums) and, in all probability, from the *Lecture
on Expression* by Charles Le Brun first published in 1698. More than
either source, however, Stubbs's horse has an open mouth, bulging
eyes and a mane flying out behind the head.[3] The result is an affec-
tivity and pathos that contest the older pathos formula – visible, for
example, in Rubens's several *Lion Hunt* pictures – that showed animals
as complicit victims of human and other predation, or as mindless
monsters. At the same time, the picture was a rebuke to the Cartesian
view of animals as mere mechanisms. Upon seeing one of the horse
and lion pictures, Horace Walpole published a tribute in which he
claimed to 'feel [the horse's] feelings', and then asked: 'Is that an
engine? That a mere machine?'[4] The horse's outcry and contortion

– the latter perhaps derived from the ancient sculpture of the *Laocoön* – violates the dignity and calm supposed to characterize the thorough-bred horses that were Stubbs's usual subjects and elevates the tragedy from the realm of nature to the time of history – from animal painting to history painting.

A shriek of pain – which arrests all thought and memory – is by its nature a sign of presentness and contemporaneity, as well as an expression of the brute facticity and resistance of a body, or of a primary process emotion. It was heard every day, as Hogarth suggested in the second of *The Four Stages of Cruelty*, on the streets and in the open-air slaughterhouses of London and in every town and city in Georgian England. The outcry in *Horse Attacked* or in the engraving titled *A Horse Affrighted by a Lion* (1788) – the sound of an animal in panic or in its death throes – was thus a sound Stubbs too would have known well. And its reverberations would be felt in many works of art and literature of the next generation and beyond. It became a cypher or symptom of the modern; of an artwork that insists on being seen for what it is, not as an allegory, symbol or metaphor.[5] It would signal the presence of realism (the opposite of a classicizing idealism) and

Lion Attacking a Horse, c. 325–300 BCE, marble.

113

find its logical culmination 150 years after Stubbs in the screaming horse at the centre of Pablo Picasso's *Guernica*.

Stubbs arrived at his insights by means both inherent and derived; that is, he learned what he did both because of who he was and because of what he studied. The son of a leather worker and merchant, he was from childhood exposed to animals – inside and out. In his early twenties, he studied human anatomy for five years at York County Hospital, even performing his own dissection of 'a woman who had died in Childbed'.[6] At the age of 32, he rented a farmhouse in Horkstow, Lincolnshire, and spent eighteen months dissecting the bodies of horses obtained live from a nearby tannery. He worked in a painstaking and apparently cold-hearted manner, first killing the horse by slitting its jugular veins before injecting wax into the arteries and veins and then suspending the animal from the ceiling of his barn by means of an elaborate contraption of hooks, metal bars and chains. The result (ten years later) was a book, *The Anatomy of the Horse*, and a successful career as an animal painter. The book was the first such original treatise in over 100 years, and its plates, like the hundreds of working drawings from which they derive, reveal an austerity, poise and placidity that belies what must have

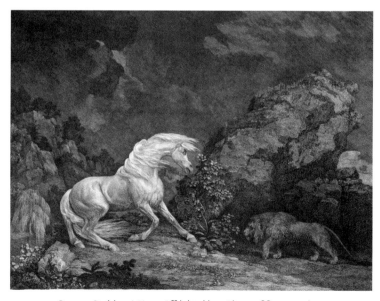

George Stubbs, *A Horse Affrighted by a Lion*, 1788, engraving.

George Stubbs,
engraving from
*The Anatomy of
the Horse* (1766).

been the macabre circumstance of their making – a barn containing six-to-eight-week-old animal carcasses, rotting, putrid and covered with flies.

Late in life, Stubbs returned to the research and observation that earlier came so naturally to him. In 1802, he began preparations for a second major anatomical treatise, *A Comparative Anatomical Exposition of the Structure of the Human Body with that of a Tiger and a Common Fowl*. It was a theme he had explored a few years before in a strange painting, the *Lincolnshire Ox* (1790), which shows an ox, a chicken and a man all striding across the picture plane from right to left. The painting reveals a peculiar and unstable pattern of affinity and non-affinity, or difference and sameness, among the three animals. All three are vertebrates; they are differently sized – small, medium and large; two are mammals, one is a bird; two are bipeds and one is a quadruped; one is a herbivore and two are (arguably) omnivores; two have teeth, and one does not; two have fur (or hair) and one has feathers. Humans are therefore part-bird and part-ox; oxen are part-human and part-chicken; chickens are part-ox and part-human, and so forth. But none, by virtue of these comparisons, is revealed to be more singular than the other; none is more advantaged by nature than the other; none is endowed by the creator with more favourable attributes than any other; and none, by extension, has any special rights of dominion over the other. Each is a species – human no less than animal – and thus simply one type among many in the natural world. Stubbs might

George Stubbs, 'Chicken', from *A Comparative Anatomical Exposition of the Structure of the Human Body with that of a Tiger and a Common Fowl* (1795–1806).

almost have been illustrating the famous passage from Bentham published just a year before:

> The French have already discovered that the blackness of the skin is no reason why a human being should be abandoned without redress to the caprice of a tormentor. It may come one day to be recognized, that the number of the legs, the villosity of the skin, or the termination of the *os sacrum*, are

reasons equally insufficient for abandoning a sensitive being to the same fate.

The *Comparative Anatomy* is a similar exercise in sameness and difference, albeit even more provocative in its rejection of hierarchy and assertion of animal autonomy. Stubbs was not able to complete it before his death in 1806, but what survives supersedes in sophistication the most advanced comparative anatomies of his day, including those of Buffon and Peter Camper, the Dutch physiologist with whom Stubbs was in correspondence. Like them, he recognized that morphological differences and resemblances among organisms were not the consequence of their proximity or distance from each other on the Great Chain of Being, but rather the result of actual historical affinity or non-affinity. Homologous organs and limbs in the tiger, chicken and human reveal a common function and possibly a common descent. This latter insight is generally understood to have been born in the mind of Charles Darwin, but in fact it was Erasmus Darwin, grandfather of the famous naturalist, who in 1792 (a decade before the Frenchman J. B. Lamarck) argued that species transmutated over generations, and that acquired characteristics may be inherited. In his *Zoonomia* (1794–6), the elder Darwin wrote:

George Stubbs, 'Tiger', from *A Comparative Anatomical Exposition of the Structure of the Human Body with that of a Tiger and a Common Fowl* (1795–1806).

when we revolve in our minds the great similarity of structure, which obtains in all the warm-blooded animals, as well in quadrupeds, birds, and amphibious animals, as in mankind . . . one is led to conclude, that they have alike been produced from a similar living filament. In some this filament in its advance to maturity has acquired hands and fingers, with a fine sense of touch, as in mankind. In others it has acquired claws or talons, as in tygers and eagles. In others, toes with an intervening web, or membrane, as in seals and geese. In others it has acquired cloven hoofs, as in cows and swine; and whole hoofs in others, as in the horse. While in the bird kind this original living filament has put forth wings instead of arms or legs, and feathers instead of hair . . . From their first rudiment, or primordium, to the termination of their lives, all animals undergo perpetual transformations; which are in part produced by their own exertions in consequence of their desires and aversions, of their pleasures and their pains, or of irritations, or of associations; and many of these acquired forms or propensities are transmitted to their posterity.

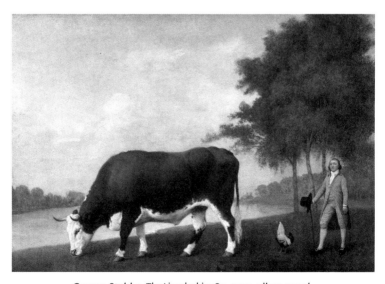

George Stubbs, *The Lincolnshire Ox*, 1790, oil on panel.

Stubbs, a detail from *The Lincolnshire Ox*.

Darwin's argument upholds a basic tenet of the emerging animal rights discourse: the idea that individual animals are autonomous by nature. Their transmutations are 'in part produced by their own exertions'. Animals in short, make their own history. And while Charles Darwin's theory of evolution by means of natural selection largely put paid to the idea that acquired characteristics may be inherited, the notion that individual animals possess 'desires', 'aversions', 'pleasures', 'pains', 'irritations' and 'associations' was validated by the great scientist's *The Expression of the Emotions in Man and Animals* (1872) and other works.

Stubbs must have known Erasmus Darwin through the pottery manufacturer Josiah Wedgwood, with whom the artist worked closely from 1778 to 1783, and then again from 1794 to 1795. Darwin and Wedgwood were close friends, and never closer than in the years during which Stubbs sought from Wedgwood a formula to create kiln-fired enamels that could represent in vivid and permanent fashion many of the same subjects he had treated in earlier oil paintings, such as *Haymakers*, a picture which represents cooperation between human and animal labourers. There is even a hint in his *Comparative Anatomy* that Stubbs may have accepted the controversial assertion of Erasmus Darwin in *The Temple of Nature* that humans may have descended from apes. 'It has been supposed by some', Darwin writes, invoking Buffon, Helvetius and Monboddo, 'that mankind

were formerly quadrupeds . . . that mankind arose from one family of monkeys on the banks of the Mediterranean', and that by development of an opposable thumb and an 'improved sense of touch, that monkeys acquired clear ideas and gradually became men'.[7] Stubbs's drawing of a human skeleton walking on all fours in the posture of an orang-utan may be contrasted to the description of Camper that humans were everywhere and always bipedal and that orang-utans and other non-human primates were quadrupedal. Monboddo, however, perhaps in common with Stubbs, believed that orang-utans were in fact humans, albeit without the same intelligence or sensibilities:

> The sum and substance of all these relations is, that the Orang Outang is an animal of the human form, inside as well as outside: That he has the human intelligence, as much as can be expected of an animal living without civility and the arts: That he has a disposition of mind mild, docile and humane: That he has the sentiments and affections common to our species, such as the sense of modesty, of honour, and of justice; and likewise an attachment of love and friendship to one individual so strong in some instances, that the one friend will not survive the other: That they live in society and have some arts of life; for they build huts, and use an artificial weapon for attack and defense, viz., a stick; which no animal merely brute is known to do . . . They appear likewise to have some civility among them, and to practise certain rites, such as that of burying the dead. It is from these facts that we are to judge whether or not the Orang-Outang belongs to our species. Mr Buffon has decided that he does not. Mr Rousseau inclines to a different opinion.[8]

Monboddo's concluding reference to Rousseau is to his celebrated footnotes in the *Discourse upon the Origin and Foundation of the Inequality among Mankind* in which Rousseau argues that the first humans were vegetarian, taking as his evidence the grinding teeth of humans and other herbivores such as orang-utans.[9]

Stubbs's insights into the human and animal dynamic were the result of deep and sustained looking and a profound curiosity. They arose from the life he lived, and his intimate association with animals. But they were also indebted to the ideas of Enlightenment philosophers including Rousseau, in all likelihood transmitted via Lord Monboddo. It was Rousseau who argued in his *Discourse* that in the primordial state of nature, humans were little different from brutes, better endowed than many with intelligence, but less endowed than most with qualities equally essential for survival such as strength, agility and speed. But both humans and animals were possessed of two special attributes that helped them to survive and prosper in the state of nature: the instinct for self-preservation; and, arising from that (by means of a kind of mimicry or repetition), an innate repugnance at the suffering or death of others, especially those of their own species. Thus it was that long before the institution of private property or the state, and before the formal invention of philosophy, human and non-human animals shared a common instinct and a common morality. Rousseau concluded from this that even if animals lacked intelligence and liberty, humans owed them protection and respect:

> It appears, in fact, that if I am bound to do no injury to my fellow-creatures, this is less because they are rational than because they are sentient beings: and this quality, being common both to men and beasts, ought to entitle the latter at least to the privilege of not being wantonly ill-treated by the former.

Stubbs's intelligent horses, *Lincolnshire Ox* and late *Comparative Anatomy* seem to attest to a similar conviction, and to anticipate the ideas of the Romantic generation that followed. This generation produced the first fully fledged treatises devoted to vegetarianism and animal rights (by John Oswald in 1791, Joseph Ritson in 1802 and Percy Shelley in 1814) and artworks by William Blake and Théodore Géricault that advanced the view that to abuse an animal is to violate the laws and forms of nature and society.

WILLIAM BLAKE AND THOMAS BEWICK

Animals are so deeply embedded in the fabric of William Blake's art and thought that it is sometimes difficult to see them at all. This can be true at a literal as well as the figurative level, and it is as apparent at the beginning as at the end of Blake's career. In the illumination for 'On Another's Sorrow' from *Songs of Innocence* (1789), birds – some barely larger than a pencil point – hover among the branches of a tall, spindly tree at right, and perch beside lines that compare a 'wren's grief and care' to the sorrow of a mother at her 'infant's groan'. In 'The Clod and the Pebble' from *Songs of Experience* (1794), cattle and sheep drink together in the upper register, while below, a duck, frogs and an earthworm all frolic in merry abandon. However, it is hard to see these as real animals. Instead, they represent Heaven and Hell: the contrasting but mutually dependent selfless and selfish character of love, as the clod sings in the first stanza, and the pebble's song in the last stanza suggest 'Love seeketh not itself to please, / Nor for itself hath any care; Love seeketh only self to please, / To bind another to its delight.' Blake's is an animistic world.

In 'The Fly', also from *Songs of Experience*, the only non-human animal in the image – more like a butterfly than any insect of the order Diptera – hovers near a branch on the upper right, beside the concluding lines 'If I live / Or if I die'. Discreet though the represented animal is, the poem and illumination occupy an important place in the history of animal art. It is an example of the poet's radical anthropomorphism.

> Little fly,
> Thy summer's play
> My thoughtless hand
> Has brushed away.
>
> Am not I
> A fly like thee?
> Or art not thou
> A man like me?
> For I dance

William Blake, 'On Another's Sorrow', from *Songs of Innocence*, 1789.

William Blake, 'The Clod and the Pebble', from *Songs of Experience*, 1794.

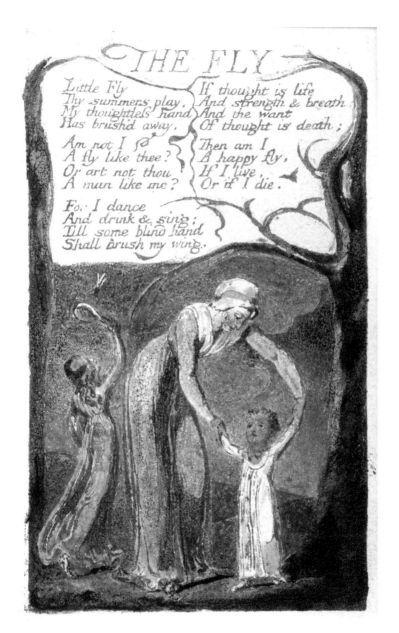

William Blake, 'The Fly', from *Songs of Experience*, 1794.

And drink and sing,
Till some blind hand
Shall brush my wing.

If thought is life
And strength and breath,
And the want
Of thought is death,

Then am I
A happy fly,
If I live,
Or if I die.

The poem appears at first to provide a lesson in kindness of the conventional sort found in Trusler's *Proverbs Exemplified*, illustrated by John Bewick (1790), and Mary Wollstonecraft's *Original Stories for Children* (1791), illustrated by Blake himself. In good Christian utilitarian fashion, Wollstonecraft's protagonist instructs the two spoiled children under her care that they must be kind to even the smallest creatures, including ants, spiders and caterpillars:

> You have heard that God created the world, and every inhabitant in it. He is then called the father of all creatures, and all are made to be happy . . . but a great number would destroy our vegetables and fruit; so birds are able to eat them, as we feed on animals . . . Do you know the meaning of the word Goodness? . . . It is first to avoid hurting any thing, and then, to contrive to give as much pleasure as you can. If some insects are to be destroyed to preserve my garden from desolation, I have it done in the quickest way.
>
> And this caution arises from two motives: – I wish to make them happy; and as I love my fellow creatures still better than the brute creation, I would not allow those that I have any influence over, to grow habitually thoughtless and cruel.[10]

Look what a fine morning it is. — Insects,
Birds, & Animals, are all enjoying existence.

Published by J. Johnson, Sept.ᵣ 1ˢᵗ 1791.

William Blake, illustration for Mary Wollstonecraft's *Original Stories for Children* (1791).

Blake's illustration for *Original Stories* features a fashionably attired woman in the centre with her arms wide, grandly gesturing to the natural world around her even as her eyes are cast downward. Beneath her at left and right are two bonneted girls looking up at their teacher. They look extremely pleased with themselves, with the one at left about to clap her hands, and the one at right with arms crossing her chest. It has been often and plausibly suggested that Blake may have been impatient with the saccharine conventionality of the text and subtly undermined it with his illustrations.

His contemporaneous illumination for 'The Fly' is similar to his illustration for *Original Stories* in format and number of figures, but differs in significant ways. It depicts a nurse and two children, one of whom is playing by herself the game of battledore and shuttlecock – the challenge is to keep the bird (or in this case, fly) up in the air as long as possible – while the other, younger child is being taught to walk. The lesson to the reader and viewer appears to be that kindness to animals is as fundamental as learning to walk and as simple and enjoyable as a game of battledore. But in fact the poem undercuts this interpretation. Unlike the conventional anthropomorphism of fables such as Aesop's 'The Ant and the Fly', which gives a fly the attributes of a human, Blake gives the human the attributes of a fly: he too may be brushed aside. At the same time, he reverses the usual metaphoric relationship between human and fly. Whereas Lear says 'As flies to wanton boys are we to the gods, / They kill us for their sport' (IV.i.38–9), Blake argues that flies are like humans. Indeed Blake suggests a striking equivalence between human and fly: 'Am not I / A fly like thee? / Or art not thou/ A man like me?' And then he makes an equally startling anti-Cartesian suggestion: that life and thought are equivalent for the fly, as for man! The final stanza, 'Then am I / A happy fly, / If I live, / Or if I die', suggests that the life of a fly is of no greater significance than that of a human, and that the death of neither signals transcendence. Though the identity of the speaker of the last line remains uncertain, the poem nevertheless offers a radicalized version of anthropomorphism – again, a version of animism – in which the variety of species and the living and non-living environment are understood as equal and interchangeable.

That Blake's visual and literary art should represent elements of popular animism – a deep engagement with the human, animal, plant and non-organic world – is not surprising. Though born in London and a resident of that city his whole life (except for three eventful years in the coast town of Felpham in West Sussex), he took long walks with his wife Catherine into the countryside and had close communion with both physical nature and local people. Though not a landscape artist, his late wood engravings for the clergyman John Thornton's *The Pastorals of Virgil* project such an intimacy with the natural and cultivated world that they inspired landscape artists for 100 years. And he had considerable knowledge of folklore and folk wisdom concerning plants and animals, as John Adlard demonstrated in his book *The Sports of Cruelty* (1972), and accordingly embraced animist ideas concerning the essential reciprocity of human relationships with nature, and the cognitive and expressive capacities of animals – from lions and robins to glow-worms and beetles.[11] The lark is perhaps Blake's most prodigious and protean creature. In his epic *Milton*, it is a boy, an angel and a messenger of dawn.

> The Lark sitting upon his earthly bed, just as the morn
> Appears, listens silent; then springing from the waving
> > Corn-field loud
> He leads the Choir of Day! trill, thrill, thrill, trill,
> Mounting upon the wings of light into the great Expanse,
> Reechoing against the lovely blue & shining heavenly Shell.
> His little throat labours with inspiration; every feather
> On throat & breast & wings vibrates with the effluence Divine.[12]

Later in the same poem, it is 28 different versions of itself, the last of which represents Los, pure, creative imagination. Its nest, covered with the purple flowers of wild thyme, 'deadly and poisonous', is above a fountain beside the Rock of Odours. (The idea that thyme signifies death and creative regeneration derives from folk tradition, as Adlard has shown.[13])

But Blake's radical anthropomorphism was also derived from more elite sources, likely including David Hartley's *Observations on*

Man, his Frame, his Duty, and his Expectations, to which the artist contributed a portrait frontispiece for the 1791 edition published by J. Johnson. Though Blake was largely unsympathetic with Hartley's doctrine of 'associationism' – believing it left too little scope for the role of imagination and invention in the creation of new ideas – he may have embraced the idea, as Hartley wrote, that there exists

> a kind of inspiration in brutes, mixing itself with, and helping out, that part of their faculties which correspond to reason in us . . . I always suppose, that corresponding feelings, and affections of mind, attend upon them, just as in us. And the brute creatures prove their near relation to us, not only by the general resemblance of the body, but by that of the mind also, in as much as many of them have most of the emotional passions in some imperfect degree, as there is perhaps, no passion belonging to human nature, which may not be found in some brute creature in a considerable degree.[14]

Many of the poems and illuminations in *Songs of Innocence* and *Songs of Experience* speak to this shared 'emotional passion' of human and non-human animals. At the conclusion of the poem 'The Little Girl Lost', Lyca – at once 'a little child' and a beautiful 'maid' – is given succour and loved by 'beasts of prey':

> Leopards, tygers, play
> Round her as she lay,
> While the lion old
> Bow'd his mane of gold.
>
> And her bosom lick,
> And upon her neck
> From his eyes of flame
> Ruby tears there came;
>
> While the lioness
> Loos'd her slender dress,

And naked they convey'd
To caves the sleeping maid.

In the succeeding poem, 'The Little Girl Found', the reconcilia-
tion of human and animal – the suggestion of a new Golden Age – is
realized. Blake begins by singing of Lyca's parents' desperate search
for their lost child. At the end of the poem, after seven days and
nights, they meet a lion who bids them:

'Follow me,' he said;
'Weep not for the maid;
In my palace deep,
Lyca lies asleep'.

Then they followed
Where the vision led,
And saw their sleeping child
Among tigers wild.

To this day they dwell
In a lonely dell,
Nor fear the wolvish howl
Nor the lion's growl.

The illumination by Blake reveals an erotic and zoophilic
denouement: the nude and fully mature Lyca sleeps between a
reclining lion and tiger, while three naked children – the apparent
offspring of human and animal – gambol and play. The scene also
of course describes a Christian kingdom of God, according to the
prophesy of Isaiah, (11.6–9) in which there would be peace between
wild and domesticated animals and between humans and beasts,
and vegetarianism would once again be the rule.

In *Auguries of Innocence*, a non-illuminated group of poems written
sometime prior to 1803 and only published 60 years after his death,
Blake is at his most pantheistic. He begins the series of couplets with
the four-line stanza:

William Blake, 'Little Girl Found', from *Songs of Experience*, 1794.

To see a world in a grain of sand
And a heaven in a wild flower,
Hold infinity in the palm of your hand
And eternity in an hour.

But Blake then proceeds to describe the violation of that natural order, and to explicitly state the political implications of cruelty to animals:

A robin redbreast in a cage
Puts all heaven in a rage.
A dove-house filled with doves and pigeons
Shudders hell through all its regions.
A dog starved at his master's gate
Predicts the ruin of the state.
A horse misused upon the road
Calls to heaven for human blood.
Each outcry of the hunted hare
A fibre from the brain does tear.

'A dog starved at his master's gate / Predicts the ruin of the state' proposes that neglect of other creatures and the poor – they are made equivalent here – presages revolution.[15] 'A horse misused upon the road / Calls to heaven for human blood' is a demand for vengeance upon people who torment animals, such as that exacted upon Tom Nero in Hogarth's *The Four Stages of Cruelty*. (Blake admired and emulated Hogarth, and was employed in 1822 to make an engraved copy of Hogarth's painting *The Beggar's Opera*.) 'Each outcry of the hunted Hare / A fibre from the brain does tear' states that the painful exclamations of a violated animal are a sign not only of damage done to the fibres and tissues of its body, but to the human soul and social fabric. The latter example of violence might have been recalled from Montaigne's passage in 'Of Cruelty', cited earlier: 'I cannot see a chicken's neck twisted without distress, or bear to hear the squealing of a hare in my hounds' jaws, though hunting is a very great pleasure to me.'

In *Auguries*, it is possible to detect the influence of Joseph Ritson, the great antiquarian, folklorist, critic, polemicist and vegetarian.

His career extended from the early 1780s until his death in 1803 following a major psychotic breakdown – or brain disease – that resulted in his placement in the Hoxton madhouse (where the poet Charles Lamb was also briefly confined). Two decades after Ritson's death, his friend Sir Walter Scott summed up his personality, diet and madness in a single quatrain:

> As bitter as gall, and as sharp as a razor
> And feeding on herbs as Nebuchadnezzar
> His diet too acid, his temper too sour
> Little Ritson came out with his two volumes more.[16]

Ritson wrote critical commentaries on Shakespeare, compiled collections of English songs and folklore, and in 1802 published *An Essay on Abstinence from Animal Food as a Moral Duty*. But his vegetarianism began in 1772 after reading Bernard de Mandeville's *The Fable of the Bees* (1723), with its description of the outcry of a slaughtered ox:

> What mortal can without compassion hear the painful bellowings intercepted by his blood, the bitter sighs that speak the sharpness of his anguish, and the deep sounding groans with loud anxiety fetched from the bottom of his strong and palpitating heart?[17]

Ritson quoted at length from Mandeville in his essay, but he was an evangelist as early as 1782, writing letters to his sister, nephew and friends admonishing them to become vegetarians:

> You will certainly find yourself healthier, and if you have either conscience or humanity, happier in abstaining from animal food, than you could possibly be in depriving, by the indulgence of an unnatural appetite and the adherence to a barbarous custom, hundreds if not thousands, of innocent creatures of their lives, to the enjoyment of which they have as good a right as yourself.[18]

It is noteworthy that Ritson here rejected the more typical argument for vegetarianism – that eating animals heated the blood and coarsened the spirit – and instead simply stated that humans have no more right to life on earth than animals.

Ritson also liked to compose vegetarian verse that could serve as grammar and arithmetic lessons to his little nephew, such as the following Blakean lines, also from 1782:

> I, thou, and he,
> Caught a flea;
> We, ye, and they,
> Set her away
> 1, 2, 3, 4, 5,
> I caught a hare alive,
> 6, 7, 8, 9, 10,
> I let her go again.

The next year, Blake was employed by the publisher J. Johnson to provide engraved illustrations (after drawings by Thomas Stothard) for Ritson's A Select Collection of English Songs, a book that associated the earliest songs with 'the chief employment of all ranks . . . the care of their flocks and herds', and the themes of 'Love, Beauty, Innocence . . . and the charms of pastoral life'. This was the very prelapsarian world described by Blake in his Songs of Innocence, published just a few years later in 1789.

But it is Ritson's Essay on Abstinence that seems closest to Blake, in particular the Blake of the Auguries. Rejecting the utilitarian arguments of Hutchinson, Bentham and others that animal suffering causes a superabundance of pain and deficit of pleasure, Ritson instead argued in the Essay – as he did in his letters – that animals have an inherent right to life as profound as that of humans. In addition, he argued that human control over animals was a kind of political tyranny. He writes:

> The Rapacity of man has hardly any limitation. His empire over other animals which inhabit this globe is almost universal. He accordingly employs his power, and subdues

or devours every species . . . Myriads of quadrupeds are annually destroyed for the sake of their furs, their hides, their tusks, their odiroferous secretions, etc. Over the feathered tribes, the dominion of man is not less usurpingly extensive. By his sagacity and address he has been enabled to domesticate turkeys, geese, and the various kinds of poultry. These he multiplies without end, and devours at pleasures. Others he imprisons in cages to afford him the melody of their song.[19]

The language here is derived from the theory of tyranny found in Montesquieu and Rousseau – the idea that oppression is greatest when it is done under the cloak of custom and law, 'by sagacity and address', as Ritson writes. Domination of the natural world is for Ritson as for Blake a political domination. Thus an act of violence against an animal is indeed 'the ruin of the state', in Blake's words, and punishment for an act of cruelty against an animal should be as severe as for that against any human. 'Each outcry of the hunted hare / A fibre from the brain does tear'.

The cries of pain of wounded or dying animals were widely featured in works of poetry and literature in the late eighteenth and early nineteenth centuries. The outcry of hares, for example, was heard as similar to the scream or cry of a baby, and sometimes intruded upon and disrupted the theatricalized rituals of the hunt.[20] In his posthumously published *Memoirs*, Thomas Bewick writes that as a boy he was at first insensitive to the cruelty of the hunt, but that his views quickly changed:

> The first time I felt the change happened by my having (in hunting) caught the Hare in my Arms, while surrounded by the Dogs and the Hunters, when the poor terrified creature screamed out so piteously, – like a child, – that I would have given anything to save its life. In this however I was prevented; for a farmer well known to me, who stood close by, pressed upon me, and desired I would 'give her to him', and from his being better able (as I thought) to save its life, I complied with his wish. This was no sooner done than

he proposed to those about him, 'to have a little sport with her', and this was to be done by first breaking one of its legs, and then setting again the poor animal off a little before the dogs. I wandered away to a little distance, oppressed by my own feelings, and could not join the crew again, but learned with pleasure that their intended victim had made its escape.[21]

Like Blake, Thomas Bewick had feet planted in both plebian and elite cultures, and drew upon both in his many wood-engraved illustrations for fables, books of poems (by Bloomfield, Thomson, Goldsmith and others) and his natural histories of birds and animals. He had an early intuition of animism – that his life would entail a reciprocal relationship with animals and that he could conjure life from inert matter – when he was a boy learning to draw the animals visible on the signs for public houses: 'the Black Bull, the White Horse, the Salmon, and the Hounds and Hare'. He writes:

I remember once my master overlooking me while I was very busy with my chalk in the porch, and of his putting me very greatly to the blush by ridiculing and calling me a conjurer . . . The beasts and birds, which enlivened the beautiful scenery of woods and wilds surrounding my native hamlet, furnished me with an endless supply of subjects.[22]

But he was also in contact with the most advanced intellectual and critical currents of the day. His frontispiece illustration for George Nicholson's On the Conduct of Man to Inferior Animals (1797), for example, was derived from Gillray's etched frontispiece for John Oswald's radical and Rousseauian Cry of Nature.[23] Nicholson's text itself is almost encyclopaedic in its citation of ancient and modern authorities, drawing upon works by Cowper, Gay, Darwin, Cicero, Porphyry, Dryden, Plutarch, Oswald, Rousseau, Buffon, Horace, Franklin, Pliny and many others.

Also like Blake, Bewick supported the French Revolution and condemned Pitt's war against the French. He criticized the 'temporary prosperity' that the war brought to farmers and aristocrats,

Thomas Bewick, frontispiece illustration to George Nicholson,
On the Conduct of Man to Inferior Animals (1797).

attacked the poverty experienced by the poor just after the war's end,
and was suspicious of the agricultural improvements of the day:

> Cattle, sheep, horses and swine, all of which were called
> 'live stock', occupied a great deal of attention, and in the
> improvement of various breeds, agriculturalists succeeded
> to a certain, and in some cases perhaps, to a great extent.
> And yet I cannot help thinking that they often suffered their
> whimsies to overshoot the mark, and in many instances to
> lead them on to the ridiculous.[24]

Bewick was referring to the grossly fat cows and sheep that were
the pride of English husbandry during these years and the subject
of paintings by Thomas Weaver and John Boultbee, such as the
famous *Durham Ox*, painted by both artists in 1802. The animal was
a prime example of Shoreham shorthorn cattle, bred in 1796 by
Charles Colling of Ketton Hall, Brafferton, near Darlington in north-
east England. Between 1801 and 1806, the ox travelled across England
and Scotland in a specially designed carriage, and was shown alike at
rural agricultural fairs and city arenas. It was famous most of all for

its weight, nearly 1,360 kg (3,000 lb). (Its grossness undoubtedly contributed to its death. It was put down in 1807 following a hip injury incurred while leaving its carriage.[25]) But it was also renowned simply for the care of its breeding; Coate's *Herd Book* and *Burke's Peerage* alike were carefully consulted by the gentry to ensure that bovine and aristocratic lineages were without blemish.[26] Given his republican sympathies, Bewick's criticism of 'improvement' – which led breeders 'to the ridiculous' – was as much a rejection of aristocratic pretension as it was of overzealous husbandry. Bewick's own wood engraving of the *Wild Bull of Chillingham* (1789), by contrast, considered the artist's early masterpiece, depicted a well-muscled, broad-horned animal said to be an untamed beast descended from Roman oxen.

Bewick's last work was a large, affecting wood engraving of a horse titled *Waiting for Death*. Derived from his own small and poignant vignette illustration of the same title drawn in 1785 and published in 1818 in his *Fables of Aesop*, the large plate was unfinished at the time of the artist's own demise in 1828. According to

Thomas Bewick, *The Wild Bull of Chillingham*, 1789, wood engraving.

Thomas Bewick, *Waiting for Death*, 1827, wood engraving.

Bewick's son Robert, it was intended to be dedicated to the new SPCA, and at the same time to be one of a 'set of cheap embellishments for the walls of cottages', thus recalling the demotic origin of his own art in tavern signs and childish sketches on a cottage floor.[27] Bewick described the genesis of the engraving as a story he heard of an actual horse that, 'having faithfully dedicated the whole of his powers and his time to the service of unfeeling man, he is at last turned out, unsheltered and unprotected, to starve of hunger and of cold'.[28] In Bewick, as in Blake, the pathos formula of sanctified oppression, beautiful death and internalized punishment is nowhere to be found. Instead, there is in the poet's words 'shudders', 'calls to heaven' and an 'outcry' following the cruel treatment of animals. There is also in Bewick, in the hundreds of small animal vignettes found at the bottom of the pages of his *Fables*, *Quadrupeds* and *Birds* volumes, and at the end of chapters, the sense of a swarm of beasts – the idea that animals communicate and contrive together to demand their freedom, and that in solidarity will come emancipation.

Waiting for Death

Thomas Bewick, 'Waiting for Death', from *The Fables of Aesop* (1818).

Thomas Bewick, 'Old Woman and Geese', from *British Birds* (1804).

JOHN OSWALD AND THÉODORE GÉRICAULT

John Oswald was a Scottish officer in the Royal Highlanders Regiment who travelled to Bombay in 1782 to defend the British East India Company against Hyder Ali, the ruler of Mysore in southern India. Within a few months, he had become so disgusted by the crimes committed by the British forces that he resigned his commission, travelled by foot across the country and took up vegetarianism in emulation of some of the Hindus he met during his travels. Judging by his later life, his choice was not dictated by a creed of non-violence. During his four years in France as a member of the Jacobin Club, beginning in 1789, he spoke out in favour of the arrest and execution of aristocrats and the king and the general conscription (*levée en masse*), claiming that '[we cannot] arrive at the age of gold without passing through an age of iron'.[29] In 1793, he organized the First Battalion of Pikers – named for the long spears used in hand-to-hand combat – and fought the monarchist counter-revolutionaries in the Vendée. He died in the attempt. His reputation for bellicosity was so great that his friend Tom Paine is said to have remarked to him: 'Oswald, you have lived so long without tasting flesh, that you now have a most voracious appetite for blood.' The appetite was probably exaggerated by those, like Paine, who opposed the execution of Louis XVI. (Paine was arrested by the Jacobins and held in prison for nearly a year.)

Oswald was a thorough democrat, rejecting representative government as being every bit as repressive as absolute monarchy. His model of democracy, based upon that described by Rousseau in *The Social Contract*, was direct.[30] 'He insisted', wrote Henry Redhead Yorke, who had known him in Paris in 1792–3, that 'as a man cannot piss by proxy, neither can he think by proxy.' And he proposed a new model of world government in which men and women would openly gather, express their views and make laws. Yorke facetiously objected that 'his plan was not sufficiently extensive, as he had excluded from this grand assembly of the animated world the most populous portion of his fellow creatures, namely cats, dogs, horses, chickens, etc.' But in fact, by the time of his acquaintance with Yorke, Oswald had made up the deficiency, composing in 1791 the most radical manifesto of animal rights ever before conceived.

The Cry of Nature; Or, An Appeal to Mercy and to Justice, on Behalf of the Persecuted Animals was Oswald's response to the misrepresentation of his views by British Whigs. Its title was derived from a sentence in Rousseau's Discourse on the Origins of Inequality:

> The first language of mankind, the most universal and vivid, in a word the only language man needed, before he had occasion to exert his eloquence to persuade assembled multitudes, was the simple cry of nature. But as this was excited only by a sort of instinct on urgent occasions, to implore assistance in case of danger, or relief in case of suffering, it could be of little use in the ordinary course of life, in which more moderate feelings prevail.

For Rousseau, as for Oswald, the cry was the first word. It was unsullied by calculation or the desire to persuade or control, and was thus unimpeachable.

The etched frontispiece to Oswald's Cry depicts a nude woman with multiple breasts – Pomona (or Abundance) melded with Artemis – shielding her eyes from the distressing scene before her: a fawn lying upon the ground, blood trailing from its chest, mourned by its crying mother. Behind the nude is the trunk of a massive tree, and in the left distance a glimpse of a church tower and steeple. In the foreground at left is an empty plate upon which rests the knife with which the deed was done. The text at bottom, taken from the tract, reads: 'The butcher's knife hath laid low the delight of a fond dam, and the darling of Nature is now stretched in gore upon the ground.' The plate is unsigned, but is almost certainly the effort of James Gillray. He had worked with Oswald before, providing a ribald illustration for the short-lived British Mercury, a journal written almost entirely by Oswald which published just four scabrous issues over two months in 1787. The image by Gillray in the Mercury, titled Moses, Erecting the Brazen Serpent in the Desert, is a quasi-pornographic illustration of a drinking song by 'The Priests of Apollo' inspired by the scandalous and privately printed book An Account of the Remains of the Worship of Priapus (1786) by Richard Payne Knight.[31] (The supposition that Oswald was acquainted with the work of Knight and his collaborator William

Hamilton is based upon textual evidence, buttressed by the knowledge that he had travelled extensively in India and earlier written a 40-page satire, *Ranae Comicae; Or, the Comic Frogs turned Methodist,* about penis worship and the supposed pagan origin of modern Methodism!) Oswald also published in the *Mercury* another parody, equally salacious, titled 'Of the Serpent that Tempted Eve', which proposes that it was Priapus, not a snake, that tempted Eve in the Garden of Eden. 'View it well in profile', Oswald writes; 'consider attentively the height and the depth, the width and the circumference of your grandmother's temptation.'[32]

Gillray's authorship of the etching is almost sufficient to account for its eroticism. He produced a large number of sexually explicit prints, though many were suppressed and only came to light when reissued by Henry Bohn in 1840. But the voluptuousness of the female figure – her long, curly locks of hair are as significant as her half-dozen breasts – has its own surprising logic here. Oswald describes the bounty of plants and fruits as limitless and sensual, rendering the spectacle of death all the more monstrous:

Can . . . the most exquisite art equal the native flavours of Pomona; or [be] worthy to vie with the spontaneous nectar of nature? . . . And innocently mayest thou indulge the desires which Nature so potently provokes; for see! The bending branches seems to supplicate for relief; the mature orange, the ripe apple, the mellow peach invoke thee, as it were, to save them from falling to the ground, from dropping into corruption. They will smile in thy hand; and blooming as the rosy witchcraft of thy bride, they will sue thee to press them to thy lips; in thy mouth they will melt not inferior to the famed ambrosia of the gods. But of animals far other is the fare. When they from the tree of life are plucked, sudden shrink to the chilly hand of death the withered blossoms of their beauty; quenched in his cold grasp expires the lamp of their loveliness; and, struck by the livid blast of putrefaction loathed, their every comely limb in ghastly horror is involved.[33]

From a Virgilian ode, Oswald's text then turned into a Gothic horror story, complete even with strained syntax and alliteration: 'Unallured to the fragrant fume that exhales from her groves of golden fruits . . . shall voracious vultures of our impure appetites speed across the lovely scenes of rural Pan . . . to load with cadaverous rottenness, a wretched stomach?'[34] And it is not only the human appetite for flesh that kills and maims, but also 'nefarious science, the fibres of agonizing animals, delight to scrutinize'. It is at this point in his manifesto, after describing the scene of the playful fawn murdered before the eyes of its mother, that Nature herself makes her plangent cry:

> Why shouldst thou dip thy hand in the blood of thy fellow creatures without cause? Have I not amply, not only for the wants, but even for the pleasures of the human race provided? . . . [Why] dost thou still thirst, insatiate wretch! for the blood of this innocent lamb, whose sole food is the grass on which he treads; his only beverage the brook that trickles muddy from his feet [?] . . . Spare, spare, I beseech thee by every tender idea; spare my maternal bosom the unutterable anguish which there the cries of agonizing innocence excite, whether the creature that suffers be lambkin or lamb.[35]

Returning to the dam and the murdered fawn, Oswald's Nature then asks: 'Alas, she will seek him in vain . . . Her moans will move to compassion the echoing dell; her cries will melt the very rocks!'

For Oswald, the cry of nature is multiple – it is the wrenching expression of the animal that is killed, the tears of the family and companions who mourn the dead, and the outcry of Nature who deplores the injustice and ingratitude of humans who would kill and eat animals despite the abundance of plant-based foods. Later in the text, Oswald also states that 'savages' or 'Aborigines' (he cites the natives of the Canary Islands) are so sensitive to the authority of the cry of nature that they use it to propitiate the gods: they 'conducted their cattle to a place appointed, and severing the young ones from their dams, they raised a general bleating in the flock, whose

cries, they believed, had power to move the almighty god to hear their supplication'.

The 'cry of nature' is thus unmediated nature: the sound of animals – non-human and human alike – in pain and anguish, and the direct speech of Nature herself. Like Rousseau's cry, as well as Montaigne's, Blake's and Bewick's, Oswald's is uncalculated and disinterested, a rebuke to artifice and cupidity and the violence that attends them. It is the sound and sight that undercuts the ancient pathos formula described and condemned by Oswald and cited earlier:

> Yet even the venerable veil of religion, which covers a multitude of sins, could hardly hide the horror of the act [of sacrifice]. By the pains that were taken to trick the animal into a seeming consent to his destruction, the injustice of the deed was clearly acknowledged; nay it was even necessary that he should offer himself as if [he] were a voluntary victim, that he would advance without reluctance to the altar, that he should submit his throat to the knife, and expire without a struggle.[36]

Théodore Géricault, *A Horse Frightened by Lightning*, c. 1813–14, oil on canvas.

Ancient blood sacrifice was a conspiracy enacted by the powerful upon the unwary, the wickedness of which was implicitly acknowledged in the very attempt to make it seem natural and voluntary. Only when they came together in the circumstances of modern husbandry, manufactures and slaughter were animals able to see, know and understand each other, and wordlessly – but by means of their cries – demand emancipation.

Here too Oswald learned from Rousseau, adapting for his purposes the tone and imagery of Part II of the *Discourse*, where the *philosophe* described the trick engineered by the rich and powerful to secure the political subservience of the poor and the weak: 'All ran headlong to their chains, in hopes of securing their liberty; for they had just wit enough to perceive the advantages of political institutions, without experience enough to enable them to foresee the dangers.' And in response to potential counter-arguments that people have embraced their seeming fetters, and that even slaves are content in their servitude, Rousseau replies:

> An unbroken horse erects his mane, paws the ground and starts back impetuously at the sight of the bridle; while one which is properly trained suffers patiently even whip and spur: so savage man will not bend his neck to the yoke to which civilized man submits without a murmur, but prefers the most turbulent state of liberty to the most peaceful slavery.

The sentiment and imagery inspired not only Oswald, but another man intoxicated by revolutionary warfare and emancipation: the French painter Théodore Géricault.

Géricault's *A Horse Frightened by Lightning* (c. 1813–14) depicts a finely proportioned thoroughbred, seen in profile, standing on bare ground in the middle of an open field by a seashore. It might almost be a 'sporting picture', like those commissioned by the English aristocracy and made by James Seymour, Sawrey Gilpin and George Stubbs. The sub-genre was well known to Géricault, and a few years later he even tried – without success – to engage the racehorse picture market with his *Epsom Derby* (1821).

Heads of horses from Johann Kaspar Lavater, *Essays on Physiognomy* (1792).

But Géricault's horse lacks the regal bearing essential to the genre. Instead of equipoise, he exhibits the classic signs of fright: he steps back, his head is held high, his eyes bulge (the whites are just visible) and his ears tip forward in the direction of the perceived threat. He froths at the mouth, his hide glistens with sweat and his loins seem to quiver. (Like lightning, this muscular quickening is nearly impossible to represent and is thus a pleasurable challenge to the artist's skill and the viewer's attention.) Though the horse's tail is down, it is not relaxed; in a moment it will start to switch. In short, the animal displays its essential wildness, like Rousseau's unbroken horse. Fear of nature's sublimity has not been bred or beaten out of him, and he responds as any wild and powerful animal would when confronted by an unknown force.

The horse's expression was inspired in part by that found in the suite of horses drawn for the Swiss Johann Kaspar Lavater's *Physiognomy*, editions of which appeared in 1792, 1804 and 1810 and were certainly known to Géricault. One engraving of a horse in *Physiognomy* is described there in the following way:

The bone of the nose, its breadth, and its profile, the contour, so full and so strongly marked, of these large, expanded eyes, their perfect harmony with the nostrils – all these traits

148

are in man, and in the horse, characteristic signs of energy and valor.[37]

The *Horse Frightened*, like a number of other of Géricault's animal paintings of the early nineteenth century, such as *The Race of the Riderless Horses* and *Butchers of Rome*, is an image of the 'turbulent state of liberty' chafing against slavery.

About seven years after painting *Horse Frightened*, Géricault travelled to England to exhibit his great and enormous *The Raft of the Medusa* (1818) and try to expand his clientele. In the course of that sojourn, he produced an album of lithographs titled *Various Subjects Drawn from Life and on Stone* (1821). In one plate from this series, titled 'Horses Going to a Fair', we see a Clydesdale strutting across a rocky foreground bending his head to the right. He will soon turn left and join four other horses, led by a percheron and rider. The groom on foot will not need the switch on his shoulder because the horses stride with purpose and need no whipping. Their flowing manes, massive backs, loins, rumps and thighs, and ample testicles reveal their health, power and virility – and their worth at market. When in 1782 James Watt provided an equation comparing 'horsepower' with the energy

Théodore Géricault, 'Horses Going to a Fair', from *Various Subjects Drawn from Life and on Stone*, 1821, lithograph.

Géricault, 'Horses Exercising', from *Various Subjects Drawn from Life and on Stone*.

generated by his own newly developed coal-fired steam engine, he was establishing a means to precisely value the life and industrial capacity of an animal, and offering at the same time a rationale for replacing it with a machine – and thus for ending its life.[38] A horse for Watt was no longer an animate, sentient being; it was a unit of energy to be expended, or an inanimate machine to be used until worn out.[39] And indeed, old, tired, lamed or simply unproductive horses were quickly dispatched, their meat and hides bringing their owners one final profit.

'Horses Exercising' from the same series depicts not draught horses, but racehorses, bred according to the modern principles of selected husbandry practised by Lord Monboddo and recorded in *The General Stud Book*, first published by James Weatherby in 1793. Swift and slender of limb, these animals veritably (and unnaturally) fly through the air, necks and heads straining, and legs extending forward and back. (Their conformation was influenced by the Englishman Henry Alken, whose album of engravings, *The Beauties & Defects in the Figure of the Horse Comparatively Delineated*, was owned by Géricault.[40]) They are shown unsaddled within a walled enclosure –

probably on an aristocratic estate – and the one at back is mounted by a trainer or groom, whose job is to be sure that these elite athletes are properly broke-to-ride (prepared for riding) and that after exercise they are cooled out: walked, brushed, sponged and given the right amount of water to drink before being returned to their stalls. The value of these horses may be proved at races or when they are retired and put out to stud. The value of the grooms is tied to that of the horses they tend.

Two years later, Géricault produced 'Horses Being Led to the Slaughterhouse' from his *Suite of Eight Small Works*. It too is a lithograph, and depicts three emaciated horses being pulled by an unkempt groom. They appear to understand their fate, and resist it as far as they are able. These are not the powerful draught animals – embodiments of horsepower – depicted in 'Horses Going to Fair', or the fleet aristocrats in 'Horses Exercising', but mere drudges, their worth limited to the value of their hides. Thus, in an age when some animals were tokens of aristocratic wealth and others were mere tools for industry, horses – like humans – were assigned a fixed social rank and a determined course in life. The horses 'being led to slaughter' were clearly the slaves or proletarians of their kind. In

Géricault, 'Horses Being Led to the Slaughterhouse', from *Suite of Eight Small Works*, 1823, lithograph.

1823, Géricault even drew and published a lithograph simply called *Dead Horse*, which depicts the bloated body of a horse lying by a stream in a wintry landscape and circled by crows or magpies. If Bewick's *Dying Horse* represents a fourth stage of cruelty, Géricault's lithograph may be considered to depict the fifth. It is an image of abandonment, death and decay.

Given their unshrinking honesty, it is not surprising that Géricault's lithographs did not provide him the entrée he desired into the profitable domain of English sporting pictures. Instead, they kept him on the periphery of that world, revealing him to have been an advocate of animal rights. Far from idealizing 'human control over the bestial world', as the art historian Albert Boime once argued, Géricault condemned such domination, idealizing energy and independence in human and animal alike.[41] His lithographs recall the words of the French naturalist Buffon a generation before:

> As man becomes civilized and improved, other animals are repressed and degraded. Reduced to servitude, or treated as

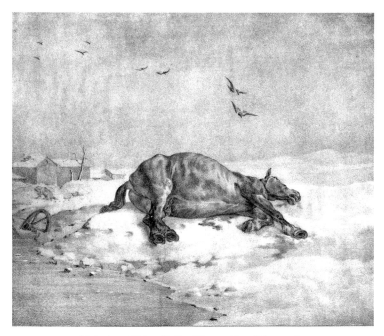

Théodore Géricault, *Dead Horse*, 1823, lithograph.

rebels, and dispersed by force, all their societies are dissolved, and their talents rendered nugatory; their arts have disappeared, and they now retain nothing but their solitary instincts, or those sovereign habits that they have acquired by example or human education. For this reason there remain no traces of their ancient talents and industry, except in those countries where man is a stranger, and where, undisturbed by him or a long succession of ages, they have freely exercised their natural talents, brought them to their limited perfection, and been capable of uniting in their common designs.[42]

Left alone in the state of nature, Buffon argues – 'where man is a stranger' – animals retain their arts and industries, their complex social being and their political independence. But confronted by human civilization, they are 'reduced to servitude or treated as rebels' and rendered servile or made abject. The domesticated animal is far less noble than the wild one, Buffon argued, in conformity with Rousseau's famous observation at the beginning of *Emile, or On Education* (1762): 'Everything is perfect, coming from the hands of the Creator; everything degenerates in the hands of man.'[43] Indeed, in the state of nature as Rousseau imagined it, humans lived in conditions of equality, just as wild animals still do.

If we compare the prodigious diversity, which obtains in the education and manner of life of the various orders of men in the state of society, with the uniformity and simplicity of animal and savage life, in which every one lives on the same kind of food and in exactly the same manner, and does exactly the same things, it is easy to conceive how much less the difference between man and man must be in a state of nature than in a state of society, and how greatly the natural inequality of mankind must be increased by the inequalities of social institutions.[44]

As we have seen, Ritson and Oswald followed Rousseau in this idea, believing that the state of nature was a state of equality among people

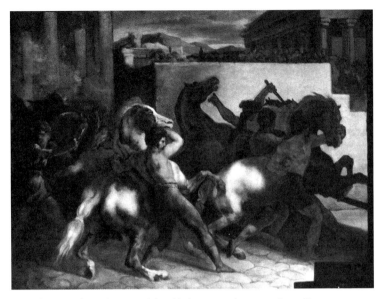

Théodore Géricault, *Race of the Riderless Horses in Rome*, 1817, oil on canvas.

and between people and animals, and that the purpose of the political order was to restore that balance.

Géricault apparently shared Rousseau's view that inequality and violence attended passage from the state of nature to the state of civilization. He condemned the corruption of power in *The Raft of the Medusa*, which depicted the imminent rescue of the survivors of a ship bound for Senegal that had struck a reef due to the incompetence of a captain promoted upon the basis of birth rather than ability. He also planned a monumental history painting – a pendant to *The Raft* – dedicated to the subject of slavery, an institution which Rousseau specifically described as contrary to the natural order because unlike property, which is a convention of society, liberty is a gift of nature and therefore inalienable. One of Géricault's preparatory drawings for the painting, *African Slave Trade* (1822–3), represents white Europeans as brutal oppressors and indigenous Africans as noble and loving parents and children. In his representations of animals, too, Géricault celebrated those that are untamed. The proud and tormented beasts in his *Butchers of Rome, Race of the Riderless Horses in Rome* (1817) and *A Horse Frightened by Lightning* have not been broken by their handlers; they possess the energy and spirit of rebellion of their wild ancestors.

We cannot know precisely what permitted Géricault to achieve this complex understanding of domination and resistance; it is always easier to account for blindness than vision. But we may surmise that, as with Blake, Stubbs and others before him, his perspective arose from some combination of Rudé's 'inherent' and 'derived' ideology: the first being those insights that arise from 'direct experience, oral tradition or folk memory'; the second, those attitudes 'borrowed from others, often taking the form of a more structured system of ideas, political or religious, such as the Rights of Man'.[45] Géricault's sympathy for animals undoubtedly derived from both. For example, his period at Versailles, where he had access to its stabled horses, allowed him to study their anatomy and behaviour; his creation of a *Blacksmith's Signboard* (1814) put him in contact with popular trades and animal lore, just as the youthful enjoyment of fanciful English pub signs did with Thomas Bewick; Géricault's observation of the privations of men returned from the battlefields of the Napoleonic Wars stirred feelings of sympathy for the poor and anger at the powerful; his personal experience of ostracism and failure in the Salon exhibitions also enhanced his empathy for victims of oppression; and his time in Rome observing cattle for sale or slaughter at the market, and seeing tormented horses as they raced down the via del Corso during the annual Carnival festivities – driven by firecrackers, bells and spiked metal plates that pierced their sides – increased his admiration for the pride and spirit of resistance in oppressed animals.

This last subject, treated in dozens of drawn and painted studies, attests to a desire to elevate animal painting, the lowest in the hierarchy of genres established by the French Academy, into history painting, the highest, and to indict animal cruelty. In addition, in 1817, after his return from Italy, Géricault began to regularly visit the Bonapartist history painter Horace Vernet, whose atelier more resembled a farmyard or zoological garden than an artist's workspace.[46] According to contemporary accounts, verified by Vernet's own painting *The Artist's Studio* (c. 1820), Gericault would have seen there a white horse named Regent, a dog, a monkey, a deer and other live animals. Perhaps this combination of experiences activated in his mind the knowledge and understanding he had derived from a

Artist unknown, engraving after Benjamin Marshall, *The Cart Horse, Suffolk*, 1820.

text by Rousseau, which described the compassion of humans and animals in the state of nature before the corruption caused by civil society. Rousseau argued that animals frequently reveal their own capacity for pity:

> Not to speak of the tenderness of mothers for their young; and of the dangers they encounter to screen them from danger; with what reluctance are horses known to trample upon living bodies; one animal never passes unmoved by the carcass of another animal of the same species: there are even some who bestow a kind of sepulture upon their dead fellows; and the mournful lowing of the cattle, on entering the slaughter-house, publish the impression made upon them by the horrible spectacle they are there struck with.[47]

Géricault's *Butchers of Rome* and *Race of the Riderless Horses in Rome*, among other works, show precisely the mournful lowing of cattle and the pained outcry of horses. In the first, most likely inspired by the artist's witnessing of the weekly slaughter of animals at a market

near the Piazza del Popolo, Géricault directs our attention to the three animals in the centre of the composition and the profiled men who hold their horns, or aim a lance in an effort to slay them.[48] In the second, the focus is upon the straining horse in the centre, barely controlled by the man with green trousers, and the rearing horse at back, its neck, head and open mouth silhouetted against the yellow-grey stone wall. The animals in these works exist within the radical tradition of the 'cry of nature'; they both suffer under the yoke of oppression and protest for their freedom.[49] (Like Stubbs's *Horse Attacked by a Lion*, the paintings were likely sources for the tortured animals in Picasso's *Guernica* more than 100 years later.)

Regardless of its origin, Géricault's conception that sentient creatures possess pity, experience oppression and should be granted autonomy was a minority discourse in his own day, even among those generally sympathetic to suffering animals. By the time of his trip to England in 1820, the welfarist perspective, which had arisen in the middle of the previous century, had gained considerable traction. It was buttressed by the passage in 1822 of the 'Ill Treatment of Horses and Cattle' bill, also known as the Martin Act in honour of the Irish MP who championed it. The law made it an offence to 'beat,

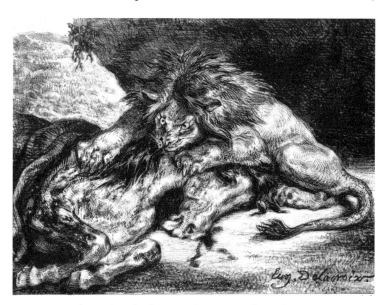

Eugène Delacroix, *Lion Devouring a Horse*, 1844, lithograph.

abuse, or ill-treat any horse, mare, gelding, mule, ass, ox, cow, heifer, steer, sheep or other cattle'. Two years later, Martin, concerned that the law was not being enforced, met with a number of other MPs, including the great slavery abolitionist William Wilberforce, and formed the Society for the Prevention of Cruelty to Animals. The men were especially concerned with stopping cruelties against livestock at London's vast Smithfield Market, and preventing abuse against carriage- and carthorses in London and elsewhere.

However well intentioned, the SPCA (given royal sanction by Queen Victoria in 1840) supported principles that were not much different from those of hunters and sportsmen: charity, kindness and ultimate mastery over animals. The viewpoint was articulated, for example, in John Scott's massive and well-illustrated *The Sportsman's Repository* (1820), intended to be a veritable bible for the hunting and horse set from whom Géricault wished for a time to find support. In the author's introduction, the paternalism was clearly expressed:

> [The foundation of] the book is that indissoluble chain of connection between man and the inferior animals, ordained

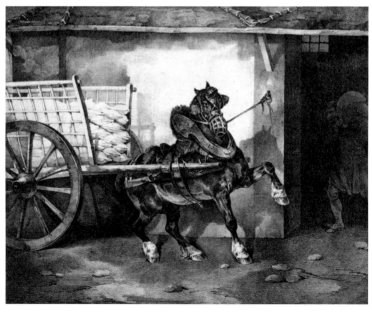

Théodore Géricault, *The Plasterer's Horse*, 1822, lithograph.

by a beneficent Providence, for human use and benefit, by which those animals have been found with various and suitable qualities for every possible purpose, and endowed with a sufficient degree of intelligence, but no more, which might adapt them to our use and convenience . . . [Be] it your duty and your interest, to domesticate, to cultivate and improve them, but above all things, not to forget that these inferior beings, partaking in degree, of your own nature, and in great measure, of your intellectual powers, were given for your *use*, but not your *abuse*; and that JUSTICE and MERCY are due even to the beast.[50]

A comparison of Scott's engraving after Benjamin Marshall's painting The Cart Horse, Suffolk – Horses in the Background, and Géricault's lithograph of The Plasterer's Horse (1822), clarifies the distinction between the two perspectives. The first represents Dumpling, owned by Messrs Horne and Devey, standing at rest in profile in the foreground, his right rear leg forward, body squared and head erect. His master stands at left, holding a whip in his right hand, while with his left he holds up the shafts of the cart so that the horse may freely submit himself to service. Géricault's lithograph of a plasterer's horse, by contrast, shows the animal locked between the shafts, raising his left front leg, twisting and straining against his yoke and harness, and tethered by a rope leading from his muzzle to a hook on the wall. His eyes bulge and stare in anger and fear, while a man enters from right carrying another sack of plaster to pile on top of the already overloaded cart. The lithograph refutes the pathos formula of the supposed voluntary submission to authority in the name of resistance and a longing for freedom. Géricault's proposition was developed by a number of philosophers in the twentieth century, such as Theodor Adorno, who argued that animals manifest in their behaviours some of the very qualities of desire that humans repress in the course of building civilization, and that if humans could only access their animality they would become more fully human. To destroy or constrain an animal, therefore, is to constrain what is fundamental to humans.

Géricault's lithographic images of animals were a basis for a few similar prints by his Romantic successor Eugène Delacroix, such

J. J. Grandville, 'Congress of Animals', from *Scènes de la vie priveé et publique des animaux* (1842).

as *Lion of the Atlas* (1829) and the Stubbs-inspired, gruesome *Lion Devouring a Horse* (1844). But they have their comic corollary in the work of the slightly younger graphic artist J.J. Grandville. The great French caricaturist represented the struggle for animal rights in a series of comic trials in his *Fables of La Fontaine* (1838) and *Scènes de la vie privée et publique des animaux* (1842) that recall the actual animal trials of the late medieval and early modern period. In *Animals Sick from the Plague* from the *Fables*, the artist depicts a lion as judge, a fox

as prosecutor – wearing a gown – and a leopard and dog as bailiffs holding down the seated ass, who will soon pay the ultimate price for having made the mistake of blaming himself for a social transgression.[51] In Scènes, Grandville begins his book – really an anthology of writings by various notable contemporaries including Balzac – with an imagined International Congress of Animals: 'Weary of insult, ignominy and the constant oppression of man, we, the so-called lower animals, have at last resolved to cast off the yoke of our oppressors, who, since the day of their creation, have rendered liberty and equality nothing more than empty names.'[52] The artist depicted an ass as the president of the assembly, standing at a dais directly above a gesturing lion, amid serried ranks of dogs, monkeys, elephants, rabbits, turtles and crabs.[53] In his print, Grandville drew upon the same Rousseauian language of democracy that had stirred the imagination of Oswald, Géricault and other Romantics, but this time with irony and perhaps a sense of defeat. Indeed, the age of counter-revolution had begun.

FOUR
Counter-revolution

THE BIRTH OF THE SLAUGHTERHOUSE

Géricault's choice to depict horses led to slaughter and cattle at a Roman abattoir was not the detour it might seem for an artist concerned with important historical subjects. The slaughter and sale of meat was a major issue during and after the French Revolution, with the public clamouring for cheap meat and the guild of butchers demanding the preservation of their longstanding monopoly over the most lucrative butchers' stalls in the city. The one claimed that the right to meat was as fundamental as the right to bread, and the other that the right to control the butchering and sale of meat was as basic as the right to property. At the height of the Revolutionary Terror in late 1793 and early 1794, the scarcity of meat led to protests by the Hébertists (followers of the radical journalist Jacques Hébert) and the imposition of a series of laws rationing meat consumption, fixing its maximum price and establishing the Hospice de l'Humanité (one of the three main hospitals of Paris) as the only officially sanctioned slaughterhouse.[1] (Thus the origin of the centralized slaughterhouse and the birth of the clinic may be said to have coincided.) But the measures quickly led to a black market in meat from animals slaughtered outside the city and brought in clandestinely. All of these state controls ended with the execution of Robespierre in July 1794 and the establishment first of an oligarchic Directory, and then a dictatorship under Napoleon.

The revolutionary abolition of feudal and monarchical privileges gradually ended the last vestiges of guild authority, and by 1810 the meat trade was definitively placed by Napoleon under the authority

of the Paris police, with most private *tuerie* (killing shops) closed. The main slaughterhouses – the first such large, specially designed, centralized facilities in modern history – were now located in five locations across the city (though primarily on the Right Bank): Ménilmontant, Roule, Grenelle, Villejuif and Montmartre.[2] The largest markets for cattle meanwhile remained well outside the city gates at Poissy and Sceaux. For the first time, slaughter was segregated from the eyes, ears and nostrils of most Paris citizens, and farm animals themselves – alive or dead – were now rarely seen. So when Géricault painted the butchers of Rome in 1817, he was depicting a subject that had been highly contested during the Revolution, and representing it in such a way as to invoke the bad old days of guild privilege, the public spectacle of cruelty toward animals and palpable danger to butchers and city residents alike. Escaped animals were regularly known to trample and sometimes kill Parisians, and the effluvia of slaughter were understood to foul the city's air and water. Géricault must have considered this history when he contemplated making a monumental version of the *Cattle Market* the artistic token of his triumphal re-entry to the Paris art world after his self-imposed exile in Rome. In the event, he chose a different kind of meat and slaughter – the murder and cannibalism onboard the raft of the *Medusa* – as his stake to artistic and public fame.

Though butchering was at last fully segregated from the selling of meat, seemingly ensuring greater public safety, the new slaughterhouses were generally just as cruel, labyrinthine, dark, filthy and odoriferous as the old, private killing stalls. The Napoleonic dictatorship and the subsequently restored Bourbon regime prioritized the cheapness over the salubriousness of meat, and paid even less attention to either the safety of workers or the treatment of the animals. Killing proceeded pretty much as it always had – a process described by Louis-Sébastien Mercier in 1782:

> A young bull is thrown down and his head is tied to the ground
> with a rope; a strong blow breaks his skull, a large knife gives
> it a deep wound in the throat; steaming blood spills out in
> big bursts along with the life . . . Bloody arms plunge into
> its steaming innards, a blowpipe inflates the expired animal

and gives it a hideous shape, its legs are chopped off with a cleaver and cut up into pieces and at once the animal is stamped and marketed.[3]

But whereas animals had previously been slaughtered one at a time, the process was now multiplied by dozens, hundreds and even thousands of animals. In the century following the Revolution, grain production in France nearly doubled, while meat production tripled, though the agricultural population remained the same.[4] Nevertheless, despite this greatly increased production, the price of meat rose 275 per cent between 1790 and 1880 while that of wheat increased by around 16 per cent.[5] The reason for the price differential was rapidly rising demand for meat, and the fact that animals were now either stall-fed on grain and hay or grazed on rich lands formerly reserved for growing cereals and vegetables. The new grazing land was much more expensive than the old marginal lands, and the returns consequently had to be much greater. And with more animals being raised and fed, and more expensive meat, the size and scope of the Paris slaughterhouses again had to be increased. The cycle of growth associated with the modern industrial capitalist economy was now fully launched and the slaughter of animals was becoming rationalized.

CITY OF BLOOD

The slaughterhouse at La Villette, called by the butchers who worked there the City of Blood, was opened in 1867.[6] Located in the nineteenth arrondissement, northeast of the city centre, it consisted of three main livestock markets for sheep, cows and pigs and about three dozen smaller nearby buildings containing discrete *échaudoirs* (stalls) intended for slaughtering and butchering. The whole complex, designed by Louis-Adolphe Janvier under the direction of Victor Baltard (who also designed Les Halles, the central markets of Paris), resembled from the outside a miniature Haussmannized city with smart avenues and street trees, a police station, a post office and even a stock market. Trains from the countryside brought animals directly to market, and from market to slaughter. Though the

surrounding neighbourhood was chaotic, poor and crime-ridden, La Villette itself resembled – at least from the outside – an island of idealized French rationalism. However, once again, the interiors of the slaughtering rooms were an irrational and macabre warren of *échaudoirs* controlled by individual entrepreneurs zealous to protect their small fiefdoms from the prying eyes of either competitors or state authorities. In addition, a layer of middlemen – wholesalers and commissioners who represented distant ranchers and breeders – exerted authority of their own, further fracturing whatever cohesion and hierarchical clarity might have existed at the markets and slaughterhouses. Killings here were undoubtedly often careless, haphazard and cruel in the extreme.

But the governing myth of La Villette was that the killing and butchering of animals there was 'artisanal' (*abattage*). Though numbering in the hundreds of thousands per year (reaching more than 2 million by the century's end), the volume of slaughter was significantly lower than at English or American abattoirs such as those adjacent to the Smithfield Market in London and the Union Stockyards in Chicago, and each master butcher in Paris commanded a brigade of men with specialized skills: moving the animals, killing or stunning them with a single blow to the head, cutting their throats to empty their blood, removing entrails and skin and so on.

Postcard, La Villette, *c.* 1900.

The workers were said to constitute a closely knit and mutually supportive team under the leadership of their enlightened *patron boucher*. The aestheticized killing at La Villette and the display and sale of meat at Les Halles was a main subject in Zola's novel *Le Ventre de Paris* (1873), the third of the Rougon-Macquart series representing the lives of an extended French family in the years between the *coup d'état* of Louis-Napoléon in 1851 and the Franco-Prussian War and Commune in 1870–71. The character of Florent in the novel is lean, hungry, wild and filled with dangerous ideas about liberty. His brother and sister-in-law, on the other hand, who own a pork butcher's shop on the perimeter of Les Halles, are dull and self-satisfied, and increasingly appalled by Florent's burgeoning radicalism. Florent is nevertheless intoxicated by his first look at the butcher's shop:

> There was a wealth of rich, luscious, melting things. Down below, quite close to the window, jars of preserved sausage-meat were interspersed with pots of mustard. Above these were some small, plump, boned hams. Golden with their dressings of toasted bread-crumbs, and adorned at the knuckles with green rosettes. Next came the larger dishes, some containing preserved Strasburg tongues, enclosed in bladders coloured a bright red and varnished, so that they looked quite sanguineous beside the pale sausages and trotters; then there were black-puddings coiled like harmless snakes, healthy looking chitterlings piled up two by two; Lyons sausages in little silver copes that made them look like choristers; hot pies, with little banner-like tickets stuck in them; big hams, and great glazed joints of veal and pork, whose jelly was as limpid as sugar-candy. In the rear were other dishes and earthen pans in which meat, minced and sliced, slumbered beneath lakes of melted fat. And betwixt the various plates and dishes, jars and bottles of sauce, coulis, stock and preserved truffles, pans of *foie gras* and boxes of sardines and tunny-fish were strewn over the bed of paper shavings. A box of creamy cheeses, and one of edible snails, the apertures of whose shells were dressed with butter and parsley, had been placed carelessly at either corner.

Finally, from a bar overhead strings of sausages and saveloys of various sizes hung down symmetrically like cords and tassels; while in the rear fragments of intestinal membranes showed like lacework, like some *guipure* of white flesh. And on the highest tier in this sanctuary of gluttony, amidst the membranes and between two bouquets of purple gladioli, the window stand was crowned by a small square aquarium, ornamented with rock-work, and containing a couple of gold-fish, which were continually swimming round it.[7]

For Zola, the spectacle of flesh – and Florent's brother, sister-in-law and niece, too, are described as fat and porcine – signalled bourgeois complacency, corruption, cruelty, licence and human alienation from animals and the countryside. Most of all, the aestheticizing of the killing, butchering and dressing of meat is revealed as a barbarism, almost a cannibalism: 'Lyons sausages in little silver copes that made them look like choristers . . . [And] in the rear were other dishes and earthen pans in which meat, minced and sliced, slumbered beneath lakes of melted fat.' The pathos formula itself is here cut, sliced, skewered and subject to mockery. All the euphemisms of meat and slaughter are exposed to ridicule.

By contrast, Zola's contemporaries the Impressionist painters Claude Monet and Gustave Caillebotte accepted and reproduced the modern myth of the painless, rational and redeemed animal death. In *Pair of Dead Mullets* (1869), and *Still-life with Pheasants and Plover* (1879), Monet took up the challenge laid by Chardin more than 100 years before: to construe a painterly surface that suggests an animating spirit while nevertheless upholding anthropocentrism. In the first picture, the facture is loose, with colour and gesture being the primary instruments of energy and motion. But the vigorous paint handling is nevertheless secondary to the composition, as Monet uses the fish as formal props in a shallow space that almost parallels the picture surface, illustrating and mocking the frequent critical barb against modern painting that it looks the same upside-down as right side up. Turn the work on its head and little is lost, though the uppermost fish will seem slightly to defy gravity. In the second, later painting by Monet, two pairs of male birds lay diagonally across a table.

It is autumn or early winter, hunting season, and the artist must have killed these himself since one would normally buy at the market a brace of birds – a male and female – not two males, as here. And the atmosphere in the room is frosty: the background wall as well as the tablecloth in the foreground is composed of white, grey and many shades of blue, the former inflected with dabs of orange and pink to bring it just a bit closer to the picture's surface, and cause it to interact with the orange and yellow of the dead pheasants. But of empathy or the suggestion that these were once living, sentient creatures, there is not a trace.

A still greater detachment from the lives of animals and the circumstances of their deaths is revealed in the work of Gustave Caillebotte. He staked a considerable part of his claim to artistic seriousness upon a group of works depicting dead birds or slabs of meat hanging from hooks in a butcher's shop. Reminiscent of Rembrandt's *Flayed Ox* in the Louvre, but at the same time marking its great difference from the earlier, more sombre canvas, Caillebotte's *Calf in a Butcher Shop* (1882) represents a brightly coloured carcass festooned with a long necklace of flowers and a pink corsage in the

Claude Monet, *Still-life with Pheasants and Plovers*, 1879, oil on canvas.

Gustave Caillebotte, *Calf in a Butcher Shop*, 1882, oil on canvas.

middle, suggesting a young *cocotte* posing for her portrait, or a maiden laid out in her grave. It recalls some lines from Baudelaire's poem 'The Carcass' ('*Une Charogne*') from *Flowers of Evil*:

> My love, do you recall the object which we saw,
> That fair, sweet, summer morn!
> At a turn in the path a foul carcass
> On a gravel strewn bed,
> Its legs raised in the air, like a lustful woman,

Burning and dripping with poisons,
Displayed in a shameless, nonchalant way
Its belly, swollen with gases.
The sun shone down upon that putrescence,
As if to roast it to a turn,
And to give back a hundredfold to great Nature
The elements she had combined;
And the sky was watching that superb cadaver
Blossom like a flower.
So frightful was the stench that you believed
You'd faint away upon the grass . . .

And yet you will be like this corruption,
Like this horrible infection,
Star of my eyes, sunlight of my being,
You, my angel and my passion!
Yes! thus will you be, queen of the Graces,
After the last sacraments,
When you go beneath grass and luxuriant flowers,
To molder among the bones of the dead.
Then, O my beauty! say to the worms who will
Devour you with kisses,
That I have kept the form and the divine essence
Of my decomposed love![8]

Like Baudelaire's poem, Caillebotte's painting juxtaposes the blossoms of 'luxuriant flowers' with the death and corruption of a 'superb cadaver'. But unlike the poem, the painting is lacking in irony; rather than suggesting, as Baudelaire's poem does, that the beauty of youth – representing fashion, modernity and desire – is already disfigured by death and decay, Caillebotte's painting suggests that the beauty of the carcass is timeless. The painting also plays upon the French butcher's term *fleurer*, which means 'to make shallow artistic sketches using the tip of the blade on the bleached skin of the calf' or small, contrasting cuts with a specialized knife in order 'to detach the skin from the flanks'.[9] In addition, the white drapery behind the calf and the wooden hanger from which it is suspended invokes

Gustave Caillebotte, *Calf's Head and Ox Tongue*, c. 1882, oil on canvas.

the idea of *habillage*, 'dressing' the carcass – that is, chopping and cutting it so that it may be sold at retail. The dead calf is shown here to be thoroughly modern and well dressed.

In Caillebotte's *Calf's Head and Ox Tongue* (c. 1882) there is also an absence of irony or empathy, as well as the fanciful suggestion that a calf's head and an ox's tongue are the product of a clean, safe and salubrious system of rationalized butchering, transport and refrigeration. The steely grey-blue of the background and the steel hooks and

rack at the bottom of the picture propose that the butchering and sale of meat in Paris occur in a hospital-like, almost antiseptic environment, when in fact the master butchers of La Villette were actively hostile to modern refrigeration because it would have meant that meat from elsewhere in Europe or even North America might be able to be transported into France, potentially undercutting their market and lowering prices. Indeed, by the first decade of the twentieth century, La Villette was called 'the laughing stock of Europe' for its inefficiency and filth; it was noted, for example, that the contents of the stomachs and intestines of slaughtered animals regularly splashed upon already cleaned carcasses.[10] Even the economics of the market and slaughterhouse were obscure or opaque to outsiders; the price of meat was generally set by an estimate and a handshake, not by weighing the animal and a signed contract, thus again denying outside oversight or interference. But for Caillebotte, a veritable cheerleader for the liberal modernization of France, butchering and meat (La Villette and Les Halles) were as rational and necessary as the long boulevards, railway stations and apartment blocks of Haussmann's Paris, depictions of which were his stock-in-trade.

London's Smithfield Market: Dickens and Darwin

In England and the U.S., growth in the production and consumption of meat was at least as dramatic as in France, leading to changes in the industrial infrastructure of slaughter. Until the late nineteenth century, animal slaughter in England – including London – was mostly private: a matter of thousands of small sheds, barns, stalls, yards and even private houses. However, a considerable amount of killing took place at or near Smithfield in London, the largest cattle market in the world before the Union Stockyards opened in Chicago in 1865. In 1855, the market, located just 200 yards from the rebuilt Newgate Prison, with St Paul's Cathedral not much further away, was moved 2 miles north to Islington. There it remained for a few years until the modernized Smithfield Market with its grandiloquent ironwork canopies was reopened. The ostensive reason for relocating and then rebuilding was the improvement in traffic, sanitation and public safety; but, as in France, the effect was the segregation of urban dwellers from the

living tokens of their own agrarian and pastoral roots and habits, and from the sights, smells and outcries associated with death.

The former Smithfield market, which had existed since the Middle Ages, was a veritable symbol of urban danger, disease and decay; noisy, crowded and insalubrious, it signified to many an uncontrolled political, social and moral order. In addition to being a cattle market, Smithfield had for generations been a site of executions, bear-baiting, public floggings and other displays of barbarity. When Charles Dickens wanted to convey an ambience of violence, criminality and disorder in *Oliver Twist* (1838), he could do no better than to have Oliver and Bill Sikes pass through Smithfield as they prepare to rob the house of Mrs Maylie:

> It was market morning. The ground was covered nearly ankle deep with filth and mire; and a thick steam perpetually rising from the reeking bodies of the cattle, and mingling with the fog, which seemed to rest upon the chimney tops, hung heavily above . . . Countrymen, butchers, drovers, hawkers, boys, thieves, idlers, and vagabonds of every low grade, were mingled together in a dense mass: the whistling of drovers, the barking of dogs, the bellowing and plunging of beasts, the bleating of sheep, and the grunting and squealing of pigs; the cries of hawkers, the shouts, oaths, and quarrelling on all sides, the ringing of bells, and the roar of voices that issued from every public house; the crowding, pushing, driving, beating, whooping and yelling; the hideous and discordant din that resounded from every corner of the market; and the unwashed, unshaven, squalid, and dirty figures constantly running to and fro, and bursting in and out of the throng, rendered it a stunning and bewildering scene which quite confused the senses.

This was the space of popular protest and criminality, judged as residing together by Whigs and Tories alike. It was a place where public order and political discipline could not be maintained, and where the mingled cries of people and animals – that brute proletariat portrayed a dozen years earlier by Géricault – were still heard.

The common character of those expressions of anguish was now increasingly the subject of literature, art and science. In *Oliver Twist*, Sikes and his dog Bullseye share an emotional volatility, a propensity for violence and a mutual wariness. It is the dog in the end who is his master's undoing.

After striking down Nancy with his club, the robber and murderer Sikes flees the crime scene, accompanied by Bullseye. He walks, runs, stops and then wanders, unsure where to go and haunted everywhere by the 'last, low cry' and 'those widely staring eyes' of his victim. Finally he determines to return to London – to hide amid the crowd until the tumult following the murder begins to die down. Fearing that the appearance of his dog will give him away, Sikes 'resolved to drown him, and walked on, looking about for a pond: picking up a heavy stone and tying it to his handkerchief as he went'.

> The animal looked up into his master's face while these preparations were making; whether his instinct apprehended something of their purpose, or the robber's sidelong look at him was sterner than ordinary, he skulked a little farther in the rear than usual, and cowered as he came more slowly along. When his master halted at the brink of a pool, and looked round to call him, he stopped outright.
>
> 'Do you hear me call? Come here!' cried Sikes.
>
> The animal came up from the very force of habit; but as Sikes stooped to attach the handkerchief to his throat, he uttered a low growl and started back.
>
> 'Come back!' said the robber.
>
> The dog wagged his tail, but moved not. Sikes made a running noose and called him again.
>
> The dog advanced, retreated, paused an instant, turned, and scoured away at his hardest speed.
>
> The man whistled again and again, and sat down and waited in the expectation that he would return. But no dog appeared, and at length he resumed his journey.[11]

A little later in the book, the dog indeed gives away Sikes's presence in London, and leads the mob in hot pursuit. At the very last,

George Cruikshank,
illustration from
Charles Dickens,
Oliver Twist (1838).

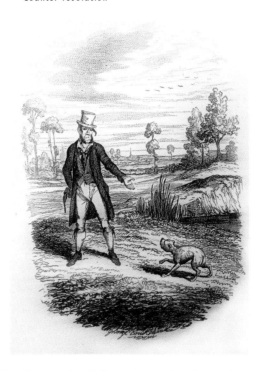

Sikes sees his dog in the dim evening light and mistakes its staring eyes for those of Nancy: '"The eyes again!" he cried in an unearthly screech.' And at that, Sikes stumbles off the roof and is hung by the rope he had intended to use for his escape. 'A dog, which had lain concealed till now, ran backwards and forwards on the parapet with a dismal howl, and collecting himself for a spring, jumped for the dead man's shoulders.' But the animal misses his mark, and falls to the ground, dead.[12]

George Cruikshank's illustrations for each of these scenes – the only two in the book in which either Sikes or the dog appear – constitute a distinct pairing. They emphasize a fraught bond between human and animal, since in the first Sikes aims to drown his companion, and in the second the dog causes Sikes to fall into a hangman's noose. In each, the space between man and dog is animated by outstretched arms and extended muzzle, though in the first Sikes is in the superior position, while in the second it is Bullseye. And both man and dog have the capacity of second sight or sixth sense: everywhere he goes, Sikes sees the body, face and especially the eyes of his victim; and for

his part, Bullseye is able to detect by the look in 'his master's face', that Sikes intends to do him harm and utters 'a low growl' in response.

Some years later, a scene that might have been taken from Smithfield was exhibited at the Royal Academy and greeted with considerable public incomprehension. In 1854–6, the Pre-Raphaelite painter William Holman Hunt painted *The Scapegoat*, a picture that also appears to express the 'cry of nature'. His putative subject, the ritual sacrifice of a goat cast into the desert to suffer and die in expiation of human sins, was derived from Leviticus. But what Hunt painted instead was an actual starved and distressed goat bleating an anguished 'neah', as it struggled to survive in the brine and heat of the Dead Sea. (Hunt worked on location with an actual goat – in fact, several goats.) To the great Victorian critic John Ruskin, Hunt's picture evinced 'a too great intensity of feeling'. Rather than prefiguring the sacrifice of Christ, the picture was an image of animal suffering of the kind condemned by the RSPCA and still commonly seen in London in the days before the establishment of the new dead animal market at Smithfield

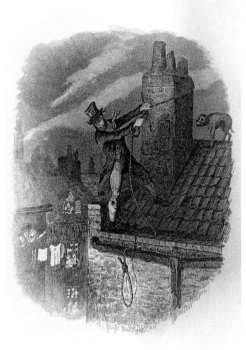

Cruikshank,
illustration from
Oliver Twist.

William Holman Hunt, *The Scapegoat*, 1854–6, oil on canvas.

in 1868. Moreover, the composition was decidedly populist, recalling those pictures by Bewick or Géricault based upon butchers' or publicans' shop signs: 'I have hardly ever seen a composition', Ruskin wrote, 'left apparently almost to chance, come so unluckily: the insertion of the animal in the exact centre of the canvas making it look as if it were painted for a sign'.[13]

THE EXPRESSION OF THE EMOTIONS IN MAN AND ANIMALS

In his *The Expression of the Emotions in Man and Animals* (1872), Charles Darwin remarked upon the universality of outcry when humans and animals 'suffer from an agony of pain'. The shared response indicated to him 'that certain actions which we recognize as expressive of certain states of mind, are the direct result of the constitution of the nervous system, and have been from the first independent of the will, and to a large extent, of habit'.[14] All animals, in other words, with a similar matrix of nerves – including creatures now extinct, or that appeared much earlier than humans on the tree of life – react in similar ways when exposed to common stimuli. 'When animals suffer from an agony of pain, they generally writhe about with frightful contortions; and those which habitually use their voices utter piercing cries or groans.' And further: 'An agony of pain is expressed by dogs in nearly the same way as by many other animals,

177

namely by howling, writhing, and contortions of the whole body.'[15] Even animals that are habitually silent may use their voices 'in the extremity of their sufferings, as when a wounded hare is killed by the sportsman, or when a young rabbit is caught by a stout. Cattle and horses suffer great pain in silence, but when this is excessive, and especially when associated with terror, they utter fearful sounds.'[16] The significance of Darwin's observation is that similar grimaces and vocalizations of pain are additional proof that humans evolved from non-human animals. The expression of pain, in short, is literally the cry of nature: the sound of evolutionary inheritance.

Darwin's examination of emotional expressions also suggests that humans and animals are the products of the same fundamental laws and forces of nature; no divinity was required to create Man, and no impermeable divide exists between human and animal. And in contrast to earlier physiognomic treatises by Charles Le Brun and Johann Kaspar Lavater, Darwin's book denied that character traits were permanently imprinted upon the face and can be read like a book. If a person has leonine or mouse-like features, Darwin implicitly argued, it is not because he is as fierce as a lion or as timid as a mouse; it is because animals and humans express fundamental emotions or drives in similar ways as a result of their common evolutionary heritage. Fierceness and timidity are not fixed on any animal's face by the hand of God; they are transient emotions that leave impermanent traces.[17]

In this understanding of animal emotion, Darwin differed from his contemporary, the English animal painter Sir Edwin Landseer. While Landseer was evidently deeply concerned with animal welfare, and convinced that animals were, as one of his early biographers wrote, 'deeply sentient beings only removed from man by their lack of the medium of human speech', his best works consistently deny animals their uniqueness and autonomy.[18] By repeatedly painting dogs, his most frequent and popular subject, in a highly sentimental or hyperbolic vein, he diminished their expressive and emotional complexity. In *Dignity and Impudence* (1839) and *Alexander and Diogenes* (1848), for example, Landseer employed his formidable naturalist skills to depict dogs as representatives of idealized modes of human comportment and as embodiments of antique virtues. The former picture shows a

Edwin Landseer, *Dignity and Impudence*, 1839, oil on canvas.

bloodhound and a West Highland terrier snugly tucked inside their
doghouse or kennel. They appear content with their lodging and
even their constraints – a chain is visible in the left foreground –
thereby highlighting approved Victorian notions of obedience, sub-
servience and domestication.[19] The latter picture shows a bulldog
and a farrier's dog enacting the meeting of the powerful Macedonian
king and the philosopher-cynic who, when asked what he wanted,
famously replied, 'Get out of my light.' The patent absurdity of the

Edwin Landseer, *Alexander and Diogenes*, 1848, oil on canvas.

scene thus suggests that humans alone posses nobility and animals must remain in all ways subservient to them. As Landseer's biographer wrote: 'With the dog, in this humanizing effort, he often strained the rational limits set about him, merging the semi-tragic into the ridiculous.' The latter picture, exhibited at the Royal Academy in 1848 and then again in London in 1859, invited the criticism of Darwin himself (a photograph of the painting was found among his papers on animal expression), although on narrower grounds: he thought the posture and fur of the bulldog unrealistic.[20]

A similar denial of animal autonomy may be ascribed to Rosa Bonheur, perhaps the most renowned of all animal painters. Daughter of a radical Saint-Simonian, she rejected conventional gender norms early on, dressing as a man and choosing women as her life companions, and began her exhibition career as an *animalier* in 1841 at the age of nineteen. Influenced by Géricault, the sculptor Antoine-Louis Barye and (after 1856) by Landseer, she achieved enormous success with her pictures *Ploughing in the Nivernais: The Dressing of the Vines* (1849) and *The Horse Fair* (1853). Each picture manifests great knowledge of husbandry and breeding – in the first case the oxen

of the Morvan, and in the second the percheron horses of the Huisne River region – but little concern with the individuality or life history of particular animals. The standing, white-shirted man with rearing horse in the centre of *The Horse Fair* might derive from Géricault's *The Race of the Riderless Horses*, but the cruelty and tragedy of the latter has been largely drained out of the scene. After a trip to England in 1856, Bonheur began to paint animals with greater detail and individuality, but her work also became increasingly sentimental and conventional in the manner of Landseer, as in her watercolour *The King Watches* (1887). By contrast, Gustave Courbet rejected sentimentality in his many hunting pictures, offering an alternative set of anthropocentric conventions: the supposed courage, strength, concentration and authority of the huntsman. Like Ernest Hemingway 100 years later, Courbet embraced what he called 'the spirit of the hunt' – he was himself an avid hunter – proposing that it is the tracking, pursuit and final conquest of the prey more than the killing itself that is the hallmark of genuine masculine venery culture.[21] His pictures, such as *The German Huntsman* (1859), accordingly dwell as much upon the hunter as the prey, injecting a measure of introspection and even tragedy into a genre that rarely accommodated either.

With Darwin, however, what had once been a matter of mere anecdote and conjecture – that humans and animals cry out when subjected to stimuli known to cause emotional anguish or physical pain – was now a matter of scientific observation and evolutionary fact. And this discovery was the basis of a much wider set of

Rosa Bonheur, *The Horse Fair*, 1853, oil on canvas.

observations about the shared 'intellectual emotions and faculties' of humans and animals: 'Animals enjoy excitement and suffer from ennui, as may be seen with dogs . . . All animals feel wonder, and many exhibit curiosity.'[22] In *The Descent of Man* (1871), Darwin provided examples of the curiosity of deer, ducks and monkeys, and discussed the qualities of imitation, attention, memory, imagination and reason among animals.

> Few persons any longer dispute that animals possess some power of reasoning. Animals may constantly be seen to pause, deliberate, and resolve. It is a significant fact that the more the habits of any particular animal are studied by a naturalist, the more he attributes to reason and the less to unlearned instincts.

Here Darwin specifically cited Lewis Henry Morgan's work on the beaver, though demurring that 'he goes too far in underrating the power of instinct'.[23]

Darwin concluded his discussion about animal emotion by stating that, in contrast to widespread assertions to the contrary, humans share with the 'higher animals, especially the Primates', the capacities (albeit varying in degree) of progressive improvement, tool use, abstraction and language, self-consciousness, a sense of beauty, a sense of humour and feelings of gratitude and mystery. 'Articulate language', Darwin says, is peculiar to humans, but in common with animals, 'our cries of pain, fear, surprise, anger . . . are more expressive than any words.' Just as importantly, since 'every language has been slowly and unconsciously developed by many steps', it is impossible to absolutely distinguish the line between human and non-human animal communication and expression.[24] Discussing the protrusion of the lips of chimpanzees and orang-utans, Darwin argued – employing for the purpose a wood engraving after a drawing by Thomas Wood – that human babies use their lips to express the same feelings as primates: 'The accompanying drawing represents a chimpanzee made sulky by an orange having been offered him and then taken away. A similar protrusion of the lips, though to a much slighter degree, may be seen in sulky children.'[25] This similarity,

Darwin proposed, is not surprising: 'For it is not at all unusual for animals to retain, more or less perfectly, during early youth, and subsequently to lose, characters which were aboriginally possessed by their adult progenitors, and which are still retained by distinct species, their near relations.'[26]

With the work of Darwin, therefore, the radical assertions of Oswald, Ritson and their artistic contemporaries that humans and animals are sufficiently alike that the one cannot by rights claim dominion over the other is given empirical support; artistic support, too, since Darwin employed the designs of the renowned animal painter Briton Rivière and several others to illustrate his ideas about the homologies of human and animal expression.[27] Though he did not explicitly speak out in favour of animal rights, Darwin argued convincingly that animals and humans are similar in all the ways that matter most: they feel pain and experience joy, sadness, boredom and expectation; they think – albeit with different levels of complexity – and possess self-consciousness and even empathy. They seem to possess what modern cognitive psychologists call 'theory of mind'. Therefore any decision by humans to kill or abuse animals must be entirely without sanction by God or nature, giving pause to any who would allow the reckless killing that took place – often without any

Gustave Courbet, *The German Huntsman*, 1859, oil on canvas.

THE CRY OF NATURE

stunning – in the many slaughterhouses near London's Smithfield. Among animals awaiting slaughter, wrote the anti-vivisectionist and slaughterhouse reformer the Revd John Verschoyle in 1903, 'Every sign of terror was manifest in their bearing.'[28]

Animal rights activists and anti-vivisectionists frequently appealed to Darwin to speak out against the numberless animal abuses of his age, believing that he above all others would understand the rational basis of their cause, but to little avail. In fact, he publicly supported a bill introduced in the House of Commons in 1875 in support of vivisection in the conviction that science should suffer no interference from anyone. The new law was intended to head off alternative legislation introduced by Frances Power Cobbe – founder that year of the Society for the Protection of Animals Liable to Vivisection – that would have banned the practice. Darwin approved only of regulation, not prohibition, of animal experimentation.[29] He and others were confident that new ameliorative laws and humanitarian societies would protect animals from the worst abuses by humans without interfering either in trade or scientific experimentation. Though laws restraining certain blood sports easily advanced through parliament, those that concerned vivisection and humane butchering languished for decades. It was not until the third decade of the twentieth century that large centralized slaughterhouses became the norm in England, and cattle were required to be stunned before being cut. The irony is that the very welfarist perspective that demanded that centralized abattoirs be remote from public view essentially silenced the cries of protest of slaughtered animals and advanced the counter-revolution against animal rights. Out of the sight and hearing of the public, the age of mass or industrial slaughter could begin.

THE UNION STOCKYARD, CHICAGO: THE JUNGLE

Rationalized animal breeding and industrialized slaughter expanded rapidly in the U.S. in the decade that followed the Civil War. In Chicago, the Union Stockyard and Transit Company opened on Christmas Day 1865. It was the joint effort of a consortium of meatpackers, railroad companies and private investors, and quickly became the

largest livestock market in the country, delivering meat from western pasturelands and feedlots to East Coast markets. (The name 'Union' has nothing to do with labour unions – in fact, the Amalgamated Meat Cutters were defeated and disabled by management and scab workers in major strikes for better wages in 1894 and 1904.[30] In the late 1930s, unionized Chicago meat cutters gained some power, but the decentralization of the meatpacking industry in the 1970s reduced national union membership from 80 per cent in 1980 to less than 30 per cent today.)

Slaughterhouses in Chicago were initially located well south of the stockyards, and drovers were required to bring animals several miles down Halsted Street, but beginning in the 1870s, Swift, Armor, Morris, Hammond and a few other companies established modern facilities just to the west of the stockyards, accelerating the speed of transformation from animals into meat. The creation of refrigerated train cars in the 1880s expanded still further the quantity of meat shipped east. Labour in the packinghouses was increasingly divided and subdivided as the century drew to a close, obviating the need for highly skilled labour and driving salaries lower and lower. By the time Upton Sinclair published his muckraking novel *The Jungle* (1906), many of these labourers were immigrants, wages were very low, the pace of labour was accelerating and the conditions of work were dangerous.

At its peak, the Yards supplied 82 per cent of all the meat eaten in the United States. By 1921, 40,000 people were employed there,

Stereoscopic-photograph showing a bird's-eye view of the Union Stockyards, Chicago, in 1897.

and dozens of miles of roads and railroad tracks linked it to the surrounding neighbourhoods on the south and west sides of Chicago and the rest of the country. Between 1865 and 1900, some 400 million animals were killed at the Union Stockyards. At the start of the twentieth century, a single slaughterhouse could kill and dismember 1,200 pigs an hour by running their hoists, wheels, chains and conveyor belts for sixteen hours per day, six days a week. Slaughter was now fully mechanized. Mere seconds separated the live pig from the cut-up hog; 25 feet distinguished the walking cow from cut and dressed beef. Some workers stunned the animals, others killed them, and still others cut, sawed, chopped and carved the meat in a grim and relentless machinery of death. When the Stockyards began, much of the slaughtered animal was discarded as refuse, dumped in the South Fork of the Chicago River. But within a couple of decades, nearly all of the killed animal was used in some way – to make margarine, dog food, candles, tennis racket strings and much more. The common packinghouse slogan became: 'We use everything but the squeal of the hog and the bellow of the ox.'

The pulleys, conveyor belts and trolleys in use at the slaughterhouses – combined with stationary workers – anticipated the system of manufacture used at automobile assembly lines beginning in 1913. Indeed, Henry Ford confirmed this origin when he wrote in 1922: 'I believe that this was the first moving line ever installed. The idea came in a general way from the overhead trolley that the Chicago packers use in dressing beef.'[31] (The industrial system in Chicago had still another progeny: the conveyance of animals by railroad cars from all parts of the country, their concentration in pens or stalls, their dreadful intuition of what would befall them, their movement along prescribed routes and their mass deaths predicted the Nazi extermination camps. At Treblinka, Belzec and Sobibor, victims were first corralled into a pen and then forced to march within 'the Tube', a 10-to-15-foot-wide, 150–300-foot-long curved path that culminated in a gas chamber. At Treblinka and Sobibor, ss guards euphemistically called it the *Himmelfahrtsstrasse*, or 'road to heaven'.[32] Rudolf Höss, the first commandant of Auschwitz, described his camp as 'the largest human slaughterhouse that history had ever known', and boasted that he could with ease 'dispose of 2,000 head in half an hour'.[33])

The work of stunning and then killing animals in the Chicago Packinghouse fell to a few specialists. Here is a description of the occupations of 'knockers' and 'shacklers' from a bulletin from the Bureau of Labor Statistics of 1917:

> *Knockers* – walk on boards at the top and over the edge of the knocking pen, strike the cattle on the forehead with a hammer which weighs about 4 pounds, pull the rope attached to the hoisting machinery and dump the cattle to the killing floor . . . *Shacklers* or *slingers* – attach one end of a short chain (with a hook on each end) around the hind feet of the cattle, hook the other end to the hoisting machinery, and pull a rope setting the machine in operation which hoists the cattle to an overhead rail, leading to a point on the killing floor where the animals are to be stuck.[34]

Note that the animals are not yet dead when they are hoisted up, only stunned. This is so that when they are 'stuck' – that is, have their throats cut – their hearts will still be pumping, quickly draining the bodies of blood.

Though the very point of these modern facilities was to consolidate and segregate killing and remove it from public view, packing companies were proud of the speed and efficiency of their operations, and tours of the large slaughterhouses were a common entertainment for curious residents and tourists in the late nineteenth and early twentieth centuries. The *Visitor's Reference Book* for Swift & Co. of 1903 indicates that visitors were able to view most stages of the slaughter of pigs.[35] One illustration shows a little girl dressed in a pinafore perched on a railing as she and her parents watched the hogs turned on a giant wheel on their way to another room to be 'dispatched'. (Whereas cows were stunned before their throats were cut, pigs were not.) While written descriptions of the process are replete with euphemism – 'knocking', 'slinging', 'dressing', 'dispatching' and so on – nothing could have hidden the gore from the spectators, or masked the noise. The latter was in fact as unavoidable and overwhelming as the former, and soon found literary representation.

In *The Jungle*, the protagonist Jurgis's first intimation of the proximity of the Yards was the smell and then immediately after the sound of the place:

> This too, like the odor, was a thing elemental; it was a sound – a sound made up of ten thousand little sounds. You scarcely noticed it at first – it sunk into your consciousness, a vague disturbance, a trouble. It was like the murmuring of bees in the Spring, the whisperings of the forest; it suggested endless activity, the rumblings of a world in motion. It was only by an effort that one could realize that it was made by animals, that it was the distant lowing of ten thousand cattle, the distant grunting of ten thousand swine.[36]

A little later on, Jurgis, accompanied by his friend Jacobus, tours the meatpacking plant where he will soon be employed. After witnessing the pigs being led from a holding pen down a series of passages and chutes, the two men arrive in a long, narrow room, where they see one pig after another shackled by the leg, 'jerked off his feet and borne aloft'.

> At the same instant the ear was assailed by a most terrifying shriek – the visitors started in alarm, the women turned pale and shrank back. The shriek was followed by another, louder and yet more agonizing – for once started upon that journey, the hog never came back; at the top of the wheel he was shunted off upon a trolley and went sailing down the room. And meantime another was swung up, and then another, and another, until there was a double line of them, each dangling by a foot and kicking in frenzy – and squealing. The uproar was appalling, perilous to the ear-drums; one feared there was too much sound for the room to hold – that the walls must give way or the ceiling crack. There were high squeals and low squeals, grunts, and wails of agony; there would come a momentary lull, and then a fresh outburst, louder than ever, surging up to a deafening climax. It was too much for some of the visitors – the men would

look at each other, laughing nervously, and the women would stand with hands clenched, and the blood rushing to their faces, and the tears starting in their eyes. Meantime, heedless of all these things, the men upon the floor were going about their work. Neither squeals of hogs nor tears of visitors made any difference to them; one by one they hooked up the hogs, and one by one with a swift stroke they slit their throats. There was a long line of hogs, with squeals and life-blood ebbing away together; until at last each started again, and vanished with a splash into a huge vat of boiling water.[37]

Sinclair's narrator drew the inevitable conclusion, that the animals were tricked, traduced and killed in 'cold-blood', and that their loud protests were more than justified:

It was all so very businesslike that one watched it fascinated. It was pork-making by machinery, pork-making by applied mathematics. And yet somehow the most matter-of-fact person could not help thinking of the hogs; they were so innocent, they came so very trustingly; and they were so very human in their protests – and so perfectly within their rights! They had done nothing to deserve it; and it was adding insult to injury, as the thing was done here, swinging them up in this cold-blooded, impersonal way, without a pretense at apology, without the homage of a tear. Now and then a visitor wept, to be sure; but this slaughtering-machine ran on, visitors or no visitors. It was like some horrible crime committed in a dungeon, all unseen and unheeded, buried out of sight and of memory.

And in fact, while tours were conducted with the goal of persuading the public of the efficiency and cleanliness of the facility and the wholesomeness of the product, the Union Stockyards, and especially the killing floors of the meatpacking plants, remained mostly out of sight of city residents. The collective cries of the victims of slaughter – 'the distant lowing of ten thousand cattle' and the 'terrifying shriek' of pig after pig hoisted on the

wheel – were unheard by the vast majority of Chicagoans and most other consumers.

Given that the key product of stockyards and slaughterhouses – apart from meat itself – was silence and invisibility, it is unsurprising that apart from postcards, tourist books and other ephemera, there is little or no visual art of the Chicago Stockyards or packinghouses. What there is instead at the end of the nineteenth century is the 'game picture', which signalled by opposition the existence of the former institutions. Whereas Armour & Co. dispatched their victims in a manner both massive and impersonal, the trompe l'oeil pictures of William Harnett and others describe small-scale and idiosyncratic killing; and whereas the slaughter at Swift & Co. was mechanized and myriad, the deaths remembered in still-life painting are artisanal and few.

The pictures that made Harnett famous are his four *After the Hunt* paintings, made during and just after his period of study and exhibition in Munich from 1880 to 1884.[38] The large one from 1885 in the Fine Arts Museum of San Francisco consists of a wooden door with elaborate cast iron hinges and keyhole, functioning as shallow background for a brass hunting horn, Tyrolean hat, flintlock, powder horn, pistol, game bag, antlers, walking stick with long metal tip, horseshoe at the top, skeleton key at left and jug at bottom. Hung amid this bric-a-brac (apparently collected by the artist from antique and other curio venders) are the dead animals: in the middle of the brass horn is a red grouse and below that a red-legged partridge. Two smaller birds hang beneath the coil and bell of the horn. A dead European rabbit (*Oryctolagus cuniculus*) dangles by his left foot, its lifelike fur an homage to Chardin. This last creature, animate and unbloodied, reveals the intended mood of nostalgia and gentlemanly ease. The hunt, by Harnett's reckoning, is clearly an unhurried affair – a matter of practised rituals, comfortable clothes and out-of-date weapons – and the deaths it occasions are similarly discreet and expected. There are no cries or shrieks in evidence, and no suggestion of tragedy or pathos.

Harnett's *For Sunday's Dinner* (1888) is a more difficult image to understand. On the one hand, it simply invokes by metonymy what is taken to be the timeless bourgeois or petty bourgeois ritual of

William Harnett, *After the Hunt*, 1885, oil on canvas.

William Harnett, *For Sunday's Dinner*, 1885, oil on canvas.

the Sunday meal. We know from cookbooks of the period that the poultry would be roasted, baked or stewed and accompanied by glazed, baked or boiled sweet potatoes, or by baked, boiled, riced, mashed, scalloped, fried, shredded or chipped white potatoes, along with carrots, parsnips, dandelions, squash, cauliflower, turnips, asparagus or even truffles, if the eaters were very wealthy. The chicken and the cupboard door in Harnett's work have been painted with his usual startling illusionism. The animal itself, which could have been home-raised or purchased from market, has been recently plucked and a few downy white feathers cling to it and even seem to hover in the air like falling snow-flakes. In a little while, the chicken will be more thoroughly cleaned and dressed: the remainder of the feathers will be singed away, and the guts, gizzard, heart, liver and gall bladder will be removed (the last with great care, so the bitter-tasting bile is not spilled on the surrounding meat). The lungs, kidneys, windpipe and crop, too, will be excised. And if, after all that, the meat has an unpleasant smell, it must be washed inside and out with soda water, according to Fannie Farmer's *Boston Cooking-School Cook Book* (1896), and dusted with charcoal, especially under the wings.[39] The animal depicted here is long past any possible outcry, and indeed, the picture is suffused with silence. But there is just a trace of the tragic in the evident nakedness of the bird revealed by the clinging down and contrasting bare flesh.

A decade after the publication of Sinclair's *The Jungle* – well after the furore caused by its revelation of contaminated meat had died down (and after the passage, in 1906, of the Food and Drugs Act and the Federal Meat Inspection Act) – Carl Sandburg began and ended his famous poem 'Chicago' with the anodyne lines:

> Hog Butcher for the World,
> Tool Maker,
> Stacker of Wheat . . .

Now the Yards were to American artists and writers objects of patriotic and chauvinist pride more than examples of human and animal subjugation and exploitation. For the next 50 years, the sights, smells and especially sounds of the slaughterhouses would grow ever more

remote from individual experience as meat became a thing to be purchased prepackaged in supermarkets, or consumed in forms unrecognizably animal in origin: hamburgers, meat loaf, hot dogs, sausages, fish sticks, fried clam strips and all the rest. By 1964, the Union Stockyards were for songwriters Jimmy van Heusen and Sammy Kahn nothing more than a nostalgic trademark of the city of Chicago. Sung by Frank Sinatra that year in the film *Robin and the 7 Hoods* (dir. Gordon Douglas), the final lyrics of 'My Kind of Town' include 'And each time I leave, Chicago is / Tugging my sleeve', for Chicago is

> The Wrigley Building, Chicago is
> the Union Stockyard, Chicago is
> One town that won't let you down,
> It's my kind of town.

FIVE
Primal Scenes

ANIMAL AGONISTES

The Western discourse of human–animal relations from the seventeenth to the twentieth century was agonistic. Descartes, as previously discussed, understood animals to be unfeeling, unthinking machines due no moral consideration of any kind. Indeed, he made the very distinction between animals and humans one of his chief arguments for the existence of God: on the dissecting table, they are alike in many ways, but humans possess the unique ability to think and reason. And since there are no discernable organs of speech or thought in humans, they must have been endowed with immaterial gifts – reason and a soul – which can only have come from an equally immaterial being: God.

Montaigne, on the other hand, as well as the fabulist La Fontaine, the materialist philosopher La Mettrie and Rousseau, had quite different views. The first two claimed that animals, no less than humans, possessed language and reason, and that if the latter were uncomprehending of the former, the deficit was as much human as animal. La Mettrie argued that humans, like animals, were machines; that both experienced pain and possessed reason; and that their apparently different capacities were the result of changing environmental, biological and cultural forces. God had no role in any of it. And Rousseau supported a vegetarian diet because of his conviction that killing animals conditioned humans to be cruel to each other. He also believed that the natural sympathies observed in animals are evidence of the innate goodness of humans before the corruption of civilization.[1]

In the exact middle of the eighteenth century, the artists Hogarth and Chardin assumed opposite positions in what was becoming an increasingly contentious debate over what responsibility, if any, humans had toward animals. In *The Four Stages of Cruelty*, the former argued that the suffering and death of animals was a tragic but purely contingent matter that might be changed or ended if humans recognized their own callous indifference to the other's pain. 'The four stages of cruelty, were done in hopes of preventing in some degree that cruel treatment of poor animals which makes the streets of London more disagreeable to the human mind, than any thing what ever.' For Hogarth, the suffering of animals was a moral evil not simply because it conditioned humans to callousness toward each other, but because animals themselves deserve to be protected from ill use. His engravings thereby proposed that animals belonged within the sphere of moral rights. Chardin, on the other hand, embraced in his art a longstanding and morally indifferent pathos formula that beautified death, in his case by paradoxically bringing the dead animal to life by means of a highly animated facture. He thereby made the suffering and killing of animals appear to be events outside of time – essential and foreordained. *A Rabbit, Two Thrushes and some Straw on a Table* is a small-scale pietà by Chardin depicting archetypal as much as particular deaths.

The historical and social particularity of these philosophic and artistic contests gave them their true matter and substance. The growth of urban centres brought with it a large increase in the number of animals brought to market and to slaughter, increasing also the number of occasions when people would see on the streets great masses of calves, pigs, chickens and geese, and hear, in their collective bleats, squeals, clucks and honks, cries of fear and pain. Though proportionally fewer people had direct experience of living with and raising animals, more were now witnesses to animal cruelty, and many of them shrank from its sights and sounds. The culture of 'sensibility' – manifested in the poetry of William Cowper, among many others – was in part a refuge from that cruelty, though it might as well be called an 'alibi', since it assured readers of their own benevolence while generally leaving existing human–animal relations unchallenged.

In this politically and emotionally fraught context, a genuine movement for animal rights arose for the first time. Animals themselves, gathered in vast numbers and cacophonous in their outcries, were the avant-garde of the movement. By virtue of their species-natures, of course, they could not directly enter the political arena, but they attracted many articulate followers and supporters. Taking inspiration from Rousseau – who spoke of the first human language as a 'cry of nature' uttered 'in case of danger, or relief in case of suffering' – John Oswald proposed that humans and animals shared an interest in a life free from enslavement and violence. He described and condemned the pathos formula that naturalized the killing of animals, saying that since antiquity, humans had devised diabolical ways to trick creatures into surrendering themselves for slaughter in order to relieve themselves of the moral responsibility for taking innocent lives. Joseph Ritson made a similar argument, saying that animals had an intrinsic right to life and liberty and that it was only by means of humanity's devious 'sagacity and address' that they managed to subdue animals.

The visual artists of this revolutionary generation contributed startling new insights into the nature of animal psychology and physiology, often by highlighting the antagonisms of human and animal or by suggesting that the oppression of animals was simply a mirror of the despotism visited by humans on other humans. Stubbs revealed the subtle expectancy of the horse waiting to run, or about to be returned to his stall to be brushed, watered and fed. He exposed the circuit of silent or sub-linguistic communication between and among different animals and humans, and revealed the physiological homologies between, for example, tiger, chicken, ox and human. (These investigations were essential for Erasmus Darwin and, later on, his grandson Charles, both of whom proposed that homologous forms were the consequence not of a divinely conceived template but of common ancestry.)

Géricault observed the energy and love of freedom of the unbroken horse, and offered in many of his lithographs the stunning observation – absent even in the writings of Bentham, Oswald or Ritson – that a class hierarchy existed within some animal species: as, for example, between the sturdy, labouring Clydesdales and

Percherons and the more refined and aristocratic Arabians. (All of these animals, however, as Géricault and Bewick both observed, might end up in the slaughterhouse or glue factory.) William Blake generally resisted the language or imagery of rights, suggesting instead that an entirely new world of peace and love among all creatures offered the only assurance of a peaceful and prosperous Albion, the poet's name for a restored England. For Blake, rights and law were a concession to the very oppressive political and religious institutions whose authority he wished to challenge. He preferred Gay's *Fables* – which he illustrated – to Rousseau's *Social Contract*.

In subsequent generations, the human–animal antinomy assumed different forms. As part of the drive to secure plentiful meat for a growing urban population and at the same time assure profits for the capital-intensive meat industry, an effort was made in the middle of the nineteenth century to facilitate the concentration and slaughter of large quantities of animals. The majority of cows, pigs, sheep and chickens thus began to be moved by train from farms to markets – notably Smithfield, La Villette and the Union Stockyards – eliminating the appalling spectacle of enormous herds being cruelly driven through urban streets. (The elimination of the class of drovers, hawkers and other transients was an added benefit; many urban reformers wished to remove the politically unstable lumpen or 'dangerous' classes from urban centres. Even revolutionaries were distrustful of this urban sub-group.[2]) In addition, the passage of animal protection laws (however limited) and establishment of national societies for the prevention of cruelty to animals (however ineffectual) had the effect of persuading most consumers of animal products that slaughter was done humanely and perhaps even without causing pain. The utilitarian dream world, it was supposed, had arrived: the majority of the population could enjoy a bounty of meat and none would be the worse for it. Indeed, spared a cruel death from 'nature red in tooth and claw', animals were even said to benefit from the new regime!

And yet the 'Animal Question' remained.[3] As recognition grew that animals, like humans, experienced physical and emotional pain, the movement for animal rights gained new supporters.[4] But more than any humane society, anti-vivisection tract or work of art, Darwin's

On the Origin of Species, as well as *The Decent of Man* and *The Expression of the Emotions in Man and Animals*, decisively shifted the terms of the debate. No longer was the animal question simply a matter of understanding the differences between humans and other creatures, and mitigating the latter's suffering; now it was a question of realizing that humans were but one among thousands of animal species, and that whatever differences existed between them were historical and contingent, not essential and divinely ordered. Indeed, Darwin can even be said to have undermined the very thing he set out to explain: the species concept, and with it the uniqueness of humans. In a letter of 1856 to J. D. Hooker, he admitted the impossibility of precise definition:

> It is really laughable to see what different ideas are prominent in various naturalists' minds, when they speak of 'species' in some, resemblance is everything & descent of little weight – in some, resemblance seems to go for nothing & Creation the reigning idea – in some, descent the key – in some, sterility an unfailing test, with others not worth a farthing. It all comes, I believe, from trying to define the indefinable.[5]

Ernst Mayr's now widely accepted definition of species also denies any notion of morphological distinctness or essential type: 'A species is a reproductive community of populations (reproductively isolated from others) that occupies a specific niche in nature.'[6] A generation later, Sigmund Freud accelerated the process Darwin and his followers had begun: the permanent displacement of the human species from the core of creation.

SIGMUND FREUD

Though Freud is correctly understood to be the inventor of psychoanalysis – the 'talking cure' – he began his career as a materialist and in most respects remained one. Like Darwin, he conceived of the mind as a neurophysiological event, or at the very least as epiphenomenal; what Thomas Huxley called 'the whistle of the steam

engine' of the brain.[7] Freud clearly stated his belief that mind was a material fact in his essential paper from 1895, 'Project for a Scientific Psychology', in which he stated his intention to 'furnish a psychology that shall be a natural science: that is, represent psychical processes as quantitatively determinate states of specifiable material particles, thus making those processes perspicuous and free from contradiction'.[8]

Unlike earlier psychologists, Freud proposed that the human mind is animal at its core – an 'appendage to physiologico-psychical processes . . . in the nervous system'.[9] He further argued, against Descartes, that the absence of consciousness, which he supposed characterized some animal brains, does not in any way change the fact that the human mind is simply one among 'all the other natural processes of which we have obtained knowledge'.[10] This idea that the human mind evolved from the animal brain, derived from Darwin, Lamarck, Haeckel and George John Romanes, among others, was especially germane to Freud's writings on children and child psychology.[11] In works such as *Studies on Hysteria* (1895) and *Totem and Taboo* (1912–13), as well as in his many case studies, he argued that childhood terrors were a form of instinctive knowledge inherited from early man or from other animals that appeared on lower branches of the tree of life.[12]

Freud also embraced the view – developed from Haeckel's principle that ontogeny (the development of the organism) recapitulates phylogeny (the development of the species) – that as a purely animal instinct, the sexual drive emerges early in children's psychological development, while shame, modesty and morality, the more distinctly human emotions, appear at a later time. Freud's studies of childhood sexuality – which constitute the basis of his most fundamental ideas, such as the Oedipus complex – are therefore at the same time studies of animality. And his three chief case studies, of the Rat Man, Little Hans and the Wolf Man, which concern the role of childhood sexual fears in the creation of adult neuroses, accordingly involve animals. The confrontation of human and animal, the recognition of the presence of the animal in the human and the observation of animal suffering thus constitute for Freud, as well as for many artists and writers of his generation, a primal scene and the origin

of what has been called a 'posthumanist perspective'. But however perspicuous Freud was in recognizing the significance of animals in the primary psychic processes, his diagnoses of patient illnesses and interpretations of their stories sometimes failed to escape the close confines of anthropocentrism.

CASE STUDIES

The Rat Man, described in Freud's 'Notes Upon a Case of Obsessional Neurosis' (1909), concerned a young man, now identified as Ernst Lanzer, plagued by obsessional thoughts which usually involved animals, especially rats.[13] The most harrowing of these thoughts arose from a story of torture related to him by one Captain Nemeczec, a man, according to Lanzer, 'obviously fond of cruelty'. In therapy, Freud coaxed the captain's story from his patient by assuring him that he would be able to

> guess the full meaning of any hints he gave me. Was he perhaps thinking of impalement? 'No, not that . . . the criminal was tied up . . .' – he expressed himself so indistinctly that I could not immediately guess in what position ' . . . a pot was turned upside down on his buttocks . . . some *rats* were put into it . . . and they . . .' he had again got up and was showing every sign of horror and resistance ' . . . *bored their way in* . . .'. Into his anus, I helped him out.[14]

The origins of the strange torture have frequently been interrogated and have even become the basis of modern urban legend.[15] But rats and other animals figured in many other less macabre dreams, fantasies and recollections of the Rat Man, and Freud generally associated them with anger at his father combined with guilt over his death, desire for his mother, feelings of attraction and repulsion toward his cousin-fiancée, repeated sexual liaisons with a seamstress, fears of homosexual attachments to his brother and anxiety about excessive masturbation. The Rat Man spoke about seeing rats caught and hurled alive into a boiler. He heard one night a 'fearful caterwauling' and saw a man beating a sack against the ground and then

throwing it into a boiler – it was a cat. He recalled stories his mother told about her stepbrother who, in order to emotionally toughen himself, cut the heads off chickens. She also said that her own mother 'koshered a cat' by putting it in the oven and then skinning it. He dreamed of a 'big fat rat' being given a name and treated like a pet. He also dreamed about rats tossed live in a cooking pot, and related to Freud a presumably true story of some cousins in America fed a meal that contained a rat-tail. Lanzer also repeatedly made elaborate word-play with the German words *Ratten* (rats), *Raten* (instalments) and the Latin *ratum* (rear), associating them with money, faeces and syphilis. He repeatedly told Freud about obtaining offices 'near the cattle market', about his little nephews' fear of dogs (and dogs' habit of sniffing at each other's anuses) and about his own association of rats with sexual intercourse: 'for every copulation with the dressmaker, a rat for my cousin'. On one occasion he saw a large rat near his father's grave – Freud believed it was a weasel – and imagined it must have been eating his father's corpse. He recalled being appalled at finding tapeworms in his own stool when he was a boy, and seeing them as well in the faeces of another boy. And he described what he called 'the greatest fright of his life' when as a boy of five he was given a stuffed bird that had been an ornament on his mother's hat. While playing with it, he thought he saw one of its wings move – it had come to life!

The case of Little Hans was Freud's only published child-analysis and an important demonstration of the theory of child sexuality first stated in the *Three Essays on the Theory of Sexuality* (1905).[16] It was also an object lesson for future analysts of the principle that the repression of childhood sexuality (pre-genital or auto-erotic) can lead directly to a psychic compromise and neurotic symptoms.[17] According to Freud's account, Hans was at first a happy, curious child whose auto-erotic preoccupations were appropriate for his age. At three, he was very interested in his own penis, playing with it, showing it to his mother and his little friends. He took a normal erotic interest in defecation, and displayed curiosity about his parents' genitals, as well as pregnancy and childbirth. But before reaching the age of five, he started to become constipated, shy and most of all terrified of horses – a significant disability given his family's proximity to a warehouse

Giraffe, from Sigmund
Freud, 'Analysis of a
Phobia in a Five-year-old
Boy', 1909.

and coach house and the general ubiquity of horses in the streets
and culture of *fin de siècle* Vienna. Hans's father wrote to Freud: 'He
is afraid a horse will bite him in the street, and this fear seems some-
how connected with his having been frightened by a large penis.'
(The analysis was conducted mostly through the intercession of the
father. Freud rarely interviewed the boy directly.)

However, Hans himself, when asked by his father the reason for
his fear of horses, said he was afraid that when 'furniture horses
are hauling a heavy van they'll fall down . . . I'm most afraid too
when a bus comes along.' 'Why,' his father asked, 'because it is so
big?' 'No,' Hans answered: 'Because once a horse in a bus fell down.'
'What did you think when the horse fell down?' 'Now it'll always be
like this. All horses in buses'll fall down.' (Hans had in fact had seen
a horse break down from pulling a bus overloaded with passengers.
The animals were probably whipped, like the horse illustrated by
Hogarth in the *Second Stage of Cruelty*.[18]) Later, when asked by his
father why he was also afraid of coal-carts, Hans answered: 'because
they're so heavily loaded, and the horses have so much to drag and
might easily fall down. If a cart's empty, I'm not afraid.'[19]

Hans's fears continued to intensify. He told his father about a
new dream he had: 'In the night there was a big giraffe in the room

and a crumpled one: and the big one called out because I took the crumpled one away from it. Then it stopped calling out: and I sat down on top of the crumpled one.' The boy and his father had regularly visited the zoo at Schönbrunn and seen the giraffes. Hans's father actually drew one for him, to which the boy added a long 'widdler'. In another session the boy told his father that he became especially upset when he saw white horses with black marks around their mouths and blinders around their eyes. (Hans's father had a black moustache and wore glasses.) He once shouted to his father, 'Don't trot away from me!'

In the middle of the long case study of Little Hans, Freud confidently wrote: 'We may at once explain that all of these characteristics are derived from the circumstance that the anxiety had originally no reference at all to horses but was transposed on to them secondarily.'[20] He proposed, for example, that the story of the giraffe was a metaphoric representation of the boy seeing his father's penis (the big giraffe) one morning when he joined his parents in bed. (His mother was 'the crumpled one'.) He interpreted horses in general to be the boy's father, fear of them to be fear of castration (punishment for Hans's Oedipal desire for his mother), fear of being bitten by horses to be anxiety about masturbation, and the buses and carts to be his pregnant mother. Hans subsequently recovered from his phobia and presented himself to Freud thirteen years later, averring, however, that when he read the published analysis he directly recalled nothing of its contents.

THE WOLF MAN

The case of the Wolf Man exhibits an equally wide range of animal fears, phobias and preoccupations combined with a significant visual record. The patient was a wealthy young aristocrat from Odessa named Sergius Constantinovich Pankejeff, born in 1886. From the age of nineteen, he spent increasing amounts of time in expensive sanatoria outside Russia in order to treat his depression. (Mental illness affected his whole family. His sister committed suicide in 1906, and his father a year after.) After consulting a physician in Munich, he travelled to Vienna in 1910 to begin four years of intensive therapy

with Freud. Psychoanalysis was briefly resumed with Freud in 1919, and periodically thereafter with other doctors, including Ruth Mack Brunswick in 1926. Freud published his findings in 1914 as part of an effort to uphold his basic theory of the pathogenic, sexual origin of neurotic illness against the apostasies of Alfred Adler in 1911 and Carl Jung a little later.

The case history is long and detailed, and though marked by numerous improbabilities, it is nevertheless a tour de force of psychoanalytic logic and method.[21] The key that unlocks the door leading to an understanding of the Wolf Man's neurosis, according to Freud, is the following dream, experienced at age four, and recalled during adult analysis:

> I dreamt that it was night and that I was lying in bed. (My bed stood with its foot towards the window; in front of the window there was a row of old walnut trees. I know it was winter when I had the dream, and night-time.) Suddenly the window opened of its own accord, and I was terrified to see that some white wolves were sitting on the big walnut tree in front of the window. There were six or seven of them. The wolves were quite white, and looked more like foxes or sheep-dogs, for they had big tails like foxes and they had their ears pricked like dogs when they pay attention to something. In great terror, evidently of being eaten up by the wolves, I screamed and woke up. My nurse hurried to my bed, to see what had happened to me. It took quite a long while before I was convinced that it had only been a dream; I had had such a clear and life-like picture of the window opening and the wolves sitting on the tree. At last I grew quieter, felt as though I had escaped from some danger, and went to sleep again.

In order to clarify his remembrance of the dream, which after all had occurred almost twenty years before, Pankejeff produced a simple line drawing that described its main features. (Later in life, he made a number of paintings of the same subject in order to earn some money from his psychoanalytic celebrity.) There appears a

Sergius Pankejeff, dream drawing by the Wolf Man, c. 1910.

tree with a broad, central trunk tapering as it rises, nine branches, alternating between long and short and extending left and right, and five animals – with their pointy chins and tall ears, they look more like foxes than wolves – sitting on the branches: two at left and three at right. It is not clear why there are only five wolves in the tree when six or seven are described in the dream. The drawing appears to have been made with pen and ink – the original is lost – and consists, somewhat obsessively, of parallel lines: there is no hatching (with the possible exception of the base of the first major branch at lower left) and almost no curves (except for a few meandering lines at the upper left). Where branches bend, they are generally represented by means of overlapping lines.

Freud's initial interpretation of the dream was straightforward enough. Through an extensive set of questions and answers, he was able to determine that 1) the six or seven wolves were associated with tales from the Brothers Grimm – 'Little Red Riding Hood' and 'The Wolf and the Seven Little Goats'; 2) that the large tails of the wolves in the drawing may have been compensation for the docked

tail of the wolf in a story told by the patient's grandfather; and, more significantly, 3) that the wolves were a 'father surrogate' and indicated the young boy's fear of his parent. But Freud then went further. Because the emotional importance of the dream greatly exceeded its manifest content, he reasoned there must have been some profound early triggering event that set in motion the chain of associations that led to the dream and the subsequent efflorescence of neurotic symptoms. Upon further interrogation, he elicited from Pankejeff an additional detail about the dream: that at its beginning 'the window suddenly opened of its own accord'. Freud took this to mean that at some earlier point in his life, his patient had been awakened from his sleep and opened his eyes to see something terrifying. By a further chain of associations – including the immobility of the wolves in the dream (signalling its opposite); the coincidence of Christmas and young Pankejeff's birthday; an early malarial attack; and a daytime nap and his parent's coincident siesta – he proposed that when just one and a half years old, his patient had witnessed his parents having sex '*a tergo*' (doggy-style). Moreover, Freud argued that this 'primal scene' had a pathogenic effect on his patient, creating an unreasonable fear of his father (a castration anxiety), an animal phobia, sadomasochism, homosexuality and generalized anxiety. Revelation of the source and meaning of the dream during psychoanalysis, according to Freud, had the intended effect of reestablishing the proper degree of identification with and rebellion toward his father (the Oedipus complex), and of relieving the man of many of his worst obsessional neuroses.

Near the end of *Totem and Taboo*, Freud provided an explanation for the frequent appearance of animals in the dreams and nightmares of children. Drawing upon theories of animism and totemism found in the writings of E. B. Tyler, W. Robertson Smith and others,[22] he proposed that children have a natural affinity to other creatures because of an innate animism, but that:

Not infrequently a curious disturbance manifests itself in this excellent understanding between child and animal. The child suddenly begins to fear a certain animal species and to protect himself against seeing or touching any individual

of this species. There results the clinical picture of an animal phobia, which is one of the most frequent among the psycho-neurotic diseases of this age and perhaps the earliest form of such an ailment. The phobia is as a rule in regard to animals for which the child has until then shown the liveliest interest and has nothing to do with the individual animal. In cities the choice of animals which can become the object of phobia is not great. They are horses, dogs, cats, more seldom birds, and strikingly often very small animals like bugs and butter-flies. Sometimes animals which are known to the child only from picture books and fairy stories become objects of the senseless and inordinate anxiety which is manifested with these phobias; it is seldom possible to learn the manner in which such an unusual choice of anxiety has been brought about . . . It cannot therefore be asserted that the general meaning of these illnesses is known, and I myself do not think that it would turn out to be the same in all cases. But a number of such phobias directed against larger animals have proved accessible to analysis and have thus betrayed their secret to the investigator. In every case it was the same: the fear at bottom was of the father, if the children examined were boys, and was merely displaced upon the animal.[23]

Freud's confidence about the basic etiology of animal phobias – fear of the father – would appear to be born out by his case stud-ies.[24] But in each instance, an alternative point of origin, consistent with Freud's own conception of animism, is equally plausible: that is, empathy, the 'animal connection' or, more particularly, the 'cry of nature'.

As a child and young person, the Rat Man witnessed and later described the frequent capture and killing of rats and the brutal killing of cats. As a small child, he was also given a dead bird to play with – a hat ornament – and had the uncanny experience of seeing it come to life ('the greatest fright of my life').[25] He was reacting to the then current fashion across Europe of adorning women's hats and dresses with the wings and bodies of dead birds, a practice deplored in Britain by the Society for the Protection of Birds (founded 1889)

G. F. Watts, *A Dedication*, 1898, oil on canvas.

Gustave Doré's illustration for 'The Sheep and the Wolves', from *The Fables of La Fontaine* (1885).

and by the Victorian painter G. F. Watts in his *A Dedication* – '*To those who love the beautiful and mourn over the senseless and cruel destruction of bird life and beauty* (1898). Almost twenty years before, Watts had already decried the cruelty of the practice – as well as its uncanny aesthetic results – when he wrote:

> A whole creation of loveliness is in danger of being swept
> from off the face of the earth, for the object of sticking
> stuffed specimens about wearing apparel, where they

are, notwithstanding their supreme beauty, wholly in bad taste, the extreme improbability of the real creatures' presence in such places making the effect more grotesque than charming.[26]

The Rat Man experienced that grotesquerie.

Little Hans witnessed the breakdown and death – right before his eyes – of a horse used to pull an omnibus. He repeatedly protested that it was not horses per se that frightened him, nor even horses pulling carts, but horses hauling heavy loads – coal, barrels of beer or people – and the prospect of their falling down, as well as the sound of their hooves on the cobbled road. Hans also made regular visits with his father to the zoo at Schönbrunn, where he undoubtedly saw whips used to control many of the animals, including elephants and giraffes.

The case of the Wolf Man presented a large number of potentially traumatic and transforming life-experiences concerning horses, butterflies, caterpillars, goats, pigs, dogs, sheep and wolves. In Freud's analysis – and in Pankejeff's autobiography – it emerged that the child was witness to a catastrophe in which 200,000 sheep on his family's estate near Kherson in southern Ukraine died as the result of tainted vaccine. This must have been an event of historic proportions. It would have occasioned family discussion about the sheep – some 750,000 – owned by the nearby family of Baron Friedrich Eduardovich von Falz-Fein. The baron had the largest herds in the region, and employed many of the unique, white, Ukrainian Ovharka sheepdogs to protect them against wolves. Thus stories and images of sheep, dogs, wolves and wolf-hunts would have been a major part of the Wolf Man's childhood.[27] He probably knew Gustave Doré's illustration for *The Sheep and the Wolves* from the fables of La Fontaine. Its wolves are strikingly like those in the Wolf Man's dream, even revealing a linear style (non-cross-hatched) similar to that used in the dream drawing.[28] As a boy, Pankejeff may also have visited the vast Askania-Nova wildlife sanctuary established in 1898 by the Falz-Feins, or seen its zoo.[29] As a university student in St Petersberg, and then in Munich and Berlin from 1908 to 1910 – long after his famous dream but before his session

with Freud and his dream-drawing – he had many opportunities to visit zoos and natural history museums and see animals: alive and dead, fierce and gentle, tame, wild and taxidermied.

Judging by his memoir and his analytic sessions, the Wolf Man – who until his death in 1979 embraced his peculiar moniker, despite it being the name of a famous movie character played by Lon Chaney Jr – was preoccupied and haunted by non-human animals, their sufferings and outcries, and a sense of the shared animality of human and non-human species. His own outcry upon seeing the wolves in the tree outside his window was a Rousseauian cry of nature: 'The wolves were quite white, and looked more like foxes or sheepdogs, for they had big tails like foxes and they had their ears pricked up like dogs when they pay attention to something. In great terror, evidently of being eaten by wolves, I screamed and woke up.' Indeed, the very silence of the scene may have prompted by opposition the experience of the cry of nature. In a late essay, the contemporary philosopher Jacques Derrida discussed the fabled silence of the wolf – suggested by the French expression *à pas de loup* (to move silently or with great stealth) – as the sign of sovereign authority or violence.[30] The Wolf Man's terror, then, whether arising from the sight of frightened, suffering or dying sheep, the dread of castration or fright in the face of the sovereign (king or father), was an animal fear. In his *New Introductory Lectures on Psychoanalysis* of 1933, Freud returned to his early materialism in order to highlight the important role of the superego in harnessing aggression. He, however, noted that the ego does not gladly yield the violence it 'would have been glad to employ against others. It is like a prolongation in the mental sphere of the dilemma of "eat or be eaten" that dominates the organic animate world. Luckily, the aggressive instincts are never alone but always alloyed with the erotic ones.'[31]

Acceptance of the animality of humans – physical and emotional – and the humanity of animals are preconditions for the making of animal rights, and were fundamental expressions of the age of Darwin and Freud. They were subsequently embraced and elaborated by a number of modern artists, and constituted the afterlife of the eighteenth-century cry of nature and the basis of a posthumanist perspective.

The Horse in *Guernica*

A few years after the publication of Freud's *New Introductory Lectures*, Pablo Picasso represented in the centre of the composition of *Guernica* a twisted, tortured horse, and to the left of it a large bull, its naturalistic body and Cubist head pivoted in a direction opposite to that of the horse. The mural-sized *Guernica* was not intended to represent the seen world but to invoke instead the fear, destruction and death visited by the Nazi Luftwaffe upon the defenceless Basque town of Guernica in 1937. The implied point of view, however, is not that of the artist or spectator, but the animals. Though the bull may be both Picasso's alter ego and an allegory of Spain – see, for example, his *Minotauromachia* from 1935 and the *Dream and Lie of Franco* two years after – the mode of vision is primarily animal, not human. The scene is told from the horse's perspective.

From its inception, Cubism was a non-naturalistic, non-narrative style that employed colliding planes, multiple perspectives and distorted or exaggerated anatomies in order to challenge the oppressive logic of cold reason. Though Picasso at times employed other styles – most notably a flattened and relaxed Neoclassicism reprising Ingres – he never used it in his most ambitious pictures. In *Guernica*, Picasso deployed Cubism with a vengeance, using flat silhouettes and cut-outs, fractured and faceted forms and shapes, and a non-linear (or simultaneous) mode of temporality: events do not unfold, they happen all at once, and the story of the destruction of the town and its human and animal inhabitants is not told in a narrative but in a blinding flash. Simulating the perceptual cognition of animals, Picasso dispenses with syntax. The story of Guernica is not told in the sentence: 'Danger and death are reigning down from the skies! We must flee our homes or be killed by German bombs.' It is instead expressed by means of the asyntactic expression of terrified animals: danger-flee-noise-pain-cry. It is the untranslated cry of nature, a rhetoric used by humans as well as animals *in extremis*: during wartime and in the throes of passion.

Picasso's *Guernica* thus rejects the pathos formula of the welcome or easeful animal death as shown so often in Greco-Roman antiquity, or in French and other European artworks made from the

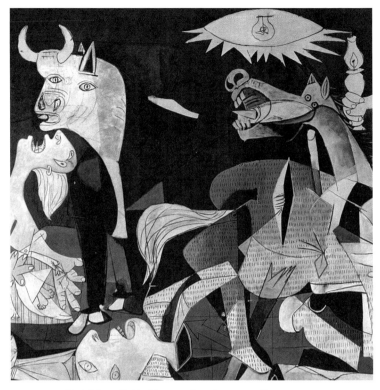

Detail from Pablo Picasso, *Guernica*, 1937, oil on canvas.

mid-eighteenth to mid-twentieth centuries, from Chardin to Monet. Picasso's horse has not been tricked and led gently to his slaughter, as are the cattle led to sacrifice on the Pan-Athenaic frieze from the Parthenon, but instead screams in terror and pain – the same pain felt by the similarly open-mouthed, wailing women at left and right. Here Darwin's observation about the evolutionary continuity between humans and animals and the universality of outcry when they 'suffer from an agony of pain' is abundantly clear. We see in *Guernica* no enemy and no authority (god, king or judge) who might make claims for the justice of the event; there are only human and animal victims, releasing the same outcry.

CHAIM SOUTINE AND ISAAC BASHEVIS SINGER

In Chaim Soutine's painting *Carcass of Beef* (c. 1925), the application of thick washes of blood-red paint beside viscous smears of white, ultramarine and blue-green creates a vivid, dissonant and relatively flat and abstract composition. Clement Greenberg, the great theorist of modernism, discovered in Soutine a brilliant colourist, but also an artist who was unable to free himself from the scaffolding of an Old Master tradition reliant on tonal modelling and theatrical chiaroscuro, a tradition represented, as we have seen, by Rembrandt's *The Ox*, in the Louvre, which Soutine knew well. Reviewing a 1951 MOMA retrospective, Greenberg wrote that Soutine 'was one of the most painterly painters there ever were . . . one of those who succeeded best in converting the substance of pigment into signified emotion'.[32] He added: 'The paint matter is kneaded and mauled, thinned, thickened and rubbed in order to render it altogether chromatic, retinal.' But then Greenberg offered this demurral: Soutine often 'tried to overpower his medium . . . the distortions are too exclusively and too immediately dictated by feeling and, in evading plastic controls, destroy unity.' This failing, according to the critic, became particularly evident in the artist's middle period, after his first brush with success in 1923. '*Carcass of Beef* of 1925', Greenberg wrote, 'has a complete and unusual unity, but suffers I feel, from an overripe translucency of surface, due to glazing that makes it a bit too picturesque.'[33] The language in these passages is telling: 'mauled', 'rubbed', 'rendered' and 'overripe' are terms associated with meat and fat, and the critic was clearly offended by the visceral character of the paintings, and possibly too by what he took to be their Jewishness – twice in the short essay he made substantive reference to Soutine's Judaism. For Greenberg (himself Jewish), the questions of meat, animality, *kashrut* (dietary laws) and identity were awkward and unavoidable, and all violated what he took to be the artist's chief mandate: to excise the quotidian, the anecdotal, the narrative and the allegorical from the practice of modern art.

Indeed, the colours and expressive handling in *Carcass of Beef* suggest the flayed animal's torment and death; its hind limbs are

Chaim Soutine, *Carcass of Beef*, 1925, oil on canvas.

Chaim Soutine, *Two Pheasants*, 1924–5, oil on canvas.

chained to the wall, and its forelimbs end in knuckles that look like fists clenched in pain. This is the visual expression once again of 'the cry of nature', in Rousseau's words: 'man's first language . . . elicited only by a kind of instinct in pressing circumstances to beg for help in great dangers, or for relief of violent ills'. It is also the exclamation of someone who is witness to cruelty and bloodshed, as was Soutine. He wrote:

> Once I saw the village butcher slice the neck of a bird and drain the blood out of it. I wanted to cry out, but [the butcher's] joyful expression caught the sound in my throat. This cry, I always feel it there. When, as a child, I drew a crude portrait of my professor, I tried to rid myself of this cry, but in vain. When I painted the beef carcass it was still this cry that I wanted to liberate.[34]

In representing this cry – shared by human and animal alike, as Darwin first proposed, in times of anguish or pain, or at the moment of our deaths – Soutine was reaching back to his pre-modern remem-

brance, to the time before he moved to Paris, and before his period at the Vilnius Academy of Fine Arts. Soutine's primal scene of domesticated violence occurred in the *shtetl* (town) of Smilovitz (near Minsk), where he was born and lived until the age of seventeen.[35] The same gruesome spectacle, or worse, also affected the modern Yiddish writer Isaac Bashevis Singer, who made a parallel pilgrimage – as much chronological as geographical – from *shtetl* to metropolis, in this case to Manhattan's Upper West Side. As a teenager, Singer witnessed animals brought by peasants from the countryside to the small village of Bilgoray (near Lublin, Poland), and watched as the kosher slaughterer (*shochtet*) did his work. The writer drew upon that remembrance in his first novel, *Satan in Goray*, published in 1935, in which the ritual butcher Reb Gedaliya undertakes a massive public orgy of killing in anticipation of what he believes will be the long-dreamed-of final redemption of mankind: 'Slaughtering innumerable calves and sheep, hens, geese, and ducks . . . Wings fluttered and beat, blood spurted, smearing faces and dresses.' Like the butcher recalled by Soutine, Reb Gedaliya smiled and joked, 'for he hated sadness, and his way of serving God was through joy'. Soutine's depiction of a brace of pheasants (1924–5) purchased from a market in Paris – grotesquely flattened, possibly decomposing – could not be further from that of Monet.

In Bilgoray, as elsewhere in the Jewish Pale of Settlement, the *shochet* killed an animal and drained its blood in a manner precisely prescribed by the rules of *kashrut* and *shechita* (the ritual of animal slaughter): the animal had to be healthy and fully conscious when its throat was cut, and could not first be stunned by a blow to the head. The knife, known as a *chalaf*, had to be free of any defects and be perfectly sharp, and there could be no 'pressing' (pushing the knife into the throat instead of slicing), 'pausing', 'tearing', 'piercing' or 'covering' (losing sight of the incision). In addition, no animal could be killed within sight of another, nor any animal killed on the same day as its offspring. *Shechita* also requires that blood be quickly drained from the carcass and leave little residue. Marc Chagall, whose grandfather was a *shochet*, showed the death to be so quick that his *Flayed Ox* (1947) had time to lap up its own blood. (Of course, by consuming its own blood, it became no longer kosher!)

The killing of animals according to the rules of *shechita* was controversial during the youth of Chagall, Soutine and Singer. (Singer, born in 1902, was nine years Soutine's junior, and fifteen years Chagall's.) Gentiles claimed it was unnecessarily cruel as well as inefficient, and in 1892, the Russian Society for the Prevention of Cruelty to Animals in St Petersburg commissioned a study of the practice. Their decision that it was indeed cruel and should be outlawed was a forgone conclusion: anti-*shechita* bans had already been passed in Switzerland, Germany and Scandanavia.[36] But in 1894 the judgement was contested by J. A. (Isaac) Dembo, a German-Jewish doctor from the Alexander Hospital in St Petersburg, who claimed that it was anti-Semitic prejudice, not concern for animal welfare, that led to the findings. He published his research into the question that year in a book titled *The Jewish Method of Slaughter Compared with Other Methods from the Humanitarian, Hygienic and Economic Points of View.*[37] After examining the butchering of more than 400 animals in several countries, Dembo concluded that the practice of *shechita* was in fact much less painful than clubbing or stunning animals before hanging them upside down and cutting their throats. The cut from a razor-sharp blade, he said, is almost painless, and the severing of the carotid artery leads to unconsciousness and death within three and five seconds. The alternative methods, on the other hand, often leave an animal stunned but not unconscious, and butchering sometimes begins while the animal is still alive and even alert. In any event, *shechita* remained legal in the Pale of Settlement until Soviet days. Today it is controversial among animal rights activists, though the practice has recently been upheld by the European Union.

The precise historical origin of *shechita* remains obscure, and the passages concerning it in Deuteronomy (12:21) are perfunctory. It was for centuries part of Jewish oral tradition – the so-called Oral Torah – and was only first written down in the Mishna in the third century CE, and later in the Talmud. But the practices it describes must have originated, along with the other rules of *kashrut* (described in Leviticus), among the nomadic ancient Hebrews and expressed their distinctive definitions of 'purity and danger', as the anthropologist Mary Douglas famously argued.[38] Whatever its exact basis

and symbolism, however, *shechita* is clearly a pre-modern practice, representing a pastoralist understanding of how herds must be protected, managed and culled, and how animals possess, to cite Ingold, 'powers of sentience and autonomous action'. The Talmud contains explicit prohibitions of animal cruelty ('*tza'ar ba'alei chayim*') and the Torah commands that animals as well as men rest on the Sabbath.[39] It also prohibits the slaughter of a cow on the same day as its calf, a welcome but somewhat mysterious rule – incorporated as we have seen into *shechita* – explained by the twelfth-century Torah scholar Moses Maimonides as an effort to prevent a mother from seeing her own offspring killed: 'For in these cases animals feel very great pain, there being no difference regarding this pain between man and the other animals.'[40] Notwithstanding the practices of many current, industrial kosher slaughterhouses, *shechita* therefore represents a very different understanding of animal welfare from the modern, agricultural and capitalist one, which treats animals as inert units of production.

In Singer's, Chagall's and Soutine's *shtetls*, where the pre-modern logic of the peasant or pastoralist still largely prevailed, mass slaughter or wanton cruelty naturally aroused anguish and revulsion, a collective 'cry of nature'. To kill large numbers of animals at once, 'smearing faces and dresses' with blood, as Singer wrote, was clearly against the laws of *kashrut*. It was instead a form of modern, capitalist and Gentile killing – of utmost cruelty and a religious abomination – and it led Singer to a life of vegetarianism. In a short story titled 'The Letter Writer', penned two decades after *Satan in Goray*, Singer's narrator and protagonist Herman Gombiner discovers that he is sharing his small New York apartment with a mouse. He names the mouse Huldah and begins to provide it with food and water. After suffering a serious illness, Gombiner realizes he has neglected to feed Huldah and fears she is dead:

> In his thoughts, Herman spoke a eulogy for the mouse who had shared a portion of her life with him and who, because of him, had left this earth. 'What do they know – all those scholars, all those philosophers, all the leaders of the world – about such as you? They have convinced

themselves that man, the worst transgressor of all the species, is the crown of creation. All the other creatures were created merely to provide him with food, pelts, to be tormented, exterminated. In relation to them, all people are Nazis; for animals it is an eternal Treblinka. And yet man demands compassion from heaven.[41]

For Singer, the moral and intellectual passage from shtetl to Nazi death camp to the everyday treatment of animals was almost inevitable. The shadow of Treblinka was long and could not easily be evaded.

Soutine too was revolted by what he saw at the ritual slaughter-house in Smilovitz – or at least his retrospective memory of it – and he too carried the vision everywhere he went. The beef carcasses he painted were ostentatiously non-kosher and therefore signal the cruelty and violence associated with treyf (non-kosher food), as well, perhaps, as the anti-Semitism of the opponents of shechita.[42] They are shown smeared with dried and clotted blood in blatant violation of kashrut, and legend has it that Soutine regularly carted buckets of blood up to his studio to pour on the slab of meat to keep it looking fresh. This was what modernity looked like for Soutine: the collision between the old Talmudic prohibition of cruelty to animals and modern indifference to pain and suffering. Soutine summarized his premises when he said: 'In the body of a woman Courbet was able to express the atmosphere of Paris; I want to show Paris in the body of an ox.' The remark is indebted to Baudelaire's famous conclusion to his essay 'The Heroism of Modern Life', where he spoke of the modern nude found in the bed, the bath and the dissecting table – and is just as bitterly ironic.

Soutine's many canvasses of dead animals, no less than the novels and tales of Singer, are dialectical reflections upon the rationalized regimes of slaughter that became predominant in Europe and North America in the twentieth century, and an old order – still vivid in popular consciousness – that animals are sentient beings with vivid perceptions and emotions. They are also works that directly confront the domination of nature that emerged in the course of Enlightenment and modernization, and propose a posthumanist future.

ADORNO, BENJAMIN, KAFKA AND SARTRE

In addition to human and animal casualties, the Second World War and the Holocaust produced unprecedented intellectual, moral and artistic ones: it seemed that the civilization, progress and classicism of the European Enlightenment lay in ruins like the bombed cities of Dresden, Coventry and Rotterdam. The inevitable Shakespearian question was asked: 'Is this the promised end?' Were the seeds of the catastrophe – a war and holocaust that killed 70 million people and hundreds of millions of animals – planted in the remote past? Was the recent barbarism always there, incipient, and the population of politicians, philosophers and artists too blind or complicit to pay heed? The German philosophers and critics Theodor Adorno and Max Horkheimer, writing in exile in Los Angeles in 1944, put the matter in the following terms in the introduction to their book *Dialectic of Enlightenment*:

> The dilemma that faced us in our work proved to be the first phenomenon for investigation: the self-destruction of Enlightenment. We are wholly convinced . . . that social freedom is inseparable from enlightened thought. Nevertheless, we believe that we have just as clearly recognized that the notion of this very way of thinking, no less than its actual historic forms – the social institutions – with which it is interwoven, already contained the seed of the reversal universally apparent today. If enlightenment does not accommodate reflection on this recidivist element, then it seals its own fate . . . In the enigmatic readiness of the technologically educated masses to fall under the sway of any despotism, in its self-destructive affinity to popular paranoia, and in all un-comprehended absurdity, the weakness of the modern theoretical faculty is apparent.[43]

In their book, Horkheimer and Adorno proceeded to interrogate the unreason of European reason and the barbarism of civilization and to trace its long history from Homer to Hollywood. What had occurred in Europe and the world with the rise of fascism was so

monumental, so criminal and so complete that the past itself had now to be remade if an alternative future was to be possible. Historic atrocities could no longer be covered up, or, worse, made to seem rational and even beautiful. The pathos formula I have described, of humans and animals represented as striving toward their own annihilation, would need to be decisively refused. The authoritarianism of former times would have to be exposed, and the chain of unreason and brutality recognized and described. Humanism, the general belief that people – not gods, animals or nature – constituted the core and measure of all existence, would be unmasked as a version of barbarism.

In the dolorous historical circumstances of the war years and afterwards, the destruction of animals was understood by Adorno and Horkheimer to be both criminal in itself and the expression of a still wider form of violence: the domination and control of physical and human nature. They described the oppression of animals in an extended 'Notes and Drafts' section of *Dialectic of Enlightenment*: 'The idea of man in European history', they wrote,

> is expressed in the way in which he is distinguished from the animal. Animal irrationality is adduced as proof of human dignity. This contrast has been reiterated with such persistence and unanimity by all the predecessors of bourgeois thought – by the ancient Jews, Stoics, Fathers of the Church and then throughout the Middle Ages down to modern times – that few ideas have taken such a hold on Western anthropology. The antithesis is still accepted today. The behaviorists only appear to have forgotten it. The fact that they apply to humans the same formulas and findings that without restraint, they force from defenseless animals in their nauseating physiological laboratories stress the contrast quite adroitly.[44]

In other words, the ideology of human dominion over animals devised in distant antiquity survives almost unchanged today except where it is challenged by still more oppressive beliefs and practices, such as those of the behaviourist psychologists who treat

humans as well as animals as mere things to be probed, tested and even tortured.

Adorno and Horkheimer then continued their assault on humanism with ironies like those found in the writings of I. B. Singer:

> The whole earth bears witness to the glory of man. Unreasoning creatures have encountered reason throughout the ages – in war and peace, in arena and slaughterhouse, from the lingering death-throes of the mammoth overpowered by a primitive tribe in the first planned assault down to the unrelenting exploitation of the animal kingdom in our own days. This visible process conceals the invisible from the executioners – existence denied the light of reason, animal existence itself.

Throughout history, animals have been exploited and destroyed by a violence masked by reason, from the Neolithic hunt to animal domestication (the world-historical defeat of animal rights), modern vivisection, stockyards, abattoirs, blood sports and battlefield massacres of horses and men. Beyond the deaths of animals themselves, these acts of violence mask from people the injuries they do to their own animal natures, the understanding of which would constitute true reason and genuine liberation. Violence against animals is thus people's war against themselves. 'That should be the true theme of psychology since only the animals's life is governed by mental impulses.' What is meant here is that psychology or psychoanalysis are only called into play when basic (animal) desires are repressed, and neurotic or psychotic symptoms appear. For that reason, Adorno and Horkheimer implicitly argue, psychology should be a branch of animal liberation!

The critic and philosopher Walter Benjamin, writing a decade earlier, shared his friend Adorno's belief that Western humanism and the rejection of animal reason – rooted in antiquity but exemplified by Kant, the pre-eminent Enlightenment philosopher – constituted a vicious rejection of 'non-identity'. (More recently, the philosophers Emmanuel Levinas and Jacques Derrida and the literary critic Edward Said instead employed the term 'the Other' to describe those who

stand outside political, social, religious, class, moral and other norms.)
For this reason, Benjamin and Adorno especially embraced the Czech
author Franz Kafka, whose animals often manifest a more supple
reason than his humans and who capably reflect upon their outsider
status. 'The reader follows these animal tales a fair distance', Benjamin
wrote in 1931, 'without even noticing that they do not deal with
human beings at all. Then when the animal is identified for the first
time – as a mouse or a mole – you are suddenly jolted and realize
how far you have drifted away from the continent of human beings.'[45]
A few years later, Benjamin wrote: 'This much is certain – of all Kafka's
creatures, the animals have the greatest opportunity for reflection.'[46]
They remind us of the fact that 'the most forgotten source of strange-
ness is our body – one's own body.'

In Kafka's 'A Report to an Academy', the speaker tells his audi-
ence 'of the life that I formerly led as an ape'.[47] He lives on the bound-
ary between animal and human, but is only able to recall the former
state with the help of those who captured him on the Gold Coast of
Africa and transported him to Europe. He purchased his liberation
from confinement – different from true freedom – at the price of
his animality. 'No one promised me that if I became like them the bars
of my cage would be taken away. Such promises for apparently
impossible contingencies are not given.' But gradually he adopted
the habits of his captors – spitting, smoking, drinking and finally
talking – and gained their acquiescence to his emancipation.
Subsequently faced with the choice of the zoo or the vaudeville stage,
he chose the latter without hesitation:

> And so I learned things, gentlemen. Ah, one learns when
> one has to; one learns when one needs a way out; one learns
> at all costs. One stands over oneself with a whip; one flays
> oneself at the slightest opposition. My ape nature fled out
> of me.

In his 'Notes on Kafka' (1953), Adorno recognized that Kafka's
animals are first of all really animals, and that his humans are ani-
mals too. The obvious example is *Metamorphosis*:

> As Gregor Samsa awoke one morning from uneasy dreams, he found himself transformed in his bed into a giant insect. He was lying on his hard, as it were armor-plated back and when he lifted his head a little, he could see his dome-like brown belly divided into stiff arched segments on top of which the bed quilt could hardly keep in position and was about to slide off completely. His numerous legs, which were pitifully thin compared to the rest of his bulk, waved helplessly before his eyes.[48]

In this famous passage, the animality of a human body is made clear, and the transformation of one to the other is both literal and metaphoric. 'Each sentence says "interpret me" and none will permit it', writes Adorno. Here the rule is 'take everything literally; cover up nothing with concepts invoked from above'.[49] Only by fully embracing the animal, argues Adorno – the domain of the irrational and the repressed – can people recover their own species being, their essential humanness. Only by rejecting the antagonism human/animal, and the opposition of human to nature (both internal and external), can an autonomous self be liberated and affirmed.[50]

Similar sentiments motivated the post-war French philosopher Jean-Paul Sartre and the Swiss-born sculptor Alberto Giacometti. In Sartre's introduction to a 1948 exhibition catalogue of works by the sculptor, he described the undermining of humanist reason as it had been formerly understood by artists, and the creation of sculpture *ex nihilo*: 'For three thousand years, sculpture modeled only corpses', Sartre wrote, whether lying on tombs, seated on thrones or perched atop horses. But now, the actuality of that has become apparent and the task of Giacometti and other sculptors 'is not to enrich the galleries with new works, but to prove that sculpture itself is possible'.[51] He does this, Sartre reveals, by showing human beings and animals, such as his *Dog* (1951), from a distance – no matter how close one may actually stand to his bronzes or plasters. This effect of distance is achieved by placing small sculptures on large pedestals, by rendering facial or bodily features and anatomy in approximation, and by exaggerating the

lengths of arms, legs and necks, as if the figures were seen from extremely oblique angles, or from a worm's-eye view, making them both remote and insectivorous. The bodies might almost be exoskeletons, like the body of Gregor Samsa. (The sculptor's *Woman with her Throat Cut* of 1932 in fact closely resembles an insect on its back.) These figures are at once, Sartre says, 'the fleshless martyrs of Buchenwald' and 'made of the same rarified matter as the glorious bodies that were promised us'. What Sartre apparently means by this contradictory description is that Giacometti's sculptures require us to rethink the human, history and our relation to other animals.

In Sartre's most famous explanation of his philosophy, 'Existentialism is a Humanism' (1946), he rejects the Renaissance version of humanism – man as the measure of all things – as 'absurd, for only the dog or the horse would be in a position to pronounce a general judgment upon man and declare that he is magnificent, which they have never been such fools as to do – at least, not as far as I know'.[52] In fact, for people to be so self-admiring would be to establish a cult of the human that 'ends . . . in fascism'. Thus Sartre, in addition to Adorno, provided a basis for posthumanism: the broad set of beliefs and practices – in the domains of intellectual and legal history, artificial intelligence, reproductive technologies, ethology, art, medical ethics and moral philosophy – that share the basic idea that previous understandings of the human body as both exalted (uniquely endowed by God with reason) and circumscribed (distinct from all other organisms) are mistaken or outmoded. Instead, posthumanists argue that the boundaries between human and animal, human and machine, human and nature, and culture and biology are fluid and contested. An additional implication of a posthuman perspective is the view – anticipated by animists and pastoralists, as well as by critical thinkers and artists from Porphyry to Montaigne, and from Géricault to Picasso – that animals possess by nature and by right a selfhood or autonomy that demands recognition and respect.

In his embrace of human choice, Sartre ultimately retreated from some of the more radical, posthumanist implications of his own ideas. His purpose was ultimately redemptive: it was to restore humanism, rather than entirely discard it.

[Existentialism] is humanism, because we remind man that there is no legislator but himself; that he himself, thus abandoned, must decide for himself; also because we show that it is not by turning back upon himself, but always by seeking, beyond himself, an aim which is one of liberation or of some particular realization, that man can realize himself as truly human.

Though proposing that people extend their reach beyond their own grasp, Sartre nevertheless upheld the divide between human and non-human animals.

FRANCIS BACON, GEORGE ORWELL AND JOSEPH BEUYS

The English artist Francis Bacon, whose work was regularly compared to Giacometti's (and with whom the sculptor maintained a friendship in the 1940s), was motivated by few such humanistic illusions or ideals. Though he sometimes spoke like an existentialist – 'we give this purposeless existence a meaning by our drives' – he was instead engaged in a project to discover and articulate the basis of human unreason, and perhaps to erase the antithesis between human and animal identified by Adorno.[53] His *Crucifixion* (1933), *Three Studies for Figures at the Base of a Crucifixion* (1944) and *Three Studies for a Crucifixion* (1962) – the right-hand panel of the latter consists of a side of beef (or a side of human) – are simply efforts, as he told David Sylvester in 1962, to expose 'an act of man's behaviour, a way of behaviour to another'.[54]

Bacon also said to Sylvester of his paintings of the Crucifixion:

I've always been very moved by pictures about slaughter-houses and meat, and to me they belong very much to the whole thing of the Crucifixion. There've been extraordinary photographs which have been done of animals just being taken up before they were slaughtered; and their smell of death. We don't know of course, but it appears by these photographs that they're so aware of what is going to happen to them, they do everything to attempt to escape.

I think these pictures were very much based on that kind of thing, which to me is very, very near this whole thing of the Crucifixion.

Some of the photographs Bacon had in mind were likely those of La Villette taken by Eli Lotar in 1929 and commissioned by the novelist and critic Georges Bataille for the Surrealist journal *Documents*. They depict the killings, carcasses and effluvia of the Paris abattoir, most famously an array of legs and hooves neatly lined up against a wall.[55] For Bataille the photographs signalled that slaughter had been divorced from ancient sacrifice, segregated from daily life and made into an insipid routine. But whereas for Soutine and others that latter fact indicted that a terrible crime was being committed unseen, for Bataille it indicated the self-imposed exile of the bourgeoisie to 'a flabby world in which nothing fearful remains and in which, subject to the ineradicable obsession of shame, they are reduced to eating cheese'. The abattoir, in other words, is horrible not because of the violence it enacts against numberless animals but because it denies humans the satisfaction of their essential, sanguinary desires.

After 1945, Bacon would examine and collect photographs of scenes at least as 'fearful' as the abattoirs revealed by Lotar. For the painter, at least, these images of Nazi leaders and concentration camp victims would have a profound impact, though one he sometimes strained to deny. He proposed that humans and animals were subject to the same cruelty and that the agony of the one was no more historic or eventful than that of the other. *Painting* (1946) depicts a grotesque male figure with half-open mouth standing in a kind of cage or space-frame, like the defendants' dock at the Nuremberg war crimes trials that began in November 1945. The top of his head is obscured by the gloom of an umbrella, and above that is the carcass of an animal suspended beneath some flowered garlands. On the encircling railing below are additional, smaller hunks of meat, with the ribs and spine prominent in the slab shown at right. Bacon described the picture as 'like a butcher's shop', but told David Sylvester – improbably – that the image came about 'as an accident' after he had been working on a painting of 'a bird alighting on a field'.[56]

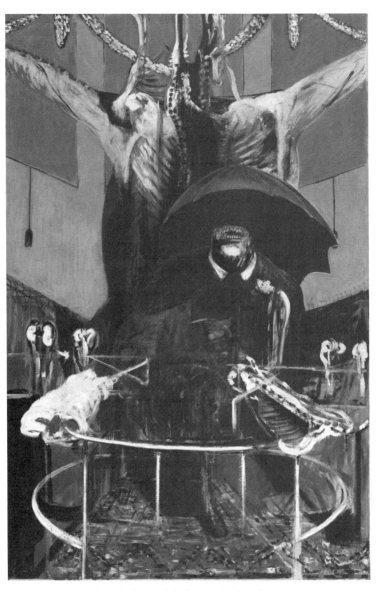

Francis Bacon, *Painting*, 1946, oil on linen.

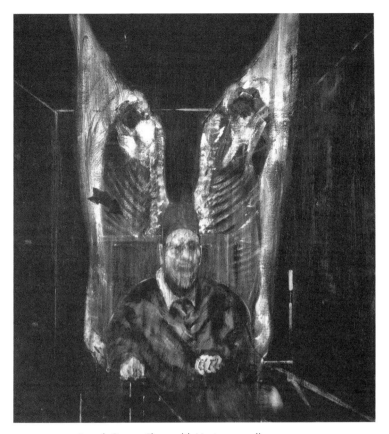

Francis Bacon, *Figure with Meat*, 1954, oil on canvas.

Figure with Meat (1954) represents a seated man – evidently Pope Innocent X as painted by Velázquez in 1650 – sitting on a chair or throne between two slabs of beef. He is in a dark room described by white lines forming a cube. (The dark background was painted last, giving the figure, and especially the meat, a pronounced three-dimensionality.) The gap between the two sides of beef frames the head of the man and the plane of the back of the chair is co-extensive with the meat. Near the top of the two slabs of meat – that is, the inner thighs of the animal, near the anus – is a thick, clotted knob of red paint, like blood, recalling the work of Soutine. The hands of the figure end in a knot created by thick smears of paint, again suggestive of Soutine, while also recalling the clenched fists of Hogarth's Tom Rakewell in the last, Bedlam scene from *A Rake's Progress* (1733). The

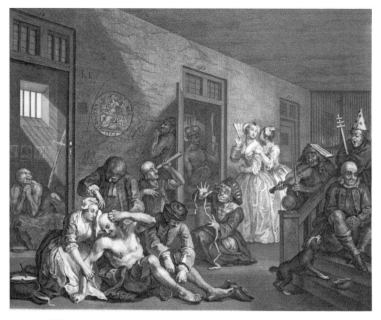

William Hogarth, plate 8 from *A Rake's Progress*, 1733, engraving.

face of Bacon's monstrous man, with teeth bared and a rictus grin, is construed by dragging downward a dry brush through wet oil paint. It is a smear as much as it is a face.

Humanity, Bacon stated, is 'nothing but meat', and *Figure with Meat* among many other works is explicit on this point.[57] But it argues equally clearly that animals also are nothing more than meat; apart from the stray dog who wanders through from time to time, meat is the form in which animals appear in Bacon's canvases. 'If I go into a butcher's shop', Bacon told David Sylvester, 'I always think it is surprising that I wasn't there instead of the animal.'[58] Bacon is not in the least horrified by the cruel treatment of animals, merely surprised that people are not treated in the same way. Thus if the pernicious 'antithesis' described by Adorno is here denied, it is not because the artist has any faith that humans can at last attain a true self-understanding of their animal being. Nor is it because he believes that animals possess or might recover their own autonomy. It is because he thinks that freedom and bodily pleasure are ultimately impossible for both. Even protest is impossible in Bacon's world. For him, the cry of nature – and the scream is perhaps the

most important motif in his work – is always a strangled expression. It offers no hope of rescue or redemption; it is not even an expression of protest. After telling Sylvester that his paintings of 'the human cry' were indebted to the Odessa steps scene from the Soviet director Sergei Eisenstein's film *Battleship Potemkin* (1925) and Nicolas Poussin's *Massacre of the Innocents* in the museum at Chantilly, he added that he was inspired as well by a French book concerning diseases of the mouth.

> You could say that a scream is a horrific image; in fact, I wanted to paint the scream more than the horror. I think, if I had really thought about what causes someone to scream, it would have made the scream that I tried to paint more successful because I should in a sense have been more conscious of the horror that produced the scream . . . I like, you may say, the glitter and colour that comes from the mouth, and I've always hoped in a sense to be able to paint the mouth like Monet painted a sunset.[59]

Bacon's paintings of humans are also paintings of animals, and their outcries are soundless, unheard, and without protest. For Bacon, human and animal alike are without sentience, and neither is due any particular pity or compassion. When asked by Sylvester if he was much bothered by 'the kinds of suffering . . . endured by some people as a result of social injustice', Bacon answered:

> It's quite possible that people could be helped in extremely poor countries . . . But I'm not upset by the fact that people do suffer, because I think the suffering of people and the differences between people are what have made great art, not egalitarianism.[60]

Bacon had much in common with his contemporary George Orwell. Though the latter, unlike Bacon, had a lifelong commitment to social justice, both men distrusted grandiose schemes for human improvement or social reconstruction – capitalist, communist or fascist – believing they all led to the same outcome: exploitation and

oppression of the many by the few. In addition, both men trod on the boundary between human and animal, rejecting the antithesis that structured history from antiquity to the modern era. Orwell's major intervention in this domain was his short novel *Animal Farm*, published in 1945. In it, he drew upon animal trials, fables and animal rights treatises to tell the story of a rebellion by the animals of Manor Farm against their human oppressors and the subsequent collapse of their experiment in 'Animalism'. 'Four legs good, two legs bad' was the slogan that portended descent into dogma. Following that were deceit, petty corruption, factionalism, demagoguery, thuggery, rewriting of history, a cult of leadership, purges, strikes, scapegoating, show trials, forced confessions, executions, dictatorship, war and, at last, a complete reversion to the same system of domination and repression that had existed before, only this time with the complicity of animals themselves, led by the autocratic pig Napoleon and his pampered retinue.

Orwell knew his animal history no less than his Soviet history. His description of the death of Boxer, the powerful but slow-witted draft horse whose constant self-exhortation was 'I will work harder', may have been derived from Bewick's poignant engraving *Waiting for Death*. After years of faithful service and back-breaking labour, Boxer is too weak to work and, like Bewick's animal, is ready to be put out to pasture. But before that can happen, he is tricked into the knacker's van and taken to be killed and rendered into hides, glue and bonemeal.

Orwell was also attuned to the longstanding figure of the cry of nature, though he employed it not to signify animal protest against human oppression, but the onset of animal violence against their own kind. In the middle of a debate with rival pig Snowball, Napoleon

stood up, and casting a peculiar sidelong look at Snowball, uttered a high pitched whimper of a kind no one had heard him utter before.

At this there was a terrible baying outside and nine enormous dogs wearing brass-studded collars came bounding into the barn. They dashed straight at Snowball, who sprang from his place just in time to escape their snapping jaws.

Then again a few days later, as the animals gathered to bestow medals upon Napoleon, the pig stood sternly survey-ing his audience; then he uttered a high-pitched whimper. Immediately the dogs bounded forward, seized four of the pigs by the ear and dragged them, squealing with pain and terror, to Napoleon's feet.[61]

The cry of nature, which in the art and writings of Hogarth, Oswald, Géricault, Blake, Soutine, Picasso and others was a collec-tive demand for safety and emancipation, is here a call for violence and vigilantism.

Before their rebellion, the animals at Manor Farm were oppressed by their human masters and lived lives that were nasty, brutish and short. And in the end, after a brief honeymoon of freedom and pros-perity at Animal Farm, they again lived essentially the same lives. Thus the propositions that are visible in the paintings of Bacon are once again made apparent: animals are humans, humans are animals, and both are indelibly stained by corruption, a propensity to violence or a fatal obedience to superior authority. For Orwell in *Animal Farm* and for Francis Bacon in general, as John Berger writes concerning the latter, 'the worst has already happened . . . and so [he] proposes that both refusal and hope are pointless'.[62]

But there is one other possible reading of Orwell's *Animal Farm* that places its author in the camp of the posthumanists who speak with passion about the possibility of animal liberation. Suppose that instead of being concerned with human revolution, warfare, duplic-ity, treachery and so on, *Animal Farm* was really about the animals? Suppose it was not an allegory of the failure of Soviet communism, but was actually about pigs, horses, ducks, cats, dogs and all the rest, striving but failing to achieve freedom? Adorno made a similar claim about Kafka – that the rule in his stories is 'take everything literally'. Perhaps Orwell's book was first of all an examination of the lives and deaths of a certain number of fictional farm animals. Orwell himself suggested that this might be the case. In the introduction to the Ukrainian edition of *Animal Farm*, he accounted for the origin of the book by reference to an incident like those that stimulated Hogarth, Bewick, Little Hans and many others in the visual and

literary history of animal liberation. He wrote that he saw a boy beating a carthorse and then

> proceeded to analyse Marx's theory from the animals' point of view. To them it is clear that the concept of a class struggle between humans was pure illusion, since whenever it was necessary to exploit animals, all humans united against them: the true struggle is between animals and humans.[63]

Indeed, there are many elements in the book that buttress this non-metaphoric, Marxist reading, including the absence of any clearly drawn human figure who may be compared to the animals, and most of all, the individualism of each animal: some are vain, some humble; some lazy, some industrious; some arrogant, some shy; some able to read and think critically, and others who can read no more than the first four letters of the alphabet. Owing to absent species-level generalizations such as those found in fables and bestiaries, it is difficult to see the animals in *Animal Farm* as mere metaphors of essential human ambition, avarice, anger and duplicity, or the typology of revolutions. Instead, they are individuals united in protest and revolution.

But that radical assertion of animal autonomy is undercut in the conclusion of Orwell's book. Here, Bacon's cynicism is once again recalled, as human and animal literally join hands. Pigs and humans pledge mutual solidarity in the struggle against the army of labour:

> Between pigs and human beings there was not, and there need not be, any clash of interests whatever. Their struggles and their difficulties were one. Was not the labor problem the same everywhere? . . . 'If you have your lower animals to contend with,' he said, 'we have our lower classes.' This *bon mot* set the table in a roar; and Mr Pilkington again congratulated the pigs on the low rations, the long working hours, and the general absence of pampering which he had observed on Animal Farm.

If Orwell has audaciously removed animals from the subservience of metaphor, he has denied them any capacity for autonomy. They are as oppressed and alienated, or as domineering and violent, as the people of any modern human community. What Orwell does not recognize in *Animal Farm* is the capacity of animals – whether human or non-human – to act altruistically, according to the Kantian principles which Kant himself denied to animals but which modern science has recognized. That animals are capable of observing the intrinsic worth of humans and other species despite the fact that they are unlike, and can form affectionate relations (even love relations) without the bond of sameness, is a proposition largely unexamined in Orwell's book.

After Orwell, a number of artists in Europe and the United States, including Jean Dubuffet, probed the boundary between post-war hopelessness and the posthuman dream of reintegrating the worlds of humans and animals. But for them, the animal was always ancillary to the human, simply a further instance of existential being and the drive for human liberation. The German artist Joseph Beuys, on the other hand, undertook a more sustained engagement with animality. Associated with the Fluxus movement, he began his career in the 1950s with a series of drawings for a proposed Auschwitz memorial, and later created a series of objects and multimedia installations partly composed of felt, fur and fat. These materials are found in his uncanny *The Pack* (1969), consisting of 24 sledges carrying felt, fat and a torch appearing to spill from the back of a Volkswagen bus. The installation invoked his frequently repeated wartime narrative of Tartars rescuing him from freezing by wrapping him in animal fat, but also, inevitably, the fat supposedly rendered from Nazi death camp victims and used for soaps and pharmaceuticals.[64] Beuys thereby suggests the liminal character of prisoners of war (with whom he identified), people in the Nazi death camps and farm animals reduced to sheer existence, or what Giorgio Agamben would later call 'bare life': the condition of being taboo, untouchable (in that sense sacred), excluded from the human community and constantly 'exposed to an unconditioned threat of death'.[65] Indeed, the industrial abattoir, from which animal fat is obtained, was from its origins located outside cities (or, as with La Villette, in its own city), very much like

concentration camps. It was the place where animals were beyond humane protection and where a death sentence could be imposed at any time.

In some of Beuys's performances, including *How to Explain Pictures to a Dead Hare* (1965) and *I Like America and America Likes Me* (1974), in which he spent three days with a coyote in the René Block Gallery in New York City, he again asserted his own liminal status by closely associating himself with two of the world's most hunted and despised animals. Legendary for their lustfulness and fertility, hares are generally regarded as pests and are hunted with guns, traps, nets and dogs, but they are also objects of affection and pity. They shed real tears when hurt, and their outcries recall those of children, as Montaigne, Cowper, Bewick, Blake, William Sommerville and Darwin, among others, attested.[66] Beuys's choice of the coyote was equally salient as an expression of his neo-shamanic wish to erase the barrier between human and animal. Some 6 million coyotes may have been trapped, shot, poisoned or otherwise killed during the years from 1937 to 1981, when the U.S. Fish and Wildlife Service attempted to extirpate the species.[67] The coyote is thus perhaps the exemplary figure of 'bare life' or *Homo sacer*: it is an outcast or scapegoat everywhere it is found and yet at the same time an animal sacred to Native American communities of the American Southwest, who see it at once as a trickster and an heroic figure.[68] (Today it is found almost everywhere in the U.S.[69]) Beuys was himself a notable trickster, fabulist, mythmaker and fraud. He employed animals – from his early drawings of elk, goats, foxes and rabbits to his rabbit and coyote performances – to pose a challenge to an economic and political order that denied animals autonomy and divorced humans from nature and their own animal being. In his drawn and typed broadside *A Political Party for Animals* (1969), he listed his own name among many other 'active members', who included Elk, Wolf, Beaver, Horse and Stork. In an interview with Willoughby Sharp, he was asked: 'Do you have a lot of members in the party?' He answered: 'It's the largest party in the world.'[70] His animal party was conceived in the same year that a number of postgraduate philosophy students at Oxford, in alliance with the novelist Brigid Brophy, the psychologist Richard

Ryder (who coined the word 'speciesism') and others (soon to include Peter Singer), formed a group to oppose animal experimentation and to organize in favour of animal rights.[71] The contemporary movement can be said to have begun there and then.[72]

Conclusion: Art and Animals Right Now

CRUELTY AND KINDNESS

One and the same culture produces the Outdoor Channel, a cable outlet dedicated in large part to hunting and killing non-human animals, and Animal Planet, whose programming is devoted to the conservation of endangered species. The same economy supports factory farms that kill billions of animals every year and a pet products industry that manufactures food, medicines, soaps and toys intended to nourish, heal, pamper and entertain approximately 165 million dogs and cats in the U.S. alone.[1] The same politicians that enable oil companies to 'drill baby drill' and in the process despoil vast swathes of sea and shoreline cry an ocean at the sight of oiled pelicans and dead sea turtles. The same person may consume hamburgers and hot dogs made from cattle and pigs cruelly slaughtered in industrial abattoirs and then adopt and unreservedly love a stray dog or cat. Today, people of every age, class, gender and ethnicity participate in the same strange self-cancelling rituals of violence and love, cruelty and kindness. It seems that Oliver Goldsmith's lament, uttered 250 years ago in an age of sensibility, remains apposite:

> And yet (would you believe it?) I have seen the very same men who have thus boasted of their tenderness, at the same time devouring the flesh of six different animals tossed up in a fricassee. Strange contrariety of conduct! They pity, and they eat the objects of their compassion.[2]

Just as a genuine movement for animal rights emerged from eighteenth-century contrariety, so the present drive for rights and protections arose from a similar set of contradictions. The recent movement, however, is much more geographically extensive than the earlier one, reaching into every continent and nearly every nation.[3] It is also more scientifically informed, buttressed, as we have seen, by discoveries concerning language, empathy (theory of mind) and the field of affective neuroscience. This last, for example, has shown that primary process emotions (fear, lust, care, panic, grief, seeking and play) are found in the same regions of the brain in humans and other mammals, and that stimulation of these areas triggers the expected emotional response. Just as Darwin and Freud intuited, the expression of emotion in both human and non-human animals indicates the presence of genuine affective experience.[4]

The significance of research in each of these areas – language, cognition and emotion – is to have finally put paid to the idea that animals are so lacking in cognitive capacity that they may on that basis be denied access to the domain of moral rights. And this realization has in turn bolstered the growth of a variety of movements for change, from the animal welfarism of the Humane Society of the United States and Farm Sanctuary (which accept animal exploitation but reject what they determine to be excessive suffering associated with factory farms), to PETA (which promotes veganism) and the radical abolitionism of the Animal Liberation Front (whose members support direct action to free animals held in laboratories and farms).[5] All of these movements and organizations cite scientific research concerning the mental and perceptual capacities of animals to bolster their positions. But more important than biology, psychology or ethology for the establishment of the contemporary movement for animal rights and animal welfare are developments in economic and social life during the last two generations that have led people both to challenge existing habits of animal exploitation, and intensified the bond between people and animals.

Factory Farms

The 1960s saw the development of so-called 'factory farming': the practice of raising domesticated animals in conditions of maximum density for the purposes of achieving the lowest costs and greatest return on investment.[6] Factory farms are often highly vertically integrated, with many, if not all, meat production and distribution functions handled by the same corporation, resulting in cheaper meat, greater consumption and higher profit. In the u.s., annual meat consumption rose from 63.5 kg (140 lb) per capita in 1960 to almost 77.1 kg (170 lb) a decade later, as single-species meatpacking plants appeared across the Midwest and Great Plains.[7] Steaks and chops that had once been luxuries were now common fare, symbols to some artists and writers of a generalized prosperity, and to others of decadence and complacency. When Carolee Schneemann mounted an orgiastic performance titled *Meat Joy* (1964) in which men and women slithered and writhed naked on a floor, clutching and covering themselves with raw steaks, sausages and fish, she was articulating the contradiction of an historical moment when meat was at once ubiquitous and luxurious, a sign of both middle-class taste and erotic emancipation. Schneemann's performance and video appear to argue that though women were treated as pieces of meat within bourgeois, male chauvinist culture, they at the same time have an equal right to indulge their own desires for abundant animal flesh and sexual pleasure. She wrote:

> *Meat Joy* has the character of an erotic rite: excessive, indulgent, a celebration of flesh as material: raw fish, chickens, sausages, wet paint, transparent plastic, rope brushes, paper scrap. Its propulsion is toward the ecstatic – shifting and turning between tenderness, wilderness, precision, abandon: qualities which could at any moment be sensual, comic, joyous, repellent.[8]

When the photographer and artist Allan Sekula stole some high-priced cuts of meat from a Safeway supermarket in the u.s. and tossed them onto a freeway under the wheels of a passing truck

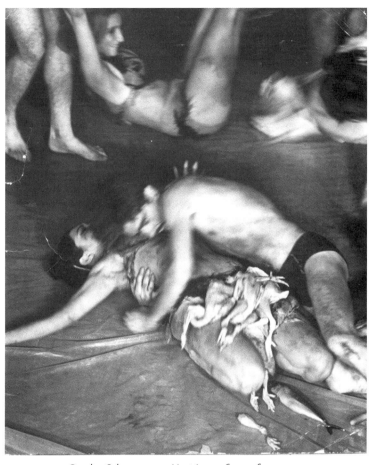

Carolee Schneemann, *Meat Joy*, 1964, performance.

(*Meat Mass*, 1972), he claimed he was 'interrupting the capitalist circulation of luxury goods through robbery and waste'. In fact he was representing what had in the previous decade become a social fact: that animals and meat were cheap and disposable, and that as much meat was wasted as actually eaten. The sacred Mass had become a ritual of mass consumption. When Suzanne Lacey imitated a housewife learning the names of the parts of a lamb carcass and then imitated a lamb in her video *Learn Where the Meat Comes From* of 1976, she was recognizing that meat was both a toy for anyone with aspirations to become Julia Child, and an oppressive instrument for inscribing gender roles.

The paradox of modern meat was apparent beyond the U.S. too. When in 1962 the Vienna Actionist Hermann Nitsch first performed his *Theatre of Orgies and Mysteries*, during which he crucified a (dead) lamb and exhibited its bloody entrails, it was already anachronistic. Meat had become sufficiently banal – its association with actual animals so vitiated – as to lose its residual association with burnt offerings and the mystery of the Eucharist. In Germany, France and other nations in Western Europe, meat-eating increased per capita at approximately the same rate as in the U.S. during the same period. Nitsch's theatre was not so much Nietschean tragedy as consumer farce. Fluxus artist Dieter Roth recognized the absurdity of such heavy-handed and sanguinary grandiloquence. His *Literaturwurst* (1961–74) consisted of classic works of literature or journalism ground up with spices and stuffed into a sausage casing. (Soon he dispensed with the meat casing and used plastic, making his books vegetarian.) He called his works 'Kitsch. Heavy Kitsch. Kind of a Nietzschean Pudding.'[9]

By the early twenty-first century, factory farming was the predominant means of meat production in the world. Nearly 75 per cent of the world's poultry is raised in highly intensive farms, often in so-called 'battery cages', in which egg-laying chickens are kept in small wire boxes placed side by side in long rows, stacked one on top of another. They must urinate and defecate on each other, are prevented by their confinement from moving or exercising, and are often crippled from being overweight.[10] The horror has not escaped artistic oversight, first by British-born American artist Sue Coe in her painting of the subject titled *Egg Machines* (1991) and by Douglas Argue in his identically composed (but much bigger) painting *Untitled* (1993). The latter considerably diminishes the horror of the battery-caged chickens but nevertheless includes details of the animals' outcry, the inevitable visual sign of animal suffering. The motif is literally central in Edwin Brock's celebrated poem 'Song of the Battery Hen', which includes the lines

I am in the twelfth pen
On the left-hand side of the third row . . .
But even without direction, you'd

Discover me. I have the same orange-
Red comb, yellow beak and auburn
Feathers, but as the door opens and you
Hear above the electric fan a kind of
One-word wail, I am the one
Who sounds loudest in my head.[11]

Sue Coe depicted the 'one-word wail' in an untitled drawing of chickens intended to highlight the absurdity of the Humane Society's promotion of 'enhanced cages'. Her work recalls the line by Brock as much as it does Edvard Munch's *The Scream.*

Pigs are also raised in conditions of close confinement. (The packing house run by Smithfield Foods in Tar Heel, North Carolina, for example, was by the year 2000 slaughtering more than 32,000 pigs a day.[12]) Though not stacked on top of each other like chickens, they

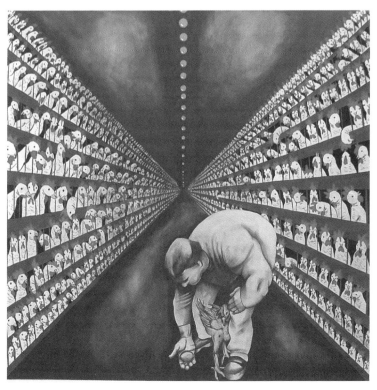

Sue Coe, *Egg Machines*, 1991, graphite and gouache on board.

Sue Coe, *The Scream*, 2012, graphite, gouache and watercolour
on Bristol board.

are mostly housed in euphemistically named 'hog parlors' which
deny them access to the outside and even much chance to move.
'Gestation crates' are metal-railed enclosures measuring 2 m × 60 cm
(6′ 6″ × 2′) that hold single female pigs during their pregnancies,
and often for their whole lives. They are so narrow that a full-grown
sow, who may weigh 272 kg (600 lb), cannot turn around or lie on
her side.[13] Their usage has now been banned in the UK, Sweden
and Denmark and in several American states (most significantly

Still by Philippe Halsman, from the making of Salvador Dalí's *Chaos and Creation*, 1960.

California); Smithfield Foods, the largest pork producer in the U.S., and the fast-food chain McDonald's have pledged to phase out the use of the crates over the next few years. It is not clear that the proposed substitute crates are much better, though it is likely that the reform will encourage more consumers to eat pork.

When empty, gestation crates – invented in 1965 by a pair of swine breeders from Lubbock, Texas – are like minimalist sculptures by Robert Morris, such as *Untitled* (1967). Both employ steel strips,

mesh, tubes or bars to constitute geometrical forms that possess volume but have little mass. Both are types of cages or prison cells too small to comfortably accommodate human or animal inmates. Morris had a long-standing interest in boxes and confinement, from his claustrophobic *I-box* (1962) to his *Self-portrait in S & M Gear* (1974) and his prison drawings titled *In the Realm of the Carceral* (1978).[14] The association between Morris and gestation crates is less unlikely than it may seem. In his short film *Chaos and Creation* (1960), Salvador Dalí made a connection between putatively minimal art and minimal conditions of confinement. The most important shot in the film shows a tripartite geometric composition by Piet Mondrian changed into a three-dimension construction of boxes containing a pig, a woman and a motorcycle.[15] Dalí's film suggests that the myriad boxes, cages and grids of Modernist art have their origins in the physical and mental strictures of human and animal confinement.

Though cattle farming is somewhat less rationalized than chicken and pig farming, the dairy industry is very highly mechanized, with cows artificially impregnated every year in order to maintain their milk production. Calves are typically separated from their mothers within a day of birth. If male, they are sent to feedlots or confined in crates until they are killed for veal, and if females, fed artificially and sent as soon as possible to the milk assembly line. Though a cow's natural lifespan is around 25 years, animals used for dairy are typically slaughtered after just four or five years, when their milk production declines, or sooner if they become sick or lame from the strain of constant pregnancy or conditions of close confinement. In the end, however, all cattle are slaughtered, whether intended for beef or milk, generally by one of the handful of large meatpacking companies such as Cargill, Tyson Foods and JBS SA (Brazil), the world's largest beef producer, which in 2007 acquired Swift & Co., then the third largest beef producer in the U.S.[16] (In 2010 the Five Rivers Cattle Feeding LLC, owned by JBS, had a capacity of 839,000 head on thirteen feedlots, the largest with a capacity of 125,000.[17])

Early in the history of factory farms, film-maker Frederick Wiseman in his documentary *Meat* (1976) depicted the congregation and slaughter of cattle as well as sheep at the Monfort meatpacking plant in Greeley, Colorado. The plant had been founded in the midst

of the Great Depression when the replacement of horses by tractors led to a huge surplus of grain and lowered prices, permitting Warren H. Monfort to supply fattened cattle for slaughter all year round. But it was the vertical integration of his business in the 1960s that was Monfort's greatest innovation and the clearest expression of the factory farm system: Monfort fed the cattle, slaughtered them, cut them up, processed ('boxed') them for final sale and even shipped them to restaurants and supermarkets, capturing surplus value every step of the way.[18] When Wiseman made his film, however, the company was in the midst of a crisis: a combination of high grain prices due to expanded sales to the Soviet Union, lowered meat prices due to government wage and price controls, and increased government regulation of food additives reduced company profits, leading to attempts to cut wages and increase the efficiency and productivity of labour. A series of labour disputes in the mid-1970s and after, also documented in Wiseman's film, eventually led to the sale of the company to ConAgra Red Meat Companies in 1987, and then to a further set of consolidations in the years following. By the time that Coe turned to the subject of cattle feedlots in 1995 in her book (with Alexander Cockburn) *Dead Meat*, the industry had been consolidated, the unions mostly broken and profits restored to previous high levels. Her drawings of feedlots for *Dead Meat*, such as *Feedlot* and *Lo Cholesterol Buffalo*, represent not a highly rationalized industrial system, but one that is so replete with animals – shoulder to shoulder and hoof against hoof – that it appears on the verge of revolution. The animals form a continuous mass, almost becoming a single body and brain.

Though efforts to curtail the worst animal abuses on factory farms have gained limited traction in recent years, it is not at all clear that alternative farming methods (small-scale, organic, free range and so on) yield significant reductions in animal pain and suffering. The practice of fattening up organic, range-fed cattle on crowded feedlots prior to slaughter, the replacement of battery cages with only moderately larger cages or densely packed sheds, de-beaking of chickens, the destruction of male chicks, tail-docking, castration, forced insemination of cows, branding, the routine separation of animals from their young and of course the final slaughter itself (generally

Frederick Wiseman, still from *Meat*, 1976.

centralized in a few, regional slaughterhouses) suggests that labels like 'free range' and 'cage-free' are more promotional that protectionist.[19] Indeed, humane farming, promoted by corporations such as Whole Foods, is the very enactment of the pathos formula described here. To produce meat that is putatively 'happy' or humanely raised

is to encourage the idea that slaughtered animals gratefully surrender their lives for the human dinner table.

Meat and eggs from factory farming are a major vector in the spread of E-coli, campylobacter and salmonella, as well as BSE (bovine spongiform encephalopathy), a rare but invariably fatal disease.[20] Potentially still more devastating are the zoonotic diseases – viruses spread from animal to human – that have the potential to become pandemic, especially SARS, avian flu (H5), swine flu (H1N1) and MRSA (methicillin-resistant Staphylococcus aureus). The most recent outbreaks of all these diseases have been traced to factory farms. Beyond these hazards to human health, the mass consumption of meat and milk, made possible by the economies of scale created by factory farming, is generally believed to be a leading cause of heart disease, and an important factor in the etiology of many other diseases from acne to cancer.[21] Factory farming is not only devastating for the physical and emotional health of animals, but may be hurting or killing an enormous number of people. And it is equally destructive of the environment. Water quality, especially in rural areas, is severely degraded by run-off from animal waste stored in 'lagoons'.[22] Phosphorous and nitrogen in manure may cause algae to bloom, producing toxins that poison rivers and lakes; high levels of antibiotics in animal wastes enter the water and food supply, compromising the immune systems of both humans and animals; and the release of ammonia, hydrogen sulphide and methane poison the air near farms and increase global warming.

RELATIONAL IDENTITY

In recent years, growth in meat consumption in the U.S. has stalled and then declined, from a high of 83.5 kg (184 lb) per capita in 2004 to 75.3 kg (166 lb) in 2012, a 10 per cent drop in just eight years. The Great Recession is surely one factor in the decline, but another is increased recognition of the cruelty, ecological destructiveness and sheer unhealthiness of factory farming and a meat-based diet, publicized by books and films such as Meat, Coe's Dead Meat (1995), Eric Schlosser's Fast Food Nation (2008) and Food, Inc. (dir. Robert Kenner, 2008). But it is not just revulsion at factory farms that has led to

the recent burst of interest in animal rights and welfare from super-market aisles to seminar rooms. The changed nature of contemporary lives has also fostered a greater intimacy with companion animals and, by extension, an increased sensitivity toward the needs and inter-ests of other non-human animals, including wild and farm animals.

Unattached for long to any single community or employer, sep-arated from classic kinship groups, with changing partners and few children, a growing number of people in the West occupy an economic and social location on the margins of the bounded geog-raphical and ideological territories of capital. Gathering resources where they can, forming bonds based upon friendship and mutual interest rather than consanguinity or affinity, luxuriating when they have plenty and scrounging or conserving when they have less, this floating world of artists, intellectuals, independent professionals, students, entrepreneurs, part-timers, immigrants, retired persons and the unemployed often develop a set of mental coordinates that can be described as 'relational' rather than 'substantive'.[23] Their identity is determined not by static kinship, work or even gender identities, but by fluid or transactional modes of being, dependent upon circum-stance and the surrounding community or landscape.[24] Freedom and agency, too, are experienced as arising out of multiple contingencies not from individual being or will. By extension, the modern binary categories of self/other, nature/culture, individual/society and mind/body, as well as animal/human – upheld at least since the time of Descartes (and with roots in the ancient world, as we have seen) – are also cast into a state of indeterminacy and flux. Relational iden-tity is multiple, hybrid and dependent upon other beings and things for its changing definition.

This emerging relational or transactional character of modern identity shares some points of comparison with the attitudes of indigenous hunter-gatherers whose belief system, discussed earlier, is generally described as animist.[25] Hunting and gathering when they must, eating when they can and enjoying leisure whenever possible, animists such as the Nayaka of the Gir Valley (Nilgiri region) of South India make no sharp distinctions between human individuals, instead seeing community members as what the anthropologist Marilyn Strathern called 'dividuals' (as opposed to individuals): people defined

by constant cooperation, interrelationship, gifts and exchange.[26] In this context, as we have seen, the Nayaka also form close relationships with non-human beings in their vicinity – animals, hillsides, rivers and the spirit hybrids called *devaru* – not because they have an a priori understanding that these entities are humans like themselves, but because they are their constant companions and thus come to possess personhood.[27] The Nayaka, like other hunter-gatherers (and some horticulturalists too), may for example maintain a dialogue with trees and animals in order to gain a greater sense of their physical character and subsistence needs, and an increased understanding of mutual responsibilities.[28]

This animist understanding of relational identity, hybridity and dialogue partly inspired the philosopher Bruno Latour to consider by comparison the situation of people under the aegis of contemporary capitalism. In *We Have Never Been Modern* (1993), he argued that the subject/object dualism (me/you, I/it) of modernity was in fact never anything more than a rigid imposition upon a hybrid social order; it was a system of classification (part of a 'constitution') that bestowed rights upon some (humans, males, the rich) and withdrew them from others (animals, women and the poor).[29] In his own utopian vision, by contrast, the many machines we have devised – so overwhelming in their complexity and authority – as well as oppressed animals and the degraded environment would all be granted rights in a new 'parliament of things'. This body – its name apparently derived from the Old Icelandic assembly called the 'Althing' and Chaucer's visionary love poem 'The Parliament of Fowls' – would be a worldwide democratic body (shades of John Oswald and J.J. Grandville) that determined rules and procedures for managing and governing the universe of objects, animals and people. 'The imbroglios and networks that had no place now have the whole place to themselves.'[30] The parliament would construct new constitutions that would recognize the rights and agency of animals and things, and decide which scientific or other innovations are beneficial and which are destructive, assuming the perspective of the whole planet.

Somewhere between the relational system of animism and the dream-networks of Latour, and between foraging and the factory farm, lies the current, unstable constitution of humans and animals.

It is derived at once from the fixed, Cartesian, dualistic paradigm of human vs animal that has prevailed since the early modern period, and an emerging model of relational identity that invites animals into the shared transactional space of personhood. Articulations of the incipient relational order are today everywhere apparent. For example, the long-standing habit of adopting animals (alloparenting) and treating them like family members, friends and partners continues to grow: in the U.S., 62 per cent of households (72.9 million homes) contain a pet; 95 per cent of U.S. pet owners consider their pets to be friends, and 87 per cent family members; in a national survey (2007–8), 100 per cent of people interviewed said they intended to give their pets holiday presents, and 87 per cent to include them in holiday celebrations; 52 per cent of people interviewed routinely prepared special food for their pets, and the same percentage had taken time off from work to care for a sick pet; 44 per cent sometimes take their pets to work.[31]

More significant than these surveys of attitudes is the increasing role that animals play in regulating our social, psychological and physical health. Numerous studies over the past 35 years have shown the many mental and physical health benefits of a close relationship with pets. Dogs, cats and other animal companions have been proven to lower cholesterol and serum triglyceride levels as well as blood pressure. Their companionship reduces stress, depression, anxiety and loneliness as much as or more than a spouse or friend. They can help reduce the symptoms of serious mental disorders such as schizophrenia, and extend the lives of cancer patients and people with heart disease.[32] Compared to relationships with spouses and friends, attachments to pets are consistently stronger and more secure, and symbolic interactions – play, exchange of gaze and conversation – are as frequent and as vivid. With individuals moving in and out of families and households with greater frequency, companion animals provide stability and aid with social transitions, often functioning as best friends or partners.[33]

The point here is not just that animal companions can deliver therapeutic benefits; it is that they are already occupying highly important social, psychological and medical niches. They have in the last two generations entered into the web of modern relational

identity as never before, and a number of psychologists, sociologists and others have begun to argue in favour of a biocentric approach to clinical therapy that encompasses interspecies as well as human relationships.[34] And one consequence of all this is an animal rights movement that has started to demand that the personhood of animals be recognized in law, just as it de facto is in certain social practices.[35] The precise rights of animals would be determined on a case by case basis according to their degree of 'practical autonomy': that is, their capacity to desire, act intentionally and have self-awareness. In the current rights struggle too, as in the eighteenth century, animals may be the instruments of their own emancipation. The pleas of dogs and cats for attention and respect, their pleasurable yips and purrs and their alternate gratitude and importuning, affection and impatience, are the communication both of individuals and an entire class, demands for political representation in the new parliament of things.

ART NOW

If we are indeed living in an age of transition between one episteme and another, we would expect to see a widely divergent, antagonistic and highly experimental artistic regime that recognizes the growing and sometimes uncanny closeness between human and animal. And in fact, though no survey has been taken, there appears today to be more artists who use the bodies of animals in their art – real as well as virtual – than ever before. To effectively represent this material would demand a much larger canvas than is available here. A survey would perhaps begin with the taxidermied animals of Ed Kienholz from the 1960s, whose bodies and heads are often attached to human mannequins or effigies. The sculpted horses and camels of Deborah Butterfield and Nancy Graves would also receive notice, as would Jeff Koons's balloon and topiary dogs, and his *Michael Jackson and Bubbles* (1988), the latter being an example of the camp cynicism that became predominant in much animal art of the 1980s and after. The chief case in point would be the serio-comic installations of Maurizio Cattelan, which include *Ballad of Trotsky* (1996), consisting of a taxidermied horse held in a leather harness and suspended in the air, and *Bidibidobidiboo* (1996), which consists of an actual dead squirrel

slumped over a table with a small toy gun on the floor next to him. Here the divide between the mental lives of humans and animals has been erased, and both are characterized by depression. But to make even this basic observation about Cattelan's installation would be to take too seriously its engagement with the lives and thoughts of animals. What is presented to the spectator is simply old-fashioned ridicule of the non-human – a trumpeting of human prerogative and a reiteration of the ancient principles of speciesism.

Also included in the panorama of recent, animal expression would be the transgenic art of Eduardo Kac, who in his work titled *Alba* (2000) injected a rabbit with a fluorescent protein (GFP) from the jellyfish *Aequorea victoria*, causing her to fluoresce green.[36] It would include the photographs of the South African Pieter Hugo, whose series *The Hyena and Other Men* (2007) represented a group of itinerant Nigerian hyena handlers who have brought the African wild into uncomfortable proximity with the modern and the urban. A survey would look at the meat garments made by Jana Sterbak, *Flesh Dress for an Albino Anorectic* (1987), Tania Bruguera, *Body of Silence* (video, 2001) and Zuang Huan, *My New York* (2002), each of whom determined that animal flesh must become their own second skin. And it would examine the videos of Adel Abdessemed, whose *Don't Trust Me* (2008) depicted animals (deer, goat, horse, pig, sheep and ox) in a rural Mexican town being hit on the head with a sledgehammer and stunned prior to their slaughter.[37] All of these works rely for their effect upon the uncanny closeness – the relational identity – of human and animal today.

A comprehensive review of contemporary animal art would also examine the field of photography.[38] Here the principal monuments include the well-known photo series by Garry Winogrand *The Animals* (1969), and the pictures taken over several decades by *Life* magazine photographer Art Shay, many of which were assembled in *Animals* (2002). His photograph of a *Piglet Suckling at the Teats of his Dead Mother* depicts a tragic subject well known to visitors to slaughterhouses (the newborn pigs are supposed to be euthanized before their mother is killed) but unknown to the wider public.

More recently, Nick Brandt collected nearly 50 of his grand and tragic African wildlife photographs in the folio-sized book *On this*

Nick Brandt, *Elephant Drinking, Amboseli 2007. Killed by Poachers, 2009.*

Earth, A Shadow Falls (2012). Made over a decade, the photos, including Elephant Drinking, Amboseli (2007), document the habits and appearance of African megafauna – elephants, lions, cheetahs, zebras, giraffes, gorillas and others – and invite reflection upon the likely fate of many of these animals: extinction in the wild. (In fact, poachers later killed a number of the elephants Brandt photographed, including the one illustrated here.) What is most remarkable – apart from the self-conscious pictorialism of some of the photographs – is their unapologetic anthropomorphism. Animals are shown in close-knit families, among their friends, as isolated individuals and as loving partners, manifesting the very diversity of identities that characterize human relationships. The animals in Brandt's collection are revealed to be autonomous individuals living complex emotional lives. Brandt's photography is relational in another sense as well: it is part of a complex institutional web comprising art, commerce and his charitable Big Life Foundation, which is dedicated to ending the poaching of endangered African animals. Indeed, as with the artist, activist and illustrator Sue Coe, his photography and animal rights activities are completely intertwined, with expeditions undertaken to bring attention to the plight of African wildlife, photographs sold to raise money for his foundation, and his foundation operating to engage other philanthropists and the public in a common conservation effort.

An examination of contemporary animal art would also consider the strange antithesis of Damien Hirst and Sue Coe, both of whom are British-born (the latter is now a U.S. citizen), working class in origin and concerned with the transformation of moving, living animals into still, dead commodities, as well as people's uncanny fears that they themselves will be killed, stuffed, preserved in formaldehyde or cut and packed as meat. Hirst produces zombies: non-human animals that appear to exist in a liminal realm between life and death. In his art, a real, dead shark, sheep, cattle, doves and butterflies are presented in postures that bestow upon them at least a semblance of life: a tiger shark, jaws agape is poised mid-swim in a tank of watery blue formaldehyde (The Physical Impossibility of Death in the Mind of Someone Living, 1991); a sheep, sawn in half lengthwise, is exhibited in two flanking tanks (The Black Sheep with Golden Horns (Divided), 2009) – the effect is that of a magician's trick gone terribly wrong. In a pair

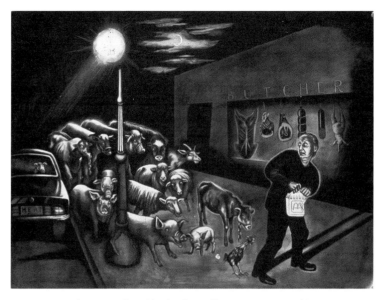

Sue Coe, *Modern Man Followed by the Ghosts of his Meat*, 1990, graphite on paper.

of glass and steel vitrines, an adult cow – sliced lengthwise (one half in each vitrine) – is immersed in blue-green formaldehyde; in a pair of adjacent vitrines, a calf is similarly dissected and preserved (*Mother and Child, Divided*, 1993). Each pair is exhibited a short distance apart so that it is possible for the spectator to walk between the two halves and see inside the animal, gaining a macabre intimacy. The animals have all been killed for Hirst's benefit.

In his *Natural History* series of sculptures using dead and dissected animals, Hirst recapitulates the Cartesian principle that animals are living machines lacking sentience, but does so in a way that nevertheless facilitates a disturbing intimacy between human and animal. Coe, in her paintings, drawings and prints about animals, does much the same thing, albeit from an opposing, posthumanist philosophical perspective identified with the animal liberation movement. *Modern Man Followed by the Ghosts of his Meat* (1990), part of her large series of *Porkopolis* paintings, drawings and prints, has the immediacy of a good joke. It is a shortcut, as Freud said of all jokes, between two thoughts; in this case between the thought of fast food and the idea that we are morally culpable for the deaths of the animals we eat. Beneath the wan light of a crescent moon and the harsh glare of a streetlamp, four

cows, one goat, three sheep, three pigs, a piglet, a calf and a chicken track the steps of a black-suited man who turns in alarm to spy his pursuers. To the right are cuts of meat hanging from hooks before a butcher's shop; to the left is a parked car with a small pig gazing from the rear window, and a licence plate that reads 'MEAT'. This must be Meatville. The man in black is slightly stooped, his mouth is open and his eyes are agape. He clutches a McDonald's bag protectively in front of his groin. His fears are primal: they concern the undead and castration. He is afraid that he will become meat.[39] The idea may have been inspired by George Bernard Shaw's comment, quoted by Peter Singer in *Animal Liberation*, that he would likely be escorted to his grave by sheep, cattle, pigs, chickens and a shoal of fish, grateful for having been spared because of his vegetarianism.[40] But the print inverts the meaning of the remark, turning the scene from a respectful funeral cortège to a haunting.

Hirst and Coe occupy vastly different social, political and institutional worlds, but they each make artworks that reflect upon the intense, uncomfortable and even uncanny relation we have with animals whom we both kill and consume, protect and love. That brutal contradiction has characterized much of the art and writing examined in this book, and still awaits its resolution; one that will only come when the cry of nature is more generally heard and understood.

References

Epigraphs on page 7: Muntzer is cited by Karl Marx, 'On the Jewish Question', *Early Writings* (London, 1992), p. 239. William Blake, 'The Marriage of Heaven and Hell', *The Complete Poetry and Prose*, ed. David V. Erdman (New York and London, 1988). For Soutine, see M. Tuchman, E. Dunow and K. Perls, eds, *Chaïm Soutine (1893–1943): Catalogue raisonné* (Cologne, 1993), vol. I, p. 16.

Introduction

1 See, for example, John Lawrence, *A Philosophical and Practical Treatise on Horses, and on the Moral Duties of Man Towards the Brute Creation* (London, 1802).
2 Jeremy Bentham, *An Introduction to the Principles of Morals and Legislation* (Oxford, 1879), pp. 29–32. Bentham proposed that a wise legislator consider the value of an act according to the pleasure or pain it engendered, measured by its intensity, duration, certainty or uncertainty, propinquity or remoteness, fecundity and purity (pp. 28–9). A less elaborated model of hedonic utilitarianism is found in the work of Francis Hutcheson: 'In the same manner, the moral evil, or vice, is as the degree of misery, and number of sufferers, so that action is best, which procures the greatest happiness for the greatest numbers, and that worst, in like manner, occasions misery.' *An Inquiry into the Original of Our Ideas of Beauty and Virtue* (London, 1753), pp. 184–5. John Gay and William Paley also proposed utilitarian models: see John Gay, *Concerning the Fundamental Principle of Virtue or Morality, British Moralists*, ed. Sir Lewis Amherst Selby-Bigge (Oxford, 1897), pp. 267–85; William Paley, *The Principles of Moral and Political Philosophy*, in *The Works of William Paley*, ed. Edmund Paley (London, 1825), pp. 14–28. It is notable that all four authors posited the idea

that animals might belong within the domain of moral rights. See chapter Three below.

3 Paley, *The Principles*, p. 67.

4 For a brief history of the RSPCA and a searchable index of animal protection statutes, see 'The History of the RSPCA' (1972), www.animallaw.info.

5 In 1822, Martin's Act was passed, authorizing the arrest of anyone who would 'wantonly and cruelly beat, abuse, or ill-treat any Horse, Mare, Gelding, Mule, Ass, Ox, Cow, Heifer, Steer, Sheep, or other Cattle'. Two years later, the Society for the Prevention of Cruelty to Animals was founded.

6 Peter Singer, *Animal Liberation* (London, 1975).

7 John Oswald, *The Cry of Nature* (London, 1791), pp. 38–9.

8 See, for example, Tom Regan, *The Case for Animal Rights* (Berkeley, CA, 1980), and Gary Francione and Robert Garner, *The Animal Rights Debate: Abolition or Regulation?* (New York, 2010). On the term 'abolitionism' and animal rights, see Marjorie Spiegel, *The Dreaded Comparison: Human and Animal Slavery* (New York, 1996). On the parallels between the struggle or women's and animals rights, see Carol J. Adams, *The Sexual Politics of Meat* (New York, 2000).

9 See, for example, Ann Norton Greene, *Horses at Work: Harnessing Power in Industrial America* (Cambridge, 2008). Also Richard Moore-Colyer, 'Aspects of Horse Breeding and the Supply of Horses in Victorian Britain', *Agricultural History Review*, XLIII/1 (1995), pp. 47–60.

10 P. Karlson and M. Lüscher, 'Pheromones: A New Term for a Class of Biologically Active Substances', *Nature*, CLXXXIII/4653 (1959), pp. 55–6.

11 'Humans Smell Fear and It's Contagious', *Live Science*, 6 November 2012, www.livescience.com.

12 For example, John Locke stated in his *Some Thoughts Concerning Education* [1692] that 'tormenting and killing . . . beasts, will, by degrees, harden [children's] minds even towards men; and they who delight in the suffering and destruction of inferior creatures, will not be apt to be very compassionate or benign to those of their own kind' (§116, www.bartleby.com). The idea has antique roots, and become a staple of modern criminal forensics. See, for example, Andrew Linzey, ed., *The Link Between Animal Abuse and Human Violence* (Eastbourne, 2007).

13 William Hogarth, 'Remarks on Various Prints', *Anecdotes of William Hogarth, Written by Himself: With Essays on His Life and Genius, and Criticisms on his Work* (London, 1833), pp. 64–5, 233–8, 336.

14 Pat Shipman, 'The Animal Connection and Human Evolution', *Current Anthropology*, LI/4 (August 2010), pp. 519–25.

1 What is an Animal?

1 It has long been argued that human dentition, digestion, locomotion and so on are classically those of herbivores, not carnivores or even omnivores. See, for example, Percy Bysshe Shelley, *Queen Mab* (London, 1821), pp. 166–8. A popular, scientifically updated version of this argument is Neal Hendrickson, 'Meat in the Human Diet', *MacDougall Newsletter*, 11/7 (July 2003), www.nealhendrickson.com, and PETA, 'The Natural Human Diet', www.peta.org, accessed 11 February 2013. See the following scholarly accounts: Katharine Milton, 'Hunter-gatherer Diets: A Different Perspective', *American Journal of Clinical Nutrition*, LXXI/3 (March 2000), pp. 665–7; K. Milton, 'Nutritional Characteristics of Wild Primate Foods: Do the Diets of Our Closest Living Relatives Have Lessons for Us?', *Nutrition*, XV/6 (June 1999), pp. 488–98. Also, Marion Nestle, 'Animal v. Plant Foods in Human Diets and Health: Is the Historical Record Unequivocal?', *Proceedings of the Nutrition Society*, LVIII/2 (1999), pp. 211–18. For the contrary argument that the Palaeolithic diet was more animal- than plant-based, see L. A. Frassetto, M. Schloetter, M. Mietus-Synder, R. C. Morris and A. Sebastian, 'Metabolic and Physiologic Improvements from Consuming a Paleolithic, Hunter-gatherer Type Diet', *European Journal of Clinical Nutrition*, LXIII/8 (August 2009), pp. 947–55; Eaton M. Konnor, 'Paleolithic Nutrition: Twenty-five Years Later', *Nutrition and Clinical Practice*, XXVI/6 (December 2010), pp. 594–602; Michael P. Richards, 'A Brief Review of the Archaeological Evidence for Palaeolithic and Neolithic Subsistence', *European Journal of Clinical Nutrition*, LVI/12 (December 2002), pp. 1270–78.
2 For a cogent review of the literature on 'man the hunter', see Manuel Domínguez-Rodrigo, 'Hunting and Scavenging by Early Humans: The State of the Debate', *Journal of World Prehistory*, XVI/1 (March 2002), pp. 1–54. For a critical examination of the evolutionary, ecological and ethical basis of a plant-based diet, see Steven L. Davis, 'The Least Harm Principle May Require that Humans Consume a Diet Containing Large Herbivores, Not a Vegan Diet', *Journal of Agricultural and Environmental Ethics*, XVI/4 (2003), pp. 387–94. On the protein sources for Neanderthals versus humans, see Michael P. Richards, Erik Trinkaus and Richard G. Klein, 'Isotopic Evidence for the Diets of European Neanderthals and Early Modern Humans', *Proceedings of the National Academy of Sciences*, CVI/38 (22 September 2009), pp. 16034–9.
3 Pat Shipman, 'The Animal Connection and Human Evolution', *Current Anthropology*, LI/4 (August 2010), pp. 519–25.

4 Semiosis is not, however, only a property of macro-organisms and nervous systems. The cell itself is a semiotic system, as Marcello Barbieri has argued, consisting of sign and meaning, as well as a codemaker that translates signs into meanings and directs the whole show. Within the cell, the role of cellular codemaker is performed by transfer RNA (ribonucleoproteins); signs are played by the codons (the triplet of nuceotides that encode the twenty amino acids), and meaning by the proteins (formed from the amino acids). The codons and proteins are wholly dependent for their articulation upon the structure of the transfer RNA. Communication is therefore not simply a characteristic of so-called advanced animals such as humans, but of all living things.

5 The nervous system of human beings, for example, according to the philosopher and semiotician Charles Morris, is comprised of designative, appraisive and prescriptive signs. The first evaluates the physical properties of an observed object or event; the second selects objects of preference; and the third determines how an action or object is to be acted upon in order to satisfy a desire. Morris's system – obviously more complicated than I have suggested here – was intended to provide a means to classify all forms of human discourse: 'scientific', 'fictive', 'mythical', 'moral', 'religious' and so on. But his basic model of designative, appraisive and prescriptive signs describes the communication systems of many other animals as well. Charles Morris, 'Signs and the Act', in Semiotics: An Introductive Anthology, ed. Robert E. Innes (Bloomington, IN, 1985), p. 182.

6 Michael A. Arbib, Katja Liebal and Simone Pika, 'Primate Vocalization, Gesture, and the Evolution of Human Language', Current Anthropology, XLIX/6 (December 2008), p. 1055.

7 Dorothy L. Cheney and Robert M. Seyfarth, How Monkeys See the World: Inside the Mind of Another Species (Chicago, IL, 1990).

8 Similarly nuanced predator warnings – suggesting the presence of complex semantics and syntax – have also been found among prairie dogs. See Con Slobodchikoff, 'The Language of Prairie Dogs', in Kinship with the Animals, ed. Michael Tobias and Kate Solisti-Mattelon (Hillsboro, OR, 1998).

9 K. Arnold and K. Zuberbühler, 'Meaningful Call Combinations in a Non-human Primate', Current Biology, 18 (2008), R202–R203.

10 Donald R. Griffin, Animal Minds: Beyond Cognition to Consciousness (Chicago, IL, and London, 2001), p. 173.

11 K. Zuberbuhler, 'A Syntactic Rule in Forest Monkey Communication', Animal Behaviour, 63 (2002), pp. 293–9.

12 Arbib et al., 'Primate Vocalization', p. 158.

13 Edward Kako, 'Elements of Syntax in the Systems of Three Language-trained Animals', *Animal Learning and Behavior*, XXVII/1 (1999), p. 6.

14 I. M. Pepperberg, *The Alex Studies: Cognitive and Communicative Abilities of Grey Parrots* (Cambridge, 1999).

15 L. M. Herman, 'Cognition and Language Competencies of Bottlenosed Dolphins', in *Dolphin Cognition and Behavior: A Comparative Approach*, ed. R. J. Schuisterman, A. J. Thomas and F. G. Wood (Hillsdale, NJ, 1986).

16 Oscar Pfungst, *Clever Hans (The Horse of Mr von Osten), A Contribution to Experimental Animal and Human Psychology*, trans. Carl Rahn (New York, 1911).

17 F. Patterson, 'Linguistic Capabilities of a Lowland Gorilla', in *Sign Language and Language Acquisition in Man and Ape*, ed. F.C.C. Peng (Boulder, CO, 1978), pp. 161–201; H. L. Miles, 'The Cognitive Foundations for Reference in a Signing Orangutan', in *'Language' and Intelligence in Monkeys and Apes*, ed. S. T. Parker and K. R. Gibson (Cambridge, 1990), pp. 511–39.

18 Sue Savage-Rumbaugh and R. Lewin, *Kanzi: The Ape at the Brink of the Human Mind* (New York, 1994).

19 See the documentaries filmed for Japanese NHK Television, available at http://kanzi.bvu.edu.

20 See, for example, P. M. Greenfield and E. S. Savage-Rumbaugh, 'Grammatical Combination in *Pan paniscus*: Processes of Learning and Invention in the Evolution and Development of Language', in *'Language' and Intelligence in Monkeys and Apes*, ed. Parker and Gibson (Cambridge, 1990), pp. 540–78.

21 Lewis Henry Morgan, *The American Beaver and his Works* (Philadelphia, PA, 1868), p. 18.

22 Ibid., p. 256.

23 Donald Griffin, *Animal Thinking* (Cambridge, 1984), p. 132.

24 Cf. Stephan Achim, 'Are Animals Capable of Concepts?' *Erkenntnis*, LI/1, special issue: Animal Mind (1999), pp. 79–92

25 Jean Piaget, *The Language and Thought of the Child*, trans. Marjorie Gabain (New York, 1973), p. 28.

26 Noam Chomsky, *Language and Mind* (Cambridge, 2006), p. 60.

27 If animals are indeed unthinking, they are like humans much of the time, since the latter often act without premeditation, and rarely reflect upon what they have done. Thinking, as the anthropologist Tim Ingold has written, may be simply 'an inessential byproduct' of consciousness, process and movement. As a decisive marker of the

line between the human and non-human animal, therefore, it is highly
overrated. Tim Ingold, *What is an Animal?* (London, 1988), p. 9.

28 D. Premack and G. Woodruff, 'Does the Chimpanzee have a Theory of
Mind?', *Behavioral and Brain Sciences*, 4 (1978), pp. 515–26.

29 J. Call, J. and M. Tomasello, 'Distinguishing Intentional from Accidental
Actions in Orangutans (*Pongo pygmaeus*), Chimpanzees (*Pan troglodytes*),
and Human Children (*Homo sapiens*)', *Journal of Comparative Psychology*,
112 (1998), pp. 192–206.

30 Griffin, *Animal Minds*, p. 15.

31 Ibid., p. 278.

32 Gary Steiner, *Animals and the Moral Community: Mental Life, Moral Status,
and Kinship* (New York, 2008), p. 73.

33 Ibid., p. 83.

34 Evidence for the existence of mental images and 'internally felt
experiences' in animals has been found by Jaak Panksepp, 'Cross-
Species Affective Neuroscience Decoding of the Primal Affective
Experiences of Humans and Related Animals', PLOS ONE, VI/9 (2011).

35 Jaak Panksepp, 'Affective Consciousness: Core Emotional Feelings
in Animals and Humans', *Consciousness and Cognition*, XIV/1 (2005),
p. 41.

36 See, for example, Rocco Gennaro, *Higher Order Theories of Consciousness:
An Anthology* (Amsterdam and Philadelphia, PA, 2004), pp. 45–92.

37 Inbal Ben-Ami Bartal, Jean Decety and Peggy Mason, 'Empathy
and Pro-Social Behavior in Rats', *Science*, CCCXXXIV/6061 (2011),
pp. 1427–30.

38 Jayson L. Lusk, F. Bailey Norwood and Robert W. Prickett, Department
of Agricultural Economics Oklahoma State University, *Consumer
Preferences for Farm Animal Welfare: Results of a Nationwide Telephone Survey*,
17 August 2007. See 'Vegetarianism in America', Harris Interactive
Survey for *Vegetarian Times* (2008), www.vegetariantimes.com.

39 David Crary, 'Number of Hunters Falls, Worrying Some', USA Today,
2 September 2007, www.usatoday.com. Also Kirk Johnson, 'For
Many Youths, Hunting Loses the Battle for Attention', *New York Times*,
25 September 2010, www.nytimes.com.

40 Spain is the only country that has so far granted legal rights to great
apes, banning experimentation and granting them the right to life
and freedom. They have been granted more limited rights in Britain
and New Zealand: Lee Glendinning, 'Spanish Parliament Approves
"Human Rights" for Apes', 26 June 2008, www.guardian.co.uk.

41 Judith Nasby and Irene Avaalaaqiaq Tiktaalaaq, *Irene Avaalaaqiaq: Myth
and Reality* (Quebec City, 2002), p. 26.

42 Jon Altman and Nicolas Peterson, 'Rights to Game and Rights to Cash among Contemporary Australian Hunter-gatherers', in *Hunters and Gatherers: Property, Power, and Ideology*, ed. Tim Ingold, David Riches and James Woodburn (Oxford, 1988), vol. II, pp. 78–9.

43 Fred R. Myers, *Painting Culture: The Making of an Aboriginal High Art* (Durham, NC, 2002), p. 17.

44 Kate Owen Gallery and Studio, 'Artist List', www.kateowengallery.com, accessed 11 February 2013.

45 Emile Durkheim, *The Elementary Forms of Religious Life* (New York, 1915), p. 53, cited in Nurit Bird-David, '"Animism" Revisited: Personhood, Environment, and Relational Epistemology', *Current Anthropology*, XL (February 1999), p. 69.

46 Graham Harvey, ed., *Readings in Indigenous Religions* (New York, 2002), at http://books.google.com.

47 Bird-David, '"Animism" Revisited', p. 75.

48 Nurit Bird-David, 'Beyond "The Original Affluent Society": A Culturalist Reformulation', in *Limited Wants, Unlimited Needs*, ed. John Gowdy (Washington, DC, 1998), pp. 123–4.

49 Mathius Guenther, 'Animals in Bushman Thought, Myth and Art', in *Hunters and Gatherers*, ed. Ingold et al., vol. II, p. 193.

50 Tim Ingold, *The Perception of the Environment: Essays in Livelihood, Dwelling and Skill* (London and New York, 2000), pp. 61–76.

51 In recent years, both groups have been forced to accept more sedentary ways and a regime of individual instead of collective property. R. Cincotta and N. Pangare, eds, *Pastoralism and Pastoral Migration in Gujarat* (Anand, 1993); J. T. McCabe, 'Risk and Uncertainty Among the Maasai of the Ngorongoro Conservation Area in Tanzania: A Case Study in Economic Change', *Nomadic Peoples*, I/1 (1997), pp. 54–65.

52 See S. Budiansky, *The Covenant of the Wild: Why Animals Chose Domestication* (New York, 1992). Also, J. Clutton-Brock, 'Origins of the Dog: Domestication and Early History', in *The Domestic Dog: Its Evolution, Behaviour and Interactions with People*, ed. J. Serpell (Cambridge, 1995), pp. 7–20; and *A Natural History of Domesticated Mammals*, 2nd edn (Cambridge, 1999).

53 Ingold, *The Perception of the Environment*, p. 74.

54 Hugh Beach and Florian Stammler, 'Human–Animal Relations in Pastoralism', *Nomadic Peoples*, X/2 (2006), p. 21.

55 William T. Brande and G. William Cox, eds, *A Dictionary of Science, Literature and Art* (London, 1867), p. 611. For comparison, see the classic

ethnography: Roy Rappaport, *Pigs for the Ancestors: Ritual in the Ecology of a New Guinea People* (New Haven, CT, 1968).

56 George Rudé, *Ideology and Popular Protest* (Chapel Hill, NC, 1995), p. 22.

2 Animals into Meat

1 Juliet Clutton-Brock, 'The Unnatural World: Behavioral Aspects of Humans and Animals in the Process of Domestication', in *Animals and Human Society*, ed. Aubrey Manning and James Serpell (New York and London, 1994), p. 28.

2 'Global Livestock Counts: Counting Chickens', *The Economist* (online), 27 July 2011, www.economist.com. The higher figure of 50 billion is found in Jonathan Safran Foer, *Eating Animals* (New York, 2010), p. 136.

3 Joan Dunayer, *Speciesism* (New York, 2004).

4 Everett Fox, ed., *The Five Books of Moses* (New York, 1995), p. 17.

5 Fragment 130 cited in Arthur O. Lovejoy and George Boas, *Primitivism and Related Ideas in Antiquity* (Baltimore, MD, 1935), p. 33.

6 Ibid., pp. 46–7.

7 *The Natural History of Pliny*, trans. John Bostock and H. T. Riley (London, 1855), vol. I, p. 95. See also Andrew Jones, *Prehistoric Europe* (London, 2008), pp. 16–34.

8 *The History of Herodotus*, ed. and trans. George Rawlinson (New York, 1885), vol. III, Book 4, chap. 23, p. 68.

9 *The Geography of Strabo*, trans. H. C. Falconer and W. Falconer (London, 1854), vol. I, pp. 232; 236.

10 *Select Works of Porphyry*, trans. Thomas Taylor (London, 1823), p. 95.

11 Ibid., p. 97.

12 Virgil, *The Eclogues*, trans. J. W. Mackail (Portland, ME, 1898), pp. 35–6.

13 *Aristotle's History of Animals*, trans. Richard Cresswell (Oxford, 1862), p. 194.

14 A. O. Lovejoy, *The Great Chain of Being: A Study in the History of an Idea* (Cambridge, 1936).

15 Epictetus, *The Discourses, Books III–IV: Fragments, Encheiridion*, trans. W. A. Oldfather (Cambridge, MA, 2000), p. 103, cited in Gary Steiner, *Anthropocentrism and its Discontents: Animals and their Moral Status in the History of Western Philosophy* (Pittsburgh, PA, 2005), p. 87.

16 Varro, *Of Country Life, Three Books*, §2, 'Concerning the Equipment of a Farm', part 17, http://thriceholy.net.

17 Julide Aker, 'Workmanship as Ideological Tool in the Monumental Hunt Reliefs of Asurbanipal', *Ancient Near Eastern Art in Context: Studies in*

Honor of Irene J. Winter, ed. Irene Winter, Jack Cheng, Marian H. Feldman (Leiden and Boston, MA, 2007), p. 246.

18 Catherine Breniquet, 'Animals in Mesopotamian Art', in *A History of the Animal World in the Ancient Near East*, ed. Billie Jean Collins (Leiden and Boston, MA, 2002), p. 166.

19 Stephen F. Eisenman, *The Abu Ghraib Effect* (London, 2007). Also see Georges Didi-Huberman, 'Dialektik des Monstrums: Aby Warburg and the Symptom Paradigm', *Art History*, XXIV/5 (November 2001), pp. 621–45.

20 On medieval and modern inheritance of Stoic views about animal mentalities, see Richard Sorabji, *Animal Minds and Human Morals* (Ithaca, NY, 1993).

21 Ingvild Sælid Gilhus, *Animals, Gods and Humans: Changing Attitudes to Animals in Greek, Roman and Early Christian Ideas* (London, 2006), pp. 250–58.

22 Ibid., p. 171.

23 St Augustine, *The Catholic and Manichaean Ways of Life*, trans. D. A. Gallagher and I. J. Gallagher (Boston, MA, 1966), p. 120, cited in Peter Singer, *Animal Liberation* (London, 1975), p. 192.

24 This opposition would be fundamental to anatomical and other treatises of the English Renaissance. Erica Fudge writes: 'In all these works, whatever their apparent foci, the animal emerges as humanity's other, the organism against which human status was asserted.' Erica Fudge, *Brutal Reasoning: Animals, Rationality, and Humanity in Early Modern England* (Ithaca, NY, 2006), p. 2.

25 *Aberdeen Bestiary* (c. 1250), Aberdeen University Library, MS 24, f.23v.

26 Debra Hassig, 'Beauty in the Beasts: A Study of Medieval Aesthetics', *Res*, 19–20 (1990–91), p. 140.

27 Thomas Aquinas, *Summa Theologica*, trans. the Fathers of the English Dominican Province, Part One, Question 3, Article Eight, www.gutenberg.org.

28 Xenia Muratova, 'Workshop Methods in English Late Twelfth-century Illumination and the Production of Luxury Bestiaries', in *Beasts and Birds of the Middle Ages: The Bestiary and Its Legacy*, ed. Willene B. Clark and Meradith T. McMunn (Philadelphia, PA, 1991), pp. 54–68.

29 *The Deipnosophists; or, Banquet of the Learned, of Athenaeus*, trans. C. D. Yonge (London, 1854), vol. III, sec. 82, p. 602.

30 Cf. *The Fables of Aesop, with a Life of the Author* (London, 1793). This is the Stockdale edition with a 65-page biography of the fabulist whose unjust death at the hands of the Delphians was expiated by 'a destructive pestilence' (p. lxv).

31 Annabelle Patterson, 'Fables of Power', in *Politics of Discourse: The Literature and History of Seventeenth-century England*, ed. Kevin Sharpe and Steven N. Zwicker (Berkeley, CA, 1987), pp. 271–96. Also see Jayne Elizabeth Lewis, *The English Fable: Aesop and Literary Culture, 1651–1740* (Cambridge, 1995); and Mark Loveridge, *A History of Augustan Fable* (Cambridge, 1998). 'All-black SA Acting Company Evicted from Theatre', *Arts* section, *Mail & Guardian Online*, 24 November 2010, http://mg.co.za.

32 Keith Thomas, *Religion and the Decline of Magic* (Oxford and New York, 1997), p. 223.

33 Karl von Amira, *Thierstrafen und Thierprocesse* [1891], cited in Hans Kelsen, *Nature and Society: A Sociological Inquiry* (London, 1946), p. 321. Also see E. P. Evans, *The Criminal Prosecution of Animals* (New York, 1906), and James George Frazer, *Folklore in the Old Testament Studies in Comparative Religion, Legend and Law* (London, 1913), pp. 405–18.

34 Evans, *The Criminal Prosecution of Animals*, p. 143.

35 Esther Cohen, 'Law, Folklore and Animal Lore', *Past and Present*, 110 (February 1986), p. 14, n. 27.

36 On animals that performed good deeds and were popularly taken to be martyrs (unacknowledged by the Church bureaucracy), see Laura Hobgood-Oster, 'Holy Dogs and Asses: Stories Told through Animal Saints', in *What Are the Animals to Us?: Approaches from Science, Religion, Folklore, Literature and Art*, ed. David Aftandilian, David Scofield Wilson and Marion Copeland (Nashville, TN, 2007), pp. 189–203.

37 Jacobus de Voragine, *The Golden Legend or Lives of the Saints*, trans. William Caxton, ed. F. S. Ellis (London, 1902), vol. V, p. 105; vol. VI, p. 42.

38 Erwin Panofsky, 'Dürer's St Eustace', *Record of the Art Museum, Princeton University*, IX/1 (1950), p. 8.

39 Aristotle, *De anima*, 413a20–25, trans. J. A. Smith, in *The Works of Aristotle* (Chicago, IL, 1952), vol. I, p. 653, cited in Fudge, *Brutal Reasoning*, p. 8.

40 For a summary of Dürer in Italy, see Mark Evans, 'Dürer and Italy Revisited: The German Connection', British Museum online, www.britishmuseum.org, accessed 12 February 2013.

41 In other works, however, such as the engraving of *Adam and Eve* (1504), Dürer used animals to symbolize the four bodily humours – melancholic/elk, choleric/cat, phlegmatic/ox and sanguine/rabbit – that according to scholastic theory comprise the human soul. See Bruce Boehrer, *A Cultural History of Animals in the Renaissance* (Oxford, 2009); also Erica Fudge, ed., *Renaissance Beasts: Of Animals, Humans,*

and Other Wonderful Creatures (Bloomington, IL, 2004).

42 Jacobus de Voragine, *The Golden Legend*, vol. III, pp. 4–8.

43 Jonas Liliquist, 'Peasants against Nature: Crossing the Boundaries between Man and Animal in Seventeenth- and Eighteenth-century Sweden', *Journal of the History of Sexuality*, 1/3 (January 1991), pp. 398–9.

44 Cotton Mather, *Magnalia Christi Americana: or, The Ecclesiastical History of New-England*, intro. by Thomas Robbins (Hartford, CT, 1853), vol. II, pp. 405–6.

45 John Berger, 'Why Look at Animals', in *About Looking* (New York, 1992), p. 6.

46 Ibid., p. 11.

47 Niccolò Machiavelli, *Il principe, e discorsi sopra la prima deca di tito Livio*, intro. by Giuliano Procacci (Milan, 1960), p. 72, cited in Perry Anderson, *Lineages of the Absolutist State* (London, 1979), pp. 165–6.

48 Fernand Braudel, *The Structures of Everyday Life: The Limits of the Possible* (Berkeley, CA, 1981), pp. 190–99.

49 François Rabelais, *Gargantua and Pantagruel*, trans. Thomas Urquhart and Peter Le Motteux (London, 1900), vol. II, p. 193.

50 Michel de Montaigne, *The Diary of Montaigne's Journey to Italy in 1580 and 1581*, trans. Emil Julius Trechmann (New York, 1929), p. 66.

51 Braudel, *The Structures of Everyday Life*, pp. 191–2.

52 Wolfgang Stromer von Reichenbach: 'Wildwest in Europa. Der transkontinentale Ochsenhandel in der frühen Neuzeit', *Kultur & Technik: Zeitschrift des Deutschen Museums München*, III/2 (1979), pp. 36–43.

53 On declining meat consumption, see Catharina Lis and Hugo Soly, *Poverty and Capitalism in Pre-industrial Europe* (Hassocks, Sussex, 1979), pp. 13–14. On the debate about wages and standard of living between c. 1500 and 1800, see, for example, J. L. van Zanden, 'Wages and the Standard of Living in Europe, 1500–1800', *European Review of Economic History*, 2 (1999), pp. 175–97.

54 Margaret A. Sullivan, 'Aertsen's Kitchen and Market Scenes: Audience and Innovation in Northern Art', *Art Bulletin*, LXXXI/2 (June 1999), p. 241.

55 Ibid., pp. 251–2.

56 Kenneth M. Craig, 'Pieter Aertsen and *The Meat Stall*', *Oud Holland*, XCVI/I (1982), pp. 114–26.

57 Francis Yates, *The Rosicrucian Enlightenment* (London, 1972).

58 Michael Mayerus, *Lusus Serius or Serious Passe-time: A Philosophical Discourse Concerning the Superiority of Creatures under Man* (London, 1654), p. 120.

59 Ibid., p. 139.
60 He also made a version of the same composition in 1630 (Glasgow Art Gallery).
61 Kenneth Clark, *An Introduction to Rembrandt* (New York, 1978), p. 114.
62 See Tertullianus, *Liber de Pudicitis*, VIII–IX, pp. 994–9, cited in Tyrell J. Alles, *The Narrative Meaning and Function of the Parable of the Prodigal Son* (Ann Arbor, MI, 2009), pp. 3–4.
63 *The Letters of Saint Jerome*, trans. C. C. Mierow (London, 1963), pp. 122–3, cited in Kenneth M. Craig, 'Rembrandt and the Slaughtered Ox', *Journal of the Warburg and Courtauld Institutes*, XLVI (1983), p. 236.
64 Mariët Westermann, *Rembrandt* (London, 2000), p. 13. Also see Sanford Budick, 'Descartes' *Cogito*, Kant's Sublime, and Rembrandt's Philosophers: Cultural Transmission as Occasion for Freedom', *Eighteenth-century Literary History: An MLQ Reader*, ed. Marshall Brown (Durham, NC, 1999), p. 246.
65 Other writers beside Descartes who discounted animal sentience and consciousness include Pierre Chanet, *Considérations sur la sagesse de Charron* (Paris, 1643); Chanet, *De l'instinct et de la connaissance des animaux, avec l'examen de ce que M. de La Chambre a éscrit sur cette matière* (La Rochelle, 1646); Antoine Dilly, *De l'ame des bêtes, ou après avoir démontré la spiritualité de l'ame de l'homme, l'on explique par la seule machine, les actions les plus surprenantes des animaux* (Lyon, 1676).
66 W. Hazlitt and W. O. Wight, eds, *Works of Michel de Montaigne* (Boston, 1879), p. 137.
67 The precise origin of the notion that animals possess positive rights is a much-debated question, but a proximate beginning in the English tradition is Francis Hutcheson, who argued in 1755 that moral reason resided not simply in individuals, but in the logic and goodness of nature as a whole, thus mandating a respect for animal rights: 'these considerations would clearly shew that a great increase of happiness and abatement of misery in the whole must ensue upon animals using for their support the inanimate fruits of the earth; and that consequently it is right they should use them, and the intention of their Creator.' Francis Hutcheson, *A System of Moral Philosophy* (Glasgow, 1755), I–II.vi.ii, cited in Aaron Garrett, 'Francis Hutcheson and the Origin of Animal Rights', *Journal of the History of Philosophy*, XLV/2 (2007), p. 259.
68 *Works of Michel de Montaigne*, p. 136.
69 As Martin Heidegger observed, 'In our everyday preoccupations we do seem to cling to this or that particular being and to get lost in this or that region of beings. But no matter how fragmented our everyday

existence may seem to be, it always deals with what-is in the unity of a
"*whole*", even if only vaguely. In fact it is precisely when we are not
preoccupied with things and with ourselves that this "in-terms-of-a-
whole" overtakes us – for example, in genuine boredom. Genuine
boredom has not yet arrived if we are merely bored with this book
or that movie, with this job or that idle moment. Genuine boredom
occurs when *one's whole world is boring.* Then abysmal boredom, like
a muffling fog, drifts where it will in the depths of our openness,
sucking everything and everyone, and ourselves along with them,
into a numbing sameness. This kind of boredom reveals what-is in
terms of a whole.' Martin Heidegger, 'What is Metaphysics?' [1929],
trans. Thomas Sheehan, *The New Yearbook for Phenomenology and
Phenomenological Philosophy* I (Madison, WI, 2001), n.p., www.
stanford.edu.

70 Letter to the Marquess of Newcastle, 23 November 1646, in *The
 Philosophical Writings of Descartes*, trans. John Cottingham et al., vol. III,
 p. 302, in Hassan Melehy, 'Silencing the Animals: Montaigne,
 Descartes and the Hyperbole of Reason', *Symploke*, XIII/1–2 (2006),
 p. 264.

71 Jacques Derrida, *The Animal That Therefore I Am*, ed. Marie-Louise
 Mallet, trans. David Wills (New York, 2008), p. 6.

72 Michel de Montaigne, *The Essays of Michael de Montaigne*, trans. Peter
 Coste (London, 1811), pp. 32–7. Also see Fudge, *Brutal Reasoning*,
 pp. 76–9.

73 *Fables of La Fontaine*, trans. Elizur Wright Jr (Boston, MA, and New
 York, 1861), vol. I, p. 13.

74 *The Complete Fables of Jean de la Fontaine*, trans. Norman Schapiro and
 intro. by John Hollander (Champaign, IL, 2007), p. xxix.

75 Ibid., p. xxx.

76 Jean de La Fontaine, 'Discours à Madame de La Sablière', in *Longer
 French Poems, Selected and Prepared for Class Use*, ed. Thomas Atkinson
 Jenkins (New York, 1904), p. 13.

77 *Fables of La Fontaine*, vol. II, p. 8.

78 Sarah R. Cohen, 'Animal Performance in Oudry's Illustrations to the
 Fables of La Fontaine', *Studies in Eighteenth Century Culture*, XXXIX
 (2010), p. 54.

79 The common origin of humans and animals was part of the materialism
 of Maupertius, who proposed that spontaneous generation and
 chance produced a great diversity of species, but that only a few
 of these were sufficiently well adapted to survive. See his *Venus
 physique* (Le Haye, 1745); and *Essai de cosmologie* (Paris, 1751). Also s

ee Ernst Mayr, *The Growth of Biological Thought* (Cambridge, 1982), pp. 328–9.

80 'Let us take the Beavers for an Instance. These Animals, to be under Covert and Secure, live in small Huts of Clay, which they build for themselves with amazing Dexterity on the Border of a Lake, and set upon Piles. But they have found that, as they stood in need of each other's Help to build their Dwellings, they must of course live in Society. They then get thirty, forty, more or less together, and after they have pitched upon a Soil fit for their Habitation, and where they hope to live more conveniently and secure, they divide among themselves the Works necessary for the Construction of their Abodes. Some go and fetch the Wood: Others provide the Clay which some of them are commissioned to bring, and this by lying upon their Back with their Paws up, and we know they do, to make a sort of Cart of their Body, which the others drag along to the Place where it is to be used. There one does the Part of a Mason, another that of a Labourer, and a third, that of an Architecture. A Tree is first cut at the Root, and falls into the Lake. This done, other Artificers work at it: Some prepare the Piles, others drive them into the Ground, while others are forming the several Timbers necessary. All is done orderly and in perfect Concert. You would think you saw the *Tyrians* building the City of *Carthage*. The lazy or the forward are undoubtedly punished. The Centries faithfully do their Duty. The Work is carried on to Perfection. It is the Admiration of Men themselves; and then the little Corporation quietly enjoying the Benefit of Work, no longer have any other Thought, but that of living easy, and of multiplying their Species each in his little Family.

Does not so coherent and so well executed an Understanding evidently intimate the Necessity of a Language among these Animals, and their having a Speech whereby they mutually communicate their Thoughts to each other?' Guillaume Hyacinthe Bougeant, *Amusement philosophique sur le langage des bestes* (Paris, 1739), pp. 69–72, trans. online at Animal Rights History (2003), www.animalrightshistory.org.

81 Sarah R. Cohen, 'Chardin's Fur: Painting, Materialism, and the Question of Animal Soul', *Eighteenth-century Studies*, XXXVIII/1 (Fall 2004), pp. 39–61.

82 Denis Diderot, *Œuvres*, ed. Laurent Versini, 5 vols (Paris, 1994–7), vol. IV, p. 843, trans. in P. Conisbee, *Chardin* (Oxford, 1986), pp. 18–19.

83 Denis Diderot, *Diderot's Early Philosophical Works*, trans. and ed. Margaret Jourdain (Chicago, IL, and London, 1916), pp. 36–8. Also see Aram Vartanian, 'La Mettrie and Diderot Revisited: An Intertextual Encounter', *Diderot Studies*, XXI (1983), pp. 155–97.

84 Diderot, *Early Works*, p. 37.

85 Julien Offray de La Mettrie, *Man A Machine* (London, 1750), pp. 23–4.

86 Ibid., pp. 38–9.

87 Cohen, 'Chardin's Fur', p. 39.

88 John Gay, *Fables* (London, 1801), p. 17.

89 Now in the State Museum, Kroměríz, Czech Republic. Jutta Held, 'Titian's *Flaying of Marsyas*: An Analysis of the Analyses', *Oxford Art Journal*, XXXI/2 (2008), pp. 179–94.

90 The woodcut vignettes in this edition of Gay are by John Bewick, brother of the more famous engraver Thomas. They are charmingly archaizing, recalling the woodcuts of the Renaissance Nuremberg artist Virgil Solis, especially his Ovid's *Metamorphosis*. (John's brother Thomas – the more renowned illlustrator with whom John collaborated, owned a copy of the *Ovidii Metamorph* (1569)). See Robert Robinson, ed., *Bewick Memento* (London, 1896), p. 6. This backward glance served to recall a time when the connection between human and animal, the product of what I have called 'popular animism', was stronger and less threatened than in the artist's own day.

91 Gay, *Fables*, p. 16. See, for example, Pieter Brueghel the Elder's etching and engraving 'Spring', from his series *The Seasons* (1570). In the middle ground at centre right, a lamb is shown being sheared.

92 Ibid., p. 29.

93 Ibid., p. 96. The lines from Garth are slightly different than Gay remembered: 'Where little villains must submit to fate / That great ones may enjoy the world in state'. Samuel Garth, *The Dispensary, A Poem in Six Cantos* (London, 1714), p. 3.

94 Gay's emphasis upon the moral value of increasing pleasure and diminishing pain places him at the origin of the utilitarian tradition. See his *Concerning the Fundamental Principle of Virtue or Morality*, *British Moralists*, ed. Sir Lewis Amherst Selby-Bigge (Oxford, 1897), p. 285.

95 John Locke, *Some Thoughts Concerning Education* (London, 1693), para. 110, p. 130. Also see Fielding, 'Covent Garden', in *Awe for the Tiger, Love for the Lamb: A Chronicle of Sensibility to Animals*, ed. Rob Preece (Vancouver, 2002), p. 135, cited in Monica Flegel, *Conceptualizing Cruelty to Children in Nineteenth-century England: Literature, Representation and the NSPCC* (London, 2009), p. 43.

96 'A bitch had once all her litter stolen from her, and drowned in a neighbouring brook: she sought them out, and brought them one by one, laid them at the feet of her cruel master and looking wistfully at them for some time, in dumb anguish, turning her eyes on the destroyer, she expired! I myself knew a man who had hardened his

heart to such a degree, that he found pleasure in tormenting every creature whom he had any power over. I saw him let two guinea-pigs roll down sloping tiles, to see if the fall would kill them. And were they killed? cried Caroline. Certainly; and it is well they were, or he would have found some other mode of torment. When he became a father, he not only neglected to educate his children, and set them a good example, but he taught them to be cruel while he tormented them: the consequence was, that they neglected him when he was old and feeble and he died in a ditch.' Mary Wollstonecraft, *Original Stories from Real Life: With Conversations, Calculated to Regulate the Affections* (London, 1796), pp. 15–16.

97 Thomas Young, An Essay on Humanity to Animals (London, 1798), p. 5.

98 Julius Bryant, *Kenwood: Paintings in the Iveagh Bequest* (New Haven, CT, and London, 2004), p. 218. Also see *Gainsborough*, ed. Michael Rosenthal and Martin Myrone (London, 2002), p. 142.

99 John Trusler, *The Works of Mr Hogarth, Moralized* (London, 1768), pp. 133–4.

100 John Toogood, *The Duty of Mercy and Sin of Cruelty to Brutes*, taken chiefly from D. Primatt's dissertation (Boston, MA, 1802), p. 38.

101 Trusler, *The Works of Mr Hogarth*, p. 143.

102 William Hogarth, 'Autobiographical Notes', in *The Analysis of Beauty*, ed. Joseph Burke (Oxford, 1955), p. 226.

103 Hutcheson, *A System*, I-II.vi.ii; cited in Garrett, 'Francis Hutcheson', p. 259.

104 Jeremy Bentham, chap. XVII: 'Of the Limits of the Penal Branch of Jurisprudence', n. 122, in *An Introduction to the Principles of Morals and Legislation* (Oxford, 1879), p. 312. In fact, the Code Noir, inspired by Colbert but only passed in 1689 after his death, offered very few protections to slaves – principally against torture and murder. Severe corporal punishments including branding, cutting off of the ears, severing the hamstring muscle and execution for striking the master or any member of his family) was permitted: *Le Code Noir ou Recueil des réglements rendus . . . concernant la discipline et le commerce des nègres* (Paris, 1742), articles 40–43.

105 William Cowper, *The Task* (London, 1785), p. 108.

106 Ibid., pp. 254, 260–61. See Tristram Stuart, *The Bloodless Revolution: A Cultural History of Vegetarianism from 1600 to Modern Times* (New York and London, 2007), pp. 222–3.

107 Alexander Pope, *Essay on Man* (London, 1762), p. 62.

108 Stuart, *Bloodless Revolution*, pp. 220–21; Francis Hutcheson, *A Short Introduction to Moral Philosophy* (Glasgow, 1765), vol. I, pp. 159.

109 Similar arguments continue to be made today. See, for example,
R. R. Hare, 'Why I Am Only a Demi-vegetarian', in *Singer and his Critics*
(Oxford, 1999), pp. 233–46; Temple Grandin, *Animals Make Us Human*
(Orlando, FL, 2009), pp. 295–304; Kathy Rudy, *Loving Animals: Towards
a New Animal Advocacy* (Minneapolis, MN, 2011), pp. 73–110.

110 On the happiness of wild animals and the adaptive significance of
pleasure, see Jonathan Balcomb, *Pleasurable Kingdom: Animals and the
Nature of Feeling Good* (New York, 2006).

111 David Williams, *Lectures on Education*, vol. II (London, 1789), p. 281.
Also see Williams, *Lectures on the Universal Principles and Duties of Religion
and Morality* (London, 1789), pp. 48–61, cited in Stuart, *Bloodless*, p. 332.

112 On the chimera of 'happy meat' (free range, organic, cage free, pasture-
raised and so on) see www.humanemyth.org and Ashley Capps, 'A
Comprehensive Analysis of the Humane Farming Myth', 27 September
2012, http://freefromharm.org. Also Mathew Cole, 'From "Animal
Machines" to "Happy Meat"? Foucault's Ideas of Disciplinary and
Pastoral Power Applied to "Animal-centred" Welfare Discourse',
Animals, I/I (2011), pp. 83–101.

113 Stuart, *Bloodless*, p. 219.

114 Immanuel Kant, *Lectures on Ethics*, ed. Peter Heath and J. B.
Schneewind, trans. Peter Heath (Cambridge, 1997), p. 125.

115 Ibid., p. 147, cited in Gary Steiner, *Animals and the Moral Community*
(New York, 2008), p. 95. While Kant did not share Descartes' view
that animals are mere machines completely lacking sentience, he
nevertheless believed that humans owed them no duty. If kindness
toward animals was a virtue, it was only because such treatment
advanced human's own moral worth. Generosity, gentleness and
gratitude toward animal companions and servants predisposed
humans to the same virtuous behaviour toward each other. In this
way, Kant embraced and continued ancient Stoic speciesism, but
because of his categorical imperative – the idea that any action must
be judged on the basis of whether it should be a universal law – he
could not sanction the wanton cruelty and gross exploitation that
followed from Stoic attitudes.

116 Kant's position is subjected to immanent critique in Theodor Adorno,
Negative Dialectics, trans. E. B. Ashton (New York, 1973), p. 299,
discussed in Christina Gerhardt, 'The Ethics of Animals in Adorno
and Kafka', *New German Critique*, 97 (Winter 2006), pp. 159–78.

3 The Cry of Nature

1 Richard Lawrence, *An inquiry into the structure & animal œconomy of the horse* (London, n.d.), p. 175.

2 Comte de Buffon, *Natural History, General and Particular*, ed. William Smillie, vol. III (Edinburgh, 1780), pp. 270–74, cited in Diana Donald, *Picturing Animals in Britain, 1750–1850* (New Haven, CT, and London, 2007), p. 73.

3 See Jenifer Montagu, *The Expression of the Passions: The Origin and Influence of Charles Le Brun* (New Haven, CT, 1994). Also Christopher Allen, 'Painting the Passions: the *Passions de l'Âme* as a basis for Pictorial Expression', in *The Soft Underbelly of Reason: The Passions in the Seventeenth Century*, ed. Stephen Gaukroger (London and New York, 1998), p. 96.

4 *Public Advertiser*, 4 November 1763, cited in Donald, *Picturing Animals*, p. 73.

5 'The Pathosformel must not be translated in terms of a semantics or semiotics of corporeal gestures, but in terms of a psychic symptomatology. Pathos formulae are the visible symptoms – corporeal, gestural, presented, figured – of a psychic time irreducible to the simple thread of rhetorical, sentimental, or individual turns.' Georges Didi-Huberman, 'Dialektik des Monstrums: Aby Warburg and the Symptom Paradigm', *Art History*, XXIV/5 (November 2001), p. 622. Didi-Huberman's usage of Warburg's conception reverses mine. In the present book – as in my *The Abu Ghraib Effect* – the term 'pathos formula' signifies the longstanding motif whereby humans or animals are represented as willing participants in their own chastisement or even death. Those artists and others who represent the 'cry of nature' on the other hand, reject this motif in favour of a more direct, even instinctual rhetoric of the body and primary process emotions – fear, pain, joy and so on.

6 Judy Egerton, *George Stubbs, Painter* (New Haven, CT, and London, 2007), p. 17.

7 Erasmus Darwin, *The Temple of Nature: A Poem with Philosophical Notes* (Baltimore, MD, 1804), pp. 67–8.

8 James Burnet, *Origin and Progress of Language* (Edinburgh, 1789), vol. V, pp. 289–93.

9 J.-J. Rousseau, *A Discourse upon the Origin and Foundation of the Inequality among Mankind* (London, 1761), pp. 187–96.

10 Mary Wollstonecraft, *Original stories from real life; with conversations, calculated to regulate the affections, and form the mind to truth and goodness* (London, 1791), pp. 5–6.

11 John Adlard, *The Sports of Cruelty: Folk-songs, Charms, and Other Country*

Matters in the Work of William Blake (London, 1972).

12 William Blake, *Milton a Poem, and the Final Illuminated Works*, ed. Robert N. Essick and Joseph Viscomi (Princeton, NJ, 1993), p. 184.

13 Adlard, *The Sports*, p. 57. Also see William Blake, *Milton*, pp. 193–4. Many thanks to Bob Essick for his valuable suggestions.

14 David Hartley, 'On the Intellectual Faculties of Beasts', in *Observations on Man* (London, 1791), pp. 244–5.

15 The echo is again from *Lear* (III.4):

> Poor naked wretches, whereso'er you are,
> That bide the pelting of this pitiless storm,
> How shall your houseless heads and unfed sides,
> Your looped and windowed raggedness, defend you
> From seasons such as these? Oh, I have ta'en
> Too little care of this! Take physic, pomp.
> Expose thyself to feel what wretches feel,
> That thou mayst shake the superflux to them
> And show the heavens more just.

16 Sir Walter Scott, *The Poetical Works of Sir Walter Scott* (Edinburgh, 1841), p. 703.

17 Bernard de Mandeville, *The Fable of the Bees: or, Private Vices, Publick Benefits* (London, 1724), p. 196.

18 Joseph Ritson, *The Letters of Joseph Ritson . . . in the Possession of his Nephew*, ed. Sir Harris Nicolas (London, 1833), vol. I, p. 41.

19 Joseph Ritson, *An Essay on Abstinence from Animal Food: As a Moral Duty* (London, 1802), pp. 33–4.

20 Henry Tegner, *Wild Hares* (London, 1969), pp. 36–7, cited in David Perkins, 'Animal Rights and "Auguries of Innocence"', *Blake: An Illustrated Quarterly*, XXXIII/1 (Summer 1999), p. 11. Also see William Somerville's poem 'The Chase', which contains the lines describing the last moments of a hare's life: 'with infant screams / she yields her breath' (Birmingham, 1767), p. 52.

21 Thomas Bewick, *A Memoir of Thomas Bewick Written by Himself* (Newcastle upon Tyne, 1862), p. 9.

22 Ibid., p. 7.

23 Bewick's naturalistic fawn (engraved after a drawing by W. M. Craig) lies stricken in a now notably English countryside with a thatched and half-timbered farmhouse to the right, and a Gothic parish church in the background to the left. The text below it is copied from Oswald's lines from *The Cry*, 'It was a playful fawn . . .', though changed to omit

the more sensational and irreligious phrases 'bosom of parent earth' and 'darling of nature'.

24 Ibid., p. 181.

25 Harriet Ritvo, *The Animal Estate: The English and Other Creatures in the Victorian Age* (Cambridge, 1989), pp. 45–81.

26 George Coates, *The General Short-horned Herd Book* (Otley, 1822).

27 Charles Bird, 'Black Beauty', *Cherryburn Times*, IV/6 (Spring 2004), pp. 1–2.

28 Ibid., p. 332. 'The generous horse, who has carry'd his ungrateful master Lo many years, with ease and safety, worn out with age and infirmitys contracted in his service, is by him condemn'd to end his miserable days in a dust-cart, where the more he exerts his little remains of spirit, the more he is whip'd to save his stupid driver the trouble of whipping some other, less obedient to the lash.' Ritson, *An Essay*, p. 229.

29 Letter of 1802 from Henry Redhead Yorke, *Letters from France* (London, 1804), pp. 160–63; in David V. Erdman, *Commerce des lumières: John Oswald and the British in Paris, 1790–1793* (New York, 1986), p. 8.

30 See, for examples, the discussion of 'General Will', in Oswald's translation of Goodman Gerard: J.-M. Collot-D'Herbois, *The Spirit of the French Constitution, or the Almanach of Goodman Gerard* (London and Paris, 1791), pp. 20–22.

31 *The British Mercury* (London, 1788), pp. 137–8. On Oswald, see Erdman, *Commerce des lumières*.

32 Ibid., p. 106.

33 Johann Oswald, *The Cry of Nature, or, an Appeal to Mercy and Justice on behalf of the Persecuted Animals* (London, 1791), pp. 21–2.

34 Ibid., p. 24.

35 Ibid., pp. 38–40.

36 Ibid., pp. 72–3.

37 Johann Kaspar Lavater, *Essays on Physiognomy*, trans. Henry Hunter (London, 1792), vol. II, p. 119.

38 H. W. Dickinson and Rhys Jenkins, *James Watt and the Steam Engine* (London, 1989), pp. 353–5.

39 C. McShane and J. A. Tarr, *The Horse in the City: Living Machines in the Nineteenth Century* (Baltimore, MD, 2007).

40 Lorenz Eitner, 'The Sale of Géricault's Studio in 1824', *La Gazette des Beaux-Arts* (1959), p. 120.

41 Albert Boime, *Art in an Age of Counterrevolution, 1815–1848* (Chicago and London, 2004), p. 158.

42 Georges-Louis Leclerc, Comte du Buffon, *Buffon's Natural History* (London, 1792), vol. VI, pp. 287–8.

43 J.-J. Rousseau, *Emilius: or, an Essay on Education*, trans. Mr Nugent (London, 1763), p. 1.

44 J.-J. Rousseau, *A Discourse upon the Origin and Foundation of the Inequality among Mankind* (London, 1761), p. 89.

45 George Rudé, *Ideology and Popular Protest* (Chapel Hill, NC, 1995), p. 22.

46 Nina Maria Athanassoglou-Kallmyer, 'Imago Belli: Horace Vernet's *L'Atelier* as an Image of Radical Militarism under the Restoration', *Art Bulletin*, LXVIII/2 (June 1986), pp. 268–80.

47 Rousseau, *A Discourse upon the Origin and Foundation of the Inequality*, pp. 71–2. Recent research in primatology has described mourning behaviour among chimpanzees. See Katherine A. Cronin, Edwin J. C. Van Leeuwen, Chitalu Melunga and Mark D. Bodamer, 'Behavioral Response of a Chimpanzee Mother Toward her Dead Infant', *American Journal of Primatology*, LXXIII (2011), pp. 415–21.

48 Whitney Wheelock, *Géricault in Italy* (New Haven, CT, and London, 1997), pp. 74–5.

49 Géricault may have known the work of Oswald, the radical Scotsman who died fighting the counter-revolution in the Vendee. He certainly would have been aware of the almost legendary reputation and writings of the revolutionary Girondins such as J.-P. Brissot and the Marquis de Valady, who cultivated a vegetarian diet. Even the poet and historian Alphonse de Lamartine, Géricault's contemporary and the author in 1847 of the *History of the Girondins*, was a vegetarian. (He was a follower of the vegetarian novelist and *philosophe* Jacques-Henri Bernardin de Saint-Pierre, author of *Paul et Virginie*, a Rousseau-inspired story of life in the harmonious isle of Mauritius.) While in London, Géricault may also have come to know Shelley's *Queen Mab* (London, 1821), with its well-known Note VIII concerning the virtues of the vegetarian diet (pp. 161–82). The greatest other radical vegetarian of the day was Joseph Ritson. See his *An Essay*.

50 John Scott, *The Sportsman's Repository* (London, 1820), p. vii.

51 *Fables de La Fontaine*, illustrated by J.J. Grandville (Paris, 1838), p. 250.

52 J.J. Grandville, *Public and Private Life of Animals*, trans. J. Thomson (London, 1877), p. 1.

53 J.J. Grandville, *Scènes de la vie privée et publique des animaux* (Paris, 1842), pp. 1–29.

4 Counter-revolution

1 Adolphe Thiers, *The History of the French Revolution*, vol. III (London, 1881), pp. 449–50.

2 *Correspondance de Napoléon I, publiée par ordre de l'empereur Napoléon III*, vol. xx (Paris, 1866), vol. xx, p. 190.

3 Louis-Sébastien Mercier, *Tableau de Paris*, 5 vols (Paris, 1782), vol. v, pp. 123–4.

4 *Conseil Général d'Administration des Hospices et Secours de la Ville de Paris* (Paris, 1806), p. 27, cited in Vincent J. Knapp, 'The Democratization of Meat and Protein in Late Eighteenth- and Nineteeth-century Europe', *The Historian*, LIX/541 (2007), p. 546.

5 Edward William Shanahan, *Animal Foodstuffs: Their Production and Consumption* (London, 1920), pp. 255–6.

6 Kyri Claflin, 'La Villette, City of Blood: 1867–1914', in Paula Young Lee, ed., *Meat, Modernity, and the Rise of the Slaughterhouse* (Durham, NC, 2008), pp. 27–45.

7 Emile Zola, *The Fat and the Thin*, trans. Edward Vizetelly (London, 1896), n.p.

8 Charles Baudelaire, 'A Carcass', *The Flowers of Evil*, trans. William Aggeler http://wiki.creativecommons.org/Books, pp. 95–6.

9 Académie d'agriculture de France, *Mémoires d'agriculture, d'économie rurale et domestique* (Paris, 1853), p. 559; Gaston Leroux, *La Double vie de Théophraste Longuet* (Paris, n.d.), p. 222.

10 Claflin, 'La Villette', pp. 40–41.

11 Charles Dickens, *The Adventures of Oliver Twist*, intro. by Andrew Lang (London, 1897), pp. 454–5. Uncertain if dogs are motivated by instinct or cognitive understanding, Dickens offers both explanations for Bullseye's behaviour.

12 Ibid., p. 479.

13 John Ruskin, *The Works of John Ruskin* (London, 1904), vol. XIV, p. 66.

14 Charles Darwin, *The Expression of the Emotions in Man and Animals* (London, 1873), p. 66.

15 Ibid., p. 122.

16 Ibid., p. 83.

17 Phillip Prodger, 'Illustration as Strategy in Charles Darwin's *The Expression of the Emotions in Man and Animals*', in *Inscribing Science: Scientific Texts and the Materiality of Communication*, ed. Timothy Lenoir (Stanford, CA, 1998), pp. 140–82.

18 McDougall Scott, *Sir Edwin Landseer, RA* (London, 1907), p. 42.

19 Martin A. Danahay, 'Nature Red in Tooth and Paw: Domestic Animals and Violence in Victorian Art', in *Victorian Animal Dreams: Representations of Animals in Nineteenth-century Literature and Culture*, ed. Deborah Denenholz Morse and Martin A. Danahay (Aldershot, 2007), p. 107.

20 Jonathan Smith, *Charles Darwin and Victorian Visual Culture* (London and Cambridge, 2006), pp. 206–8.

21 Gustave Courbet, 'Notes sur la chasse', in *Courbet raconte par lui-meme et par ses amis*, ed. Pierre Courthion (Geneva, 1948), vol. 1, pp. 38–9, cited in Shao-Chien Tseng, 'Contested Terrain: Gustave Courbet's Hunting Scenes', *Art Bulletin*, XC/2 (June 2008), pp. 218–34. Though ostensibly protectionist, Michelet's condescension is perhaps the mirror of Courbet's self-absorption: 'The animal! Somber mystery . . . Immense world of mute dreams and pains . . . Though, in default of language, these pains are expressed by too visible signs. All nature protests against the barbarity of the man who disowns, degrades, who tortures his inferior brother, and accuses him before Him who created them both!' Jules Michelet, *The People*, trans. G. H. Smith (New York, 1846), p. 126.

22 Charles Darwin, *The Descent of Man* (New York, 1871), vol. 1, p. 38.

23 Ibid., p. 45.

24 Ibid., p. 52.

25 Ibid., p. 141.

26 Ibid., p. 234.

27 Smith, *Charles Darwin*, p. 208.

28 John Verschoyle, *Slaughter-house Reform* (London, 1903), p. 7.

29 Adrian Desmond and James Moore, *Darwin* (London, 1991), pp. 615–16.

30 Lee, *Meat*, pp. 164–6. For an account of the working conditions of Chicago meat cutters pre-Upton Sinclair, see John R. Commons, 'Labor Conditions in Meat Packing and the Recent Strike', *Quarterly Journal of Economics*, XIX/1 (November 1904), pp. 1–32.

31 Henry Ford (with Samuel Crowther), *My Life and Work* (Garden City, NY, 1922), p. 81.

32 Eugen Kogon, Hermann Langbein and Adalbert Rückerl, eds, *Nazi Mass Murder: A Documentary History of the Use of Poison Gas* (New Haven, CT, 1993), p. 110, cited in Charles Patterson, *Eternal Treblinka: Our Treatment of Animals and the Holocaust* (New York, 2002), p. 113. For a point by point defence of the validity of the comparison between the Holocaust and the treatment of animals, see David Sztybel. 'Can the Treatment of Animals be Compared to the Holocaust?', *Ethics and the Environment*, XI/1 (Spring 2006), p. 97. Temple Grandin, whose slaughterhouse designs have decreased animal fear and increased the speed and efficiency of their slaughter, calls her system 'the stairway to heaven'. She described her rationale in an interview with NPR reporter Daniel Zwerdling: '"And another reason to make sure we're not doing atrocious things at the slaughter plant is that if it is too easy to do

something really atrocious to an animal – with the poor animal
screaming and everything – the person who could do that might not
have any problem torturing people", says Grandin. "I remember
one of the reasons that St Thomas Aquinas said that we have to treat
animals right is so that people themselves don't get corrupted." When
Grandin designed the ramp that takes the cattle to their deaths, she
gave it a nickname, and now people all over the industry use it – "the
stairway to heaven". She got the name from one of her favorite songs;
by the rock group Led Zeppelin. She takes a cassette out from the bin
between the seats, pops it in and sings along. "There's a lady who's
sure all that glitters is gold, and she's buying a stairway to heaven,"
Grandin sings, driving home from the Excel slaughterhouse on the
plains of Colorado'. Daniel Zwerdling, 'Kill Them With Kindness',
American Radio Works (April 2002), http://americanradioworks.
publicradio.org.

33 Rudolf Höss, *Commandant of Auschwitz: The Autobiography of Rudolf
Höss* (Cleveland, OH, 1958), p. 230; Gustave Gilbert, *Nuremberg Diary*
(New York, 1995), pp. 249–50.

34 United States Bureau of Labor Statistics, *Wages and Hours of Labor in
the Slaughtering and Meat-packing Industry, 1917* (1919).

35 Swift & Company, *Visitor's Reference Book* (1903). Duke University
Libraries Digital Collections, http://library.duke.edu. See Nicole
Shukin, *Animal Capital: Rendering Life in Biopolitical Times* (Minneapolis,
MN, 2009).

36 Upton Sinclair, *The Jungle* (New York, 2006), p. 27.

37 Ibid., pp. 37–8.

38 Alfred Victor Frankenstein, *After the Hunt: William Harnett and Other
American Still Life Painters, 1870–1900* (Berkeley, CA, 1953), p. 66.

39 Fannie Merritt Farmer, *Original 1896 Boston Cooking-school Cook Book*
(New York, 1997), pp. 216–17.

5 Primal Scenes

1 On Rousseau's inconsistent vegetarianism, see Rod Preece, *Sins
of the Flesh: A History of Ethical Vegetarian Thought* (Vancouver, 2008),
pp. 218–24. Also see Kelly Oliver, *Animal Lessons: How they Teach us to be
Human* (New York, 2009), pp. 27–55.

2 It is noteworthy that in the *Eighteenth Brumaire of Louis Bonaparte* (1852),
Marx describes this class with language derived in part from the
meat markets: 'vagabonds, discharged soldiers, discharged jailbirds,
escaped galley slaves, swindlers, mountebanks, lazzaroni, pickpockets,

tricksters, gamblers, *maquereaux*, brothel keepers, porters, literati, organ grinders, ragpickers, knife grinders, tinkers, beggars – in short, the whole indefinite, disintegrated mass, thrown hither and thither, which the French call *la bohème*; from this kindred element Bonaparte formed the core of the Society of December 10. A "benevolent society" – insofar as, like Bonaparte, all its members felt the need of benefiting themselves at the expense of the laboring nation. This Bonaparte, who constitutes himself *chief of the lumpenproletariat*, who here alone redis-covers in mass form the interests which he personally pursues, who recognizes in this *scum, offal, refuse of all classes* the only class upon which he can base himself unconditionally, is the real Bonaparte, the Bonaparte *sans phrase*', www.marxists.org.

3 Paola Cavalieri and Catherine Woollard, *The Animal Question: Why Non-human Animals Deserve Human Rights* (Oxford and New York, 2001).

4 In the last quarter of the nineteenth century, anti-vivisection and animal rights movements grew at a greater rate than ever before. A key figure in the development was Henry Salt, author in 1892 of *Animal Rights*. Salt was the first true historian of the animal rights movement, and he traced in his book the development of the theory of animal rights from antiquity through the Enlightenment to his own day. Rejecting the idea that the struggle for human rights must always trump that for animal rights, he argued that 'it is only by a wide and disinterested study of both subjects that a solution of either is possi-ble.' H. S. Salt, *Animal Rights: Considered in Relation to Social Progress* (New York and London, 1892), p. 21. On the relationship of the animal rights movement to other progressive movements during the *fin de siècle*, see Leela Gandhi, *Affective Communities: Anticolonial Thought, Fin-de-siècle Radicalism, and the Politics of Friendship* (Durham, NC, and London, 2006), pp. 67–114.

5 Darwin to J. D. Hooker, 24 December 1856, *Darwin Correspondence Project*, www.darwinproject.ac.uk. On the development of Darwin's understanding of species, see Ernst Mayr, *The Growth of Biological Thought* (Cambridge, 1982), pp. 265–70.

6 Ibid., p. 273.

7 T. H. Huxley, 'On the Hypothesis that Animals are Automata, and its History', *Fortnightly Review*, n.s., XVI, §240: http://alepho.clarku.edu.

8 Sigmund Freud, *Project for a Scientific Psychology: The Standard Edition of the Complete Psychological Works of Sigmund Freud*, ed. and trans. James Strachey (London, 1953–74), vol. I: (1886–1899): *Pre-psycho-analytic Publications and Unpublished Drafts*, p. 295.

9 Ibid., p. 311.

10 Sigmund Freud, 'Some Elementary Lessons on Psycho-analysis', *The Standard Edition*, vol. XXIII, p. 284, cited in D. L. Smith, *Freud's Philosophy of the Unconscious* (Dordrecht, 1999), p. 32.

11 Frank J. Sulloway, *Freud, Biologist of the Mind: Beyond the Psychoanalytic Legend* (New York, 1979), pp. 245–51. Also see Eliza Slavet, 'Freud's "Lamarckism" and the Politics of Racial Science', *Journal of the History of Biology*, XLI/1 (Spring 2008), pp. 37–80.

12 On Freud's debt to recapitulation theory, G. J. Romanes and the Wolf Man's drawing as an evolutionary tree, see Whitney Davis, 'Sigmund Freud's Drawing of the Dream of the Wolves', *Oxford Art Journal*, XV/2 (1992), pp. 78–81.

13 Freud, 'Notes Upon a Case of Obsessional Neurosis', *The Standard Edition*, vol. X: (1909): *Two Case Histories ('Little Hans' and the 'Rat Man')*, pp. 151–318.

14 Ibid., p. 166. On politics, power, and torture in The Rat Man, see Jose Brunner, 'Wordly Powers: A Political Reading of the Rat Man', *American Imago*, LVIII/2 (Summer 2001), pp. 501–24.

15 Gerbiling is the supposed practice of putting small animals, usually rodents, in the anus for the purpose of obtaining sexual pleasure. See Jan Harold Bruvand, 'Gerbiling', *Encyclopedia of Urban Legends* (New York, 2001), p. 166.

16 Freud, 'Analysis of a Phobia in a Five-year-old Boy', *The Standard Edition*, vol. X, pp. 1–150.

17 ' . . . the sexuality of neurotics has remained in, or been brought back to an infantile state.' Freud, 'Three Essays on the Theory of Sexuality', *The Standard Edition*, vol. VII, p. 172. Also see Jane Temperley, 'The Analysis of a Phobia in a Five Year Old Boy', in *Freud: A Modern Reader*, ed. Rosine Jozef Perelber (London, 2005), p. 61.

18 Though Hans told his father about seeing the breakdown of a single horse, two horses, not one, drew the buses of *fin de siècle* Vienna. See F. T. Aman, 'Vienna: Its Tramway System and Sections of Boulevards Tramways', *Town Planning Review*, 1/4 (January 1911), p. 294.

19 Sigmund Freud, 'Analysis of a Phobia in a Five-year-old Boy', in *The Sexual Enlightenment of Children*, ed. James Strachey (New York, 1974), p. 94.

20 Freud, 'Analysis of a Phobia in a Five-Year-Old Boy', 1974, p. 91.

21 For a specifically gendered criticism of Freud's interpretation of his patient's phobias, see George Dimock, 'Anna and the Wolf-man: Rewriting Freud's Case History', *Representations*, L (Spring 1995), pp. 53–75.

22 Cf. J. G. McClennan, *An Inquiry into the Origin of the Form of Capture in Marriage Ceremonies* (Edinburgh, 1865); and W. Robertson Smith,

Kinship and Marriage in Early Arabia (Cambridge,1885). Also see A. G. Wilken, *Het Matriarchaat bij de oude Arabieren* (Amsterdam, 1884); Lewis Henry Morgan, *Ancient Society; or, Researches in the Lines of Human Progress from Savagery, through Barbarism to Civilization* (New York, 1877); and G. J. Frazer, *Totemism and Exogamy* (London, 1910). On Freud's use and misuse of anthropology, see Edwin R. Wallace, *Freud and Anthropology: A History and Reappraisal* (New York, 1983).

23 Sigmund Freud, *Totem and Taboo*, trans. A. A. Brill (New York, 1918), p. 58, at www.bartleby.com.

24 On the etiology of animal phobias, see Richard J. McNally and Gail S. Steketee, 'The Etiology and Maintenance of Severe Animal Phobias', *Behavioral Research Therapy*, XXIII/4 (1985), pp. 431–5. Their research found that most phobias began in early childhood, grew worse over time, and had no common 'mode of onset'.

25 The profound psychic effect of 'the uncanny' – *das Unheimlich* – was the subject of Freud's celebrated essay of 1919: 'The "Uncanny"', *The Standard Edition*, vol. XVII: (1917–1919): *An Infantile Neurosis and Other Works*, pp. 217–56.

26 G. F. Watts, 'Art Needlework', *Appleton's Journal*, X (January–June 1881), p. 428.

27 See the Wolf Man's own account of his childhood: *The Wolf Man by the Wolf Man*, ed. Muriel Gardiner (New York, 1971), pp. 3–21.

28 Given that the Wolf Man spent time in Munich during the period that Franz Marc was there, it is tempting to suppose that the latter influenced the former. However, the bulk of Marc's animal paintings and drawings – and their exhibition – seems to just post-date the session with Freud in 1910 during which the drawing was produced. Marc, a leader of the German Blaue Reiter group, believed that the fate of human and animal life was deeply interconnected, and that mutual survival depended upon acceptance of what he considered spiritual treasures and rejection of material wealth. He projected the highest moral values upon animals, depicting them with non-naturalistic colours that conformed to his theosophically influenced colour theory: blue as the masculine and spiritual principle, and red and yellow as feminine and earth-based hues. Influenced by the war, however – a nd possibly by his observation of the use of horses in warfare – Marc began to believe that animals share the same character traits as humans, bad as well as good, and that they could not serve as a recourse for hope and spiritual emancipation. See Franz Marc, *The Complete Works*, 3 vols, ed. Annegret Hoberg and Isabelle Jansen (London, 2004–11).

29 See Lisa Heiss, *Askania-Nova: Animal Paradise in Russia: Adventure of the Falz-Fein Family* (London, 1970).

30 Jacques Derrida, *The Beast and the Sovereign*, trans. Geoffrey Bennington (Chicago, IL, 2011), vol. I, pp. 2–6.

31 Freud, *New Introductory Lectures on Psychoanalysis*, *The Standard Edition*, vol. XXII, p. III. See Oliver, *Animal Lessons*, pp. 222–52.

32 Clement Greenberg, 'Soutine', in *The Collected Essays and Criticism: Affirmations and Refusals, 1950–1956*, ed. John O'Brian (Chicago, IL, 1995), p. 73.

33 Ibid., p. 76.

34 M. Tuchman, E. Dunow and K. Perls, *Chaïm Soutine (1893–1943)*, *Catalogue raisonné* (Cologne, 1993), vol. I, p. 16.

35 On the distinction between 'domestic' and 'post-domestic' ages – the first of human–animal intimacy and the second of separation – see Berger, 'Why Look at Animals?', and Richard W. Bulliet, *Hunters, Herders, and Hamburgers: The Past and Future of Human–Animal Relationships* (New York, 2005).

36 Michael F. Metcalf, 'Regulating Slaughter: Animal Protection and Antisemitism in Scandinavia, 1880–1941', *Patterns of Prejudice*, 23 (1989), pp. 32–48.

37 J. A. Dembo, *The Jewish Method of Slaughter Compared with Other Methods from the Humanitarian, Hygienic and Economic Points of View* (London, 1894).

38 Mary Douglas, *Purity and Danger: An Analysis of the Concepts of Pollution and Taboo* (London, 1966), pp. 41–57.

39 Talmud B.M. 32a, cited in Michelle Hodkin, 'When Ritual Slaughter isn't Kosher: An Examination of Shechita and the Humane Methods of Slaughter', *Journal of Animal Law*, I/I (2005), p. 136.

40 Moses Maimonides, *Guide for the Perplexed*, 3:48, cited in Hodkin, 'When Ritual Slaughter isn't Kosher', p. 136.

41 Isaac Bashevis Singer, 'The Letter Writer', trans. Alizah Shevrin, Elizabeth Shub, *New Yorker*, 13 January 1968, p. 44. Singer's story was surely a basis for Art Spiegelman's famous graphic oral history, *Maus* (New York, 1986).

42 The extent to which large-scale Jewish slaughterhouses today conform to traditional *shechita* has been called into question by the case of AgriProcessors Inc. of Postville, Iowa. In 2004, witnesses from PETA saw and filmed unspeakable cruelties, and after pressure from them and Temple Grandin – the noted expert on humane slaughtering – the U.S. Department of Agriculture demanded new procedures and new oversights. Subsequently, however, a raid by the U.S. Immigration and Customs Enforcement Agency led to an

investigation that revealed gross financial improprieties by the owner
and founder of Agriprocessor Inc., Shalom Rubashkin, who was
convicted of fraud and sentenced to 27 years in prison. The company
was sold at auction in 2009 and now operates under the name Agri
Star. The meatpacking plant recently received the designation of
'glatt kosher' (meaning that the lungs of its slaughtered cattle are
guaranteed to be smooth and without defect), and its CEO, Hershey
Friedman, has promised to increase its production to more than
1,000 head of cattle per day. None of its public pronouncements have
concerned animal welfare. Jean Caspers-Simmet, 'Agri Star Promises
Big Economic Effect in Postville', *Iowa News*, 29 March 2010, www.
agrinews.com; Rod Boshart, 'Agri Start Chief Talks of Company
Rebirth', 13 April 2010, *Cedar Valley Business Monthly Online*,
http://wcfcourier.com.

43 Max Horkheimer and Theodor W. Adorno, *Dialectic of Enlightenment*,
trans. John Cumming (New York, 1972), p. xiii.

44 Ibid., p. 245.

45 *Walter Benjamin, Selected Writings*, ed. Marcus Paul Bullock, Michael
William Jennings and Howard Eiland (Cambridge, 1999), p. 478.

46 Ibid., p. 810.

47 Franz Kafka, *The Penal Colony: Stories and Short Pieces*, trans. Willa and
Edwin Muir (New York, 1948), p. 173.

48 Ibid., p. 67.

49 Theodor Adorno, *Prisms*, trans. Samuel Weber and Shierry Weber
(Cambridge, MA, 1983), pp. 246–7.

50 In recent decades, the posthuman perspective has proposed that in
place of the former admonition never to treat humans like animals,
should be established one that demands that animals never be treated
like animals. Also widespread is the proposition, derived in part
from Adorno, that the animal and human bond is indissoluble. The
philosophers Giorgio Agamben and Bruno Latour are particularly
insistent upon the latter point. In Agamben's *The Open: Man and Animal*
(Stanford, CA, 2004), he describes the indistinctness of the genus
Primate, and seeks to evaluate, by means of an interrogation of the
work of Martin Heidegger, the very few metaphysical distinctions
between human and animal.

51 Jean-Paul Sartre, 'The Search for the Absolute', in *Theories and
Documents of Contemporary Art: A Sourcebook of Artists' Writings*, ed.
Kristine Stiles and Peter Howard Selz (Berkeley, CA, 1996), pp. 185–6.

52 Jean-Paul Sartre, 'Existentialism is a Humanism', trans. Philip Mairet;
text reproduced at www.marxists.org, accessed 20 February 2013.

53 Armin Zweite with Maria Muller, eds, *Francis Bacon: The Violence of the Real* (London, 2006), p. 91.
54 David Sylvester, *Interviews with Francis Bacon* (London, 1975), p. 23.
55 Georges Bataille, 'Slaughterhouse', trans. Annette Michelson, *October*, XXXVI (Spring 1986), pp. 10–13.
56 Ibid., p. 11.
57 David Plante, 'Bacon's Instinct', *New Yorker*, 1 November 1993, p. 96, cited in Matthew Gale and Chris Stephens, eds, *Francis Bacon* (New York, 2008), p. 28.
58 Sylvester, *Interviews*, p. 46.
59 Ibid., pp. 49–50.
60 Ibid., p. 125.
61 George Orwell, *Animal Farm* (New York, 1946), pp. 45; 70.
62 John Berger, *About Looking* (New York, 1992), p. 117.
63 George Orwell, 'Author's Preface to the Ukrainian Edition of *Animal Farm*', in *The Collected Essays, Journalism, and Letters of George Orwell*, ed. Sonia Orwell and Ian Angus, 4 vols, vol. III: *As I Please, 1943–1945* (New York, 1968), p. 406. There can be little doubt that Orwell understood the character of animal suffering and the yoke of human oppression. His essay 'Shooting an Elephant' [1936] describes the shooting of an elephant by an English policeman (possibly Orwell himself) in Burma. The death is long, slow and agonizing and described as utterly without redemption: 'I often wondered whether any of the others grasped that I had done it solely to avoid looking a fool.' George Orwell, *A Collection of Essays* (New York, 1981), p. 155.
64 On the myth that the Nazis used Jewish fat to make soap, see Ralph Klein, 'Der Wille zur Reinheit: Antisemitismus und hygienischer Furor', *Zeitschrift für Geschichtswissenschaft*, L/2 (2002), pp. 603–21. Also see Mark Jacobson, *The Lampshade: A Holocaust Detective Story From Buchenwald to New Orleans* (New York, 2010).
65 Giorgio Agamben, *Homo Sacer: Sovereign Power and Bare Life* (Stanford, CA, 1998), p. 171.
66 Susan Lumpkin and John Seidensticker, *Rabbits: The Animal Answer Guide* (Baltimore, MD, 2011), pp. 74–9.
67 Charles L. Cadieux, *Coyotes: Predators and Survivors* (Washington, DC, 1983), p. 51, cited in David Levi-Strauss, *Between Dog and Wolf: Essays on Art and Politics in the Twilight of the Millennium* (New York, 1999), http://luminer.org.
68 Cf. Claude Lévi-Strauss, *Structural Anthropology*, trans. Claire Jacobson (New York, 1963), pp. 224–26; *The Story of the Lynx* (Chicago, IL, 1996).

69 M. E. Gompper, 'Top Carnivores in the Suburbs? Ecological and
 Conservation Issues raised by Colonization of North-eastern North
 America by Coyotes', *BioScience*, LII (2002), pp. 185–190. Also see Stanley
 D. Gehrt, Seth P. D. Riley and Brian L. Cypher, eds, *Urban Carnivores:
 Ecology, Conflict, and Conservation* (Baltimore, MD, 2010), pp. 79–96.
70 Nichol Zurbrugg, *The Parameters of Postmodernism* (Carbondale, IL,
 1993), p. 112.
71 Marc Bekoff, ed., *The Encyclopedia of Animal Rights and Animal Welfare*
 (Santa Barbara, CA, 2010), p. 527.
72 The key book arising from this period was: Rosalind and Stanley
 Godlovitch and John Harris, *Animals, Men and Morals: An Inquiry
 into the Maltreatment of Non-humans* (London, 1971). On the history
 of the movement in the U.S., see Diane L. Beers, *For the Prevention
 of Cruelty: The History and Legacy of Animal Rights in the United States*
 (Athens, GA, 2006).

Conclusion: Art and Animals Right Now

1 In 2012, the annual expenditure on pets in the U.S. was $52.8
 billion, up from $29 billion a decade before. American Association
 of Pet Product Manufacturers 2012, 'Industry Trends', www.
 americanpetproducts.org, accessed 20 February 2013.
2 Oliver Goldsmith, *The Miscellaneous Works of Oliver Goldsmith*, vol. III:
 The Citizen of the World (Glasgow, 1816), p. 42.
3 On China's embrace of Western factory farming methods – including
 bear farming – and the concomitant rise of a movement for animal
 rights, see Paul Waldau, *Animal Rights, What Everyone Needs to Know*
 (Oxford, 2011), pp. 185–6; and Michael Charles Tobias, 'Animal Rights
 in China', 2 November 2012, www.forbes.com.
4 Jaak Panksepp, 'Cross-species Affective Neuroscience Decoding
 of the Primal Affective Experiences of Humans and Related Animals',
 PLOS ONE, VI/9.
5 Steven Best and Anthony Nocella II, *The Animal Liberation Front*
 (Herndon, VA, 2011). Also see www.animalliberationfront.com.
 There has recently emerged a group in Germany that combines animal
 and human rights beneath a broader banner of anti-capitalism:
 Assoziation Daemmerung. For its manifesto, see 'Social Theory,
 Ideology and Class Struggle', www.assoziation-daemmerung.de,
 accessed 20 February 2013.
6 R. Harrison, *Animal Machines: The New Factory Farming Industry*
 (London, 1964).

7 Earth Policy Institute, 'Data Highlights' (2012), www.earth-policy.org.
Also see Wilson J. Warren, *Tied to the Great Packing Machine: The Midwest
and Meatpacking* (Iowa City, IA, 2006).

8 Artist's website: www.caroleeschneemann.com. In a recent communi-
cation with the author, Schneemann wrote to deny any suggestion
that her work signalled indulgence, or that the rights of animals
were denied: 'My meaning/my intention/my motive had to do with
celebratory flesh – not that women are "mere meat", but that I as a
female artist envisioned and produced the sensuous ritual of *Meat
Joy*. My work with the body/with this "meat" has insisted on my
imagery of the pleasured female body, defined as a source of erotic
power in resistance to long-held male stereotypes. The premise
of *Meat Joy* is joy. (The chickens, sausages, and 24 mackerel active
in each performance of *Meat Joy* had to have a disclaimer that these
meats were too old for human consumption – this meat is not about
luxury or indulgence, it is about an extension of human physicality.)'

9 Daniel Birnbaum, 'Dieter Roth', *Artforum* (September 2003),
www.mutualart.com.

10 For information and links to poultry treatment, see www.upc-online.org.

11 Edwin Brock, *Invisibility is the Art of Survival* (New York, 1972), p. 46.

12 David Barboza, 'Goliath of the Hog World; Fast Rise of Smithfield
Foods Makes Regulators Wary', *New York Times*, 7 April 2000.

13 On the history of the gestation crate, see John C. McGlone, 'The Crate
(Stall, Cage, Box, etc.): Its History and Efficiency', www.depts.ttu.edu,
accessed 20 February 2013.

14 Stephen F. Eisenman, 'The Space of the Self: Robert Morris's *In the
Realm of the Carceral*', *Arts Magazine* (September 1980), pp. 104–9.

15 Mathew Gale, ed., *Dalí and Film* (London, 2007), pp. 207–8.

16 'Beef Giant Buys Assets in the U.S. and Australia', *New York Times*,
5 March 2008, Business News, p. C2.

17 Traci Hobson, 'Factory Farming in America: An Introduction',
www.isfoundation.com, accessed 20 February 2013.

18 Carol Andreas, *Meatpackers and Beef Barons* (Niwot, CO, 1994).
For an excellent summary of the history, see 'Montfort, Inc.', www.
answers.com, accessed 20 February 2013.

19 See, for example, Gary L. Francione and Robert Garner, *The Animal
Rights Debate: Abolition or Regulation?* (New York, 2010). Also, Sue
Donaldson and Will Kymlicka, *Zoopolis: A Political Theory of Animal
Rights* (Oxford and New York, 2011).

20 The writing on factory farming and public health is by now vast. The
following recent titles are a good introduction: Daniel Imhoff, *The*

CAFO Reader: The Tragedy of Industrial Animal Factories (Healdsburg, CA, 2010); Gail A. Eisnitz, Slaughterhouse: The Shocking Story of Greed, Neglect, and Inhumane Treatment Inside the U.S. Meat Industry (Amherst, NY, 2006); and Moby and Miyun Park, eds, Gristle (New York, 2010). For a general introduction to zoonotic diseases, see David Quammen, Spillover: Animal Infections and the Next Human Pandemic (New York, 2012). Also see 'Zoonotic Diseases: The Next Global Plague?', 8 March 2010, http://animalrighter.blogspot.com.

21 See An Pan et al., 'Red Meat Consumption and Mortality Results from 2 Prospective Cohort Studies', Archives of Internal Medicine, XLXXII/7 (9 April 2012), pp. 555–63. For an earlier, dissenting view with follow-up debate, see R. Micha, S. K. Wallace and D. Mozaffarian, 'Red and Processed Meat Consumption and Risk of Incident Coronary Heart Disease, Stroke, and Diabetes Mellitus: A Systematic Review and Meta-Aanalysis', Circulation, CXXI (2010), pp. 2271–83.

22 Robin Marks, Cesspools of Shame: How Factory Farm Lagoons and Sprayfields Threaten Environmental and Public Health (New York, 2001). Also see 'Facts about Pollution from Livestock Farms', www.nrdc.org, accessed 20 February 2013.

23 Mustafa Emirbayer, 'Manifesto for a Relational Sociology', American Journal of Sociology, CIII/2 (September 1997), pp. 281–3, 17.

24 See David M. Sluss and Blake E. Ashforth, 'Relational Identity and Identification: Defining Ourselves through Work Relationships', Academy of Management Review, XXXII/1 (2007), pp. 9–32; Mustafa F. Özbilgin, Relational Perspectives in Organizational Studies: A Research Companion (London, 2006); Jocelyn Downie and Jennifer J. Llewellyn, Being Relational: Reflections on Relational Theory and Health Law (Vancouver, 2012); Jon Mills, ed., Relational and Intersubjective Perspectives in Psychoanalysis: A Critique (Lanham, MD, 2005).

25 Alejandro F. Haber, 'Animism, Relatedness, Life: PostWestern Perspectives', Cambridge Archaeological Journal, XIX (2009), pp. 418–30.

26 Marilyn Strathern, The Gender of the Gift: Problems with Women and Problems with Society in Melanesia (Berkeley, CA, 1988), p. 131.

27 Nurit Bird-David, '"Animism" Revisited: Personhood, Environment, and Relational Epistemology', Current Anthropology, XL/SI (February 1999), pp. S67–S91.

28 Ingold writes: 'Responsiveness, in this view, amounts to a kind of sensory participation, a coupling of the movement of one's attention to the movement of aspects of the world. If there is intelligence at work here, it does not lie inside the head of the human actor, let alone inside the fabric of the tree. Rather, it is immanent in the total system

of perception and action constituted by the co-presence of the human and the tree within a wider environment'. Tim Ingold, *The Perception of the Environment: Essays on Livelihood, Dwelling and Skill* (London and New York, 2000), p. 74.

29 Bruno Latour, *We Have Never Been Modern* (Cambridge, 1993), pp. 142–5. Also Bruno Latour, 'From Realpolitik to Dingpolitik or How to Make Things Public', www.bruno-latour.fr, accessed 20 February 2013.

30 Ibid., p. 144.

31 M. Wells and R. Perrine, 'Critters in the Cube Farm: Perceived Psychological and Organizational Effects of Pets in the Workplace', *Journal of Occupational Health Psychology*, VI/1 (2001), pp. 81–7.

32 Froma Walsh, 'Human–Animal Bonds 1: The Relational Significance of Companion Animals', *Family Process*, XLVIII/4 (2009), pp. 466–7.

33 F. Walsh, *Normal Family Processes: Growing Diversity and Complexity* (New York, 2003), cited in Walsh, 'Human–Animal Bonds', p. 470.

34 G. F. Melson, 'Child Development and the Human–Companion Animal Bond', *Animal Behavioral Scientist*, XLVII/1 (2003), pp. 31–9.

35 Stephen Wise, *Drawing the Line: Science and the Case for Animal Rights* (New York, 2003); Cass Sunstein and Martha Nussbaum, *Animal Rights: Current Debates and New Directions* (Oxford and New York, 2005).

36 Eduardo Kac, *Telepresence and Bio Art: Networking Humans, Rabbits, and Robots* (Ann Arbor, MI, 2005).

37 On Abdessemed's other animal-based works, see Philippe-Alain Michaud, 'Abdessemed', in *Adel Abdessemed: À l'attaque* (Zurich, 2007), p. 49. On Hugo, see Pieter Hugo, *The Hyena and Other Men* (Munich, 2007). On Cattalan, see Nancy Spector, *Maurizio Cattelan: All* (New York, 2011).

38 See, for example, Steve Baker, *The Postmodern Animal* (London, 2000); *Picturing the Beast: Animals, Identity and Representation* (Champaign-Urbana, IL, 2001); and *Artist Animal* (Minneapolis, MN, 2013). Also see Giovanni Aloi, *Art and Animals* (London, 2011).

39 I take the castration anxiety to be operative for women as well as men. See Sandor Rado, 'Fear of Castration in Women', *Psychoanalytic Quarterly*, II/3–4 (July–October 1933), pp. 425–75.

40 Peter Singer, *Animal Liberation* (London, 1975), p. 163.

Further Reading

Adams, Carol J., *The Sexual Politics of Meat* (New York, 2000)

Agamben, Giorgio, *Homo Sacer: Sovereign Power and Bare Life* (Stanford, CA, 1998)

—, *The Open: Man and Animal* (Stanford, CA, 2004)

Aloi, Giovanni, *Art and Animals* (London, 2011)

Baker, Steve, *Artist Animal* (Minneapolis, MN, 2013)

—, *The Postmodern Animal* (London, 2000)

Balcomb, Jonathan, *Pleasurable Kingdom: Animals and the Nature of Feeling Good* (New York, 2006)

Beers, Diane L., *For the Prevention of Cruelty: The History and Legacy of Animal Rights in the United States* (Athens, GA, 2006)

Bekoff, Marc, ed., *The Encyclopedia of Animal Rights and Animal Welfare* (Santa Barbara, CA, 2010)

Berger, John, 'Why Look at Animals?', in *About Looking* (New York, 1992), pp. 3–28

Best, Steven, and Anthony Nocella II, *The Animal Liberation Front* (Herndon, VA, 2011)

Bewick, Thomas, *A Memoir of Thomas Bewick Written by Himself* (Newcastle upon Tyne, 1862)

Boehrer, Bruce, *A Cultural History of Animals in the Renaissance* (Oxford, 2009)

Bulliet, Richard W., *Hunters, Herders, And Hamburgers: The Past and Future of Human–animal Relationships* (New York, 2005)

Cavalieri, Paola, and Catherine Woollard, *The Animal Question: Why Non-human Animals Deserve Human Rights* (Oxford and New York, 2001)

Clark, Willene B., and Meradith T. McMunn, eds, *Beasts and Birds of the Middle Ages: The Bestiary and Its Legacy* (Philadelphia, PA, 1991)

Collins, Billie Jean, ed., *A History of the Animal World in the Ancient Near East* (Leiden and Boston, MA, 2002)

Darwin, Charles, *The Descent of Man* (New York, 1871)

—, *The Expression of the Emotions in Man and Animals* (London, 1873)

Derrida, Jacques, *The Animal that Therefore I Am*, ed. Marie-Louise Mallet, trans. David Wills (New York, 2008)

—, *The Beast and the Sovereign*, trans. Geoffrey Bennington (Chicago, IL, 2011), vol. I

Donaldson, Sue, and Will Kymlicka, *Zoopolis: A Political Theory of Animal Rights* (Oxford and New York, 2011)

Dunayer, Joan, *Speciesism* (New York, 2004)

Egerton, Judy, *George Stubbs, Painter* (New Haven, CT, and London, 2007)

Eisenman, Stephen F., *The Abu Ghraib Effect* (London, 2007)

Eisnitz, Gail A., *Slaughterhouse: The Shocking Story of Greed, Neglect, and Inhumane Treatment Inside the U.S. Meat Industry* (Amherst, NY, 2006)

Evans, E. P., *The Criminal Prosecution of Animals* (New York, 1906)

Francione, Gary, and Robert Garner, *The Animal Rights Debate: Abolition Or Regulation?* (New York, 2010)

Freud, Sigmund, 'Analysis of a Phobia in a Five-year-old Boy', in *The Sexual Enlightenment of Children* (New York, 1974)

Fudge, Erica, *Brutal Reasoning: Animals, Rationality, And Humanity in Early Modern England* (Ithaca, NY, 2006)

—, ed., *Renaissance Beasts: Of Animals, Humans, and Other Wonderful Creatures* (Bloomington, IN, 2004)

Gay, John, *Fables* (London, 1801)

Godlovitch, Rosalind and Stanley, and John Harris, *Animals, Men and Morals: An Inquiry into the Maltreatment of Non-humans* (London, 1971)

Grandin, Temple, *Animals Make Us Human* (Orlando, FL, 2009)

Grandville, J.J., *Scènes de la vie privée et publique des animaux* (Paris, 1842)

Greene, Ann Norton, *Horses at Work: Harnessing Power in Industrial America* (Cambridge, MA, 2008)

Griffin, Donald R., *Animal Minds: Beyond Cognition to Consciousness* (Chicago, IL, and London, 2001)

Harrison, R., *Animal Machines: The New Factory Farming Industry* (London, 1964)

Horkheimer, Max, and Theodor W. Adorno, *Dialectic of Enlightenment*, trans. John Cumming (New York, 1972)

Imhoff, Daniel, *The CAFO Reader: The Tragedy of Industrial Animal Factories* (Healdsburg, CA, 2010)

Ingold, Tim, *The Perception of the Environment: Essays in Livelihood, Dwelling and Skill* (London and New York, 2000)

—, *What is an Animal?* (London, 1988)

Kafka, Franz, *The Penal Colony: Stories and Short Pieces*, trans. Willa and Edwin Muir (New York, 1948)

La Fontaine, Jean de, *Fables de La Fontaine*, illustrated by J.J. Grandville
 (Paris, 1838)
La Mettrie, Julien Offray de, *Man a Machine* (London, 1750)
Latour, Bruno, *We Have Never Been Modern* (Cambridge, 1993)
Lawrence, John, *A Philosophical and Practical Treatise on Horses, and on the
 Moral Duties of Man Towards the Brute Creation* (London, 1802)
Lee, Paula Young, *Meat, Modernity, and the Rise of the Slaughterhouse* (Durham,
 NC, 2008)
Lewis, Jayne Elizabeth, *The English Fable: Aesop and Literary Culture, 1651–1740*
 (Cambridge, 1995)
Linzey, Andrew, ed., *The Link Between Animal Abuse and Human Violence*
 (Eastbourne, 2007)
Lovejoy, A. O., *The Great Chain of Being: A Study in the History of an Idea*
 (Cambridge, 1936)
Loveridge, Mark, *A History of Augustan Fable* (Cambridge, 1998)
McShane, C., and J. A. Tarr, *The Horse in the City: Living Machines in the Nine-
 teenth Century* (Baltimore, MD, 2007)
Moby and Miyun Park, eds, *Gristle* (New York, 2010)
Works of Michel de Montaigne, ed. W. Hazlitt and W. O. Wight (Boston, MA,
 1879)
Morgan, Lewis Henry, *The American Beaver and his Works* (Philadelphia, PA,
 1868)
Morse, Deborah Denenholz, and Martin A. Danahay, eds, *Victorian Animal
 Dreams: Representations of Animals in Nineteenth-century Literature and
 Culture* (Aldershot, 2007)
Oliver, Kelly, *Animal Lessons: How they Teach us to be Human* (New York, 2009)
Oswald, John, *The Cry of Nature* (London, 1791)
Orwell, George, *Animal Farm* (New York, 1946)
Panksepp, Jaak, 'Cross-species Affective Neuroscience Decoding of the
 Primal Affective Experiences of Humans and Related Animals', PLOS
 ONE, VI/9 (2011), pp. 1–15
Patterson, Charles, *Eternal Treblinka: Our Treatment of Animals and the
 Holocaust* (New York, 2002)
Preece, Rod, *Sins of the Flesh: A History of Ethical Vegetarian Thought* (Vancouver,
 2008)
Quammen, David, *Spillover: Animal Infections and the Next Human Pandemic*
 (New York, 2012)
Regan, Tom, *The Case for Animal Rights* (Berkeley, CA, 1980)
Ritson, Joseph, *An Essay on Abstinence from Animal Food: As a Moral Duty*
 (London, 1802)
Ritvo, Harriet, *The Animal Estate: The English and Other Creatures in the Victorian*

Age (Cambridge, 1989)

Rousseau, J.-J., *A Discourse upon the Origin and Foundation of the Inequality among Mankind* (London, 1761)

Rudy, Kathy, *Loving Animals: Towards a New Animal Advocacy* (Minneapolis, MN, 2011)

Salt, H. S., *Animal Rights: Considered in Relation to Social Progress* (New York and London, 1892)

Schapiro, Norman, trans., *The Complete Fables of Jean de La Fontaine*, introduction by John Hollander (Champaign, IL, 2007)

Shipman, Pat, 'The Animal Connection and Human Evolution', *Current Anthropology*, LI/4 (August 2010), pp. 519–25

Shukin, Nicole, *Animal Capital: Rendering Life in Biopolitical Times* (Minneapolis, MN, 2009)

Sinclair, Upton, *The Jungle* (New York, 2006)

Singer, Peter, *Animal Liberation* (London, 1975)

Smith, Jonathan, *Charles Darwin and Victorian Visual Culture* (London and Cambridge, 2006)

Sorabaji, Richard, *Animal Minds and Human Morals* (Ithaca, NY, 1993)

Spiegel, Marjorie, *The Dreaded Comparison: Human and Animal Slavery* (New York, 1996)

Steiner, Gary, *Animals and the Moral Community: Mental Life, Moral Status, and Kinship* (New York, 2008)

Stuart, Tristram, *The Bloodless Revolution: A Cultural History of Vegetarianism from 1600 to Modern Times* (New York and London, 2007)

Sunstein, Cass, and Martha Nussbaum, *Animal Rights: Current Debates and New Directions* (Oxford and New York, 2005)

Sylvester, David, *Interviews with Francis Bacon* (London, 1975)

Thomas, Keith, *Religion and the Decline of Magic* (Oxford and New York, 1997)

Toogood, John, *The Duty of Mercy and Sin of Cruelty to Brutes, taken chiefly from D. Primatt's dissertation* (Boston, MA, 1802)

Waldau, Paul, *Animal Rights: What Everyone Needs to Know* (Oxford, 2011)

Wheelock, Whitney, *Géricault in Italy* (New Haven, CT, and London, 1997)

Wise, Stephen, *Drawing the Line: Science and the Case for Animal Rights* (New York, 2003)

Wollstonecraft, Mary, *Original Stories from Real Life: With Conversations, Calculated to Regulate the Affections* (London, 1796)

Young, Thomas, *An Essay on Humanity to Animals* (London, 1798)

Zweite, Armin, and Maria Muller, *Francis Bacon: The Violence of the Real* (London, 2006)

Acknowledgements

The path to this book has been circuitous and involved such complex matters as friends, lovers, animal companions (pets), and diet (vegan) as well as libraries and art museums. It would therefore be impossible to adequately acknowledge everyone who made this book possible without writing an autobiography. But a few people must be specifically thanked for reading parts of the manuscript, facilitating research, offering ideas and references, or simply providing essential friendship while the book was composed: Rick Brettell, Sue Coe, David Craven, Carol Duncan, Fay Duftler, Echo, Sarah Eisenman, Robert Essick, Hannah Feldman, Harriet Festing, Julie Fohrman, Andrew Hemingway, Hannah Higgins, David James, Paul Jaskot, Jessica Keating, Susan King, Brian Lukacher, Peter Maunu, Irmi Maunu-Kocian, Moose, Linda Nochlin, Nigel Reading, Laurie Jo Reynolds, Evie Rooth, Christopher Pinney, Pepper, Ellen Strauss, Charles Stuckey and Robin Whatley. I am also grateful to two sets of Northwestern University art history graduate students for their questions and insights during seminars devoted to art and animal rights.

Photo Acknowledgements

The author and publishers wish to express their thanks to the below sources of illustrative material and/or permission to reproduce it. (Some locations of artworks are also given below.)

Alte Pinakothek, Munich: p. 76; Art Institute of Chicago: pp. 42, 171, 192, 231; © 2013 Artists Rights Society (ARS), New York / VISCOPY, Australia: p. 36; Ashmolean Museum, Oxford: pp. 57, 58; © 2013 The Estate of Francis Bacon – all rights reserved ARS, New York / DACS, London: pp. 230, 231; from Thomas Bewick, *The Fables of Aesop and Others* (Newcastle upon Tyne, 1818): p. 140 (top); from Thomas Bewick, *History of British Birds* (Newcastle upon Tyne, 1804): p. 140 (foot); © Nick Brandt: p. 257; British Museum, London (photos © The Trustees of the British Museum, London): pp. 12, 13, 14, 15, 51, 52, 53, 54; Capitoline Museum, Rome: p. 113; Cleveland Museum of Art, Ohio: p. 92; copyright © 2012 Sue Coe, courtesy Galerie St Etienne, New York: pp. 245, 246, 259; Columbus Museum of Art, Columbus, Ohio: p. 191; from Charles Dickens, *Oliver Twist* (London, 1838): pp. 175, 176; from *The Fables of La Fontaine* (London, 1885): p. 210; from John Gay, *Fables* (London, 1727): pp. 94, 95; photo by Al Giese, courtesy Carolee Schneeman: p. 243; from J.J. Grandville, *Scenes de la Vie Privee et Publiques des Animaux* (Paris, 1842): p. 160; Philippe Halsman / Magnum Photos: p. 247; Harvard Art Museum / Fogg Art Museum, Cambridge, Massachusetts (photo Imaging Department, © President and Fellows of Harvard College): p. 17; © J. Paul Getty Museum, Malibu, California: p. 86; Kenwood House, London: p. 99; from Roger L'Estrange, ed., *Aesop's Fables* (London, 1693): p. 87; Lady Lever Art Gallery, Port Sunlight: p. 177; from John Caspar Lavater, *Essays on Physiognomy, Designed to Promote the Knowledge and the Love of Mankind*, vol. II (London, 1792): p. 148; from Lewis Henry Morgan, *The American Beaver and his Works* (Philadelphia, 1868): p. 25; Metropolitan Museum of Art, New York: pp. 111, 181; Minneapolis Institute of Arts: pp. 168, 216;

Musée des Beaux-Arts, Lons le Saunier: p. 183; Musée de la Chasse et de la Nature, Paris: p. 91; Musée Cognacq-Jay, Paris: p. 102; Musée du Louvre, Paris: pp. 75, 89; Musées Royaux des Beaux-Arts, Brussels: pp. 68, 70; Museo Reina Sofía, Madrid: p. 214; Museum of Fine Arts, Boston: p. 78; Museum of Modern Art, New York: p. 230; National Gallery, London: pp. 62, 146; National Gallery of Canada, Ottawa: p. 41; from George Nicholson, *On the Conduct of Man to Inferior Animals; on the Primeval State of Man; Arguments from Scripture, Reason, Fact and Experience, in favour of a Vegetable Diet; On the Effects of Food; On the Practice of Nations and Individuals; Objections Answered; &c. &c.* (London, 1797): p. 138; North Carolina Museum of Art, Raleigh: p. 71; from John Oswald, *The Cry of Nature* (London, 1792): p. 11; © 2013 Estate of Pablo Picasso / Artists Rights Society (ARS), New York: p. 214; private collections: pp. 16, 35, 169, 245, 246, 259; Sammlung E. G. Bührle, Zürich: p. 217; from George Stubbs, *The Anatomy of the Horse* (London, 1766): p. 115; from George Stubbs, *A Comparative Anatomical Exposition of the Structure of the Human Body with that of a Tiger and a Common Fowl* (London, 1817): pp. 116, 117; Tate, London: pp. 179, 180; art © Estate of Simon Tookoome / CARCC, Ottawa / VAGA, New York: p. 35; Walker Art Gallery, Liverpool: pp. 118, 119; Walters Art Museum, Baltimore: p. 154; Watts Gallery, Compton, Surrey: p. 209; from *Mary Wollstonecraft's Original Stories* (London, 1806): p. 127; Yale Center for British Art, New Haven: p. 112; York Art Gallery: p. 77; © 1976 Zipporah Films, Inc.; all rights reserved: p. 250.

Index